TRUTH
NEEDS NO
ALLY

TRUTH NEEDS NO ALLY

Inside Photojournalism

Howard Chapnick

University of Missouri Press Columbia and London

Library of Congress Cataloging-in-Publication Data

Chapnick, Howard.

 Truth needs no ally : inside photojournalism / Howard Chapnick.

 p. cm.

 Includes bibliographical references and index.

 ISBN 0-8262-0955-6 (paper)

 1. Photojournalism—Vocational guidance. I. Title.

TR820.C5235 1994

778.9'907049—dc20 94–6737

 CIP

Designer: Kristie Lee

Typesetter: Connell-Zeko Type & Graphics

Printer and Binder: Walsworth Publishing Company

Typefaces: Times and Avenir

To Jeanette

Contents

All Aspects of Fulfillment: The Evolution of Your Career in Photojournalism

Truth Needs No Ally: Creative and Ethical Issues in Photojournalism

Acknowledgments

That I, known to my family, friends, and loved ones as "the great procrastinator," should have finished this voluminous work is one of the great miracles of the twentieth century. I knew that there were thoughts, philosophical and pragmatic, dancing around in my head that could be of value to this and future generations of photojournalists. I also knew that baseball, basketball, and football games would intrude on my concentration, that it would be a continual battle to sit at the word processor, fighting my natural tendencies toward lethargy and lassitude.

This book is first of all a tribute to my Kaypro word processor, whose receptive keyboard allowed me the luxury of disciplined, well-ordered thoughts. Without the assistance of my Kaypro mentor, Jim Hughes, to solve all my computer problems, this book would not have been possible. And without the technical assistance of Hung Quach, who kept the word processor and printer alive, I would have been equally helpless.

This book is dedicated to Jeanette. Jeanette is my sweetheart, my wife, my friend, my lover, my truth, my ally, and my rock. She believed in me when I doubted myself. She helped me to simplify my circumlocutions, to clarify my obfuscations, and to keep my writing to the central core of the work—photojournalism. My dedication to her is accompanied by love, respect, and admiration for a great lady.

Thanks to Maureen Graney, an extraordinary editor, whose incisive intellect and excisive editing improved every page. She understands and loves photography and photographers. Her demands for clarity and conciseness were always with me. She shaped my thinking and expanded my mind. Above all she is a gentle and considerate person.

And a special thanks to my literate friend Alice Wolff, mistress of the precise word. She was constructive in her criticism and gracious in her praise while reading the manuscript line by line and eliminating redundancies and hyperbole.

And to all the photographers whose lives have been intertwined with mine

through the years, this is their book. What I have learned and what I pass along is the sum of all our mutual experiences, our successes and failures, moments of glory and of disappointment. Naming all the photographers is impossible, but indulge me my thanks to John Launois, Dennis Brack, Fred Ward, David and Peter Turnley, Christopher Morris, Anthony Suau, Werner Wolff, Arnold Zann, Flip Schulke, Ivan Massar, Lee Lockwood, Brian Lanker, Emil Schulthess, Thomas Sobolik, W. Eugene Smith, David Moore, Matt Herron, Eugene Anthony, Charles Moore, Lynn Johnson, Donna Ferrato, Robert Ellison, James Balog, Joseph Rodriguez, Carl Mydans, Archie Lieberman, Jim Sugar, Stephen Shames, Declan Haun, and countless others.

Thanks to Cornell Capa, my "Mr. Terrific," whose confidence, support, and enthusiasm knew no bounds.

Thanks to Black Star for being there to support my ideas. To Ben Chapnick, whose business acumen allowed me the luxury of pursuing them. To Yukiko Launois, for her love, warmth, loyalty, and devotion, and her special assistance in helping me choose the photographs for this book. To Phil and Dorothy Rosen, who helped me overcome the struggles associated with the early years of my stewardship of Black Star.

Thanks to Vi and Cliff Edom and the University of Missouri Workshop for teaching me about photojournalism. They expanded my horizons. I never saw pictures the same way, or thought about them as I had previous to my association with the workshop. They opened my world to people like Bob Gilka, Bill Garrett, Earl Seubert, Rich Clarkson, Russell Lee, Bill Strode, Bill Eppridge, Angus McDougall, Ken Paik, Bill Kuykendall, and Sandra Eisert.

And thanks to Ron Myerson of Ron Myerson Design, a colleague and friend, who used his desktop publishing expertise to develop a design concept for this book.

And to my daughters, Ilene and Denise, sons-in-law, Larry and Tom, grandkids, Kristin and Jeff, thanks for your encouragement and good wishes.

All would have been in vain without Beverly Jarrett's faith and Sara Fefer's meticulous editing on behalf of the University of Missouri Press.

TRUTH
NEEDS NO
ALLY

Introduction

The invention of the camera will rank with the invention of the printing press as a dominating influence in human development. For thousands of years, words have shaped our consciousness. For the last century and a half, the spoken and written word have had to share the spotlight with an all-pervasive, ever-intrusive upstart—the photograph.

This new visual phenomenon has already altered the course of history and promises to have even greater impact on the future. Photography is a language. Like music, it is a language that all mankind can understand. Photography cuts across the boundary of illiteracy that isolates much of the world's population.

The photograph does not exist in a communications vacuum. It almost always needs amplification with words and graphics. It propagandizes and memorializes, and it penetrates the human psyche. The Thematic Apperception Test (TAT), used extensively by clinical psychologists in connection with the Rorschach Test and other techniques, makes use of the interpretation of photographs to evaluate personalities.

Above all, the photograph is ubiquitous. It is integral to every facet of the human experience—education, information, business, science, medicine, art, architecture, geology, anthropology and space exploration, among others. The invention of the camera and film generated a need for individuals who could make constructive use of this instrument.

Under the umbrella of photography exist photographers of great diversity in their interests and approaches. Contemporary photographers are rarely generalists; they may shoot weddings, portraits, commercial or studio work, art, or architecture. And then there is a very special breed of photographer who thrives in a challenging, story-telling, sometimes dangerous profession called "photojournalism." This genus of photographer we label "photojournalist."

This book is addressed to the photojournalist. I speak not only to the professional whose credit line appears in the pages of our most distinguished magazines, but also to the aspiring photojournalist struggling for recognition, the university student refining his or her technique and communicative skills;

1

I speak to all those who use the camera as a medium for personal expression.

For five decades, I was associated with Black Star, a photographic agency in the business of representing photojournalists. Those years allowed me the opportunity to confront the important questions of survival and achievement or failure in this quixotic profession. From the knowledge I have accumulated through the years, I would like to share what I think are the ingredients for a rewarding career in photojournalism. If you think that in the book you will find an instant road to success, don't read further. Rush to your bookstore and get your money back.

Formulas for "instant success" I leave to charlatans and spinners of dreams. My lexicon includes words like dedication, commitment, and hard work. There are no substitutes for them and no way to circumvent them. Occasionally, a dilettante will become a successful photojournalist, but that's a rarity. Boors, bores, airheads, and dolts sometimes make it, but more often they fail. The race in photojournalism is won by the ultimate professionals—the craftspeople—those who are the most creative, the most reliable, and the hardest working.

This is a book about ideas and philosophies: how to take meaningful and content-filled photographs, how to put together a portfolio that will work for you and not against you. If your interest is in technical information, f-stops, exposure ratings, or photographic gadgetry, hasten to get your money back. This book will not help you.

The photographic marketplace is burgeoning with ever-new and ever-more-sophisticated uses of the still photograph. The promise of the future more than equals the explosion of knowledge of the past. Just as important is the changing perception of photojournalists by cultural aesthetes as well as the general public.

LIFE and *Look* magazines glorified the photojournalistic profession by establishing cult heroes and heroines like W. Eugene Smith, Philippe Halsman, Alfred Eisenstadt, Robert Capa, and Margaret Bourke-White. The proliferation of galleries selling photographs as art and the establishment of permanent photographic collections in museums has enhanced the photojournalist's cachet.

There are many roads that lead to photography's Shangri-la. It was once said that "every man is entitled to his favorite brand of insanity." Mine is photography. I still get excited by a great photograph or a moving photographic essay. Joel Meyrowitz, in talking about photography, said—"Aha! I'll tell you what it is. It's like falling in love."

I couldn't say it any more simply or any better. My fifty-year love affair with photojournalism has often been tested, bringing worry, pain, or disappointment. But like my love affair with my wife, comprising the same years, it has been one of my great passions, and it has made life worthwhile. I have been accused of being naive, uncompromising, and simplistic in my belief that photography can light up the dark corners of a tormented and difficult world. If I'm guilty, I make no apologies.

So, please join me as I leave behind the fantasies of academe and explore the labyrinth of the contemporary world of photojournalism.

THE VISUAL BIOGRAPHY OF MAN ON EARTH

The Foundation of Photojournalism

Photojournalism as Eyewitness
to History

Each day as the earth revolves towards sunrise, members of a select human species awaken to observe the world with three eyes instead of two. They are the press photographers of the world, men and women who write the visual biography of man on earth.

John G. Morris, *World Press Photo Yearbook*

The twentieth century belongs to the photojournalists. They have provided us with a visual history unduplicated by images from any comparable period of human existence. Whereas once we relied on cave paintings or artists' interpretations of events, photographic images have become transcendent. The camera, in the hands of well-educated and well-informed photographers, provides us with images of unprecedented power and indisputable information about the world in which we live—its struggles and its accomplishments. It is the tool that gives us photographs, the ultimate in anthropological and historical documents of our time. To ignore photojournalism is to ignore history.

Photojournalism is rooted in the consciousness and consciences of its practitioners. The torch of concern, a heritage of humanistic photography, has been passed from generation to generation, lighting the corners of darkness, exposing ignorance, and helping us to understand human behavior. It bares the truth and

Eyes of Time: Photojournalism in America is a book that documents the history of photojournalism in America. My foreword to that book best summarizes my understanding of photojournalism and the people who practice it. This is a slightly altered version of that foreword.

sometimes it lies. It informs, educates, and enlightens us about the present, and it illuminates the past. It records beauty and ugliness, poverty and opulence.

Communication and content are photojournalism's cornerstones. Photographs tell us about people and emotions, about how we deal with celebration and suffering, about understanding nature and the physical environment. The finite proportions of the photographic frame of whatever format dictate the limitations of content. The perceptive photojournalist gives us as much information as the frame will allow—from left to right, top to bottom, foreground, middle ground, and background. Top-quality photojournalistic pictures communicate simply and directly. They create order out of chaos, extract rationality from the irrational, and distill the essential elements from complex situations. They require a strong center of interest, dynamic body language, dramatic light, and good composition, and they demonstrate technical proficiency. The great photojournalists of yesterday, today, and tomorrow aim for deeper revelation and insight through their capture of spontaneous, unposed, and surprising moments.

Contemporary photographic wisdom owes a debt to the past. Dorothea Lange, humanist and photodocumentarian, based her photographic philosophy on Sir Francis Bacon's admonition that "the contemplation of things as they are, without substitution or imposture, without error and confusion, is in itself a nobler thing than a whole harvest of invention."

Photojournalists are nomads; their arena is the world. The realities of that world are markedly different from the preconceived and romantic illusions derived from film and television representations. Photojournalism is a demanding profession. Some view it as a calling. It's "down and dirty" rather than "glamour and glitz." The dashing, madcap, trench-coated heroics of a Robert Capa, or Margaret Bourke-White's hobnobbing with the greats of the world are legend, but legends do not speak to the personal privation and loneliness endured by photojournalists or the incredible pressures to perform and deliver to order under which they must work.

Photojournalists need boundless energy, unflagging enthusiasm, a spirit of adventure, the ability to survive under difficult conditions, and the courage to confront danger. Photojournalism is all-consuming, which makes for lonely mates as well as neglected children. It is also frenetic, exciting, challenging, and sometimes dangerous.

Photojournalists sometimes chronicle a world of simple pleasures and routine existence: a festival, a political campaign, a family reunion. And sometimes they explore private worlds, revealing the complex personalities of the great, the powerful, the simple, and the ordinary. But more often, photojour-

nalists' concerns are the natural or man-made disasters afflicting this planet—war, poverty, famine, drought. Their mind-searing images allow us to better understand the impact of those events on human beings. Photojournalists are a very special breed; each one hears the click of a different shutter. Photojournalists are rarely objective. They have a collective commitment to truth and reality.

My eyes have seen both the best and the worst of times for photojournalism. I shared the halcyon days when *LIFE* and *Look* were charting new photojournalistic waters. I witnessed the meteoric rise of innumerable new stars in the photojournalistic constellation whose names are unrecognizable today. The 1950s and 1960s were years of heady optimism and exciting journalistic challenges. I participated in the form of storytelling developed by W. Eugene Smith and Leonard McCombe, who wove pictures and text into photographic essays, creating a new communicative art form, by encouraging photographers to pursue photographic essays and expand their storytelling abilities.

Today's practitioners are better informed and more concerned about the world in which we live than were their predecessors. Contemporary photojournalists are reaching deeper, pushing the camera and subject matter beyond what were considered absolute limits. No subject matter, sacred or profane, has been excluded from their vision. They give a voice to the voiceless, power to the powerless, and help to the helpless. These photojournalists are everywhere: on staff at newspapers or magazines or working independently as freelance photographers for magazines, book publishers, or photographic agencies. They have shown us both ourselves and the world. And sometimes, in the process, they have died. And each time, at the inevitable somber ritual memorials that follow their deaths, we are reminded that the photographic community is a small family.

Even bored and jaundiced viewers assaulted by and satiated with visual imagery cannot help but respond to the sometimes profound, sometimes complex, sometimes painful pictures published in the world's press. Social critics and observers, who use very sophisticated techniques to penetrate the collective mind, tell us that we have been overwhelmed with images of violence, desensitized by pictures of war and suffering, that we have reached the limit of visual obscenity in documenting the wars of the last fifty years. Some editors and publishers of our most successful magazines subscribe to that thesis. The result is the publication of pictures that trivialize the profound and glorify the trivial.

High-quality journalism chooses reality over escapism, words and pictures presented with maturity, judgment, and analysis rather than blandness or vac-

uousness. The best of our photojournalists are not concerned with the sensibilities of their viewers. They do not shrink from the unpleasant or the controversial. They recognize the need for the visual recording of some of the unspeakable actions of man in this supposedly enlightened century.

Still photographs have been characterized as "frozen moments in time." Pictures of the heap of bodies in the charnel of Buchenwald, the dead from the My Lai massacre in Vietnam, and napalmed Vietnamese children running naked down the road reflect the circle of madness, death, destruction, and despair of our time. The power of these images lies in their implausibility, in their unique quality, according to writer Marvin Krone, "to preserve forever a finite fraction of the infinite time of the universe." They establish the truth of events that seem inconceivable. Their recording of history protects the facts from willful reinterpretation by those who do not accept the existence of a Holocaust or similar excesses committed in the name of patriotism.

"This is what photojournalism is all about," says a *Time* promotional booklet. "Halting the rush of impressions and singling out the one image that will capture the essence of the story. Indeed, it is the very absence of motion that gives the great photograph its unique qualities. It arrests the eye, invites reflection, provokes emotion. It is the experience shared, the moment preserved. Motionless, they move. Silent, they speak. And we are gifted with a larger vision of the world."

For almost five decades as a photographic agent and picture editor, I have vicariously experienced the great events of our times through the magic of pictures and expanded my world. I have been to Omaha Beach, Guadalcanal, and Saipan; I have walked alongside Martin Luther King, Jr., and James Meredith in the triumph of the civil rights struggle; I have grieved for the dead in the seemingly continuous wars—in Korea, Vietnam, Afghanistan, and Bangladesh—in a litany of what were once remote countries with unfamiliar names.

Photojournalists have taken me everywhere. As frontline witnesses, they have captured events to form a visual time capsule for our own generation and those to follow. Many photojournalists live on the razor's edge of personal danger and hardship so that they may bring us images of almost unbearable reality. They construct for us a bridge to better understanding of this complicated and interdependent world, and their efforts enrich journalism, enhance knowledge, and ennoble our profession.

Realism and the Receptive Eye:
The Responsibilities of Documentary
Photography

You know, so often it's just sticking around and being there, re-
maining there, not swooping out in a cloud of dust; sitting down
on the ground with people, letting children look at your camera
with their dirty, grimy little hands, and putting their fingers on the
lens, and you let them, because you know that if you will behave in
a generous manner, you're very apt to receive it, you know?

Dorothea Lange, *Dorothea Lange:*
Photographs of a Lifetime

In his foreword to a photographic book called *Appalachia: A Self Portrait,*
sociologist Robert Coles quotes a 1950 letter physician/poet William Carlos
Williams wrote to a friend:

> I try to take care of the sick, needy; but I keep my eye on them, because
> down and out as they are in Paterson, New Jersey, they have a lot to teach me.
> Sometimes I'll be driving home, and I'll see the people I've met that day in
> my mind's eye, as clear as can be. When I write my poems, I'll try to hand
> over what I've seen to others, through words. If I were a photographer, I'd
> send out pictures.

Can Photography Change the World?

Those who say that photographs cannot make a difference have not thought
the matter through. More to the point are the specific questions of whether
photographs can change public perceptions on social issues, stimulate people

to be more active in support of their causes, affect the ways in which people live and governments conduct business. During my lifetime in photojournalism, photography has had a profound effect on people's understanding of the world in which they live and on their perceptions of important social and political issues.

I have seen international political figures defined by the moments captured by enterprising and resourceful photographers. If any doubt remained that the earth was round, the breathtaking images taken from space showed us how perfectly spherical the earth is. Photography has been a valuable tool for the anthropologist working in the field. And our understanding of how the human body works has been immeasurably enhanced through the use of macro-, micro-, x-ray, and scanning electron microscopic photography. The photographs in Lennart Nilsson's landmark work show us how the sperm and ovum unite during conception. He has also shown us the different stages of embryonic development. Photography has revealed to us the natural world and how animal societies function. Even before the development of the motion picture camera, Eadward Muybridge used still photography to capture sequential human and animal locomotion.

Photojournalism has not stopped wars, eliminated poverty or conquered disease, but neither has any other medium or institution. Photojournalism was, however, influential in making plain to the American people and to the world the obscenities of the Vietnam War, and it affected the way the government conducted its war in the Gulf. Photojournalism helped to focus attention on and bring aid to the Sahel millions dying of famine and drought in the early 1980s. A decade later, the famine induced by the callous war lords of Somalia once again became the focus of caring photojournalists. They helped to awaken public sympathy and mobilize international support for relief of the populace and intervention by the United Nations in that troubled area. W. Eugene Smith personalized the impact environmental pollution has on people. His photographs showed the deformities caused by exposure to industrial mercury wastes being poured into the waters around Minamata, a fishing village in Japan. I think back to the work of Black Star photographers during the civil rights struggle of the 1960s—in Birmingham and Selma, Alabama, in Oxford, Mississippi, in Washington, D.C., Detroit, and Baltimore. It was a significant factor in how Americans ultimately perceived that movement—one of the major social milestones in the nation's history.

Even in an image-surfeited world, where television is increasingly influential, it is more often the powerful still photojournalistic image that burns itself into the consciousness of the viewer. Still images no longer survive in a visual

vacuum, but rather exist in a symbiotic and synergistic relationship to film, video, and text; each medium reinforces the others for cumulative impact. Photography more than holds its own.

Photojournalists in the employ of newspapers, magazines, and wire services, or freelance photographers pursuing the profit motive are often perceived as being unrelated to the artistic community. But documentary photographers, like poets, painters, and other artists, act as our collective conscience. Walt Whitman and Yevtushenko, Goya and Picasso, lived in different centuries and on different continents, but through all their work ran a common thread of protest against war and violence.

Photography, as witness to history, gives testimony in the court of public opinion. Photojournalists are the bearers of that witness. For example, today's historical revisionists who deny the Holocaust ever happened are rebutted by photographic evidence. Margaret Bourke-White's haunting picture of Buchenwald inmates, made on April 11, 1945, two days after the arrival of American troops, stands as a testament to the brutality and horror of the German concentration camps. Pictures of mounds of naked corpses piled into mass graves will forever serve as a visual memorial to the eight million dead Jews, gypsies, and other victims of the Holocaust.

On January 20, 1942, representatives of Germany's Nazi Party, the Gestapo, and the German Foreign, Interior, and Justice ministries met in a Wannsea villa and decreed the "final solution," the extermination of Europe's eleven million Jews. Fifty years later, that villa houses a photographic exhibition that strikes a stark and powerful blow for historic truth. Today's Germans are exposed to photographs of Jews being arrested and herded into the trucks and railroad cars that would take them to be slaughtered in Nazi death camps.

We know that My Lai happened because Ron Haeberle's photographs told us so. We know that at Kent State a student demonstration against the Vietnam War ended in a rain of bullets from the guns of inexperienced, trigger-happy National Guardsmen. John Filo's photograph captures the anguished cry of a young girl mourning the death of a protester. Despite the Chinese government's protestations of innocence, we know that a massacre took place in Beijing's Tiananmen Square on June 4–5, 1989, because there were courageous photographers on the scene who braved death to record it.

Photojournalists are not always aware that the pictures taken today are the history of tomorrow, or that pictures taken for specific editorial purposes may resonate beyond their original boundaries, having a far-reaching impact on the public's consciousness, or indeed that the world is made better by their being taken.

Elie Wiesel: The Responsibility to Remember

Elie Wiesel received the 1986 Nobel Peace Prize. Although he is not a photographer or a photojournalist, his acceptance speech at the Oslo ceremony goes to the very roots of photojournalistic credos and responsibilities. It evokes images of Nazi Germany, under which millions of Jews, Christians, gypsies and other groups were ruthlessly and systematically exterminated in the name of political and racial purity.

Elie Wiesel was witness to the Holocaust and remembers. "I remember: it happened yesterday or eternities ago. A young Jewish boy discovered the kingdom of night. I remember his bewilderment. I remember his anguish. It all happened so fast. The ghetto. The deportation. The sealed cattle car. The fiery altar upon which the history of our people and the future of mankind was meant to be sacrificed." In response to a young man's question about what Wiesel has done with his life, Wiesel says,

> I tell him that I have tried. I have tried to keep memory alive, that I have tried to fight those who would forget. Because if we forget, we are guilty, we are accomplices.
>
> And then I explained to him how naive we were, that the world did know and remained silent. And that is why I swore never to be silent whenever and wherever human beings endure suffering and humiliation. We must always take sides. Neutrality helps the oppressor, never the victim. Silence encourages the tormenting, never the tormented.

Human suffering continues unabated. Wiesel says, "There is so much injustice and suffering crying out for our attention, victims of hunger or racism or political persecution, writers and poets, prisoners in so many lands governed by the left and the right. Human rights are being violated on every continent. More people are oppressed than free." He disclaims personal presumption when he says that "no one may speak for the dead, no one may interpret their dreams and visions." Yet it is left to the documentary photographers to record all the lonely deaths in South Africa, Afghanistan, Lebanon, Nicaragua, El Salvador, Iraq, Iran, Sri Lanka, and countless other places of anguish and destruction. Contemporary photojournalism requires that record. History demands it.

Because of its power to move the world, to change people's attitudes, to stir their emotions and stimulate action, I am convinced of the importance of photojournalism within the totality of contemporary journalism in this visual age. It therefore becomes urgent that every participant in the photojournalistic process recognizes his or her responsibility to use this tool for maximum

impact. For documentary photography to be gripping and absorbing it must be imbued with immediacy, concrete reality, and emotional involvement.

The Documentary Photographer as Visual Anthropologist

Anthropology deals with the origins of man, how man is affected by physical, cultural, and environmental influences, the beliefs that underlie man's actions, the role of ethnicity in a society's development, and the social mores, customs, and behavior that are accepted in a society. Prior to the invention of the camera, cultural anthropologists relied on their ability to express themselves verbally in providing insights into the various cultures they researched. Since the advent of photography, anthropologists have found that photos almost invariably provide visual evidence to support anthropological observation. Margaret Mead realized this in her groundbreaking work when she teamed with photojournalist Ken Heyman to produce several books dealing with primitive environments.

Documentary photographers of the twentieth century, without being trained or educated in anthropological techniques, have produced an astounding body of work that has given society greater insights into the way we live, the way we think, the way we act, and the way we are. Among other things, they have revealed the primitive worlds of the New Guinea mudmen and the Yanomani tribes of Brazil, the sophisticated societies of the Western world, the last vestiges of manual labor as technological man comes into ascendancy, and the environmental impact on humans of depredations against the natural world which make it less habitable.

Dorothea Lange best articulated the role of the documentary photographer as visual anthropologist when she wrote, in *Photographs of a Lifetime,* that

> documentary photography records the social scene of our time. It mirrors the present and documents the future. Its focus is man in relation to mankind. It records his customs at work, at war, at play, or his round of activities through 24 hours of the day, the cycle of the seasons or the span of a life. It portrays his institutions—family, church, government, political organizations, social clubs, labor unions. It shows not merely their facades, but seeks to reveal the manner in which they function, absorb the life, hold the loyalty, and influence the behavior of human beings. It is concerned with methods of work and the dependence of workmen on each other and their employers. It is preeminently suited to building a record of change.

Documentary photographs inform and educate and often expose previously concealed layers of society. Throughout photographic history, photographers

involved with social concerns have concentrated on the walking wounded—
the poor, the sick, the homeless, the hungry, and the disenfranchised—the
human detritus relegated to the social ash can. Humanity demands that we not
turn our eyes away from that which discomforts society. Photography rein-
forces that humanity by forcing us to see images that we would not otherwise
see. It reminds us that there we are all of the family of man, and our fortunes
are inextricably intertwined.

The American documentary photographic tradition stems from the heroic
work of Jacob Riis and Lewis Hine. Riis, a police reporter for the *New York
Herald,* began by taking pictures of substandard housing for the homeless and
urban poor and the squalid living conditions in New York's Mulberry Bend
area. Lewis Hine continued in that tradition of social documentation as a force
for change, particularly as it affected the exploitation of child labor in the
United States. The Farm Security Administration photographers walked in the
footsteps of Riis and Hine during the dark days of the Great Depression, using
documentary photography not just to record the urban and rural upheaval
caused by adverse economic conditions, but also as an advocacy propaganda
tool for forcing social change. The Photo League, founded in 1936 by Sid
Grossman and Sol Libsohn, brought together socially concerned photogra-
phers who produced humanistic documentary projects. Today's visual anthro-
pologists owe a debt to those compassionate forebears, who defined a photo-
graphic philosophy that has expanded through the years.

Dorothea Lange: Realism and the Receptive Eye

Dorothea Lange's monumental collection of documentary photography from
the 1930s classifies her as one of photojournalism's giants. I met Dorothea
Lange only once. We had lunch shortly before her death in 1965. She was
urging the development of a documentary photographic project that would
capture the 1960s as the Farm Security Administration photographers had
documented the depression years.

That effort never succeeded. But I am pleased that I had the opportunity to
share some thoughts with this great humanitarian and documentarian. And
more than two decades after her death, I often reread some of her writings
about photography. She never talked about the gee-whiz innovations that have
made the technical aspects of photography idiot-proof. She talked about seeing
and subject matter, about being a human being first and a photographer sec-
ond, about research and understanding.

In *Dorothea Lange: Photographs of a Lifetime,* Miss Lange gives us some

words to remember. No photographic gobbledy-gook. Just down-to-earth thoughts that have universal application for documentarians at any time in history:

> For me documentary photography is less a matter of subject and more a matter of approach. The important thing is not what's photographed but how. My own approach is based on three considerations. First—hands off! I do not molest or tamper with or arrange. Second—a sense of place. Whatever I photograph, I try to picture as part of its surroundings, as having roots. Third—a sense of time. Whatever I photograph, I try to show as having its position in the past or in the present.

Her first consideration gets to the heart of the matter: hands off! Meaningful photojournalism is based on incisive and decisive-moment photography. It is the direct antithesis of much current photographic illustration, which uses manipulated elements to create contrived photographs far removed from reality. Without a sense of place defining the locale and a sense of recorded time in a dynamically changing world, documentary photographs cannot be judged in their proper context.

I well know that the economics of publishing often force the working photographer to manage photographs. There are indeed valid uses and needs for the set-up photograph. It is often found, for example, in annual report photography, where lighting, optimum depth of field, and high-tech expertise are at a premium. In advertising and editorial illustration, conceptual, problem-solving photography creating inventive images is both valuable and desirable. But these directed images do not belong in the world of documentary photography. Past and future documentary photographers whose names have been and will be lauded share a philosophy of spontaneous and unrehearsed photography.

Many photographers fear that unless their subjects are moved around, the composition of the photograph will suffer. But the first law of natural realistic documentary photography is that the photographer should do the moving—to develop his or her instincts for the one place, the one vantage point, from which he may record the scene simply and clearly, revealing its dynamics.

The alternative to realism in documentary photography is preconceived, scripted photojournalism. This fantasy world gives us personality profiles perpetuating public relations images of individuals rather than allowing readers to see people as they really are.

Robert Coles, in discussing Dorothea Lange's world, said, "She spoke often of the need for blankness, the value of the receptive eye in photography. First came the image, then the research that interlocked the intricate features of the history she was recording. Obviously this is the closest that anyone can ap-

proach to objectivity. Less obvious is the rarity of such practice, the passion for comprehensive understanding, particularly among photographers who often sacrifice breadth and profundity in the name of visual purity."

Realism and the receptive eye are the linchpins of documentary photography.

The View of the World as Seen by Documentary Photographers

There is a great misconception that the documentary photographer exclusively should address society's problems. That misconception has been perpetuated by the concerns of many documentary photographers: problems of poverty, hunger, war, disease, and drought. To too many of us, realism has become synonymous with the "ash can school of photography"—portrayal of the downbeat and the depressing. It is true that much current documentary photography stresses the negative aspects and neglects affirmations of life, but it need not be so.

I am concerned that in their preoccupation with the negative, documentary photographers exclude other worthwhile subject matter. The world is not simply a collection of problems; people experience joy as well as despair. There is a positive social tapestry to be photographed. Reality can be positive as well as negative, and documentary photographers should give balance to their work by choosing subjects that celebrate life as well as exposing those that demean it.

To those documentary photographers who see only a barren magazinescape that is ever less responsive and receptive to documentary photography, there are few words of comfort. Always optimistic, I have the feeling that the documentary's importance will ultimately be reasserted. Documentary photography is more than anything suited to witnessing and realistically recording the human experience. A documentary photographer can see the world as a montage of madness, death and destruction, or he can appreciate the rich variety of life. Documentary photography is all-encompassing, and it has room for both points of view.

My photojournalistic philosophy values coherence, content, and traditional storytelling values. That doesn't mean that photojournalism or documentary photography should not accommodate new ways of seeing, new ways of storytelling, or experimental work. Perhaps our magazines and newspapers will less frequently resort to the formulaic copycat photographs and ideas that afflict American photojournalism if more chances are taken. Our devotion to a literal and objective interpretation of events has perhaps been too slavish; we have much to gain by encouraging the publication of thoughtful, carefully chosen photographs that are allegorical and symbolic.

It will take a concerted effort on the part of those involved in the editorial process to reverse the current editorial malaise. Photographers must continue to shoot meaningful pictures about important subjects; picture editors must continue to fight for publication of those photos; editors must hark back to the past and recognize the power of honest photographs, and all journalists must recognize their responsibility to inform.

The real challenge for today's documentary photographer is to deal with subject matter that is not visually loaded, to capture simple moments eloquently, and to translate them visually so that universal human experience—the way we were and are—is recorded for present and future generations to see. The danger exists that contemporary photographic orthodoxy will embrace the art photograph to the exclusion of documentary photojournalism. Documentary photojournalism was never more needed than it is today to add visual and textual dimensions to the urgent questions that confront mankind.

The Concerned Photographer

> Photography combines those elements of spontaneity and imme-
> diacy that say, "this is happening, this is real," and creates an
> image through a curious alchemy that will live and grow and be-
> come more meaningful in a historical perspective.
>
> **Dan Weiner,** *The Concerned Photographer*

My years in photojournalism have been enriched by my contact with pho-
tographers who care about the world in which we live, who love learning for
its own sake, and who use photography as more than a means to a financial
end. These characteristics define the concerned photographer. The roster of
Black Star concerned photographers is long and distinguished; on that list are
the ones close to my heart, who share my philosophy of journalism.

The line between documentary photography and "concerned photography"
is finely drawn. Concerned photography defines the work of a special sub-
group of those documentary photographers whose overwhelming personal
dedication to and concern for mankind is transcendent. I am reminded of
James Nachtwey's response to a question about how he chooses sides when he
covers both sides of a war. His simple but eloquent reply was, "I'm on the side
of humanity. That's the only side you can take." The pantheon of concerned
photographers encompasses those who choose humanity over self-interest,
feeling over dispassionate observation.

Cornell Capa and the Concerned Photographer

Cornell Capa, founder of the International Center of Photography, didn't
invent concerned photographers, but he identified them and labeled them with
a phrase that is integral to any discussion of the photojournalistic tradition. It

is one of those phrases that will always be a part of photographic lore, as insistent and important as Henri Cartier-Bresson's "decisive moment" or Edward Steichen's "family of man."

Throughout his professional life as a photographer and keeper of the photojournalistic ideal, Cornell Capa has pursued his agenda with a single-mindedness that is inextricably linked with the work of his brother, Robert Capa, who was killed by a land mine in Indo-China in 1954. With Robert Capa's death and the subsequent deaths of Werner Bischof in the Peruvian Andes in 1954, Chim (David Seymour) at the hands of an Egyptian machine-gunner in 1956, and Dan Weiner in a plane crash in 1959, it would appear that Cornell Capa's destiny to perpetuate the memory and preserve the work of these remarkable photographers and the tradition they represented was predetermined.

In 1965 Cornell Capa, who was himself a photojournalist and who had begun curating photography exhibitions on a small scale, proposed an exhibition of the work of six photographers—Robert Capa, Werner Bischof, Chim, Dan Weiner, Andre Kertesz and Leonard Freed—to Oriole Farb, the Director of New York's Riverside Museum. The Riverside Museum had not had a photographic exhibition on its walls since its show of Lewis Hine's work thirty years before. Suggesting that she would be receptive to a thematic exhibition like the "Family of Man," Farb challenged Capa to find a comparable theme to unify the work of the proposed photographers.

Capa wrestled with the problem. Finally, in December 1965, while sailing to Yelapa, Mexico, a sudden inspiration impelled Capa to scream out to his wife, Edie, "Eureka! We keep talking about the tradition that Chim, Werner, Dan, and Bob represented. but we just recite the words. We have never defined what this tradition is. It is a concern for mankind that connects their work; it's not their style." Thus the phrase *concerned photographer* was coined. It became the theme that unified the Riverside Museum exhibition and the book published in 1966.

In his search for a more detailed definition of concerned photography, Cornell Capa looked to Lewis W. Hine himself for inspiration. "There were two things I wanted to do," wrote Hine. "I wanted to show the things that had to be corrected. I wanted to show the things that had to be appreciated." Cornell found he could organize his other ideas about preserving photojournalists' work around the notion of "concerned photography." He founded the Fund for Concerned Photography in 1966, and out of this grew the International Center of Photography, established in 1974. In the book *The Concerned Photographer,* Capa expressed his own concern about what happens to photographers' work when tragedy cuts short their brilliant careers.

Today so many pictures are being taken that no one is really interested in what has gone before. The technological advances in camera design have made photography seem easy. Photography is in danger of losing its own self-respect as well as the trust and confidence of viewers in its veracity and artistry.

Photography is demonstrably the most contemporary of art forms—it is the most vital, effective, and universal means of communication of facts and ideas between people and between nations. It is my personal conviction, however, that production demands and controls exercised by the mass communications media on the photographer today are endangering our artistic, ethical, and professional standards and tend to obliterate the individuality of the witness-artist.

The Fund for Concerned Photography and its emphasis on the accurate visual depiction of our life and times has inspired a generation of contemporary young photographers and helped to preserve the documentary heritage of the past, and it extends its philosophy into the future for photojournalists to embrace. During the years when mass media publications like *LIFE, Look,* and the *Saturday Evening Post* were losing the competition with television, it served as a beacon of photojournalistic hope on a barren horizon.

The Original Concerned Photographers

Those first six photographers included in the *Concerned Photographer* book and exhibit chose diverse approaches, subject matter, and aesthetic, but all shared Hine's philosophy. Bischof's visual aesthetic was simple, forceful, direct, and disciplined, with a remarkable humanity. Ernst Haas said, "Werner Bischof could be compared to his pictures. He was always harmonious—with measure. He was sensitive, but in a virile way sensitive. His photographs had a tendency toward the absolute—a combination of beauty with truth: a stone became a world, a child was all children, a war was all wars."

Robert Capa, renowned for his archetypal war photographs from many front lines, took pictures of greater complexity but replete with human emotion. He said of himself, "During the Spanish civil conflict I became a war photographer. Later I photographed the 'phony war' (the early days of World War II) and ended up taking pictures of the hot war (after the Allied invasion on D-day). When all this was over I was very happy to become an unemployed war photographer, and I hope to stay unemployed as a war photographer till the end of my life." Fate decreed otherwise.

David Seymour was an equally passionate and compassionate photographer, less concerned about capturing war's dramatic action than he was about its

impact on the innocents of war, particularly children. Henri Cartier-Bresson said of him, "Chim picked up his camera the way a doctor takes a stethoscope out of his bag, applying his diagnosis to the condition of the heart: his own was vulnerable."

The less-heralded Dan Weiner embodied social awareness and attempted "to distill significant fragments from the complexities of everyday life," said playwright Arthur Miller. "His work reveals not only the man's deep seriousness but his child-like wonder, his quick laughter—in a word his eager delight in the business of the planet."

Completing the circle of concern in the 1966 Riverside Museum exhibit were two disparate personalities, both still living and drawn from different generations. One, Leonard Freed, was thirty-seven years old and in the prime of his photographic career. He captured the eye of Cornell Capa with his photography of minorities in the United States and his coverage of the aftermath in Jerusalem of Israel's Six Day War. He represented an unrecognized new generation of concerned photographers and expressed his delight by saying, "Suddenly I feel I belong to a tradition." Thousands of photographers follow in this tradition as they pursue the visual recording of the history of the world. Many photographers have sacrificed for it; some have died for it.

Andre Kertesz was the last one. Kertesz had always had a special place in Cornell Capa's group of favorite photojournalists: Kertesz had been extremely kind and helpful to a youthful Robert Capa in the early days of his career. Like the Capas, Kertesz was Hungarian. The Kertesz story is one of the incredible tragedies in the life cycle of photography. He came to the United States in 1937 as a revered European photographer, working intimately and subjectively with a 35mm camera, and found his European aesthetic at odds with the slick, highly technical photography then in vogue at *LIFE* magazine. Kertesz never worked for *LIFE*; he supported himself first as a freelance and then as a contract photographer for Condé Nast Publications. Living in New York, Kertesz was bitter, disillusioned, and isolated because of the neglect of an unappreciative photographic community. Then several serendipitous events converged to vivify this wonderful contributor to the tradition of documentary photography.

In 1964, John Szarkowski arranged a forty-picture exhibition of Kertesz's work at the Museum of Modern Art. Following that, the famous editor of the Swiss *Camera Magazine,* Romeo Martinez, published a special article about Kertesz. Cornell Capa then took his work to Prague to the formidable Anna Farova, who had published books on the work of many photographers. Capa sold her on doing such a book on Kertesz. The final chapter in this confluence

of positive events happened when Cornell Capa took Kertesz to Japan, where the exhibition was opening and where Kertesz was lionized and venerated. Kertesz also received two assignments from Frank Gibney of *Encyclopaedia Britannica* during his stay in Japan.

In a sense the reclusive Kertesz had been rescued from photographic oblivion by these happy coincidences. Cornell Capa played a large role in "opening the gates for this self-imprisoned bird to fly." Kertesz's work in the *Concerned Photographer* exhibition served as an inspiration to a line of photographers who followed, with the work of Freed as the youngest photographer to carry on his concern.

In 1972, Cornell published *The Concerned Photographer 2* honoring the monumental work of eight additional photographers: Don McCullin, whose abhorrence of war has led him to cover the destructive madness of conflicts in Cyprus, the Congo, Biafra, Vietnam, Cambodia, Northern Ireland, and Bangladesh; Ernst Haas, who explores the beauty of the natural world; Marc Riboud, who searches for the unity of man; Dr. Roman Vishniac, who documents the vanishing world of European Jewry; Hiroshi Himaya, who celebrates the union of the Japanese with their environment; Gordon Parks, who delivers an interpretation of what it means to be "born black"; Bruce Davidson, who offers insights into the Harlem ghetto; and W. Eugene Smith, whose enduring essays provide an affirmation of life and the human spirit.

"The tradition of concerned photography is alive and well," says Cornell Capa. "What continues to amaze me is that photojournalists throughout the world continue to do this work without support. It is like a religion. They do it because they have a concern for mankind and because they believe in its importance and relevance to our times."

Other Concerned Photographers

Concerned photography can help change the world. Throughout my years in the business I have come in contact with many lesser-known and less-celebrated photographers who had great dedication and passion. Concerned photography can also lead to advocacy photography, where one becomes less the dispassionate photographer and more the participatory photographer who identifies with a specific cause.

Stephen Shames, who has done a seven-year project on child poverty in America, qualifies both as a concerned photographer and as an advocate using photography as a means to change the social landscape. Throughout the years of his child poverty project, Shames lived and ate with the people he photo-

graphed. Living under the same substandard conditions allowed him to develop a closer rapport with them, to be part of their lives, to share their pain, and to develop a greater understanding of them, which is reflected in his photographs. Living with subjects often blurs the line between objective journalism and subjective participatory journalism. Subjective participatory journalism may be colored by the photographer's involvement, but it also makes for greater insights and deeper revelations by the photojournalist.

Throughout the history of photography, photographers have used their cameras to promote their specific causes, social and environmental. Such a photographer was William Henry Jackson, whose wet-plate photographs helped to persuade the United States Congress to designate Yellowstone the first national park and spawned a generation of photographers that has made the preservation of the natural environment and the promotion of a better environment its primary goal.

Then there's Matt Herron, a self-styled radical committed to political and social change. Herron is also a photojournalist who uses "confrontational photography" as his primary weapon in fighting for carefully selected causes. Working his way means defining an outrage, confronting it directly, and bearing witness by putting body and camera on the line. In so doing, he hopes to effect change by dramatizing the perceived outrage.

I first met Matt Herron in 1963 when he was organizing "The Southern Documentary Project," a project designed to photograph not the civil rights struggle, but the background of the people and the land that precipitated that dramatic confrontation. His dream was built on a personal history that included Quakerism and conscientious-objector status during the Korean War. Matt was one of three organizers of the first chapter of CORE (Congress of Racial Equality) in Philadelphia. In 1962 he was jailed with the Reverend William Sloane Coffin as the result of an early sit-in effort to integrate a Maryland amusement park. Herron is distinguished from the other photojournalists previously mentioned through his involvement not just as a photographer carrying out an assignment, but also as a protagonist for a chosen issue.

In 1979, Matt Herron was arrested while protesting against the slaughter of baby harp seals in Canada's Magdalen Islands. Seventy-four percent of the pure-white harp seal pups, from three to nineteen days old, were being killed each year. In theory, a single blow to the head should kill the seals humanely, but in fact, it often takes several blows to kill a seal. The workers were paid by the pelt and were working against time, and autopsies showed that fully half the seals had not been struck on the head at all, but had been kicked in the head or the eye socket and then skinned alive.

Herron became the first mate on the *Sea Shepherd,* a two hundred-foot North Sea trawler with an ice-breaking bow, which the protesters had hired. He recalls that

> it sounded like a great adventure, but I said I would not go unless I got a text and picture assignment since the seal slaughter story was considered old-hat by magazines who had seen previous coverages of the subject. But finally I got a commitment from *Geo* magazine, which was willing to take a chance.
> I went along, unsure of my position on the subject. I had to make up my mind as to whether the slaughter was humane, whether the seals were indeed an endangered species, and whether the seal hunt was, as claimed, necessary for the economy of Nova Scotia.

An incredible adventure it was. The objective of the protesters was to destroy the commercial value of the white seal pelts by spraying indelible organic dye on as many pups as possible. Herron estimates that about a thousand animals were saved this way.

Once on the ice, First Mate Herron became a journalist intent on fulfilling his assignment. "I did not participate in the dyeing process out of journalistic conscience. I didn't want to compromise my role as a reporter. I knew there was a possibility of being arrested. If I was going to be arrested, I wanted to be arrested as a reporter and a photographer, not a seal dyer."

Sometime after dawn, having crossed the sea ice at night to reach the seal herd, Herron began to photograph. Suddenly, on the horizon, four helicopters descended on the ice. Herron recalls that "the protesters were scattering in all directions, playing cops-and-robbers with the Mounties on the ice. I felt distressed that I wasn't in the midst of the melee. I tried to run across the ice, slipping and falling, and cursing my luck. It seemed as if everyone had been arrested when two protesters emerged from an ice cave as if they were actors in a play, and an arrest drama was enacted before my cameras."

Those pictures never saw the light of day. Not only was Herron arrested, but his cameras and film were seized. An attempt to secrete film was discovered and it was confiscated as evidence. This story underlines the extent to which a "concerned photographer" will go and the personal danger he will endure in search of pictures to educate the world on a particular issue. Herron is just one of the many caring idealists who manifest the journalistic conscience of today's photographers.

And then there is Flip Schulke. Flip Schulke is a maverick. Curious, verbal, dynamic, and persistent, he prides himself on the fact that during his career he has managed to avoid commercial assignments and has always made his living as a photojournalist. Despite the stormy and tempestuous relationship we have

enjoyed through four decades, my respect for his commitment to the preservation of photographs in a historical context is undiminished. His interests and concerns are all-encompassing. "Most young photographers are using photojournalism as a stepping stone to making more money in the commercial area," says Schulke. That saddens him. "From the start you have to think about your philosophical beliefs and stick to them. You can't always be a nice guy. I'm like a pit bull when I want to do something—I hound people."

Throughout Schulke's career he has taken a personal interest in each of his subjects, and he has worked for virtually every national magazine, completing a wide range of assignments, including stories on the civil rights struggle and its leader, Dr. Martin Luther King, Jr., in the 1960s, exploration of the undersea world in the 1970s, and more recently, the American space missions.

Schulke's belief in the photojournalist's role as a historian is evident in the books he has authored. *Martin Luther King, Jr.: A Documentary from Montgomery to Memphis* and *King Remembered* are pictorial histories of King's role in the civil rights struggle. *Your Future in Space* is a compendium of every aspect of the space program. Schulke's documentation of his hometown, New Ulm, Minnesota, over the past forty years has received widespread recognition.

No discussion of concerned photography would be complete without recognition of the work of Sebastiao Salgado, the Magnum photographer who has emerged as one of the leading photojournalists of the 1980s. His work has been done primarily in the Third World. I first met Salgado when he received the 1982 W. Eugene Smith Memorial Fund Grant in Humanistic Photography. His seven-year project documenting the lives of villagers in Peru, Bolivia, Ecuador, Mexico, and Guatemala, was published in a book titled *The Other Americas.*

Jonathan Swift said, "Vision is the art of seeing things invisible." During a recent introduction of Salgado before a lecture audience, Fred Ritchin, the eminent writer, photographic critic, and curator of Salgado's exhibition, described Salgado as a photojournalist "who makes the invisible visible. He finds in the people he photographs a state of grace, he finds in them a sense of success, a sense of victory, a sense of human dignity, pride and strength tempered by the uncertainty of the conditions under which they live."

Vicki Goldberg wrote,

> At times, Salgado has been a self-assigned emissary from the Third World, reporting the suffering and endurance of people who have little say over their own fate, in hopes that people in richer lands will understand that they cannot afford to ignore problems that at first may seem distant. His themes are large, from famine in the Sahel and the close companionship of life and death in Latin America to the threatened global extinction of manual labor.

Brazilian-born Sebastiao Salgado, an economist, came to photojournalism in 1973. He is now Paris-based, but his work has taken him all over the world, most recently on a five-year project documenting the last look at global manual labor before it is replaced by the inevitable robotization and computerization of work. This odyssey has taken him to China, India, the Soviet Union, Bangladesh, Cuba, France, Brazil, and the United States. Included in this project is a stunning series of photographs of the clay-laden bodies of the gold miners of Serra Pelada in Brazil as their antlike processions swarm over every inch of the muddy earth, searching for tiny nuggets of gold.

During the mid-1980s, world attention was focused on the Sahel region of Africa, where the drought-induced famine threatened the lives of hundreds of thousands of people. Gaining access through a humanitarian-aid group, Medecins sans Frontieres (Doctors Without Borders), Salgado worked for fifteen months, recording the heroic efforts of the doctors and nurses as they labored against odds to salvage life in an apocalyptic atmosphere, or capturing the dignity of people fatalistically accepting death with resignation. No photographic coverage of that period did more to alert the world to the fate of the people of the region.

The label "concerned photographer" does not by definition confer sainthood on the photographer, although to some, Salgado has achieved that status. One should recognize that his work has brought him fame and fortune. His work is supported by every major magazine in every country of the world; his prints are purchased for large sums by important collectors of photojournalistic imagery. Concern and sanctity are not necessarily synonymous. One need not try to discover Salgado's motivation or gauge his altruism. Suffice to say that his photographs of the unfortunates of the world have made us more aware and given us greater understanding of the dreadful dichotomy that exists between the "haves" and the "have-nots" of the world.

It seems sometimes that the world is having a global nervous breakdown. Edward Steichen is reported to have said in 1969, on the occasion of his ninetieth birthday, "When I first became interested in photography, I thought it was the whole cheese. My idea was to have it recognized as one of the fine arts. Today I don't give a hoot in hell about that. The mission of photography is to explain man to man and each man to himself. And that is the most complicated thing on earth and also as naive as a tender plant."

Concerned photographers understand that. Their voices articulate man's compelling search for the ultimate meaning of human existence.

The Great Photographic Essays

> For Beethoven, like the greatest of prophets and teachers, knew
> how to pluck from the air the essential, the elementally true, and
> develop from it a complex superstructure that embraces all human
> experience.
>
> **Leonard Bernstein,** *The Infinite Variety of Music*

For the first hundred years of its existence, photojournalism consisted of single pictures seen as isolated images telling short stories. In the 1920s, Kurt Safranski, in Germany's *Berlin Illustrierte Zeitung,* and Stefan Lorant, in the *Muenchner Illustrierte,* came to an almost simultaneous realization that when two pictures were placed next to each other, a new statement was created that was different from the statements made by the pictures individually. Suddenly, when it came to pictures, one and one didn't equal two, but to some incalculable number that gave new dimension and new meanings to simple juxtapositions. If two published pictures can have such tremendous impact, think of the power of several pages of related pictures to communicate a subject.

The narrative picture story or photographic essay is based on this principle. The photographic essay was born a decade after the European efforts to use pictures in sequence, when new vehicles like *LIFE* and *Look,* devoted to pictorial journalism, were born. Editors at those magazines soon recognized that photographs tied together by a single theme could be structured and sequenced in a narrative style that could tell a full-blown coherent story.

Margaret Bourke-White

Maitland Edey's *Great Photographic Essays from LIFE* preserves the groundbreaking work published in *LIFE.* Margaret Bourke-White's "Boom

29

Town—Fort Peck," published in the first issue of *LIFE*, November 23, 1936, was "the first true photo essay ever published anywhere" according to Edey. By today's standards, the pictures used in the Bourke-White layout are static and posed, as opposed to the contemporary aesthetic, which aims for spontaneity and uses natural light photography. One has to remember that these pictures were taken with view cameras and the necessary film packs and flashbulbs on what should have been essentially a candid series of pictures taken with miniature cameras. And yet, the pictures have a 1930s look that captures the essence of what life in that period was like.

Two pictures are particularly interesting. One shows three taxi dancers in a bar entertaining the clientele: one lady is being embraced by two men as she smiles into the camera; another is with a fresh-faced youngster, and the third is dancing with a more mature man wearing his hat. The flavor of Western boom town Saturday night is caught despite the technical limitations faced by Bourke-White. The other picture catches a scene at the bar where every man but one is wearing a cap or a hat as they imbibe, with women and two little gamins with haunting eyes seated on the bar.

Leonard McCombe

The early photographic essays in *LIFE* magazine were preconceived by editors and scripted in advance, with a concomitant lack of spontaneity. It remained for a young English-born photographer, Leonard McCombe, to break the mold and produce two great photographic essays on dissimilar subject matter. Both are collected in the *Great Photographic Essays from LIFE*. One was published in *LIFE*'s October 15, 1945, issue and showed "Displaced Germans" pouring into Berlin, facing poverty, hunger, death, and despair. Such pictures based on the background of a news event were dramatic indeed, but McCombe brought to them an unselfconscious and unpremeditated immediacy.

McCombe's landmark photographic essay, "The Private Life of Gwyned Filling" was published in *LIFE* on May 3, 1948. It was an innovative essay in that he photographed scenes from the daily life of a career girl in New York. He literally became the invisible photographer, the proverbial fly on the wall, as he spent hundreds of hours chronicling every small detail of her life. Through unscripted, spontaneous, and realistic shots, Gwyned Filling comes alive in a way that had never been seen before in the pages of a magazine. Through that essay, put together with uncommon lucidity by the editors of *LIFE*, we see the birth of a personality picture essay that owes its success to

the photographer's single-minded intensity in being with the subject and cap-
turing the off-guard moments in a real person's life.

W. Eugene Smith

W. Eugene Smith has been characterized as "the master of the photographic
essay." No one in the history of photojournalism has had as profound an
impact on this narrative form as the complicated and complex Gene Smith.
From the beginning of his career, he recognized the power of the camera to
facilitate narrative. His interest always lay in weaving pictures together like a
tapestry, stringing images together in to form a coherent story.

Maitland Edey describes Smith's work as "Shakespearean in its scope and
force, and in its variety. He moves majestically from one peak to the next,
producing masterpieces that are all authentically his, but that are remarkably
different from one another, not only in their subject matter but in the photo-
graphic means used to create them."

Smith's first great photographic essay was "Country Doctor," published in
LIFE in the September 20, 1948, issue. What a simple idea! Any photographer
in America could have found a comparable rural doctor, equally dedicated to
the people he served, who coped with the same variety of dramatic situations
inherent in a rural medical practice at the time.

But Gene Smith had advantages. For one, Gene had served his apprentice-
ship as a visual storyteller at *Parade* magazine in the early 1940s, when he and
the editors scripted fictional picture essays. One such essay was a story on
Dr. Nathaniel P. Brooks, a real-life small-town doctor—the piece was a visual
fiction based on fact. That idea seems to have stayed with Smith through the
years, only to have been resurrected for presentation to *LIFE* as an idea for a
story in 1948.

The style of the legendary "Country Doctor" essay showed a maturing
Smith, who, despite the constraints of large format cameras and artificial light
in most or all of the indoor pictures, was able to capture natural, realistic, and
dynamic body language and facial expressions. I am convinced that Smith
controlled the lead picture that shows the intense country doctor carrying his
bag, walking through the weeds in an unkempt yard against the background of
a threatening sky. Gene Smith knew that he had to have a "lead picture," an
establishing picture that would say "country doctor," and he created that
picture.

I can visualize the scene as Smith set up his auxiliary flashbulbs to create
dramatic lighting and depth of field to get technically perfect pictures. I would

not be surprised if the bare bulbs in the rooms where Joe Jesmer dies are flash bulbs going off. I can hear Smith saying, "Be unconscious of my and the camera's presence and do what you do naturally," as the scenes unfolded in front of his lens. Nobody in those days, limited by the slowness of film speeds, hindered by tripods, light stands, and bags of flash bulbs, could attain the ideal of being an unobtrusive observer photographing reality in unplanned moments. It is a tribute to Smith and his keen eye for revealing human behavior that he was able to produce a believable and seemingly candid series under such circumstances.

The leap from "Country Doctor" to "Spanish Village," published only three years later in the April 9, 1951, issue is astonishing. Smith, using a 35mm camera, achieved his maximum power by combining images of incredible power in technique, composition, and content, with a spontaneity previously denied him. He used his celebrated printing methods to achieve a chiaroscuro quality in each of the pictures, particularly in the production of "The Wake," one of the most artistic photographs ever made. That picture alone reveals Smith's extraordinary talent as an imagemaker and a storyteller.

Of equal importance in the comparison of the two essays is a greater understanding of the use of layout and design to enhance the photographic essay. "Country Doctor" is straightforward, crowded, linear while eschewing white space. It is in the old-fashioned tradition of the early days of *LIFE,* when pictures rarely crossed the gutter. Compare that with "Spanish Village," designed by Bernard Quint, who uses white space for maximum effect to set off the photographs, varies picture size, and uses type for maximum effectiveness.

Quint talks about this layout in Jim Hughes's biography of Smith, *Shadow and Substance.*

> In making the layout for the essay, I was determined to break the mold of a strictly narrative format. I was trying very hard to do something better, to use the pictures as symbolic entities. The essay holds together visually because there are geometric relationships—visual connections taking place in shapes and in directional lines—that are functional in terms of the flow from one subject to another. When you compare "Spanish Village" with the layouts in *LIFE* before it, you see that it was a marked departure. Some people were disturbed by it for that reason. For example, the margins were of varying widths and the photographs of many different sizes to get away from a newspaper-style formula of filling up every column in neat rows.

If "Country Doctor" was the "harbinger of a new age in photojournalism," as Jim Hughes claimed, "Spanish Village" was the ultimate realization of the photographic essay form that "Country Doctor" heralded. From this point on,

the photographic essay form would never be the same again. It would be given an opportunity to develop its own structure, allow for the photographer's personal vision and storytelling abilities, and give photojournalists the opportunity to explore subject matter of extraordinary complexity in human society.

Before we leave Smith, it should be noted that both of his most famous essays were based on simple themes and ideas, easily accessible to other photographers. We have already alluded to the ubiquitousness of country doctors. How many photographers had been through similar timeless Spanish villages before Smith but did not recognize the photographic possibilities there? Great photographic essays do not need complex, bizarre, unusual subject matter. They need not be shot in exotic parts of the world. Almost every conceivable subject that deals with the human experience can serve as the basis for an essay.

Bill Eppridge

Photographs of drug users no longer create the stir generated by Bill Eppridge's 1965 *LIFE* essay on drug addiction. Eppridge and writer James Mills collaborated on the story of John and Karen, a couple hooked on heroin. This essay presented a story the like of which had never been published in a national magazine. Twenty-five years later we are still impressed with the power of these words and pictures to define a world that had never before been visually chronicled in such shocking detail. We see pictures of the two supporting their habit—Karen through prostitution, John by stealing a radio from a taxicab; of them pushing heroin and being questioned by narcotics agents, of John experiencing withdrawal in jail, and, in a particularly strong sequence, of Karen saving a junkie who has overdosed on heroin. That essay pointed up that photojournalists had begun to poke their cameras into every aspect of human behavior, forbidden, decadent, or profane, with increasing frequency. An even harder edge has been brought to the photojournalistic essay and narrative picture story in recent years.

Donna Ferrato

Donna Ferrato is the Anaïs Nin of contemporary photojournalism. Since the late 1970s, Ferrato's attention has been consumed with two major projects, domestic violence and human sexual behavior. One might ask what these two seemingly disparate subjects have in common. They are, in fact, seen by Donna Ferrato as individual segments in her perpetual pursuit to visually

explore the complex relationships between men and women. Her pictures of domestic violence capture moments of confrontation, such as a drug-crazed husband beating his wife and a crying child pointing an accusing finger at his father, who is being arrested by police for battering his wife, as well as images of battered women who have suffered indescribable brutality.

I first met Donna Ferrato in 1985 when she shared the then $15,000 grant of the W. Eugene Smith Fund for work in humanistic photography. In her grant proposal, she revealed shocking statistics: in America one woman is beaten every fifteen seconds; three to four million are battered every year; and in 1985, 1,350 women were killed by their spouses, ex-spouses, or boyfriends. National surveys indicate that serious violence occurs in as many as one out of every four marriages. Photography has been Ferrato's weapon in bringing this subject to the fore, resulting in publication of her pictures in *LIFE* and a two-part series in the *Philadelphia Inquirer.*

Donna Ferrato's determination to show how sex affects women's lives is a lifetime project. Ferrato accepts my Anaïs Nin comparison because, like Nin, she thinks about sex most of the time. She recognizes the risk that people might react negatively to her work, saying,

> There's always a risk of alienating certain people in going to the edge while exploring human behavior, but I particularly hope I will not alienate women. It is the sexual responses of women I find most intriguing. Until now, I feel that women's sexual nature has been misunderstood or ignored as men went about setting up women in predictable male masturbation scenarios. Helmut Newton on one end of the stick, *Penthouse*'s Bob Guccione at the other.
>
> With this aspect of my work I am attempting to reveal the many sides of women. I want to understand where their fantasies come from, how their sexual pleasure may be directly related to fantasy or corporal self-awareness. I can't begin to calculate or interpret reality without getting to know people more intimately. Sometimes that means living with them.

I have never met anyone as open, as honest, as provocative, as curious about human sexuality as Donna Ferrato. That curiosity and interest is not prurient. "It is a curiosity that came naturally," she says. "If I tried to suppress it, I think I would die. I have always followed what I am curious about. I don't participate, although I like these people a lot. What keeps me photographing them is an admiration for their being able to abandon themselves."

Ferrato is accepting and receptive rather than judgmental of the behavior of her subjects. She has explored the world of New York prostitutes who sell their bodies on the grimy, dimly lit streets of the Hunts Point area. The pictures from that project, her photos of two hundred nude couples in a mass massage

class at a Las Vegas lifestyles convention, and those of public orgiastic sessions are unpublishable in family magazines. Brutality consistently upsets her. She finds it hard to make sense out of some of the things she sees. She wants "to photograph sexuality without sentimentality. I'm not so interested in people who casually meet and then have a wild time, as much as those who have a history together. I strive to frame those moments of beauty—maybe raw or raunchy—but moments which make me say, 'I wish I was in that picture.' I want to use photography to interpret the psychology of sex rather than the pure physicality of sex."

Ferrato's domestic violence coverage, which culminated in a book titled *Living with the Enemy*, developed by happenstance. "I did not originally set out to photograph domestic violence," says Ferrato. "Ten years ago, while I was on assignment doing a story on a family that epitomized success, I saw something in their mansion I wasn't supposed to see."

What she saw and photographed was a father of five children battering his wife. She was so haunted by the experience that she undertook a ten-year odyssey into the world of domestic violence. She has given us visual insights into a social condition previously ignored by photographers and has used her camera to raise the consciousness of society. She recently founded the Domestic Abuse Awareness Project (DAAP), which will combat violence against women and raise money for battered women's shelters.

Donna Ferrato's definition of pornography differs from that found in the standard dictionary. What she finds obscene are pictures depicting violent hate-mongering fanatics or helpless children destroyed by starvation or war. According to her definition, sexual explicitness is a natural manifestation of life, while her pictures of domestic violence become the ultimate obscenity.

Photojournalism is Donna Ferrato's way of seeking greater understanding of the female experience. She admits that the work she has done so far only begins to scratch the surface. Time will reveal the extent of her success and influence as her personal project develops.

The Urgency of the Photographic Essay

Photographic essays represent the height of photojournalistic aspirations among the photographers I have known. Newspaper photographers leave well-paying jobs in search of the highest truth, as actualized by the photographic essay. Every photographer I have ever known hoped to bring to fruition his or her great photographic essay. There is great satisfaction to be derived from thinking of an idea that has depth, breadth, and visual possibilities, then

finding the subjects or locale where the idea can be translated into pictures, and finally taking the pictures and ordering them into a cohesive whole, structured to tell a dramatic story in words and pictures. Its accomplishment must be akin to a heightened sexual experience. Writers write and photographers photograph because they feel that the story has to be told and because the times demand it.

It is no coincidence that the photographic essay and *LIFE* magazine have become synonymous. *LIFE* and *Look* were the important progenitors of this journalistic form, giving it life and breath, allowing it to flourish by giving their photographers the opportunity to shoot essays and then providing the pages to display them. With the demise of *LIFE* and the death of *Look* in 1971, the American outlet for such essays has been virtually eliminated except for more forward-looking newspapers, but there is a still-burgeoning international market in England, France, Italy, Germany, and Spain.

The dearth of places to publish has not destroyed photographers' initiative and desire to produce important work in this narrative form. Much of such work ultimately finds its way into photographic books after the international marketplace has been exploited. Since 1980, the strongest incentive for preserving this form has come through the efforts of the W. Eugene Smith Memorial Fund, which devised a grant in humanistic photography to encourage photojournalists working in the spirit of W. Eugene Smith. The Alicia Patterson grant and the recently founded *Mother Jones* grant also encourage in-depth projects. But even without grants, photographers are so committed to making photographic statements of real depth, that it is impossible to kill off their passion for storytelling essays.

As one of the founders of the Smith grant, I am most knowledgeable about the impact the grant has had on the photojournalistic community. In its first thirteen years, we saw approximately 1,500 proposals and financed 14 major projects, with grants ranging from $10,000 to $20,000. At a time when photojournalistic interest was flagging and less support was generated among magazines for documentary work, it was the Smith Fund that helped keep the spirit alive. The grants have resulted in magazine publications throughout the world, publication of books on almost every project, and focused attention on important subjects in our world. Reviewing the hundreds of applications over the years points up the urgency of maintaining backing for the photographic essay.

It is interesting to see the diversity of topics explored by these photographers. Jane Evelyn Attwood, at the time an American expatriate post office worker in France and not a professional photographer, entered the world of blind children. Eugene Richards did a photographic study of a hospital emer-

gency ward, where sophisticated medical techniques confront the most violent aspects of society. Sebastiao Salgado documented the lives of villagers in Latin America. Milton Rogovin, a retired 74-year-old optometrist, showed the world of coal miners from Appalachia to Turkey. Gilles Peress did a twelve-year project documenting the alternating periods of violence and peace in Northern Ireland. Letizia Battaglia investigated the effects of Mafia violence on Sicilian society. John Vink photographed problems related to water in Africa's Sahel. Mexican photographer Graciella Iturbide did a study on the women of a matriarchal society in Mexico. Spanish photographer Cristina Garcia Rodero documented the religious customs of the people of her native country. Belgium's Carl DeKeyzer spent a year crisscrossing the United States in a motor home to document the spirit and structure of myriad religious groups, and published a book titled *God Inc.* Dario Mitidieri, an Italian photojournalist, documented the life of the street children of Bombay, India, whose number has been estimated at 100,000. The first major grant for a color project was given to British photographer Paul Graham for his depiction of problems in Western Europe as it approached "The New Europe" in 1992.

Structure of the Photographic Essay

Requirements for a photographic essay are not rigid. Each essay will dictate its own needs, depending on whether it is predicated on the interpretation of a natural phenomenon, a personality, or a segment of society. One can say, however, that a viable photographic essay should have the following attributes:

1. The photographer must start with an idea that is cogent, concise, journalistically realizable, and visually translatable.

2. The subject must have depth and diversity of situations, and visual redundancies must be avoided. Each photograph should add new dimensions of understanding to the subject being photographed.

3. Photographic essays need time—time to permit exploration of every nuance of the subject, time to allow the elements of conflict within the story to reveal themselves, time for the photographer to be immersed in the subject and grow in understanding of it.

4. Photographic essays require cooperation. Subjects of such stories should be apprised early on in the project that demands on them will be great, that the photographer might intrude on the individual's privacy in getting beyond superficial coverage.

5. If the story is based on an individual personality, it must reveal the

essence of that individual, warts and all, and not be press-puffery in lieu of honesty and reality.

6. Great photographic essays are dependent on words to amplify the photographs, to interpret photographic ambiguities, to form a journalistic whole, where words and pictures are perfectly matched.

7. On a photographic essay, preconceptions and illusions are dashed. Photographic essays can turn out to be voyages of discovery in which the subject's evolution is antithetical to the original conception. Such was Gene Smith's journey into the life of Dr. Albert Schweitzer in Lambarene. At the beginning, Smith had expected to find the saint that he had conjured up in his mind, but after months of photographing Schweitzer, Smith found him to be an autocratic man complete with human foibles.

8. The success of a photographic essay depends on attention to detail. The photographer should have a structure in mind, written or unwritten, as the essay unfolds. All along the way, the photographer should have a mental or written checklist against which the photographs are being made, so that when the work is finished there are no unfilled gaps in the story.

9. Putting together a photographic essay is personal. It cannot be done by committee. It is an individual statement, so conceived that usually only the photographer is capable of putting it together in a comprehensible way. That doesn't mean that art directors cannot contribute meaningful ways of putting the pictures on a page or that editors cannot add valuable insights into the structuring of the essay. But ultimately, the photographer has to decide what story is to be told and how.

The serious photojournalist cannot afford to ignore this photojournalistic format if he or she aspires to prominence through publication in either magazines or newspapers of the world or, in that most perfect vehicle for individual statements on larger issues, photographically oriented books.

SO YOU WANT
TO BE A
PHOTOJOURNALIST

The Basic Components of
a Career in Photojournalism

So You Want to Be a Photojournalist?

I am an idealist. I often feel that I would like to be an artist in an ivory tower. Yet it is imperative that I speak to people, so I must desert the ivory tower. To do this I am a journalist—a photojournalist. But I am always torn between the attitude of the journalist, who is a recorder of the facts, and the artist who is often necessarily at odds with the facts. My principle concern is for honesty with myself.

W. Eugene Smith, *W. Eugene Smith: Master of the Photographic Essay*

So you want to be a photojournalist? Consider it carefully, and reckon the realities. You have to know more and work harder to earn less than in many other professions you might consider. Often you will work under pressure to deliver despite personal privation: minimal sleep, fifteen hours between meals, and two days between beds. You need the strength of a packhorse to carry around all the equipment; resourcefulness, ingenuity, and adaptability to solve assignment logistics; and inventiveness and the ability to improvise to capture the pictures that tell the story.

You have to enjoy being by yourself if you are to cope with the long hours surrounded by strangers in remote places. Engagement, compassion, and intensity are absolute prerequisites. You also have to believe in the importance of what you do, how it affects your community and the world. Like Don Quixote, it helps to dream the impossible dream. In short, photojournalism is no place for dilettantes, airheads, and those in search of cheap thrills. It is a place where photographers are rewarded by the knowledge that what they have done can, to paraphrase H. L. Mencken, distress the affluent and aid the distressed. You have to remember that you can be a considerate and thoughtful person and still win out, that bitchiness is not a prerequisite for success, that people are not for

hurting and that the photojournalist who asks more from himself or herself gets more from others. You need street smarts, jungle smarts, and survival smarts. Above all you have to be your best self.

As you contemplate your future as a potential photojournalist, it might be well to remove yourself to a quiet thinking corner of your home and evaluate the personal pluses and minuses you would bring to this career. What follows are some hard questions that, when candidly answered, will give you a positive or negative profile. If it is overwhelmingly negative, choose another career or go back for more education; if positive, you have no assurance of success, but you do have a fighting chance to succeed.

Before attacking these questions, you will have to determine whether photojournalism really interests you. If not, read no further, for the questions apply only to those courageous and confident people who are willing to tackle this specialty.

1. What do you expect from the profession of photojournalism? Money, fame, glamour, ego satisfaction? Do you see yourself in the popular image of the globe-girdling photojournalist in an epauletted-and-belted tan raincoat?

If it's money you want, photojournalism is not where you'll find it. It's not a lucrative business, which is not to say that photojournalism cannot provide you with a better-than-average financial return. But advertising, corporate, and fashion photography are much more remunerative.

There are moments of glamour and periods of fame for many photojournalists. But most of the time, fame and glamour are just lights at the end of the tunnel. The day-to-day work is physically tough, psychologically stressful, and intellectually demanding.

Will photojournalism offer you ego satisfaction? That depends on whether you get to the right places at the right times and produce work deserving of recognition. Personal satisfaction transcends money in measuring the allure of photojournalism. To be at the center of the news universe, visually recording the exciting events that make today's headlines is a heady business. And when the accolades are given and the yearly prizes announced, it takes months to come down from the high you can experience if you are a winner.

2. Are you as interested in journalism as you are in photography?

There are two parts to the word *photojournalism*. The second part (journalism) is probably more important than the first. On the contemporary scene there are thousands of photographers but few journalists worthy of the appellation. Photojournalists are required to be more than image makers, they must take pictures that dramatically and succinctly sum up the essence of a situation while also being informative and revealing.

3. Are you an educated person?

Kosti Ruohomaa was one of the greatest unrecognized Black Star photographers. This moody and brooding Finn once told me "to tell the young photographers you see that they have to be educated in the arts, sciences and humanities, so that they can bring understanding and intelligence to every assignment. Each assignment is a new challenge with new people to relate to. You can't relate to them unless you have an open, receptive, inquiring and trained mind. That's the secret of being a journalist."

I have known many photojournalists who had little or no formal education. Weegee (Arthur Fellig) was a man of limited education but unlimited imagination. One needn't be an anthropologist to be a documentary photographer, or a natural historian to photograph the natural world of insects, animals, and ecology, or a scientist to photograph laser beams, but it helps. Ergo, if you're going to be a photojournalist, a generalist who has to cope with many different editorial demands, be intellectually prepared to deal with the many different subjects you will encounter. The photojournalist has to talk the language of masters and servants, scientists and business executives, painters, musicians, writers, and sportsmen. What better way to be prepared than to be educated—in the arts, the sciences, literature, music, sports, economics, sociology, psychology; above all, in people. It doesn't follow that this education can only be achieved at a university at a cost of many thousands of dollars. Education is where you find and take it, and books provide a repository of learning. No institution of higher learning has a monopoly on the availability of books.

4. Are you a photographically educated person?

The photojournalist must be technically capable of producing professional caliber black and white and color photographs. You must have the necessary equipment, camera bodies, lenses, and lighting equipment to produce high-quality work under diverse and sometimes demanding conditions.

Parallel to the expansion of the mind of the potential photojournalist, there should be other simultaneous educational processes. Photographic education requires familiarity with the technical building blocks (f-stops, shutter speeds, film speeds, etc.) as well as learning to see and translate that vision plus ability into meaningful images.

Photographic education can be found outside formal schools. Some of the best photographers I have known are self-taught, through apprenticeship to other photographers, or from books free of the rigidity and pedantry of some professional teachers.

5. Are you visually educated?

Another building block requirement is photographic history. How can you

know where you're going when you don't know where you've been? A thorough understanding of the history of photography is a prerequisite for the embryonic photojournalist. Not so that he/she can copy past photographic styles, but to help articulate photographic goals as he/she contemplates the future.

The 150th anniversary of photography gave rise to the publication of many special issues of magazines, such as *Time* and *LIFE,* that explored the great icons of photographic history. In addition to those, read books like *A World History of Photography* by Naomi Rosenblum or *The World's Great News Photos 1840–1980* by Craig T. Norback and Melvin Gray. Study the work produced during the depression by the legendary Farm Security Agency (FSA) photographers under the tutelage of Roy Stryker. Anthologies of the oeuvre of the photographic greats should be available in libraries.

And perhaps a final building block is the study of the world of the painter and a knowledge of art history. Before the invention of photography, the transmission of visual imagery belonged to the world of the artist who took us from rudimentary cave paintings to more sophisticated work, such as Goya's documentations of war. Without yesterday's artists, much of what we know about man's heritage would have been completely lost.

6. Are you visually literate?

How often do we touch without feeling, listen without hearing, eat without tasting, and look without seeing? Like beauty, information is in the eye of the beholder and visual literacy is its key. Henry David Thoreau wrote in his journals (1834–1862) that "each phase of nature, while not invisible, is yet not too distant and obtrusive. It is there to be found when we look for it, but not demanding our attention." In his wisdom, Thoreau implored us to slow down, take a closer look, and learn to see the beauty that nature provides. Although not specifically calling it visual literacy, Thoreau perhaps was really talking about it—the ability to use our eyes for more than superficial observation of the world around us.

Translating that to photography, over the years I have seen many pictures that tantalize the curious viewer, pictures that ask as many questions as they answer. Visually literate people probe deeper and ask more questions about the elements in a photograph. They draw information from every object, from body language, from mood, from gestures and expressions. Visual illiterates are unwilling to invest the time, energy, and intellect to garner the layers of information a picture holds. To be visually literate is an absolute necessity. The photojournalist has to slow down to see more; he must avoid the superficial glance in favor of deeply focused attention to see form, structure, volume,

scale, texture, content, and relationships. Only then can photography become a powerful communication tool.

7. Are you a perceptive photographer?

To be a perceptive photographer, the mind, the spirit, the heart, and the emotions have to be engaged. It goes beyond technique, craftsmanship, imagination, originality, and creativity. Perceptive photographers don't take shallow minimalist photographs. Perception rejects superficiality and demands more meaningful photographs that go below the surface.

Forty years ago, I attended a lecture by Kurt Safranski at the New School of Social Science. Safranski reminded his listeners that Henry James described all perception as apperception. Since perception doesn't develop in a vacuum, simple logic suggests that new ideas are filtered through one's previous knowledge and experiences. One can turn to the work of English photographer Don McCullin, whose extraordinary pictures rage against war, death, and human suffering. John le Carré described McCullin's purpose as something "to appall the comfortable, the wilfully blind and the unknowing."

McCullin's photographic perceptions are apperceptions. He cannot photograph in Cambodia without visions of Vietnam, Cyprus, Biafra, the Congo, Bangladesh, and other scenes from his photographic past intruding on his consciousness and informing his work.

8. Are you well informed?

Photojournalism is dependent on ideas primarily related to the news and the background of the news. It is essential for the photojournalist to be informed, to be exposed to diverse points of view, to bring to every assignment a sense of history and a deeper knowledge of the subject one is photographing.

Being informed means reading quality newspapers that report on domestic and international issues in depth. It means reading opinion journals and magazines that go beyond the simple summarizing of events. It means watching television programs and reading books that address the major political, geopolitical, and ethical issues of our time.

9. Do you have something to say?

Ideas are the lifeblood of journalism. Without ideas you are just a button pusher, a hole filler on the newspaper or magazine pages. You must be able to recognize the difference between an editorial idea that is visually translatable and one that is purely a text idea.

10. Is your verbal communication effective?

Photojournalists have to be able to persuasively and knowledgeably articulate their ideas in order to interest the editors to whom they sell those ideas. And they are often required to write extensive, accurate captions or back-

ground information to supplement their images. The photojournalist who provides incisive comments and insights to add dimension to his/her photographs is immeasurably more valuable than the pure imagemaker who operates on visual instincts alone. Photojournalists who want greater say in the presentation of their work in newspapers and magazines would be more successful in their efforts if they developed their verbal skills.

11. Do you have boundless energy?

As I've said before, photojournalism demands unflagging enthusiasm, a spirit of adventure, the ability to survive under difficult circumstances, the courage to confront danger, and a modicum of charm, poise, polish, and panache. Photojournalism must be approached with passion.

I remember seeing Leonard Bernstein conduct a New York Philharmonic Orchestra performance of Stravinsky's *Rite of Spring.* What energy! What passion! Bernstein's every motion, every gesture, and every expression induced a sometimes great orchestra to perform a difficult masterpiece to the best of its ability. What does Leonard Bernstein have to do with photography or photojournalism? Everything. Because the passion that Bernstein expended as a conductor is a basic characteristic of every great artist. Pavarotti sings passionately; Martin Luther King, Jr., spoke passionately; and Picasso painted passionately. To be a great photographer or photojournalist, one has to be a passionate photographer.

Passion is the fuel of life. It fires the intensity of the human spirit and human emotions. Love and hate thrive on it. Probing, tireless, and ultimately successful journalism demands it. The famed violinist Jascha Heifetz, whose musical virtuosity stirred the musical passions of the world, once said that "a concert violinist must have the nerves of a bullfighter, the vitality of a woman who runs a nightclub and the concentration of a Buddhist monk." He might well have been describing the prerequisites for success as a contemporary photojournalist.

12. Are you willing to be bookkeeper, secretary, business manager, publicist, and salesperson?

If one's ambition is to be a free lance, one must be willing to accept the concomitants that go with the alluring title "photojournalist." Because there is more. Expense statements need meticulous substantiation. Arranging assignments is time-consuming but necessary. When not on assignment, one must scout potential clients and open doors to generate further work.

13. Are you willing to give up your personal life?

The demands of photojournalism are often incompatible with those of sustainable relationships. Many photojournalists are on the road six to nine

months a year in pursuit of the latest conflagration, the most devastating natural disaster, or most explosive political disruption wherever it takes place.

In 1989, the globe-trotting news photojournalists were given little respite. The student uprisings in Beijing's Tiananmen Square claimed press attention for the first part of the year, and culminated in the June massacre. The tumultuous revolution in Eastern Europe saw the dismantling of Eastern European Communism occurring with precipitous and unexpected speed. Photojournalists covered the turbulent events that propelled Solidarity to power in Poland, photographed the opening of borders from East Germany to West Germany as the Berlin Wall came tumbling down, and followed the progressive deterioration of the governments in Hungary and Czechoslovakia and the vengeful bloodbath in Rumania. There was hardly time to catch one's breath before a new and unexpected geopolitical event emerged, and the nomadic photographers were on their way to a new site, a new country, a new language, a new experience, and a new visual challenge. The climactic events of those few months took place under the unrelenting eye of modern communications technology. Events unfolded with such speed that one hesitated to blink for fear of missing something. The media army of television and still photographers were there to visually record the mood swings of revolutions, from the joy of liberation to the horror of death. They recorded the resurrection of fallen leaders such as Alexander Dubcek, the destruction by hammers of the Berlin Wall, and the development of new and untested governments to fill the political vacuums.

During this period our Black Star photographers were all over. Wherever the action was anticipated or taking place, they were there. With each new crisis, these shagged-out photographers were revitalized by the inspirational events before their cameras, and they committed themselves, week after stunning week, to capturing history on film. Their pictures go beyond the spectacle of masses of people taking physical risks in their rebellion against totalitarianism. Their pictures reveal insightful moments of grief, despair, and jubilation. They and others, freelance and staff photographers for the newspapers, magazines, and wire services of the world, monumentalized a brief and magnificent moment in history when previously disenfranchised people joined together to effect a revolution.

But let us fantasize for a moment about your being "lucky" enough to become a staffer or contract photographer for *National Geographic* magazine, whose stories are not topical and take three to four months to complete. The price one pays for the opportunity to do in-depth stories about far-flung

countries is a constant diet of travel to strange places and divorcement from a stable lifestyle. Peregrination, that's photojournalism.

14. Are you a "concerned photographer?"

Since Cornell Capa first developed the concept of "concerned photography," those photographers who are not dispassionate observers were defined. They take sides and practice advocacy journalism. Lewis Hine, the pioneer in confrontational photography, said of his work, "I wanted to show things that had to be corrected. I wanted to show things that had to be appreciated."

More and more photographers have embraced visual social commentary and want to follow the photographic trails blazed by Lewis Hine, Jacob Riis, and other social reformers. Concern for the environment and the recording of man's exploitation of natural resources are increasingly commonplace. The exploration of social ills—homelessness, domestic violence, racism, and the like—has been important in advancing photojournalistic careers.

15. Do you believe in yourself?

You must believe strongly in yourself and your ability to handle an assignment, any assignment. Confidence means being able to arrive at a scene, define the essence of what is happening, select the elements to be photographed, and emerge with the cogent, coherent image that best reflects that event.

16. Do you love the work?

It may be unfair to ask that question at a juncture in your life when you're still making up your mind about the future. You will probably have to invest some time in the business to respond honestly.

Some of these questions were stimulated by a letter I received many years ago that commented on my columns in a photographic magazine. I am sorry not to be able to identify him, but I saved his pungent comments. My friend said,

> I am convinced that in the long run, it [love of the work] is probably the most necessary ingredient in a formula that will eventually produce a successful photojournalist.
>
> Only love can provide the drive to keep you shooting effectively toward the end of an exhausting 16 hour day. It is love that forces you to wade a muddy ditch with cameras held high overhead, hoping the angle will be better from the other side. And when the thrill of being published subsides, and the realization sets in that the big bucks are in advertising, it is only love that can cushion the inevitable letdown. And the knowledge that somehow, some way, you are taking pictures that matter.

It is obvious to me that one must define one's goals, one must have the creative and technical skills to compete professionally, and one must love what one does. The last item on that list is where you begin. If you don't have a

strong feeling for photography, then you might just as well sell encyclopedias, build houses, deliver babies, or newspapers, or do any one of a number of things that might provide a steadier livelihood.

Your answers to these questions will reveal your strengths and your weaknesses. You may need to rethink your interest in this profession if you are not ready to leave the safe cocoon of your hometown and family to pursue the photojournalist's undisciplined lifestyle. Or your desire to tell a story in pictures may not be that great—you may want to use your camera in other ways. Or perhaps you just need to spend a few afternoons in a library, poring over photography and art books. My hope is that you will now have a sense of what you need to step forward and take the proverbial plunge. This is the time to negate self-delusion. This is the time for discovery, and for personal honesty.

You should understand by now that photography, in general, and photojournalism, in particular, may be among the toughest of all professions to enter. Does that mean that one shouldn't go into photography because the odds against success are so great? No! Each day we see new photojournalists supplanting established talents. But success doesn't happen by accident; it comes from an inordinate enthusiasm, an all-consuming pursuit of perfection, an aspiration to creativity and a disdain for mediocrity. It requires 100 percent professionalism, unparalleled optimism, unlimited staying power, and a brain that is well-informed about every aspect of the world in which we live, burgeoning with at least one good editorial idea every eleven minutes.

Peter Howe is the British-born former picture editor of the *New York Times Magazine,* former director of photography at *LIFE* magazine, and currently consulting picture editor for *Audubon* magazine and *Modern Maturity.* He has been on the photojournalistic firing line as a photographer and has uncommon intelligence, sincerity, and understanding of the profession. In a speech recalling his beginnings in journalism he recalls,

> When I graduated from college in the 1960s, there were only three professions that any self-respecting young Englishman would consider. You could either be a rock star, a soccer player or a photographer.
>
> Photographers drove Ferraris, ate at expensive restaurants in the company of beautiful models—or so the legend went. I subsequently found that the legend was true in a small number of cases, and that these photographers were called "advertising photographers."
>
> Photojournalists, on the other hand, drove rental cars and ate in coffee shops in the company of bad-tempered disrespectful people called writers. So faced with these two alternatives, I did what any intelligent, ambitious graduate would do. I became a photojournalist.

What amazes me now is that twenty years later, legions of young people are still making the same decision that I did. It's a given that youth is foolish, but that foolish? Look at what faces the budding photojournalist today. There are fewer magazines with smaller budgets. Many of the most successful publications thrive on a diet of photogossip in which the celebrity du jour is snapped in a situation so bizarre that moments of genuine surrealism appear by accident.

I shot for more than fifteen years, all of them *freelance,* the only word in the English language ever to induce cardiac arrest in a bank manager. I use this as my authority to be optimistic, but I think that the bottom line is this. Journalists are society's witnesses and photojournalists are the front line witnesses, not only for our generation but for generations to come. I and other photo editors in other magazines will do all we can to ensure that this witness is seen, but the future of photojournalism lies where it always has been, and where it always should be, in the minds and eyes of photographers.

The camera is only a tool. It is an inanimate object incapable of more than the simple reproduction of a scene or an event. It is the well-informed photojournalist imbued with painstaking professionalism, curiosity, reliability, sensitivity, creativity, technical competence, and love of his work who will be most successful. The idealized photojournalistic Superman that I have described above needs the intellect of an Oscar Wilde, the dedication of a Nureyev, the technical brilliance of an Ansel Adams, the imagination and curiosity of an Isaac Asimov, the personality of a Katherine Hepburn, and the style of a John F. Kennedy.

In photojournalism, as in art, there are always new heights to scale, new corners of the human experience to document and interpret. The greatest enemy is the self-satisfaction that comes from believing that you've reached the top and there's nowhere else to go. That attitude ultimately leads to mediocrity and decline. I know bad photographers who make big money and excellent photographers who just survive. Clearly, talent is not the only ingredient. First one develops the brain and the technical skills; next comes the selling job.

As every successful salesperson will tell you, there's no one way to merchandise a product. Photography requires a combination of luck, perseverance, personality, patience, intelligence, a strong back, lots of shoe leather, a financial backlog, contacts, aggressiveness, self-promotion, ego, and outstanding photographic skills. I do not know any shortcuts to success in this or any field that will allow one to bypass hard work. All of this leads to a very special word in the vocabulary of the photojournalist: "commitment." I recently read a

Shearson Lehman Hutton advertisement that eloquently defined the word's meaning. "Commitment," it said, "is what transforms a promise into reality. It is the words that speak boldly of your intentions. And the actions which speak louder than the words. It is making the time when there is none. Coming through time after time, year after year after year. Commitment is the stuff character is made of; the power to change the face of things. It is the daily triumph of integrity over skepticism."

It is my hope that you have faced the realities, found yourself not wanting and remain stubbornly resolved to become a photojournalist. Where do you start? Read on.

Launching Your Career in Photojournalism

If a man has a talent and cannot use it, he has failed. If he has a talent and uses only half of it, he has partly failed. If he has a talent and learns somehow to use the whole of it, he has gloriously succeeded, and won a satisfaction and a triumph few men ever know.

Thomas Wolfe, *The Web and the Rock*

So, after evaluating your pluses and minuses, you have concluded that you are not going to be dissuaded from pursuing a career in photojournalism. You're going into business as a photojournalist. Perhaps "business" sounds too crass, and you would prefer to call it a "profession." Call it what you will, you're going to have to develop a realistic, pragmatic plan of action.

How do you start? Starting in any business requires an investment. A person who wants to open a grocery store begins by finding a location that will attract a clientele who will come to the store and buy the merchandise. A leasehold has to be signed at a reasonable rent, shelves have to be built, stock has to be purchased, and employees have to be hired. The financial investment in even the smallest establishment requires thousands of dollars. For the budding photojournalist, the commitment of money is minimal compared to most enterprises. He or she will need basic photographic equipment—comprising camera bodies and lenses—a portfolio of work to stimulate the interest of potential clients, a pleasing personality, and some ideas that will indicate a consuming interest in the world.

Preparing for Your First Job

Preparing for a photographic career requires the simultaneous development of technical proficiency and your mind. Remember, the camera is the tool with which the photographer works. You must acquire complete mastery and understanding of its capacity and limitations. The camera is just an inanimate object incapable of more than the simple recording of a scene or an event.

I have been amazed and sometimes distraught through the years at the naivete and lack of preparation for the real world revealed by many of the young photographers who have come to see me for advice, direction, or portfolio evaluation: amazed that so many of them have spent $50,000 for a four-year program and emerged without decent portfolios to reflect their visual talents; distraught at the thought that they have to enter a very difficult field without any insight or research into their chosen profession.

Before going for one's first interview, some real photojournalistic experience is valuable. The young photographer must seek out opportunities all along the way—by shooting for high school and college newspapers, working as an intern for the local newspaper, and attending workshops. Having a single picture or a series of photographs published in the local newspaper establishes your credibility as a photographer, reflects your energy and enterprise, and gives you the satisfaction of seeing your first work in print. Workshops are particularly valuable not only educationally but in terms of networking and making contacts that can be valuable in the future. Top people in photojournalism are regular participants at the Missouri Workshop, the Eddie Adams Workshop, and the Maine Photographic Workshop, to name a few.

A Strong First Portfolio

Let's talk about portfolios. The portfolio is the photographer's calling card. When a photographer walks into an editor's office and plops down a portfolio, that "book" reveals all. If it has been put together with tender loving care, it will reflect a person who takes pride in his or her pictures. If this is your first portfolio, the subject matter and the number of pictures may be limited, but the print or slide quality should be perfect, the presentation impeccable. The photographs presented will reveal personal and photographic interests and show the photographer's ability to deal with people and different kinds of subject matter. They will also reveal photographic style, technical proficiency, storytelling ability and the photographer's personal visual aesthetic.

Sam Abell, a long-time contract photographer with *National Geographic*

magazine, may have said it best. "Your portfolio is the final defense and resting place of your imagination and ambition. Photography is not a way to show off. It's not a store full of lenses and lights. It's a language, which is the chief art of life. It's like a song—your song."

Just because it's "your song," that doesn't mean that the presentation of your portfolio need be accompanied by music. Pictures are not improved by accompaniment. I have noticed that more photographers are presenting their photographic portfolios to the strains of folk, rock, or classical music. But music belongs in concert halls, opera houses, at home when reading or relaxing, or when viewing multimedia presentations for which it may be an integral element.

When I evaluate a photographer's portfolio, I want to look at pictures without embellishment, without distraction. That meeting between photographer and picture editor is not the time for show busines. Music intrudes and inhibits conversation at a time when discussion and evaluation of the portfolio should be paramount. Music may soothe the savage heart (presuming that picture editors and art directors have hearts), but it doesn't make bad pictures better or good pictures great.

In preparing the portfolio, photographers should be ruthless in the selection of the images to be presented. Mediocre pictures don't belong; they dilute the impact of the presentation and reveal a lack of editing skills. Each frame in the portfolio should stand up to rigorous scrutiny in terms of composition, technique, graphics, and content. Pictures don't get better because they are bigger. Sophisticated picture editors will recognize outstanding work just as readily in 35mm slides as in mammoth 20" x 24" prints. Lighter weight portfolios also save wear and tear on the photographer's back. This is important in a business that demands much lugging and carrying (so much in fact that "bad back syndrome" is a photographer's occupational hazard). The portfolio should be replete with pictures that would publish well, that are technically proficient and editorially clear. Newspapers and magazines are not for aspiring artists, so save the art work to show at museums, not in your photojournalism portfolio.

Some photographers call in advance and ask me what I want to see in a portfolio. How many pictures? How should they be presented—in a tray or in slide sheets or prints? My answer is, "I will be happy to look at whatever you want to show me, in whatever form you wish to present it." That imposes a great burden on the photographer, for what it means is that the photographer should prepare a presentation that moves fast and shows capability without being redundant or boring.

One admonition. Don't make the rounds of the magazine editors or picture agencies until the portfolio is good enough to "knock the socks off" the viewer. That first foray into the precincts of those who make decisions about photographers and photography is too important to waste. If the portfolio is not the best you can make it, wait until it is.

Even before your first job, you can undertake a personal project of some substance and depth to enhance your portfolio. I think it is a surefire way to prove one's photojournalistic talent and to capture the attention of the editor. It need not be a project in an exotic, distant locale. It can be right in your own backyard. It should be a subject about which you care very much, one that has journalistic underpinning and that offers you, as a photojournalist, an opportunity to say something. Since the neophyte has a comparatively small financial investment in the beginning, an investment of time in a project is well worth the effort. A later chapter discusses the work of individual photographers who have used personal projects as building blocks to success.

Newspapers, Wire Services, Freelance Opportunities: Getting Hired

With your first portfolio in hand you are now faced with three choices—to be a free lance, to aim at becoming a staff photographer on a newspaper or general-interest magazine, or to begin as a wire service photographer or wire service stringer.

Until the early 1970s, general interest magazines maintained staff photographers. *LIFE* magazine, during its greatest days, maintained a large staff that included twenty to thirty photographers. Since its death in 1971 and subsequent rebirth, *LIFE* has given up on the idea of having staff photographers and has relied exclusively on free lances. The newsmagazines have done the same. *Time* and *Newsweek* primarily use freelance photojournalists and contract photographers, to whom they guarantee a certain number of days' work on a yearly basis. *U.S. News and World Report* has several staff photographers but finds it necessary to depend on freelance photographers to give them the geographic coverage worldwide coverage demands.

The greatest opportunity for young photojournalists is with newspapers. Newspaper photojournalism is today's frontier despite the deep recession, which has had an adverse financial impact on newspapers, resulting in deep cutbacks in hiring.

Once looked down upon by magazine photographers, newspaper photographers were viewed as cigar-chomping clowns. That negative image has been

reversed by a new breed of educated and thoughtful photographers now working in the field. The newspaper world is a huge maw capable of swallowing large numbers of photojournalists when they graduate the universities and enter the field. To many of the photographers who have asked for my advice, I have suggested that newspaper photography would provide a most rewarding career. For those with freelance ambitions, it can serve as a training ground for the future. The newspaper job market is tight, but there are always openings for the most promising talents.

It is in newspaper photojournalism that a young photographer can have the security of a weekly check and the peripheral benefits of pension plans and paid vacations that come with steady employment. It is also the front line of photojournalism, where he or she will confront assignments running the gamut from taking feature weather pictures to getting shots of dramatic events. The busy newspaper photographer may be called upon to do four or five assignments daily, each representing a different approach, each a new learning experience, each bringing the photographer into contact with differing personalities and situations.

The cumulative experience that comes with newspaper photojournalism will always be long lasting. Brian Lanker started out at the *Topeka Capitol Journal* where he won his Pulitzer Prize, then did a stint at the *Register Guard* in Eugene, Oregon, before making it big at *LIFE* and *Sports Illustrated*. Jim Nachtwey's early days in photojournalism were spent at the *Albuquerque Journal* before he came to New York and became a Black Star staff photographer. Howard ("Socks") Sochurek started at the *Milwaukee Journal* as did well-known *LIFE* photographers Frank and Joe Scherschel. Newspapers have been a traditional spawning ground for some of the leading photojournalists of the last half century.

Rich Clarkson, prior to becoming director of photography at *National Geographic,* was director of photography at the *Topeka Capitol Journal* and assistant managing editor for graphics at the *Denver Post.* His incisive knowledge of newspaper photojournalism has been acquired during his experiences as a working photographer and as a management executive. Some of America's foremost photographers have come under Clarkson's influence. His concerns for content over style in visual communication have been expressed at numerous photojournalism conferences through the years.

Photographers interested in pursuing newspaper photojournalism should be concerned with the realities of what it takes to get hired as staff photographers on American newspapers. Rich Clarkson has outlined for me some of the basic principles that have guided his hiring decisions.

When I was at Topeka and Denver, I would take inventory of the staff upon learning that a vacancy was in the offing. What were its strengths and weaknesses? Did we have individuals that could insure good news and sports coverage? Did we have persons who were good in the studio? Did we have an essayist?

Then, I would take inventory in style as well. Did we have a staff that was getting to the point that someone would say, "Well, that's the Topeka look." It is important within the confines of the personality of the newspaper to have a variety of picture styles, just as any good newspaper has a variety of writing styles.

After my inventory, I could then better identify the qualities and experience level I was really looking for and could begin the search process. Many photographers I talked to thought that it was a simple matter of selecting the best portfolio and often didn't understand my choice. But the choice was based on many things.

I asked Clarkson to define the "ideal portfolio" and highlight what he looked for in the applicants' portfolios. He answered that

it is ridiculous to organize other people's portfolios. What I want to see in a portfolio is what they want to show me. What they choose and how they show it is part of those things about which I am curious. I want to see them, not someone else's version of them.

Thus what they show is a part of what I want to see. Beyond that I look for technical quality, professionalism and photographic competence. Assuming all those things are present in sufficient quantities, then I look for originality. Originality is that elusive and hard-to-define quality that will eventually cut the really good people from the competent ones. It is that extra measure. It can take many forms.

A college degree was not a prequisite for a Clarkson hire, but was to him an indicator of an individual's ability to finish an important project. "It is not the only indicator of an educational awareness or a proper curiosity," he said. "It is one of the things that count in the right direction. The educational quotient is important to me, but there are a variety of ways and places where one can get it—college being only one."

What about personality and individual traits entered into the decision? To Rich Clarkson "there is one hard-to-define quality that I rate highly in every hire I have ever made. People either have it—or they don't. *Sharpness!* If someone is really sharp—intellectually keen and able to put it to practical use quickly and efficiently—then they can learn journalism and photography and almost everything else. You can teach a sharp person almost anything. You cannot teach sharpness."

Curiously, Clarkson always looked carefully at the handwriting of the applicant based on his opinion that it tells something about the individual. And he always allowed more time for quiet individuals than for the more assertive ones, since it seems to him that the quiet person may have some real strengths that are not easily apparent.

While at Topeka and Denver, Rich Clarkson had other members of the photographic staff meet with and size up prospective hires. On newspapers, the photographic staff often has to work as a team and "it is well that the staff get along as well as possible." In twenty years, there was only one time that Clarkson's staff absolutely vetoed a person he had brought in, and Clarkson says the track record of that photographer has revealed that person to be a "full-fledged phony who has bounced from job to job without any great achievement, although he will tell you that he's a superstar."

Wire service photography gives young photojournalists much the same benefits as newspaper work. Many photographers have begun their careers as wire service stringers, primarily in the hinterlands of the United States. The wires, like Associated Press (AP), require photographers to provide them with strong single pictures summing up the essence of an event. This emphasis on the single image dictates a kind of visual storytelling discipline that stands photojournalists in good stead later on. United Press International (UPI) has long provided strong competition for Associated Press. Reuters and Agence France Presse (AFP) have become increasingly important in wire service photography.

Young photojournalists have historically made the mistake of assuming that one can do best in the Northeastern part of the United States. They have gravitated to the New York, Boston, Philadelphia, Washington axis, looking for jobs rather than exploiting the opportunities available at the many outstanding newspapers elsewhere in America. The *Louisville Courier-Journal,* the *Detroit Free Press,* the *Seattle Times,* the *Charlotte Observer,* the *Miami Herald,* and the *San Jose Mercury News* are just a few of the newspapers that have carved out a strong niche in newspaper photojournalism. Dozens of newspapers in smaller communities use photography very well. They are not the country bumpkin cousins of newspaper photojournalism. Workshops, NPPA seminars, and the inclusion of picture people in management positions at newspapers have raised picture consciousness at newspapers throughout the country.

Achieving Success

I never met anyone who worshipped failure. There are those who worship success and pursue it with obsessive single-mindedness, and others who dep-

recate the "bitch goddess" yet patiently await her benediction. Attitudes are diverse and personal and conform to individual lifestyles and philosophies. One man's financial success is another man's sellout; one man's aesthetic achievement is another man's financial failure.

Over the years I have observed all kinds of photographers seeking glamour, fame, and status. Some settled for money. But most were impelled by an overwhelming dedication to their ultimate goals. It seems useful to evaluate some of the mixed ingredients that are the basic precepts of professionalism. Pride, passion, and drive count for a great deal in photojournalism. Likewise, style and showmanship are to be respected in every profession. Obviously, the photographer who hides his light under a bushel will get less recognition than one who engages in self-promotion.

Robert Capa, Margaret Bourke-White, W. Eugene Smith, and Karsh are, again, examples of photographers whose forceful personalities, style, and showmanship brought them media attention and enhanced recognition. Robert Capa, who covered almost every conflict from the Spanish Civil War until his death in Vietnam, has become the paradigm for the flamboyant, fearless photojournalist. His lifestyle, his penchant for gambling, his romance with Ingrid Bergman, and his remarkable pictures formed a public persona that extended his fame worldwide.

The dynamic Bourke-White built her reputation on being first—the first *Fortune* photographer, the first woman staff photographer for *LIFE* magazine, she had the first cover of *LIFE,* and she was the first woman photographer allowed to fly on missions with the U.S. Air Force during World War II. A pioneer of the photo essay, she was individualistic, independent, beautiful, and her heroics contributed to her high visibility.

W. Eugene Smith's complex personality and his penchant for fighting the *LIFE* establishment to gain greater control of his work contributed to the recognition of his photography. It sometimes seems that Gene Smith calculatedly set out to develop a professional personality that would set him apart from his colleagues and enhance his legendary status.

The name Karsh has become synonymous with portrait photography. Field Marshall Montgomery referred to his session with this charismatic photographer as being "karshed." His eloquent portraits speak for themselves in justifying his international recognition. But one can't ignore his shrewd use of public relations and his planned effort to photograph every major statesman, literary figure, artist, and scientist of our time as contributory factors to his stature.

But ultimately it is not poise, polish, personality, or panache that advance a

photographic career. It all comes down to painstaking professionalism, reliability, imagination, and technical competence. Add to that insatiable curiosity, adaptability, alertness, and awareness. Photojournalists must be perpetually responsive to the world around them.

It is a business in which you live by your wits and your talent. It is rare indeed for talent to be immediately recognized. For the photojournalist, it means knocking (and knocking again) on picture editors' doors until one's possibilities are recognized. It means evaluating your work throughout your career, being responsive to change, nurturing your talent, and growing from assignment to assignment. It requires looking at and listening receptively to the criticism of others.

A few short years ago, I attended a dinner of the Overseas Press Club, where *Boston Globe* staff photographer Stan Grossfeld received an award for his photographic reporting from overseas. When I congratulated him, I said, "You don't know me, Stan, but I was one of the judges of this competition and I want you to know that I am an admirer of your work." "You're wrong," he responded. "I know you very well. I visited you in your office about seven years ago and showed you my portfolio. You criticized it and said that it wasn't very well focused. I went back to my hotel, reevaluated my portfolio and concluded that you were right. That session contributed much to my being here as an award-winner tonight."

I tell that story not to tell you what a great critic I am—I have probably been wrong many times about some of the thousands of photographers whose work I have seen. This story is important because it says something about Stan Grossfeld and others like him who are open to criticism. There's always something to be learned from constructive criticism, even if it may diverge from your own point of view.

And then there is Donna Ferrato, about whom I wrote at length earlier. After my first meeting with Donna in 1985, we had only slight contact until 1988, when she came to Black Star and said that she wanted to sever her association with another agency and join our company. I welcomed her and offered her a staff contract with a weekly draw despite her protestations that she "was not a big money earner after many years as a photojournalist." My confidence has now been validated by her achievements and the increasing demand for her work, which enable her to choose work subjects that are attuned to her social ideals and concerns while bringing her much larger financial rewards.

Our definition of success does not preclude making money. However one seeks recognition, in status or money, much is demanded of the photographer's

personality. Many overbearing photographers make it big, but for every one of them, I can point to another amiable and thoughtful photographer who has been equally successful. We all can't be $100,000-a-year photographers. Some of us have to settle for less based on our individual limitations. The greatest pity of all in any profession, however, is not to aim for the top.

Developing Your Portfolio

Our world abounds with endless possibilities when seen through creative eyes. If we all begin seeing new possibilities, just think of the worlds we could create. Part of creating is understanding that there is always more to do; nothing is ever completely finished.

Rachel Lambert Mellon, landscape designer

Anyone in a position to dispense photographic assignments or hire photographers on a permanent basis is constantly besieged by the increasing numbers of photographers who want to show their portfolios. After some years of looking at portfolios, I've discovered certain unassailable truths: no two are alike, and no editor would want them to be.

Portfolios can range from a collection of twelve dog-eared, yellowing prints with accompanying yellowing newspaper tearsheets to a dazzling display of color transparencies in a carousel tray. Wherever your portfolio falls between these two extremes, it should represent the best work of your career.

The portfolio of a working photographer is different from that of a beginner. Editors expect more from the experienced applicant, so no matter how much or how little experience you have it's important that the body of work you present fully reflects your growth and development as a photographer. Portfolios should not be static, unalterable presentations; they should be cumulative and expanding and may even include pictures from yesterday's assignment.

Updating and Refining Your Portfolio over Time

If your portfolio represents the best work you are capable of at any moment in your career, then your portfolio should never be far from your conscious-

ness. Every time you go out on an assignment, you should be thinking of pictures that might add to your collection. If the assignment calls for a journeyman picture, take it. But think about taking a picture for yourself as well, for your portfolio, which will go beyond the client's needs and perhaps show a different way of seeing banal subject matter. You may even be surprised to find that picture selected for publication. As Rachel Lambert Mellon said, "Part of creating is understanding that there is always more to do; nothing is ever completely finished." Particularly your portfolio.

But most of the photographs in the portfolio of a working photographer should be ones shot on assignment. They show the photographer's ability to fill a publication's needs and to get the job done—well and on time. We are all known for the company we keep or the clients we work for, so tear sheets of your best work should become part of the portfolio. When preparing a slide presentation, it is worthwhile to make slides of the tear sheets to show the diversified publications for which you have worked. For the photojournalist, having photographs published in such national and international publications as *LIFE, Time, Newsweek, National Geographic,* and the *London Sunday Times Magazine* is impressive and shows the breadth of receptivity to your work.

The working photographer can benefit by including a personal project in a portfolio, especially where published picture stories do not exist. But this does not mean simply leaving in the self-assigned personal project from your first portfolio. After you've been earning your living as a photographer for a few years, your technique should be improved, your eye better, and your visual thinking more disciplined and sophisticated. It's time to find another personal project—to challenge yourself further than your everyday assignments do, to improve your portfolio, and perhaps eventually to sell for publication. The development of a portfolio is a photographer's investment in the future—an investment of time, money, energy and ideas. If such a massive effort produces an unsatisfactory result, then perhaps the photographer should question his or her suitability for what is a difficult profession at best.

Editing the Portfolio

Too many photographers underestimate the importance of the portfolio. The photographer usually gets one shot at winning a potential client. Make that shot count with a presentation that shows imagination, technical ability, solid storytelling content, curiosity, spontaneity, and, of course, intelligence.

Ruthlessness with yourself and your work has its own rewards. There are eighty slots in a carousel tray, but that doesn't mean that you have to show

eighty pictures. A photographer preparing a portfolio should show only the best pictures and avoid redundancy. I've mentioned before that mediocre pictures in a tray dilute the impact of the presentation, suggest that you really don't know what good pictures are, and distract the attention of the viewer from the pictures that are outstanding. It makes sense to try out your tray on relatives, friends, and colleagues, inviting their frank and honest criticism of the work you have selected. The varied opinions will drive you crazy, but the feedback will make you think about each picture and its individual value.

Sequencing the pictures in the right order is of paramount importance. The portfolio should have a philosophy. It should have climaxes. The first pictures you show should be among your strongest pictures so that you capture the attention of the viewer from the get-go. A few yawners at the beginning will cause the editor's attention to wander. A few stunners will stimulate the editor to want to see more and keep his or her attention focused on the work.

If you are presenting a story, the sequencing becomes critical. You have to think like an editor and act like an art director—present the pictures in a linear construction so that the pictures have a natural narrative progression. The story should have a beginning, a middle, and an end with varied long shots, medium shots, and closeups to avoid visual tedium. The sophisticated cinematographer always thinks of varying camera effects, vantage points, and distance when editing his or her film. You must learn to do the same before preparing your portfolio.

If you are showing color, juxtapose different colors. You don't want five or six pictures in a row with the same basic colors. Varying the dominant colors from picture to picture will add vibrancy and vitality to the tray.

Show only first-class black-and-white prints to prove your technical darkroom abilities and pride in your work. Know the publication and what type of pictures it uses. Gear the portfolio to the publication. Bill Strode, a freelance magazine photographer, former *Louisville Courier-Journal* staffer, and now a successful book packager, thinks "the photographer should study the publication where the presentation is to be made. One shouldn't present the same portfolio to all publications or potential clients. Each publication is different. You have to retain the integrity of your style if you're a free lance, but you do have to conform to the needs of the different clients you work for."

The pictures presented in a portfolio should display versatility, style, a point of view. Your portfolio will say a lot about you, your experience, your artistic and aesthetic sense, what interests you in the world, your rapport with people, your imagination, and your sensitivity. Make sure that the pictures you choose

are an accurate reflection of who you are as well as how you photograph. You are what you show.

When making presentations to photographic agencies, remember to include a larger pool of material from which specifically tailored selections could be drawn. The agencies will have in mind many different editors whose relatively narrow needs are dictated by their publication's editorial mandates.

What the Portfolio Shouldn't Be

I have tried to define the elements that will enhance the portfolio. There are many pitfalls along the way to a winning presentation. They relate to behavior, presentation, and human considerations involved in any social transaction. You, the photographer, are concerned that your portfolio will be greeted with courtesy and get the undivided attention of the editor/viewer. Anything that intrudes on and affects that aim adversely should be avoided.

Over the years I have met with masochistic photographers, whose portfolios contain prints mounted on 30" x 40" boards with a collective weight of over one hundred pounds. Straining under this load, the photographer staggers in and is exhausted by the time he or she opens the case. Such photographers may have seen wall-sized Richard Avedon gallery prints and may operate on the premise that bigger is better. Large photographs may have greater visual impact, but blowing up a bad picture doesn't make it good. I disagree with those who believe that "if you can't make it good, make it big!" Making bad pictures bigger only reveals flaws in greater detail. Sophisticated picture people do not have to be hammered over the head to recognize content, good composition, well-handled lighting or the other elements on which judgments are made. This kind of presentation is more suited to art photographers out to impress galleries or museums than to photojournalists making a presentation to editorially oriented agencies or magazines.

There are also sadistic photographers who have never taken a bad picture and presume to show you every one of their exposures so as to impress you not only with a wide diversity of subject matter, but also to prove that they are extremely capable of overexposing and underexposing.

In contrast to the first two types, there's the photographer who, after four years in a photographic educational institution, submits a few inadequate pictures that can only make a grown photo agent or picture editor cry.

One of my pet peeves is to look at a group of prints that are alternately right-side-up and upside-down, forcing the viewer to take the time to put the prints

all in the proper direction. Such carelessness reflects a sloppiness and lack of concern in preparation of the portfolio for presentation.

Bill Strode, whose background is oriented to press photography, is turned off by portfolios that emphasize art photography. He says that "art photography applies to newspaper photography only peripherally. You have to know art, and you have to know composition. But it doesn't make sense to come into a newspaper with photography irrelevant to its needs."

What Editors Want to See

O. Louis Mazzatenta is a picture editor and sometime photographer at *National Geographic* magazine. Mazzatenta says,

> when the photographer opens up the package, I ask myself, "Is he neat, orderly or organized; or is there a ton of stuff made up of a lot of different odd-sized prints?" Most editors are busy people and they don't have time to look at too much. So we appreciate seeing a manageable amount of pictures. Standardized prints, maybe 11 x 14", should be the maximum.
>
> If you're bringing in slides, one carousel tray of your best slides should be presented in some sort of sequence. In terms of the content, we look for range of ability, including action, fashion, geography, portraits—the whole gamut of subject matter. Basic sharpness and focus are assumed. If your pictures don't meet those criteria, you're better off not coming in.
>
> The prints should be top quality. Contacts should be available to show the editor, particularly if it is a story you are showing as backup material to the key prints you have enlarged.

Ever the photojournalist, Bill Strode wants to see at least two picture stories in the photojournalist's portfolio. "I want to see them laid out," he says.

> Maybe two to three pictures on a page showing how you would want them laid out by the editors. That gives me some insight into your editing abilities. It tells me if you think clearly, if you know good progression in picture stories.
>
> I want and ask for contact sheets. I ask for two sets of contacts—one set of contacts on a story that you think you've done well, and one set of contacts on a routine story you've shot lately. It might be Aunt Mamie's tea party. By looking at those six or eight contact sheets on those two different assignments, I can see how you shoot, I can see how you frame. I can see how you think from one situation to another.
>
> I want to see a story that you liked doing and one where you thought you really did a good job, as opposed to one that you thought was hard and that you did a fairly good job on. Any competent photographer can do a good job

on a good situation. Great photographers are the photographers who bring back great photographs from bad situations. So don't just show all your best pictures. Show the ribbon cutting if you really have a super ribbon-cutting picture.

Finally, as important as showing the pictures you have shot might be, it is equally important that I know that you are a self-starter. Editors want to hire photographers who have story ideas, and who are not only followers who take assignments and do the job.

Strode's advice to show not only your best pictures goes contrary to my dictum for ruthless portfolio editing. But Strode is talking from the vantage point of a former newspaper photographer whose responsibility was to judge the photographer's potential as a staffer who would be working on diversified assignments for newspapers. So photographers applying for newspaper work should be prepared to show contact sheets, perhaps carrying them in a separate envelope and only bringing them out if they are requested. Knowing that you may be judged in part by your contact sheets and that, if you get the job, your editor will be looking at them every day reinforces the basic principle that every photograph on every assignment counts.

Presenting the Portfolio

Personal appearance matters. A former picture editor recounted to me an experience where he told an unkempt photographer "that he wasn't going to sit at the desk with him looking and smelling the way he did." I have had to light matches and open windows wide on cold winter days after malodorous photographers left my office. When you present a portfolio, you are presenting a total package—you and your work. How you look might be as important as how your portfolio looks. I subscribe to the philosophy that one doesn't judge people by the clothes they wear. But we *are* first judged by our appearance, and that appearance should coincide with your sense of yourself. Our clothes may describe our taste. Be it jeans and a casual shirt or blouse, or a business suit, I think it is imperative that one appear in a way that is not offputting to the person one is visiting. Neatness and presentability should be the watchwords.

Bill Strode has always emphasized the necessity of respect for photographs. "How a person hands me a portfolio reflects how that individual feels about photography," he says. "People know what you think of them by the way you deliver them, by the way you talk about them."

Strode's point about the handling of photographs being a reflection of that

individual's respect for his own work and for photographs in general, reminds me of the way my father handled fruit. My father was a fruit and vegetable store owner. That's not a very artistic occupation, but my father was more than an ordinary fruit stand owner. The way he handled a piece of fruit, the way he made a fruit or vegetable display, the juxtaposition of colors that he used in making his displays all proved that he was an artist in his own right. He had the grace of a professional, the same precision that a top surgeon shows in handling a scalpel, a painter his brush, a conductor his baton, a mechanic his tools. I like to think that after all these years, the way I handle prints and transparencies indicates my love and respect for photographs.

Don't show up at an editor's office without an appointment. Some art directors and picture editors have a "drop-off policy." This means that they are not willing to sit with you and look at your work and would prefer to view your portfolio in seclusion. If you accede to their policy, you are denying yourself the opportunity to get feedback on your work and you are allowing yourself as an individual to be ignored. I think all photographers should refuse to drop off portfolios to inaccessible editors, and should insist on knowing whether or not the pictures have been viewed and what impact the portfolio had.

I find it difficult to understand why editors erect barriers between themselves and photographers. Why would creative people responsible for producing a quality magazine avoid a face-to-face meeting with a potential talent or contributor? To the photographer, accessibility to the client base is a prerequisite to career advancement. But gaining access to busy people may take patience. Photographers should not forget that the people they wish to see are harried by impending deadlines. Editors and art directors have pictures to edit, meetings to attend, photographers to direct, and superiors to whom they have to respond. They have no time to waste on time-wasters. Perhaps if more photographers were more considerate of the demands on picture editors and art directors, their doors would open more freely.

Photographers tell of waiting in anterooms for a half-hour only to find that the picture editor was out sick or the appointment was forgotten, or some other discourtesy. Yet, the photography world, like all the world, is not perfect. Photographers should recognize that the flaws of editors may be matched by their own. Never miss an appointment without calling to cancel or postpone it. If you are going to be more than fifteen minutes late, let the editor know. Call the day or morning before an appointment made in advance to confirm your meeting, and always leave a phone number where you can be reached in case the editor is the one who must cancel or reschedule.

Let your pictures speak for themselves. Although you are selling yourself as

well as your photography, talking about every picture in great detail is excruciating for the editor who is being forced to listen and is the road to certain oblivion. Guided tours of your photographs are irrelevant to experienced picture people who will respond positively to photographs that relate to their personal criteria. And don't feel impelled to make conversation, even with seemingly unresponsive viewers. Forced conversation often leads to inanities that do more harm than good. Learn to accept rejection with good grace. Picture editors are just as fallible and prone to bad judgment as anyone else, but their critical evaluations of your work can be most important to you in your photographic development.

Above all, be yourself! Don't be pretentious or precious in your portfolio or in your personal approach; your attitude is an important ingredient in the portfolio review process. Be confident about your work without being stridently argumentative or defensive. Be knowledgeable about the magazine's needs without being critical of the photography used by the publication. Finally, be communicative about why you want to work for that publication and what you can offer it as a creative photographer and journalist.

On Dress, Manners, Behavior, and Intercultural Sensitivity

> For manners are not idle, but the fruit of loyal nature and of noble mind.
>
> **Alfred, Lord Tennyson,** "Guinevere"

Several years ago a young photographer Black Star was representing had an appointment with an editor for his first major color essay assignment. I confess to some apprehension about how he would dress for the appointment because I had always seen him casually attired. But since, in the Thoreauvian tradition, I have tried never to judge a person solely by external appearance, I believed it presumptuous to suggest that he wear a tie and jacket. I had nothing to worry about. When he left for his appointment, the photographer was a picture of sartorial elegance. He had used what one of my aunts used to call "common brains." What she meant, of course, was "common sense," one of the most important ingredients for success in any field.

This photographer realized that in the real world of assignment photography, photographers are not always judged by their pictures alone. The "work" does not exist in a vacuum, divorced from the personality, intellect, appearance—the total personal image that the photographer projects. It is no secret that photographers are often negatively perceived because of the excesses of paparazzi going after a picture at any price or the aggressiveness of news photographers fighting for position at events. It is up to the individual photographer to dispel any downside preconceptions and immediately put the client or subject at ease. It is nonsensical for the working photojournalist to let external factors such as bad manners or inappropriate clothes, influence the outcome of an assignment. It is commonsensical for a photojournalist to look his best.

Dress

If you were the picture editor of *Fortune, Nation's Business, Forbes* or *Business Week,* you would be called on to deliver executive portraits of leading industrialists and chief executive officers. What kind of photographer would you want representing your magazine: a slovenly individual or one who easily fits into corporate surroundings? If, as a photographer, you want to be one of "the great unwashed," consider the repercussions of presenting that image. Don't complain when you don't get an assignment to photograph important corporate or political figures.

When photographers meet their subjects, they are first appraised on the basis of how they look. There is little time for the company executives to probe photographers' inner beauty, intellect, humanity, or loyalty to their families. First impressions are important because they influence the subjects' judgment about the amount of time to allow for the photography session and the degree of cooperation they will give. Initial judgment intrudes on every aspect of the photographs—whether the body language will be relaxed or rigid, impatient or calm, revealing or guarded.

One of my colleagues, freelance photographer Harry Redl, has had over thirty years experience in dealing with globe-girdling assignments. Redl says,

> Basically, one has to consider that nobody is interested in your revolutionary ideas about dress and appearance. When taking pictures, remember that people are allowing you to participate in a slice of their lives. They're not ready immediately to participate in a dialogue with you because they are too busy with other things. You should go in so as not to elicit a violent response, either internalized or externalized. The best thing is to try to melt into whatever is the order of the day. You don't want to stand out like a sore thumb.

As a photographer, your job is to photograph people or events. If your appearance shocks or disturbs your subjects, you're making your job more difficult. You are building unnecessary obstacles to fulfilling your assignment. Blend. Be unobtrusive. Fade into the woodwork. Raccoon coats, Sherlock Holmes hats, or shirts open to the navel may have their place, but it is certainly not where you're working as a photographer. In this age of informality, there seems to be a perception among photographers that anything goes. Anything doesn't go; it is bad taste to show up in sneakers and jeans at a summit ceremony in the White House. Be an observer who is tolerable, not irritating.

Flip Schulke, a photographer who has photographed astronauts and subject matter related to space exploration extensively, was appalled by the insensitivity of television and still photojournalists covering the funeral of one of

the Challenger astronauts. Most of the photographers were dressed for a foot-ball game rather than a funeral. Casual dress probably didn't prevent the photographers from getting pictures of the event, but it surely had a negative effect on the assignment. Besides offending the sensibilities of the mourners and creating a poor impression of all photographers, those who were sloppily dressed may have forfeited choice vantage points or positions. In such cases, an appropriately dressed photographer will likely be chosen to photograph from the front of the chapel. The outrageously dressed photographer will more likely be relegated to the back of the room.

Washington-based Dennis Brack, a veteran photojournalist who has covered the Washington, D.C., scene for Black Star for three decades, is a member of the standing committee of the Press Photographer's Gallery of the United States Senate. Photographers are currently allowed into hearings of Senate Committees and are particularly visible as they crouch and sit in the well of the Senate hearing room. The well positions photographers three feet from the witnesses and allows for the best and closest vantage point for photographing celebrities such as Ollie North or SEC chairman Alan Greenspan. Since there is no Senate dress code, photographers on occasion have come in shorts and T-shirts. Dennis Brack makes it a point to explain to these photographers that the Senate could change its rules at any time and bar photographers from these hearings. To assure access, it is in the best interests of all photojournalists to maintain a sense of decorum and a standard of dress that will preserve the prestige of the Senate.

A good rule of thumb is "dress for the occasion." If you're covering a black-tie event, you would be well served to wear formal attire or a dark blue suit so that you can blend into the atmosphere. Conversely, you wouldn't want to photograph a street demonstration or a peace march while wearing a formal dinner jacket. The photographer can take a lesson from the animal world, where protective coloration is the key to survival.

Brack recalls one occasion when he had to break his general dress code. It was 1968. The Washington riots erupted while Brack was covering a dinner at which Senator Hubert Humphrey was speaking. Brack immediately ran into the streets and photographed the violence in progress dressed in an incongruous tuxedo.

Manners and Behavior

There are other ways besides dress of being obtrusive. Many of you have seen the photographer with four motorized cameras at a televised news confer-ence spooling through film as fast as his trigger finger will allow. Everybody

in the room is disturbed by the constant whirring and buzzing of the gear. Speakers lose their concentration. And when the photographer delivers five hundred exposures to the editor who needs only one picture, it wastes editorial time, dilutes the value of the individual photograph, and drives the picture editor crazy. Avoid drawing attention to yourself whenever possible. Aggressiveness has its place. Overaggressiveness creates enemies and should be avoided. Nobody can have too many friends or too much accumulated goodwill. A photographer has a responsibility not only to himself, his job, and his client, but also to his profession and his colleagues. Bad will engendered by one photographer's behavior will make things tough for others in the profession.

A corporate executive responsible for his company's annual report recently made this point to me quite strongly. Although satisfied with the work produced by a freelance photographer for the annual report, the executive had been plagued with complaints from the plant criticizing the photographer's behavior in dealing with company employees. Specifically, the photographer was seen as arrogant, demanding, supercilious, and patronizing. The executive had little choice but to change photographers. The photographer lost a lucrative account because of his insensitivity.

Another cautionary tale relates to a photographer who had been hired for extensive well-paying photographic corporate assignment that called for the design director, the photographer, and the client's representative to work together over a two-week period of time. The photographer, who was male, made a huge mistake. He made sexual advances to the client's representative, who was female. He lost both the corporate client and future work for the design firm. The moral is almost too obvious to point out: a photographer's libido should be separated from his work ethic.

Don't impose your personality on a situation and force conversation in which you gratuitously express opinions guaranteed to be confrontational and provocative. Does this mean that I am advocating your becoming a nonperson, a button pusher without personality? Hardly. What it suggests is that there is a time and place for making personal statements, but it is not when you're working as a photographer representing a leading magazine or whoever the client happens to be at the moment. You should walk into situations without creating resentment—respectfully rather than rudely.

Intercultural Sensitivity

Photographers going to foreign countries or different cultural environments in the United States need to be responsive to cultural differences. Howard

Shapiro, a Vermont-based consultant on cultural differences offers the follow-
ing advice:

> Don't use the assumptions you've made all your life when going into other
> cultures. There are no simple formulas in dealing with cross-cultural differ-
> ences. Select your informants carefully in learning the customs and mores of
> the cultures you will be entering. There are materials put out by most embas-
> sies which will help you to avoid the breaches of etiquette and commission of
> social gaffes which can cause visitors considerable embarrassment.

Many of us know that it is de rigueur to take one's shoes off before you step
on a tatami mat in Japan. We are probably less well informed about the taboos
of other societies. In Thailand, for example, one doesn't casually ruffle some-
one's hair: the head is a sacred part of the body. In many Muslim countries,
photography of women in purdah (screened from the sight of men) is forbid-
den. In Saudi Arabia, one doesn't photograph a woman without the permission
of her husband. In parts of Africa, to take someone's photograph is to capture
that person's soul, so permission should be obtained.

In Japan, one doesn't overdress or underdress—business attire is very im-
portant when dealing with government officials or industrialists. Many Ameri-
cans go to East Africa in safari outfits complete with pith helmets. While that's
certainly acceptable dress on safari, it carries colonialist overtones in Tan-
zania, or loudly announces "I am a tourist" in sophisticated cities like Nairobi.
In Germany, shaking hands borders on the ritualistic. One shakes hands on
arriving and leaving, even with one's coworkers.

The respect you generate as a person or as a photographer is in direct
proportion to your self-respect. Photographers owe it to themselves and their
profession to continue to find acceptance everywhere. They have struggled too
hard to be seen and known as artists to now appear as the "great unwashed."
The latter role was exemplified by the fictional newspaper photographer hero
called "Animal," who graced the since-departed weekly television show "Lou
Grant" just a few years ago.

9

The Photojournalist—Specialist or Generalist?

Two roads diverged in a wood, and I—
I took the one less traveled by,
And that has made all the difference.

Robert Frost, "The Road Not Taken"

The real world of photojournalism requires a photographer to be able to cover fast-breaking, dramatic news events. For most journalistic photographers, newspaper or freelance, it is imperative that they be generalists, with the ability to carry out all kinds of assignments. Many freelance photographers are specialists, preferring to concentrate their energies on specific areas of interest, rarely stepping outside self-imposed boundaries.

Newspaper photographers may be called upon to shoot a highway accident, do a food or fashion illustration, make an environmental portrait, cover a school board meeting, or photograph any of the myriad happenings in their communities on a given day. Each of those assignments requires a different mind-set and technical discipline but the same chameleonlike responsiveness. The average free lance, waiting for the phone to ring, depends on versatility and the ability to get that picture in order to insure financial survival. Photographers would be well advised to consider becoming proficient in a number of special areas of photography.

Sports Photography

Looking at the pages of daily newspapers or magazines such as *Sports Illustrated*, one is struck with their preoccupation with sports action pictures.

During my stint as a juror during the 1991 Pictures of the Year competition, the entries presented in the sports category clearly showed that most photographers believe a good sports picture is one that captures the high point of the action. Obviously such pictures are important to sports coverage, but I would like to counter that the truly memorable sports photographs are those that have human interest elements, showing the wide range of emotion that sports competition engenders.

Sports are a metaphor for life. The striving for excellence in sports is just another manifestation of the human drive to achieve everywhere. One doesn't become a celebrated concert musician without struggling through countless hours of practice. Similarly, one doesn't become an Olympic gymnast, figure skater, runner, or skier without undergoing the rigors of physical conditioning and acquiring the skills necessary to win.

Taking great sports action photographs requires knowledge of the game that is being covered. Once the photographer understands the game, he or she will be able to anticipate the action so that the camera will be pointed in the right direction to capture the decisive moments. In basketball, that means that the best photographs are going to be taken underneath the basket, where Michael Jordan and his colleagues perform outstanding physical feats. Today's basketball players are bigger, stronger, and more graceful than their forebears. They sky higher, run faster, handle the basketball with greater dexterity, and shoot more accurately. Action pictures can best reflect the changes that have occurred in both college and professional basketball.

Football action pictures all look alike to me. A fullback carries the ball into the center of the line. A tailback carries the ball, sweeping around the corner of the line. The quarterback fades back to pass. The good sports photographer who knows football and the offensive patterns of the team being covered will be able to guess with some degree of certainty when these events will take place. The down and the number of yards necessary to get that first down will dictate the offensive play. Long yardage needed for a first down will invariably dictate a pass play. The good football photographer will know these things and be able to decide whether to focus on the action behind the ball or whether to point his camera downfield to catch the action of a wide receiver or a tight end catching or missing the anticipated pass.

In baseball, the significant action plays will usually occur in the infield, primarily at second base when a runner attempts to steal a base or break up a double play, or at home plate, where violent confrontations often take place between the runner trying to score and the catcher attempting to tag the runner out. The photographer has to understand the game, foresee the strategy based on the score, reckon each

player's ability and speed, and have some knowledge of whether the manager is a gambler or more conservative in his approach to the game.

In track, the best place to focus is usually on the finish line, but there are exceptions. David Burnett caught the prize-winning picture of Mary Decker falling to the track after being tripped during the 1984 Olympics, but it was missed by the photographers who had opted for positions at the finish line. Suffice to say that the sports photographer must be informed on the game in play.

Developing Off-Beat Sports Story Ideas

The world of sports photography does not have to begin or end with sports action photographs. There is a big world of sports that can be explored by the imaginative and thinking photographer.

Let's start with sports personality stories. Sports figures are idolized. Economically they stand at the top of the ladder and are paid megamillions for putting a ball in a basket, throwing or catching a football, hitting a tennis ball mercilessly, or hurling a baseball at upwards of 95 miles an hour. The pictures we see of sports superstars rarely give us insights on their temperament. Their contrived and projected public images are usually controlled by agents or public relations people to whom the press has usually been a willing accomplice.

Millions of sports fans would welcome the opportunity to see pictures of the real Michael Jordan or Magic Johnson not only on the basketball court, where they live above the rim and perform unprecedented athletic feats, but at home. Where and how do they live? Who are their friends and what are their interests? Do their lifestyles reflect their megabuck status? Are they active in public service and in helping young blacks in the ghetto? What about their contacts with family? Life is, after all, more than a basketball game, and we all lead multi-dimensional lives. I think that an in-depth photographic essay of a sports star that goes beyond the traditional superficial celebrity coverage would be a challenging sports photographic assignment.

Sports competition, by its nature, entails losing as well as winning. Visually exploring both areas allows the photographer to highlight the intensity of the many emotions evoked by the games we play. The photographer who can find editorial ideas in this context will be giving the readers of magazines and newspapers different and penetrating insights into how we behave. It is said that how people react to victory and defeat is the tipoff to their real character, more telling than everyday behavior patterns exhibited when there is no such stress.

I recall a story that Brian Lanker photographed when he was a staff photog-

rapher for the *Topeka Capitol-Journal.* A high school football team in Topeka had lost twenty-eight consecutive games. Lanker proceeded to do a story called "The Losingest Football Team In Topeka." Whereas we are always inclined to celebrate successful teams with long winning streaks, Lanker's bright editorial idea came from the other side of the ledger. I remember two pictures from the story that had particular visual strength—one of a pint-sized player standing next to a three-hundred-pound lineman on the sideline—the other of a dejected player in the locker room surrounded by his football togs in which his slumped body eloquently summed up the story of the team cursed with a losing streak.

Although there is a tendency toward redundancy in sports action photography, that doesn't mean that sports shots should be neglected. It is possible to develop editorial ideas that can thematically make use of dramatic action photos. For example, there are many wide receivers in football who combine balletic, acrobatic mobility with their athletic ability and sure-handedness. One such player was flanker, wide receiver, and offensive end Lance "Bambi" Allworth, of the San Diego Chargers in the 1960s, who may have been the most graceful receiver in the history of the game. An enterprising sports photographer could have focused on this one player and produced a series of action photographs resulting in a visual ballet.

To emphasize my point that some of the most memorable sports pictures have been unrelated to sports action, I would isolate the picture taken when the legendary "Babe" Ruth retired from baseball: the viewer sees him standing, back to the camera, against the background of Yankee Stadium. Or the photograph of Don Shula on the sideline of the 1971 playoff football game between the Kansas City Chiefs and the Miami Dolphins, when he exultantly jumped in the air as the winning 37-yard field goal was kicked by Garo Yepremian breaking a 24–24 tie and giving Shula's Dolphins the win. This historic moment occurred after 7 minutes and 40 seconds of the second overtime period; the game was the longest in history. Or the incident created at the 1976 Olympic Games when runners Tommy Smith and Lee Evans ran around the stadium in Mexico City, brandishing upraised fists in a black power salute. Or the photograph of the nude English football spectator's genitals being covered by the police to shield them from the public gaze.

Travel Photography

I rarely think about travel photography. Seldom do I bring back visual mementos of my own travels. Most such photographs bore me. But Lisl Den-

nis, an exuberant, self-promoting, outspoken travel photographer once forced me to think about her occupation. Travel photography preoccupies more photographers than any other segment of the business. It seems that more photographers would rather shoot exotic location spots than be photojournalists following the world's calamity of the week.

Lisl Dennis's photographic overview is consumed by "destination" photography. She has written books on the subject. She is the founder of a yearly travel photography workshop in Santa Fe, New Mexico. With her husband, Landt Dennis, as writer, she does assignments for magazines, newspapers, hotels, and tourist bureaus and sells stock photography through The Image Bank.

Dennis believes that

> the bulk of travel photography today is color-coated, hyperbolic celluloid which tells us nothing new. Published travel photography is esthetically retarded primarily because advertisers, editors and publishers lack visual sophistication and insist on illustrating down to the public.
>
> Because it emphasizes the sunny side of life, destination photography appears neither to have a cutting edge nor to be of any social significance. Traditionally, the function of travel photography is to romanticize, not editorialize, to promote tourism and focus on what is good about a destination. The magazines are looking for photographs that perpetuate myths about a place, rather than promulgate facts. There isn't anything it ain't. Except it ain't real photojournalism. In fulfilling this function, travel photography relinquishes all judgmental authority and credibility as a responsible communicator of a sense of place.

Some of that may be attributable to the barter system on which most travel photography is predicated. Newspapers and magazines would have to expend astronomical sums to finance the trips of travel writers and photographers as they explore the "in spots" and exotic corners of the world. The barter system allows travel writers and photographers to exchange their editorial objectivity for free airline tickets, free hotel accomodations, and free amenities.

No one can serve two masters simultaneously. In the process of paying off obligations to the providers of these free services, the writers and photographers forego criticism for hype. The reader is fed a diet of banalities and familiarities—palm trees in the Caribbean and snow-capped peaks in the Alps.

Outstanding travel photography demands more than picture postcards. Pictures should include all the elements of good photojournalism that we have spelled out previously: communication of information, people-orientation, dy-

namic body language, a strong center of interest, dramatic light, and fine composition.

Lisl Dennis likes "to look for photographs that interpret a sense of place rather than record a sense of place. In my photographs, I try to take a more personal attitude toward the travel experience. I first recognize people as human beings and make human connections before I photograph."

Exploring the Corporate Marketplace

Much of the freelance photographic marketplace is currently dominated by the corporate dollar. In the last two decades, what had been the exclusive domain of "industrial photographers" has gradually been penetrated by photojournalists. It used to be that corporate photography demanded f64, large-format, perfectly sharp, well-lit nuts-and-bolts imagery. The successful industrial photographer was a supreme technician helped along by a coterie of assistants and hundreds of pounds of lighting equipment. Today's industrial photography no longer emphasizes the beautiful patterns of machinery to the exclusion of all else. The new focus on visual communication is evident in corporate magazines, brochures, and annual reports.

The key word is "communication." Corporations hire photographers because they want to communicate—with their stockholders, with consumers, with opinion makers and with stock market analysts. Photojournalists, by training and necessity, know how to tell a story, so they can fill industry's need. Corporate communication represents the greatest opportunity for photographers to make big bucks. Those dollars primarily come from annual report photography shot during a pressure-packed, ulcer-inducing traumatic period known as "Annual Report Season." Most annual report photography is done in the months of October, November, and December. The groundwork for getting hired to do this work is laid during big selling efforts made by photographers in July and August.

Generally, annual report photography goes for about five times the editorial day rate for magazines. America's leading corporations are producing slick, glossy, colorful annual reports designed by the best graphic artists and printed by the best printers. They are not about to scrimp on photography; they want the best, the brightest, and the most creative.

The annual report is the most important printed publication a corporation produces. The Securities and Exchange Commission (SEC), which mandates disclosure of financial data, has been increasingly demanding since 1969. The average number of pages has increased from twenty-four to twenty-eight or

thirty-six plus covers. More ambitious efforts run to seventy-two pages. Although originally designed to fulfill its obligations to shareholders, the annual report evolved into a multi-purpose communication tool, a twelve-month shelf item that can enhance corporate prestige. It is sent to potential stock purchasers, business publications, and schools, and is used for recruitment and image-making. It is the company calling card.

It is not surprising that so much money is poured into annual reports. Designers charge upward of one thousand dollars a page plus expenses to oversee design and production. Full color magnificently reproduced on top-quality paper enhances the look and feel of the report. Lately, many reports have turned back to black-and-white photography, either because the designers think it has greater impact or because of its lower reproduction cost. Some aspects of communicating are left to words, but the graphics predominate. In recent years, annual reports have tended to be thematic, embodying the most sophisticated of journalistic and photojournalistic techniques.

Some photographers view annual report photography as a compromise of their integrity, a sellout not worthy of their journalistic talents. Each photographer is the keeper of his or her conscience. Some of the leading photographers in the photographic world (Karsh, Arnold Newman, Ernst Haas, Art Kane) have seen fit to do annual reports. Some Magnum and Black Star photographers concentrate almost exclusively on exploration of this market, using their photojournalistic skills to tell the corporate story in photographs. They do not find it unworthy of their photojournalistic interests. Two-thousand-dollar-a-day jobs can go a long way toward providing the socially conscious photographer with the financial wherewithal to pursue personal projects. If you're convinced that you want to explore the potential of annual report photography, here is my three-step plan for exploiting the annual report market:

1. Procure a copy of O'Dwyer's Directory of Corporate Communications (J. R. O'Dwyer Company, 271 Madison Avenue, New York, NY 10016) or the Redbook Standard Directory of Advertisers (National Register Publishing Company, 5201 Old Orchard Road, Skokie, IL 60077). They will cover your potential marketplace of some eight thousand public companies and the people who make corporate communications decisions.

2. Prepare an annual report portfolio. The portfolio should be one carousel tray of all-color photographs, if the client is into making a color annual report. In recent years, more companies have come to appreciate black-and-white photography's ability to present a grittier, more realistic view of the company. In such cases, you will want to include a fair share of black-and-

white human-interest photographs in the portfolio. The selection should illustrate your technical, compositional, design, and communications skills. Ruthlessly eliminate commonplace pictures. Demonstrate your mastery of indoor lighting (incandescent, fluorescent, mercury vapor, or daylight). Make the portfolio content diverse—it should be predominantly industrial but should include executive portraits, landscapes, buildings, and people in dynamic industrial situations.

3. Prepare a sales strategy. Either get a representative to show your portfolio or invest in a new pair of comfortable shoes and do your own calling on designers, public relations firms, and corporate communications or public relations directors. Think about developing quality mailing pieces and graphic follow-up devices.

Food, Still Life, and Illustrative Photography

Most magazine photojournalists ignore these specialized areas of photography, recognizing that they require particular technical and artificial lighting skills as well as a refined sense of design and taste. Nevertheless, some generalists are prepared to take on these assignments when the occasion arises.

On newspaper photographic staffs it is not uncommon for all the photographers to be able to handle these assignments with equal or unequal aplomb (although there are usually designated photographers for this work). It is wise for the newspaper photographer to develop the ability to deal with these kinds of photographs as part of his or her professional skills. (You can't be too valuable to your paper.) For the most part, photographic illustrations in newspapers are mundane, unimaginative, and sophomoric. Illustrations require the photographer to allow the imagination to run wild, to reject the obvious and the literal in favor of subtlety, cleverness, and perhaps a touch of humor. The purpose of photographic illustration is to entice the reader to go beyond the illustration and read the text that the illustration is designed to interpret. Top illustrations do that; those that are commonplace defeat the purpose.

Scientific and Medical Photography

The world of scientific and medical photography is a most challenging and exciting area of photography. There are skilled photographers who have captured images that allow us to grasp scientific concepts, learn more about the natural world, and understand the processes of life. Those people are more than photographers; they are scientists with a camera.

No medical photographer has used the camera more effectively than the Swedish photographer, Lennart Nilsson. For the better part of three decades, he has pursued the subject of human reproduction with unequalled vigor. His images of the human fetus in vitro have shown us the progressive development of the fetus from conception to birth. His breakthrough series showing the path human sperm travels before it merges with the ovum has given us new photographic documentation of what had been previously described only by artistic sketches. He has used the scanning electron microscope to show us interior views of the brain. All of his work brings us greater understanding of life and how it is created.

At the other end of the spectrum is work done by photographers who interpret scientific phenomena or show breakthroughs in science and medicine by using their own imagination and their scientific understanding of the field. Black Star's Jim Sugar, once a contract photographer for *National Geographic,* prides himself on using photography to visually interpret intangible concepts, scientific and otherwise. Sugar has done many assignments for *National Geographic* on such subjects as gravity, how the earth emerged, how the solar system was formed, and most recently on "the greenhouse effect." "When you do a piece on an invisible phenomenon," says Sugar, "you can't photograph it—you have to find a way to show the results of it. To illustrate gravity, for example, I made a time exposure showing multiple images of a feather and an apple, each falling at the same rate."

Throughout his illustrious career, the Swiss photographer Emil Schulthess has been preoccupied with investigations of the sun. He has given us remarkable photographs that have graphically proven what we already knew but had never seen on film. I was first introduced to his work when Black Star distributed his photograph "Twenty-four Hours of the Midnight Sun," which he did in collaboration with another Swiss photographer, Spuhler. In that collaboration, Schulthess and Spuhler made an exposure of the sun in Spitzbergen, Norway, every hour from a precise vantage point with an immovable camera mounted on a tripod. The finished composite picture, made by placing the twenty-four strips of film in sequence, showed the progressive path of the sun rising and setting.

During his trip to Africa to produce his book about that continent, Schulthess set up a fish-eye camera and lens to record the path of the sun at the equator at Lake George, Uganda, immediately following the vernal equinox on March twenty-fifth. The horizontally positioned camera showed the celestial hemisphere on a circular disk with the zenith in the middle and the horizon on the periphery, causing slight distortion. Had the picture been taken on March

twentieth, the actual date of the vernal equinox, the series of photographs would have lain exactly on the east-zenith-west line. By photographing the position of the sun at twenty-minute intervals on March twenty-fifth, the path of the sun lies in a straight line slightly to the north of the zenith.

In 1957, during the International Geophysical Year, Schulthess fulfilled his dream of documenting the continent of Antarctica. Using the homemade fish-eye camera once again, he recorded the path of the sun at three different points in Antarctica—at Wilkes Station, Byrd Station, and at the exact center of the South Pole. The eighteen-hour exposure at the South Pole reveals a perfect full circle described by the horizontally moving sun with the zenith as its center. According to Schulthess, "This must surely be the first photographic record of the 'southern end' of the axis of the earth."

Werner Wolff, whose photographic career spanned four decades as a Black Star staffer, was the ultimate generalist. A superb technician and a highly intelligent man, Werner adapted to all kinds of assignments. I recall one story he did for the *Johns Hopkins Magazine,* in which he was challenged to photograph "The Science of Toys." Using a variety of techniques, primarily repetitive action captured by strobes, he was able to visually show the scientific principles that lay behind such popular toys as "Slinky," the coiled-metal toy capable of "walking" down a flight of stairs. The photograph—and the Slinky—illustrated the scientific principle of inertia. On another occasion, Wolff was challenged to visually translate the concept of turbulence. Wolff photographed such things as a stream of water flowing from a faucet, or cigarette smoke wafting into the air.

Fred Ward, while photographing for a story on pesticides for *National Geographic* magazine, was privileged to view deadly poisons under a microscope. He was impressed with the beautiful colors found in the bizarre crystalline structures of these poisons. "I was struck by the irony in that unusual compounds have a strange, ethereal beauty that belies their deadly intent." Using an integrated precision microscope and polarized light, Ward produced a series of photomicroscopic images that showed "The Beauty of Poisons" in an innovative unique way. The pictures were used as part of the *Geographic* story and subsequently syndicated as a self-contained feature throughout the world.

Ward, a fecund idea-man, once decided to photograph "The Human Zoo," based on the scientific fact that there are billions of unseen microscopic animals that inhabit our bodies. When seen with the great magnification of the scanning electron microscope, these animals look like terrifying insects. Rental time on scanning electron microscopes is quite expensive, but the

pictures achieved for this popular scientific story proved financially rewarding for both Ward and Black Star.

One day at Black Star, I received a letter from Alex Rakosy, a retired Illinois microbiologist. He told me about pictures he had made through a microscope of the creatures that lived in drops of water from lakes, ponds, and temporary pools he had sampled. I was intrigued by the possibilities, but little did I realize, until he sent me the pictures, that these creatures, when magnified, took on the look of miniature monsters, replete with kaleidoscopic coloration. The plants and animals were often no larger than a few thousandths of a millimeter. They lived in an ecological system with competition and coopera-tion, life and death. The algae served as the beginning of the food chain hierarchy. The second level of this food chain was the unicellular protozoa, which were eaten by minute crustaceans and insect larvae. Through the use of the microscope, camera, and polarized light, this microcosm came to life in Rakosy's "World in a Drop of Water." As in Ward's "Human Zoo," the camera and the photographer's imagination brought us a vision of a previously unseen world. This story, first published in the German *Geo,* was republished many times throughout the world.

Generalization versus Specialization

The generalist newspaper or magazine photographer must not only be trained in many different technical disciplines, but must also be capable of understanding science, technology, sports, and business, and must have the intellectual capacity to deal with diverse subject matter. The generalists prefer a wider world of photography, one that allows them to explore a greater diversity of photographic interests and enjoy the constant challenge of doing new and different things.

Some photographers, however, choose to be specialists. They concentrate on one area of photography and exclude everything else. There is much to say for specialization, for perfecting skills in one field. It allows for focus and concen-tration. Specialization can be exploited promotionally so that clients think of one person whenever an assignment in that special area of photography arises. With the concentrated approach, David Doubilet has become the great photog-rapher of the underwater world: his breathtaking color images of the flora and fauna that lie beneath the sea have given us the opportunity to better under-stand that world and its place in the natural order of things. Another specialist, Roman Vishniac, devoted his life to natural history photography except for his unforgettable documentary black-and-white photographs of "the vanished

world" of Poland's Jews in the 1930s. Neil Leifer has been the sports photographer's sports photographer for most of his professional life, creating iconic sports images through advance planning that hasn't been mastered by less disciplined photographers.

Photographers have to define their respective philosophies about the work they do and their psychological and lifestyle needs; then they can choose the road that suits them best.

Women and Minorities
in Photojournalism

It is vital that we do not see the world only through the eyes of men. A woman photojournalist needs to be herself, not one of the boys, needs to bring her own special eye to the readers.

Beverly Bethune, University of Georgia School of Journalism

"News isn't male or female," says C. Thomas Hardin, former director of photography for the *Courier-Journal and Louisville Times*. Nor is it white, black, yellow, or red, I might add. What Hardin is saying is that the subject matter of the news may be sexually related, but the gender or race of the photojournalists who cover the news is not what determines whether the pictures will be successful. The camera cannot discern the color of the finger that is pressing the shutter release to take the pictures we see in our media, nor can it determine the sex of the person to whom the finger is attached.

To accept the thesis that the reporting of the news is asexual or color blind is not to deny the history of discrimination that affected photojournalism, in particular, and the world, in general. Photojournalism in its early years was a white man's world. This was true in spite of the impact of "the queen of photojournalism," Margaret Bourke-White, the Farm Security Administration's Dorothea Lange, and *LIFE* photographer Gordon Parks.

Since the 1960s, there has been a consciousness-raising about the civil rights of all Americans, regardless of their sex, race, or sexual preference. This consciousness was stimulated by legislation like the Civil Rights Act, passed during the Johnson administration, and subsequent affirmative action. The number of women and blacks being hired today is beginning to correct the historically all-white, all-male makeup of many newspaper photographic staffs.

The pressures of the women's movement and affirmative action programs have brought about the enlightenment of most newspaper managements. In the 1990s many women and African Americans work as newspaper and magazine photographers. Open hiring results in staffs that reflect the mosaic of the community and the world. Men still outnumber women on today's newspaper staffs and among free lancers. But inroads made by women and minority photojournalists in recent years are a precursor of the day when photographic staffs will approach more realistically male-female and racial demographics. Well-entrenched male-dominated staffs, many protected by unionized security, have limited the opportunities for new hires. As advancing age and retirements take place and more openings occur, the diversity of gifted photographers on newspaper staffs will increase.

Opening Photojournalism's Door to Women and Minorities

A random sampling of seven big-city newspapers, the *Washington Post, Indianapolis Star, Philadelphia Inquirer, Hartford Courant, San Francisco Chronicle, Miami Herald,* and the *Albuquerque Tribune,* suggests that newspapers have become very conscious of the need to hire men and women from a greater variety of cultural backgrounds and races in order to more adequately represent the makeup of the community within their staffs.

In 1990, the *Washington Post* had 32 members on its photographic staff. Of these 10 were women (6 photographers, 2 picture editors, and 2 lab technicians). There were 4 African American photographers, 1 Asian-American, and 3 African American picture editors. On the *Hartford Courant*'s 26-person photographic staff, 9 were women (2 picture editors, 5 photographers, 1 lab technician, and 1 department secretary). There was 1 African American photographer and 1 Asian-American photographer. The *Philadelphia Inquirer* staff of 36 included 9 women (6 photographers, 2 photo editors, and a photo printer). There were 3 African American photographers, 1 Asian-American, and 1 Latino. The *Indianapolis Star* staff of 10 photographers included 1 African American and 2 white women. The *Albuquerque Tribune* photo staff of 4 included 1 Latino woman, 1 white woman, 1 Latino man, and 1 African American man. The *Miami Herald* had 29 photographers on a staff that included 9 Latinos, 3 African Americans and 3 women. The *San Francisco Chronicle* had 14 photographers and 2 editorial assistants. Of the photographers, 2 were African American and 2 were women (one Filipino). Gary Fong, the director of photography, says that "we are looking for qualified minorities all the time. Of those that I've seen, the photographers are usually happy where they are."

Editors Talk about Race, Gender, and Assignments

There is a unanimous feeling among graphics editors I have spoken with that assignments are based on the luck of the draw; none of the editors said they relied solely on black photographers to cover black subjects and women to cover women's issues. The *Washington Post*'s Joe Elbert thinks that most publications have yet "to learn to play to the strengths of a culturally diverse staff and there is still too much stereotyping." Every *Philadelphia Inquirer* photographer goes wherever there are pictures to be taken, regardless of the photographer's race or gender. "When, however, during the last MOVE debacle in Philadelphia, we did send a black photographer into the neighborhood because we figured correctly that the police would make the assumption that he was a resident," says Gary Haynes. "He obtained photos that no white photographer could have made because the police would have kept the white photographer away." Chip Maury of the *Indianapolis Star* says, "On rare occasions I will use our black photographer to shoot a sensitive racial situation. But that seldom happens. I try to give them all the same opportunity when they hit the bricks."

Steve Rice of the *Miami Herald* points to a situation in which a white photographer was sent to do a picture story on a man who gives clean needles to drug addicts in a black neighborhood. The photographer and subject felt the white photographer's color was hindering the development of the story. The story was successfully reassigned to a black photographer. "I don't feel we can hide from the problem of color in coverage," says Rice, "but it is not a primary concern when planning coverage."

Mike Davis, formerly of the *Albuquerque Tribune,* told of an instance when the color of the photographer was significant. Davis says,

> A disturbance on fraternity row at the local university resulted in the arrest of several black students in front of the only black fraternity on campus, though the fraternity was not involved in the disturbance. Because the only black photographer on staff had been through college at a similar university and shared some of the same frustrations these students felt, he was the choice to cover the situation. His continued efforts in covering the story gave him access to the fraternity. I asked him if being black was in itself a key factor in the fraternity's decision to let us do the story. He said, "Yes!"

Mike Davis perhaps sums it up best when he says,

> Diversification of a photo staff is essential—by gender, race, family background, experience, personality, whatever. Each photographer brings a lifetime of experiences into play on every assignment. The greater the diversity

of a photo staff, the more dynamic a publication's picture content will be. Staff composition should closely reflect the composition of the community it serves if the content is to reflect reader interests and concerns.

Women in Photojournalism Today

The 1990 Newspaper Photographer of the Year (NPPA/University of Missouri Pictures of the Year Competition) award was given to Carol Guzy, staff photographer at the *Washington Post.* Guzy was the first woman to ever win the award. (Lisa Larsen, staff photographer for *LIFE* magazine, was the NPPA's Magazine Photographer of the Year in 1953 and 1958, and was the last woman to win an NPPA "photographer of the year" award.)

In 1986, Guzy, while working for the *Miami Herald,* shared the Pulitzer Prize in the Spot News category with her colleague Michel duCille for their joint coverage of the eruption of the Nevada del Ruiz volcano and its ultimate destruction of the town of Armero, Colombia. In 1988, she received a second Pulitzer Prize in the Feature Photography category for her coverage of the decay and subsequent rehabilitation of a housing project overrun by crack.

Carol Guzy is often asked whether being a woman makes a difference.

> Fortunately I haven't personally had any real sexist sort of problems. I've been pretty much treated as a professional by professionals. Being female may help me because of the kind of stories I do, sort of intimate—getting to know a family. I'm less intimidating in the beginning than maybe a big, six-foot-four-inch man with a lot of cameras. I'm quiet, small and female. And I think that intimidates people a bit less. I could be wrong, but I've always felt that.

Many female photographers consider themselves to be under special scrutiny and feel compelled to work harder and longer hours than men and to take on hazardous assignments in order to prove their physical stamina and courage. Melissa Farlow, a *Pittsburgh Press* staffer prior to the paper's demise, sees a two-edged sword in discussing women and hazardous assignments.

> Although women photographers scoff at the past attitudes of employers who were afraid to send women into dangerous situations, safety is a concern. Sometimes women are at an advantage in a news situation. They may not seem as threatening. At other times, however, a woman may be vulnerable in an unsafe area of town. The threat of being attacked is real when you are walking in the projects on assignments with thousands of dollars of cameras around your neck. One time I was surrounded by thugs with clubs who demanded my film during a busing riot in Louisville. All I can say is that I was damn lucky that night.

Barbara Montgomery, a photographer for the *Courier-Journal and Louisville Times,* was not so lucky. In 1981 and 1982, she did in-depth coverage on Louisville's Parkway Place, an example of mean-spirited housing projects for the poor. After leaving a photo shoot with an interracial couple at 1 A.M., she was asked for a ride by a young man she had previously photographed. She agreed. It was a violent ride, during which Montgomery was raped three times over a period of three hours.

Barbara Montgomery met her crisis of confidence with courage when she was challenged by an assignment about a notorious biker gang, the Outlaws. The bikers' conscious attempts to intimidate her with stories of rapes and murders failed to thwart her, and her photo story was a success. In 1987, after the birth of her second child, Montgomery took a leave of absence from the paper and eventually resigned. Married to a *Louisville Courier-Journal* columnist, she is raising three children and doing photographic portraits in her home. "I found it difficult to be a photojournalist and a mother at the same time," she says. "Even though I never felt I got to finish the things I wanted to do, I took a new look at my priorities. When the children are grown, I will be young enough to perhaps return to photojournalism."

Vera Lentz, a comparatively unknown photographer working in Peru, exemplifies the woman photographer who produces outstanding work despite odds stacked against her. She is always faced with the difficulty of finding babysitters when she is off photographing. Getting film is a perpetual problem. Now associated with Black Star and previously with Visions, she confronts the terror and physical danger of working among the rebels of the Shining Path movement. A single parent with limited funds and little magazine support, she manages to achieve significant pictures which will appear in book form.

The ground-breaking exploits of Margaret Bourke-White have become commonplace for the contemporary woman photographer. Women are right out there on the firing line, marching through rugged terrain in one hundred-degree jungle heat, sleeping on jungle floors, risking the same exposure to gunfire as men. Several female photojournalists documented the Vietnam War. One, Dickie Chapelle, became one of the photojournalistic casualties of that war when, in 1965, she was killed while on assignment for the *National Observer.* French-born Catherine Leroy was often in danger and succeeded in winning the 1966 Overseas Press Club's Robert Capa award for "exceptional courage and enterprise" for her pictures of a medic assisting an American soldier during the height of battle on "Hill 881." This series was published in *LIFE* magazine. Since then, during more brushfire conflicts, particularly those in Central America, it is no longer unusual to find women facing combat risks,

Cindy Karp has built her career on the work she did covering the conflicts in Central America. She minimizes the personal hardships and does not find her sex a disadvantage. Many guerrillas are women, so female photojournalists are more readily accepted. However, the men are often more solicitous and concerned about protecting all the women involved in this arena. Magnum photographer Susan Meiselas received the Robert Capa Gold Medal in 1979 for her work in Nicaragua documenting the Sandinista Revolution. Prior to her moving to Nicaragua, she worked extensively in Chad and Cuba.

Judy Griesedieck is currently a free lance working out of Minneapolis, Minnesota. She is a former newspaper staffer, first with the *Hartford Courant* in Connecticut and more recently with California's *San Jose Mercury News.* She is representative of the best women photojournalists active today and, for the most part, her working experiences have been positive. She admits that a woman's physical stature can be a disadvantage when hauling heavy equipment around or in covering "pack journalism" events, where women have difficulty shooting over the heads of men who are six feet tall. In her early days at the *Hartford Courant,* she was frustrated over being pigeonholed by the assignment editor until one day she confronted him by saying, "If I can't shoot anything but school plays, I'll have to quit." Griesedieck was touched by the solicitousness of the assignment editor's reply. "If I sent you to a bad part of town," he said, "and something happened to you, I'd feel really terrible. It would be like sending my daughter, and I don't think I could live with it." Shortly after that conversation, Griesedieck's dilemma was resolved when the paper was sold to the Times-Mirror Company; Steve Rice was brought in as picture editor, and he expected every photographer, male or female, to pull a full load of assignments in all areas.

Judy Griesedieck loves covering sports. During her stay at the San Jose paper, she often had the opportunity to cover the San Francisco Forty Niners football team. All photographers were equal on the football field, but problems came up when she was denied access to the locker room because of her sex. She maintains that management is more concerned about this issue than the players are; they really don't care if women see them naked.

Practical and financial obstacles sometimes prevent women from getting certain assignments. One such situation developed when Griesedieck was forced to give up an assignment on an all-male ship because there was no berth available. The ship's captain would not allow her to sleep in an all-male dormitory. Getting around that problem would have taken weeks or months of advance planning, time that Griesedieck did not have in this case. On Forty Niner trips when four photographers were shooting, the three male photogra-

phers slept in one room, while the paper had to absorb the additional expense for Griesedick's single room. This limited the number of times Griesedieck could get assigned to such trips.

I asked Judy Griesedieck whether she thought that women photographers see things differently than men do. She said she did, "Women can feel free to show their emotions, and are more inclined to go deeper into a subject. People open to me in different ways because I am a woman and I seem less threatening."

My contacts with female photographers through the years would seem to bear out the generalization that women are more emotional, more sensitive, less threatening, more inclined to ask different questions and to see different things. I agree with Griesedieck wholeheartedly. For example, I cannot conceive of a male photographer establishing the kind of trust and rapport with subjects needed for a series on domestic violence such as Donna Ferrato's. Could a male photographer have been able to document the breast reconstruction of a woman who had undergone a double mastectomy and penetrate the psyche of her subject with the same understanding as Lynn Johnson did? Would the prostitutes of Falkland Road in Bombay have given the same access to a male photographer that they gave to Mary Ellen Mark?

Generalizations are risky. Most of the women photographers I have spoken to think that being female has made some assignments easier, others more difficult. Gender is rarely a hindrance to any story and most people respond to individuals rather than their sex. To suggest, however, that sensitivity and emotion are exclusively feminine assets would be unreasonable and unrealistic. Many male photographers whom I have observed have been highly involved with their subjects. Eugene Richards's *Exploding into Life,* Brian Lanker's Pulitzer Prize-winning birth series and Michael Schwartz's "AIDS Comes Home" are just three examples of projects in which the photographers were intensely involved.

What Women Photojournalists Say

I asked five women photographers to comment on issues aspiring women photojournalists and their male employers and colleagues might be concerned about. I've introduced each of the women below. Some of them I have mentioned earlier. Following the introductions, I offer my questions and list their responses.

Melissa Farlow, now a Pittsburgh-based free lance, was a staff photographer for the *Pittsburgh Press* and was for ten years a staff member of the *Louisville Courier-Journal and Times.* The photographic staff at the Louisville paper won

the 1975 Pulitzer Prize for its coverage of desegregation in the Louisville public school system. She also taught photojournalism at the University of Missouri while pursuing a master's degree there.

Lori Grinker is a New York-based staff photographer for the New York photographic agency Contact Press Images. Although she travels worldwide, she primarily pursues independent projects. Her book *The Invisible Thread: A Portrait of Jewish American Women* was the culmination of a six-year project. She began her career in 1980 while still a student at Parsons School of Design.

Self-educated, Donna Ferrato began her photojournalistic career in 1977. From 1982 to 1988, she was associated with Visions, a New York photographic agency; in 1988, Black Star began representing her. She is a 1986 recipient of the W. Eugene Smith Memorial Fund grant in humanistic photography for her work on domestic violence which appears in her book, *Living with the Enemy*. In 1989, she received the 1989 Robert F. Kennedy Award in Humanistic Photography for the same project.

Abigail Heyman has been a New York free lance for magazines and books since 1967. She is currently the director of The Picture Project, a company formed to facilitate the publication of important photography. She was previously associated with the International Center of Photography as director of its educational program in documentary photography.

Janice Rubin has been a Houston-based freelance photojournalist for fifteen years. An editorial and corporate photographer, her work has been published extensively in *Texas Monthly, Newsweek, Town & Country, Forbes* and many other national publications. Her exhibition and photographs on pre-Glasnost refuseniks, "Jewish Lives in the Soviet Union," was widely published and exhibited in seventeen cities in the United States and Canada.

In your work as a freelance photographer or newspaper staffer, have you been discriminated against?

Melissa Farlow: "I have always been treated as an equal. Leaving college for my first job, I believe I was given a break because I was female, and it was hoped I had potential to grow into the job. I learned from being around a talented staff of supportive people. I grew into the job. I learned to be professional. It never occurred to me that I was different."

Abigail Heyman: "I'm sure I have been discriminated against in that picture editors, in my early years (late 1960s, early 1970s) at least, hesitated to send me to dangerous locations. But this is fairly subtle. No one said I'm not going to send you to Vietnam because you're a woman. They probably did say it to

each other until the women's movement made them embarrassed to say it out loud. I'm sure they still felt it unconsciously, and some still do.

It seems clear to me that those women who wanted to photograph war like male photojournalists went off and did it, and have been recognized as fully capable after they proved themselves good at it. I think it was probably harder for them to prove it, but essentially the male photojournalist had to prove it too. While I was pigeonholed more than I like, it is also true that I consciously chose to photograph women's issues because they seem more important to me."

Donna Ferrato: "No, I haven't been discriminated against. I don't think I've been protected from different kinds of assignments. It took a while to show people that I could do the kind of things I really wanted to do. I had to put in my time and pay my dues. That took years."

Is it difficult for people to get past the stereotype of women as only fashion, portrait, or social happening photographers?

Abigail Heyman: "Is that like being just a housewife? That is, should we feel embarrassed about not being interested in 'more important things' that would matter to men. I never did fashion or portrait work, so no one has ever stereotyped me that way. I do a lot of work now about social events that I think are deeply important. I don't feel stereotyped in that. I often feel treated as though what I am doing is unimportant to a male oriented world, which, of course, includes women."

Lori Grinker: "I've gotten surprised reactions from people when they learn that I work in Cambodia, cover Mike Tyson, or photograph racial tensions in New York. 'You look so feminine. I wouldn't expect that you could get along with these macho men.' Or, 'You don't exactly look like you could defend yourself.' It seems people don't expect you to be feminine and be able to cover rough situations."

Janice Rubin: "I have not generally encountered discrimination as a woman in photojournalism. On the contrary, I often find that being a woman makes it easier for me to get the photographs I need for a story. Perhaps because I am less intimidating than a man, or perhaps I simply ask for what I need."

Is it more difficult for a woman than a man to succeed in photojournalism?

Lori Grinker: "The main difficulty I see for women's success is in dealing with relationships and family. There still seems to be a double standard. I see many more male photographers with mates who are willing to compromise their own careers for the relationship than the other way around. I believe it is

more difficult for a woman to succeed if she also wants to have a family. It's extremely difficult for a woman to have a small child and be on the road much of the time. One would have to make many concessions in order to have both, and I would assume that this means taking time away from work, which of course slows down progress in one's career. There seem to be many more women in the editing end of our business. Perhaps this is one of the reasons."

Is there a spirit of special camaraderie among female photographers? Did you ever get a feeling that there was resentment by male photographers that you had invaded what had been a male bastion?

Abigail Heyman: "Sorry to say, almost all of the photographers I have felt really close to over the years have been men. But I do think that is more because I simply knew very few women in the field. Sure, I have gotten the feeling that I am resented by male photographers. But it seems to me that when I'm really shooting, I'm alone anyway."

Lori Grinker: "In New York I have wonderful female friends in the business. We are really quite supportive of each other, giving each other help in all areas—introductions to editors, exhibitors, equipment information, etc. Out in the field, however, it seems to be a bit different. We're all secretive when it comes to discussing assignments, but that's the nature of the business. The very few women with whom I have come in contact seem to be reticent.

When I was shooting boxers, particularly Mike Tyson, I encountered some male resentment. Since I started photographing him in 1980 when he was just beginning and followed him for the next several years, I became his "personal" photographer. This gave me special access to his personal life, and we became quite good buddies. There were times that other photographers would tell me how some of the members of the corps who shoot all sports resented me and thought I was a 'bitch.' Apparently this was due to the fact that I would go with him after the fight, or get special access to the stage or area that was roped off. There are always those who accuse you of having slept with him. This sexist attitude is not just competitive jealousy."

Donna Ferrato: "I've had more of an affinity for women photographers. There are many women photographers with whom you can talk heart to heart and share all kind of professional problems. My dream is some day to have an agency composed only of women photographers."

Do women have a distinctive point of view as differentiated from that of men? If so, how is that manifested in the pictures women take or you take?

Abigail Heyman: "Others felt that only a woman could have taken the

pictures in *Growing Up Female*. I disagree. I do think that only a feminist—not necessarily a woman—could have edited that book. I don't think there is a 'female' way of composing a picture. But I was once astounded at walking into my child's nursery class to see all the females building enclosures and all the males building projectiles."

Melissa Farlow: "I don't believe differences in shooting styles have anything to do with gender. You can't say women don't shoot sports or hard news just as you can't say men can't shoot sensitive pictures and stories. There are too many exceptions to these generalizations.

I do believe that the kind of pictures people make reveals much about their personality. If a photographer is able to get into sensitive situations and make revealing pictures, you know that the person making those pictures is likely a non-threatening type of individual that people trust and allow into their lives. That person can be male or female."

Lori Grinker: "I don't think that women relate differently to their subjects than men do. I find that subjects relate differently to women than to men. I find that people are much more trusting of and open up much more easily to women. For example, when in Israel starting my project on war veterans, I was told that no photographer had been given access like I had. I learned that this was because many of these disabled men felt more uncomfortable around an able-bodied man. The fact that a woman was there and didn't have any discomfort being with them made them feel much better about themselves."

Donna Ferrato: "I think women are better photographers than men in certain kinds of photography. In the 1990s, society and ultimately the media will be dominated by women's issues—the family, sexual violence, abortion rights and the changing face of women in America. Those are major problems in America. Real women photographers like Lynn Johnson, Vera Lentz, Nicole Bengevino, Jean Marie Simon, and Maggie Steber are specially equipped to be responsive to those issues.

Women are more curious, more sensitive, more emotionally involved than men. They want to see and be surprised by the world they live in rather than accept preconceptions and the accepted orthodoxy. Women doing stories on subjects retain relationships with those subjects for life. They don't move in and out of other people's lives as quickly and easily as men."

Janice Rubin: "Though it is difficult to generalize, I do feel that women photographers do sometimes have a different approach than men. In my own case, I feel it is easier for me to gain 'my' people's trust. Hence, my images may appear more intimate. While women photographers may relate differently to their subjects than their male counterparts, it would be hard for me to say

that women photographers are more sensitive than men. Among my male photographer friends, I know a lot of guys who I would consider sensitive. Still, it may be safe to say that, as a rule, photographs made by women may often reflect a special empathy that women feel for the subject."

Are women photographers more inclined to choose different subjects to photograph than men?

Abigail Heyman: "Yes, but that has been severely tempered by their knowing that to be successful, they have to photograph the subjects that men think are important. Being a woman influenced my ideas about what I wanted to photograph. My interest in women's issues, in family issues, in photographing social relationships came out of my experience of growing up as a female. I instinctively incorporated what has recently in the psychological field become known as 'women's values,' and those are deeply my values. The fact that those stories have been considered unimportant by a male dominated society, of which photojournalism is only one small part, is the discrimination I feel, not the fact that I only receive assignments to photograph those issues."

Melissa Farlow: "Who would think at first glance that shy, sweet Carol Guzy would bring back gutsy, dramatic news pictures under adverse situations and deadline pressure from a mud slide in a foreign country? Eugene Richards says that many people tried to hire him for certain stories because they thought he was a black photographer. To look at his drug pictures in New York or his Arkansas delta pictures in the South, you might think that. But Richards' pictures, just as Carol Guzy's, tell more about those photographers' abilities than their color or sex.

People are drawn to their interests. Therefore, you may find a woman shooting 'women' stories because of her concerns. I shoot a lot of family-oriented stories. Some photographers on our staff would be bored working on those types of stories."

Lori Grinker: "I think there are stories that are inherently women's stories. My choosing to do a book on Jewish women derived from my attempt to gain an insight into the culture and destroy prevalent negative stereotypes, but also to do a 'woman's project.' As a woman, I was very excited to do a project about women.

My other two major projects, boxers and war veterans, come from another point of view. They were subjects that I found difficult to understand. It does seem ironic for a feminist and an anti-violence person to choose such subject matter. Perhaps I come into it with a woman's point of view."

Janice Rubin: "I think of myself as a professional photographer who hap-

pens to be a woman. The fact that I am a woman shapes who I am, what I do, and how I do it. But I do not feel that my gender has ever kept me from doing what I want to do. The fact that I am an observant Jew who does not photograph on Saturday has probably had a much greater effect on me in terms of missing assignments."

Do you think that in certain situations women photographers have inherent advantages over men? Disadvantages?

Abigail Heyman: "Yes. I'm sure I have advantages in a lot of places over men. In India once, I was denied permission to shoot what I was sent there to shoot, and I put my camera in a purse, and walked through the streets as a tourist, and no one felt at all threatened by me. In many ways this unthreatening, casual stance became my style. I think this unthreatening stance is much easier for a woman than a man. It's easier not to be noticed."

Melissa Farlow: "Talking to a picture editor at the *Press,* I asked if gender had anything to do with selecting a photographer for a particular story. I was told no. The only time it is considered is when the editor thinks there might be a better rapport with a woman photographer. I was selected, for example, to photograph a woman having a mammogram for a story on breast cancer. It's not that a male on our staff couldn't do the assignment. The picture editor thought the woman getting the exam might feel more comfortable with a woman photographer. I have photographed several birth stories, but my husband, Randy Olson, just photographed an Amish midwife assisting a birth that was every bit as sensitive and candid as any of my shoots."

Lori Grinker: "It depends on the culture. In Cambodia I was able to photograph in the maternity hospital where it was strictly forbidden for men, even husbands, to view the birthing. Certain religious ceremonies in certain countries are closed to women, but others are closed to men. Also in Cambodia, I gained access to the Prime Minister and his family. Male journalists said that it would not have been possible for them."

Do you think that some women use their sexuality to gain greater access?

Abigail Heyman: "Yes. And so do men. Women flirting to get access are called 'using their sexuality to gain greater access,' while men flirting to get access are called 'charming.' I think it was an early feeling of mine that I wanted to avoid accusation so badly that I never learned how to flirt or be charming. Not that I believe women should sleep their way to the shot, but charm and sexuality are much of what makes the world turn. Similarly, I never

learned to be 'in charge'—where women are called 'bitches' and men are called 'leaders'—and I think the fear of that criticism has hurt me enormously."

Lori Grinker: "I've heard this does occur, but I have no specific instances to recount. When I was in college, I had two different professors who encouraged women to use their sexuality. They advised us not to worry about talent, that we could always use our beauty to get by. I found this completely outrageous and said so. But there may be others who think this is a way."

Donna Ferrato: "It is very dangerous for women to blatantly use sexual attractiveness on the job. Men are openly resentful of such female behavior, although the male photographers are more promiscuous and love to boast about their sexual exploits to the applause and approval of their colleagues. Good photographers communicate on all levels, and I can't honestly say that their sexuality is not a part of that communication. They use their humanity, their personality—whatever it takes."

Janice Rubin: "I do agree that a woman can use the fact that she is a woman to gain a greater advantage or access. I know I do. For example, on a recent assignment for a shipping company, Ben Chapnick sent two photographers to two different locations to photograph on freighters. One photographer, a male, found the ship's crew totally unfriendly and uncooperative. On my assigned ship, the crew bent over backwards to accommodate my every request. They even offered to help me to carry my gear up several flights of stairs to the bridge (an offer I accepted!). Perhaps it was just a different crew, but I think they cooperated because I was a woman.

I have occasionally been given an assignment because I was a woman. I am sometimes asked to photograph grieving families, subjects in hospitals, or difficult and uncooperative people. I guess either the client or the subject feels more comfortable with a woman. Nevertheless, I have not missed out on an assignment because I am a woman."

Are there any situations where your sensitivities as a woman would be offended?

Abigail Heyman: "As you might guess, I am offended in anti-female places. I don't think nudity in a locker room or elsewhere is at all anti-female. Corporate offices often are. Most social events are. I don't think being offended hurts my photography. I probably do my best work when I am angry."

Lori Grinker: "I've never been permitted to photograph in the locker room till everyone was dressed. The funny thing is that they would always make me stand outside the door (even to Tyson's dressing room) and whenever someone opened the door, all these naked men would be walking about. I would be

comfortable, but if the tables were turned, I wouldn't want some male photographer walking around while I was undressed."

Janice Rubin: "I would not feel uncomfortable photographing in a men's locker room, although it seems about as appropriate to send a man to photograph in a woman's locker room. I realize that the football locker room is a favorite spot for journalists. I just wouldn't make a big issue out of it—it's my job."

Do you accept the thesis that women are not physically as strong as men, and if so, has it ever been a limiting factor in your work?

Abigail Heyman: "At first glance, yes. But physically strong just isn't one of my values. At second glance, I accept that men have more muscular strength in the arms which makes them better hunters, and women have more strength in their hips which makes them better childbearers. All of which seems irrelevant to the modern world. Male photojournalists over forty, with bad backs, using an assistant, seem pretty common practice now.

Except for a rare assignment that requires an assistant, I work with materials as light as possible to be able to work as quickly as possible. I use Leicas in part because larger cameras feel too big for my hand. I don't use long lenses if I can avoid it for the same kind of reason. It's impossible to say now if I would have made different choices along the way if I could have carried more weight in my hands, or on my shoulders. I seldom think of it as a limitation at all. It's a part of who I am."

Melissa Farlow: "I know I'm not as physically strong as some of the men on our staff, so lugging around long lenses or large cases of lights is more difficult for me. I tend to work with lighter and less equipment or get help."

Lori Grinker: "On the whole, women are not as strong as men. There are women out there who are quite strong enough, and I think we get along just fine, maybe at times we have to struggle a bit more. My male friends, however, complain just as much about back injuries."

Photojournalistic Opportunities for Minorities

The world of photojournalism is a mirror image of society. African Americans and other minorities have historically suffered economic and social discrimination. It is true in journalism as well. That's the bad news.

The good news is that for gifted African American, Latino, Native American, Asian, and other minority photographers, the hiring climate is a positive one. Urban newspapers serving communities where there are heavy concentrations of African Americans and Latinos look for outstanding minority photog-

raphers to change the formerly all-white composition of their photographic staffs.

In August 1989, under the auspices of the National Association of Black Journalists, a seminar was held at which black photographers and white and black picture editors discussed racial sensitivity in assignments and photo selection. Many black journalists expressed their concern that the black community is constantly presented in a negative light and that blacks and minorities are rarely used to represent generic situations. African American photographers are ambivalent about covering racially sensitive stories and often resent being isolated as the newspaper's link with the black community. Blacks do not want only to cover "black" stories exclusively. Has the editor chosen the black photographer for a story because white photographers fear blacks? Does that selection process preclude a minority photographer doing something of general interest?

Black journalists feel that they should be better represented in the newsroom, that editors' doors should be open for them to express their concerns, that there should be greater understanding of staff sensibilities, and that more blacks should be in "budget" meetings and involved in the editing process. Such changes would produce a greater understanding of the sensitivities of the African American community and counterbalance media preoccupation with stories intrinsic to that community, such as spiraling crime, downward mobility, drugs, and homelessness.

Mark Bussell, the former *New York Times* picture editor, is sympathetic to those goals and is always alert to potential racial sensitivities in the selection of pictures to be published. He is also pragmatic and realistic about the way newspapers use African American photographers when he says, "I think it's foolish to think that everyone's the same. To say to yourself that it doesn't matter who we send on this assignment because we're all human beings is a joke. You wouldn't send an excellent sports photographer to photograph a plate of food. If I have an opportunity to send a black person to photograph a black gang, I'm going to send that person. With a white photographer it might not work at all."

Common sense dictates that assignment editors be mindful of racial feelings on all levels and choose the photographers who can be most effective in given situations. It wouldn't make sense to send a black photographer to Bensonhurst's Italian section after the conviction of Joey Fama for the murder of Yusef Hawkins, a black teenager. The photographer's race in such an emotionally charged atmosphere would be a handicap. The photographer might well become a target and find his safety jeopardized.

What African American Photojournalists Say

Though Gordon Parks opened the door for blacks in magazine photojournalism, few black photographers, except a small number used by black magazines such as *Ebony,* have worked for magazines. Newspapers, particularly urban ones, have been more receptive to aspiring black photojournalists.

I spoke with four African American photographers of diverse backgrounds to explore their attitudes and experiences during the pursuit of their respective careers. Their answers reflect the different degrees of acceptance, rejection, or bitterness they experienced when faced with the realities of fulfilling their material and aesthetic aims as photojournalists.

Chester Higgins, Jr., is a staff photographer for the *New York Times.* He sees himself as a mainstream photographer, not as a marginal minority photographer. Born in New Brockton, Alabama, a town comprising eight hundred people and requiring only one traffic light, he was the minister's precocious nine-year-old grandson who took to the Scriptures and became a Southern Baptist child minister. His photographic ambitions were fired in 1967 while a student at Alabama's Tuskegee Institute. His undergraduate years were the years of the civil rights struggle in the South, and he participated in voter registration drives in Selma and demonstrations in Montgomery, Alabama.

It was at that time, as Higgins recalls, that the philosophical views that drive his photography crystallized. "I became very much aware and resentful of the media portrayal of what was happening in our community. It was different than the reality. It made me take a more critical view of the fact that whenever you saw photographs of my people, they were invariably photographs of the pejorative side—prostitutes or suspected felons being arrested." To better explain his photographic views, Higgins recounts a bedtime story being told by a father to his son. "A man walked into the jungle and came upon a lion. The lion set upon the man and the man won the fight." "Why doesn't the lion win?" asked the son. "The lion is bigger than the man, he has big teeth, four claws, and a huge body." "Son," said the father, "the lion will win when he writes his own book."

Chester Higgins has literally written his own book. Instead of railing against what the media was doing or not doing, he decided to become an integral part of the scene and make his own statements. The diversity of the work he is doing for the *New York Times* corroborates his stance.

Anthony Barboza began his photographic career in 1963 when he received on-the-job training in photography as a staff photographer for *The Gosport,* a Navy publication. He is a black Portuguese from Massachusetts who originally

wanted to be a photojournalist, but he migrated to fashion photography and now works for publications like *Essence* and *Harper's Bazaar* in the studio he has opened.

Barboza prides himself on bringing photojournalism to fashion photography. He introduced a spontaneous look by making realistic, storytelling photographs to replace stylized and stilted images that formerly prevailed. Today his work is still studio-based, but he does some editorial assignments, primarily for the *New York Times Magazine.* Barboza openly wears his bitterness over the discrimination he has experienced on his sleeve; his resentment often manifests itself in recrimination.

Magnum photographer Eli Reed could be mistaken for a pro-football linebacker. His imposing physical bulk belies the gentleness of his demeanor, the intellectual breadth of his mind, and the intensity of his work. Although he sees "life as darkness interrupted by an occasional bit of light," Reed is not a pessimist but a man of optimistic conviction. He credits his training in judo and the martial arts with giving him the mental, physical, and spiritual toughness to meet the difficult demands of his professional life.

In 1982 and 1983, Eli Reed was the second black photographer, after *Newsweek*'s Lester Sloan, to become a Nieman fellow at Harvard University. This valued fellowship ultimately led to his association with the Magnum agency. He first picked up a camera in 1965 while living in Perth Amboy, New Jersey, but did not become serious about photography until his last year at art school, when he took a course in art photography.

In 1977, Reed was teaching photography to inmates at the Eastern Correctional Institute when a serendipitous meeting led him to a job at an upstate New York newspaper. After that, he spent two years at the *Detroit News,* and in 1980 he became a staff photographer at the *San Francisco Examiner.* In 1983, the chance to go to Beirut, Lebanon, for Magnum arose when a three-week assignment for *USA Today* turned into a two-month commitment. A return trip on assignment for *Newsweek* ultimately turned into a published book on the strife in Beirut, *Beirut: City of Regrets.* Reed sees the Nieman Fellowship as providing "an overview of the world that I never had before. It reinforced my views of the press and politics. It allowed me to do some creative writing, which has helped me in my photojournalistic career."

Not every African American photographer has to meet the demands of the majority press. In the United States, there is an ethnically and a racially based press, each of which has its own constituency. Moneeta Sleet, Jr., who graduated from a black Kentucky college, Kentucky State, and received a master's degree in journalism from New York University, opted for a career

with black publications. After a stint as writer-photographer for the *Amsterdam News,* a Harlem-based newspaper, he became a staffer for the brilliant, ill-fated publication *Our World,* which was a predecessor of the successful black-oriented magazine-publishing empire developed by John Johnson, Jr. When *Our World* went bankrupt, the name was purchased by *Ebony*'s publisher but never used. *Ebony* also hired Moneeta Sleet, Jr., who since 1955 has developed an impressive body of work that chronicles the black experience in the latter half of this century. In 1969, he received the Pulitzer Prize for his photograph of Coretta King and her daughter, Bernice, at Martin Luther King's funeral in 1968. It was the first time that the Pulitzer Prize was given in feature photography.

It is coincidental and ironic that Sleet, a magazine photographer, was able to qualify for the Pulitzer which is only given for newspaper photographs. Because the King family was anxious to avoid a crush of photographers in the church, it was decided that there would be restricted coverage, and Sleet was designated as a "pool" photographer. His pictures were distributed by Associated Press and other wire services, used extensively in newspapers and thus became eligible for the Pulitzer. Originally all the photographers were white, but because Andrew Young and Coretta King interceded and insisted that a black photographer be included in the pool, Sleet was able to be inside the church during the service. Mrs. King decided that either a black would be included, or there would be none at all.

Through the years Moneeta Sleet has been able to visually record the positive image of middle-class black America. He has also participated in the documentation of one of the most dynamic periods in American history—the civil rights struggle. He has dealt with drugs and other problems of our inner cities, where the ghetto mentality is transcendent. Sprinkled throughout a collection of his work are personality stories on some great African Americans, including Dr. Martin Luther King, Jr., Dr. Ralph Bunche, Muhammad Ali, Ossie Davis, Thelonius Monk, Duke Ellington, and Miles Davis.

Do black photographers have a distinct point of view as differentiated from white photographers?

Chester Higgins, Jr.: "I like to think that because I am black, when I photograph my black or white subjects, my background and culture intrudes. My culture tends to deal with the humanity of things. If you look at the way we try to express ourselves, if you look at our music, our religious spirituals, the ways we relate to each other, it is done in a more humane way than we find among non-black people. Clearly, I am black, but I don't hold a camera in a

black way. I photograph all kinds of subjects, white and black, not because I am black, but because I have eyes."

Anthony Barboza: "For forty-seven years I have lived my life in a white world and a black world. Lingo is important to being a black photographer shooting black people. Since we come from the same background, speak the same language, listen to the same type of music, and lived through the same things, these people feel comfortable with me. White people have an attitude that they are superior to black people. That doesn't make for good photographs."

Eli Reed: "There is too much put on the fact that if you're black you see things differently. I'm a photographer and the fact that I am black doesn't make a damn bit of difference."

Moneeta Sleet, Jr.: "In certain situations, I don't make a point of saying that I'm objective. When I was photographing the civil rights struggle, I photographed from a black point of view. My attitude during that whole period was that there was no question that what they were fighting for was right. There was no debating the rightness of the cause. I made no attempt to be objective. Every photographer, black or white, brings with himself or herself training, background, environment, and attitude."

How does that manifest itself in the pictures you take?

Chester Higgins, Jr.: "The ideas I originate relate to my desire to present a facet of my people that has been neglected, to reinforce and show aspects of our lives that we ourselves don't get a chance to appreciate as often as I think we could."

Eli Reed: "My long term project on black America, which will be a book, obviously comes from my being black. But I haven't been doing that all the time. There are a lot of times I want to do other stories, but forget it, because I am perceived as a black photographer who can't deal with these subjects. It irritates the hell out of me."

Do you think that in certain situations black photographers have inherent advantages over white photographers? Disadvantages?

Chester Higgins, Jr.: "During the civil rights period, Charles Moore, being white and southern, had great advantages working in the South. I could not have done what he did. I may have an advantage over white photographers if I go to Haiti or if I cover Nelson Mandela and I take advantage of that. In covering any situation, we are all looking for an advantage if it is there and you go with it."

Anthony Barboza: "The main things are personality, humanity, and the

ability to get along with people. I was recently hired by *Newsweek* for a cover shot where they asked me to find real kids in Brooklyn with the guns. I got the real kids, 14 and 15, with the guns. I shot them on the rooftop and covered their faces; one had sunglasses on. I did the assignment because I think something should be done about what's going on. I had no problem with these kids—I was like a father to them. They had the guns loaded. I told them, 'unload the guns.' They did. I don't know how they would have been with a white photographer."

Eli Reed: "Of course. When I covered the Liberty City riots in 1980, being black wasn't of much help. Race riots are scary and all photographers are at risk. I just did an assignment photographing black publisher John Johnson Jr. for a book project. Johnson, the publisher of *Ebony,* was very pleased that a black photographer had been assigned to photograph him and it made my job easier. The disadvantages: you get hassled more as a black photographer. When I was covering the Klan demonstrations in Forsythe County, Georgia, a state trooper was trying to push me into a group of rednecks. It would have been unfortunate for the rednecks, because I'm not going to let myself be beaten up. The first person who touches me in a threatening manner is going to get hurt."

Moneeta Sleet, Jr.: "Initially, yes, they do. Certainly in terms of acceptance and access. But later, white photographers can gain the same acceptance by letting people know they are sympathetic and empathetic to what the people are doing. That they are there to do an honest job and are not there to degrade them."

Do you resent being typecast as a black photographer when it comes to covering black subject matter?

Chester Higgins, Jr.: "Working for magazines, more often they think of you in the context of a black story than a white story. On the newspaper, I don't have that sort of problem. I've let it be known that I want to do other things as well. But it doesn't mean that I would turn down an opportunity to let the viewers benefit from my perspective and my eye in looking at the story that had to do with my people. I do have access to certain black people that is very valuable. When Jesse Jackson came to New York to see Al Sharpton after Sharpton was stabbed, I used my twenty-year relationship with Jackson to become the pool photographer and photograph Sharpton in his room at the hospital."

Anthony Barboza: "I've been in the business for twenty years. Always black, black, black. I have never done a national ad that was white. I can shoot anything that anybody else can. I attribute my breakthroughs to Peter Howe

and Kathy Ryan at the *New York Times Magazine* for letting me shoot Cher and Joseph Heller. I get a better shot from foreign art directors than I do from racist Americans. But I never give up. They can't get rid of me."

Eli Reed: "You don't want to cover the same things all the time. In different cultures things happen. We're all Americans. When I get a call from an editor and he says, 'I've got something that only you can do,' the clock starts ticking. Something only I can do, it must be something to do with black people. A lot of the time it is."

Can you recall any instances where being black worked against you?

Chester Higgins, Jr.: "Any problems I have had over the years have come from my being a photographer, not from being black. I wasn't afraid of going to Bensonhurst after the killing of Yusef Hawkins. No one bothered me. During the Howard Beach trial, there was violence directed toward all photographers. I got jumped on in New Jersey after the suicide of four young people when I was photographing the garage door of one of the suicides. A man ran after me, started punching me in my kidneys. It turned out that he was a relative of one of the young people who had committed suicide."

Moneeta Sleet, Jr.: "An *Ebony* editor, Allan Morrison, and I were assigned to photograph a black farmworker in the South who worked for a white farmer. The farmer was anxious to protect 'his nigra' and went for his shotgun. We weren't about to run, but we drew ourselves up tall and decided to get out of there quickly."

As a photographer, have you been discriminated against because you are black?

Chester Higgins, Jr.: "You never really know. I'm sure there is some resentment on the part of white photographers on the staff. It is manifested by some people not speaking to you, never offering help when you have problems. It's their problem, not mine."

Anthony Barboza: "When the *New York Times Magazine* assigned me to do Cher, Cher's people wanted to see my book. When they sent it back, they asked us to send another book with more white subject matter in it. But that's all I had. So they said they wanted to use another photographer. Kathy Ryan refused. So they accepted me. While I'm setting up lights in Cher's house waiting downstairs, the hairdresser says, "Listen, if she doesn't like the Polaroids, she's not going to shoot." That made me more nervous. Then there was talk that I looked like a Rastafarian. I shot the Polaroid and Cher loved it. She let me do anything I wanted. I have to go through that quite a bit."

Eli Reed: "In Central America, I got the distinct feeling that my film, which almost cost me my life, was badly processed by wire service people, and that it was intentional. Sometimes you can be mistaken and think that it is racially motivated. But in this case, I was treated like I was at the bottom of the pile as far as they were concerned and that really pissed me off."

Do you have any advice for budding black photographers?

Chester Higgins, Jr: "I would give them the same advice I would give any photographer. Work very hard. Try to learn your subject. Immerse yourself in the subject. Be prepared for rejection. You have to believe in yourself and what you are doing. My principle has always been to please myself. My standards are high enough so that if I please myself I know I can sleep with myself at night."

Anthony Barboza: "You've got to do what you want to do and have the strength to do it. I'm often hurt, but I'm better for the struggle. Everywhere you turn and look the prejudice is unbelievable. I go to an advertising agency, go to the receptionist, and she tells me 'the messenger's entrance is over there.' White people, when they see a black, they think you can't take a photograph. I had a Japanese assistant when I first started in this business. We would walk in with equipment and the art directors would go up to him and say, 'Hi, Mr. Barboza.' They thought he was the photographer."

Eli Reed: "The same advice I'd give any photographer: get yourself in shape for a lot of disappointments. You have to read everything. You have to know what's going on in the world, besides your own little world. There's always going to be a lot of stuff that's not very pleasant, but there are good people out there who are not aware of this stuff. Live life to the fullest. Enjoy it."

Moneeta Sleet, Jr.: "When I talk to all the black kids, I tell them to come as well trained as you possibly can. I'm a strong believer in getting a good liberal arts education because being a photojournalist you're going to be thrown into all kinds of situations. You're going to have to deal with all kinds of people. Of course, learn your craft as well as you can and constantly work at it. Constantly honing your skills. Be the best you can possibly be. Learn to deal with people and realize that these are human beings you're dealing with; and respect them. Society is not going to let you forget that racism is a part of American life and you have to learn to deal with it. We all learn to deal with it. I get angry at appropriate times, but I don't let a little bit of slight deter me from what I am about and what I am trying to get done. You have to do what your gut says."

Picture Agencies

Business is religion, and religion is business. The man who does not make a business of his religion has a religious life of no force, and the man who does not make a religion of his business has a business life of no character.

Maltbie Babcock

World photojournalism in the 1990s is dominated by the picture agency, an amorphous unstructured kind of business that was seeded in Germany in the 1920s, transplanted to England, France, and the United States in the 1930s, blossomed internationally in the 1940s and 1950s, and exploded into unprecedented growth in the ensuing decades. Little do the readers of publications throughout the world realize that the pictures they see and the photojournalism that moves them are being distributed through a complex network of photographers, agents, and publications.

There is a photojournalistic sales chain that is as distinctive in its own right as the food chain of the natural world. The first link in that chain is the photographer who produces a set of pictures on a subject. He or she produces a picture story or a single picture related to the news and the background of the news. Those pictures may have been self-sparked, initiated and assigned by an editor at a magazine, or dreamed up by an editor at a photographic agency.

Those pictures only have communication and commercial value if they get published. The more often they get published, the greater the financial return for the photographer. And that's where picture agencies come in. Each day the mails and couriers are feeding thousands of pictures into the international agency pipeline, dictating the pictorial content of the weekly and monthly magazines of the world.

I'm not sure if invention is the mother of necessity or necessity the mother

of invention, but early on in photojournalism, it became apparent that there had to be some business-oriented entity that would bring order to the chaotic world of the photojournalist. There is an old cliché about creative people: they are notoriously incapable of grasping basic business principles. Or as my photographer friend Richard Nowitz says, "It's great to make a bagel, but it's even greater to be able to sell it." And so picture agencies were born. And with them evolved one of the last of the great businesses based on a handshake. Woodfin Camp, director of Woodfin Camp Associates, describes picture agencies as "the most labor intensive business in the world except perhaps for agriculture." In the 1990s, the business is becoming increasingly capital-intensive as new technologies become necessary. Camp says, "Technology should help us become more efficient in the storing and transmission of images. I know that we have too many pictures and we should weed out our files. I doubt if more than 50,000 of the two million pictures we have in our files ever sell."

There has been a worldwide proliferation of picture agencies during the last fifty years. Photographers don't necessarily have to be associated with one to be successful. Many photographers, in fact, attribute their success to their independence and personal initiative. But many others have mastered the art of dealing with picture agencies, and thus promoted their careers, and been stimulated by the association creatively and photographically, and in the process increased their earnings in the field. Like everything else in life, when it comes to the relations between photographers and picture agencies it is hazardous to generalize. For some photographers, such a relationship works; for others, it doesn't. And for still others, it sometimes works and sometimes doesn't. The important thing for a photographer contemplating working with a photographic agency is for that photographer to define his or her goals, to understand what an agency can and cannot do in helping achieve them, and to utilize the agency's strengths to the maximum in fulfilling those goals.

During my years at Black Star, we sometimes succeeded with photographers of mediocre talent and failed with those of great talent. That doesn't mean that magazines and other clients are receptive to mediocrity and uninterested in talent. What it suggests is that there are diverse factors beyond photographic ability and imagination that are keys to success, in this profession. The personality or appearance of the talented photographer may mitigate against success, or the human chemistry between the agent and the photographer may be deficient.

Picture agents have no secret markets. Most often their success is in direct proportion to the quality of their photographers, the creativity of their ideas,

the energy of their sales efforts and the hard work they invest in the business. The livelihoods of photographers are dependent on agency assignments and stock library sales.

The term *picture agency* is an umbrella for many different kinds of operations. Anyone contemplating using a picture agency for career advancement would be wise to make an exhaustive study of the individual agencies to determine the primary interests, clientele, and philosophical approach of each. It is even wiser, once the general type of agency is chosen, for the photographer to make personal visits to several agencies in that category to assess the human equation. Compatibility of personalities and photographic philosophy is essential to a successful relationship.

Entering into an association with an agent is much like choosing a matrimonial mate, or developing a "meaningful relationship" in the parlance of contemporary romance. Based on current statistical evidence, marriages are fragile indeed and their terminations traumatic. Trauma in the photographer's association with a picture agency obviously should be avoided, so an agency must be chosen with care. It may be the most important professional decision a photographer will make.

In this age, when mergers, acquisitions, agglomerations and conglomerations dominate the business world, the "mom-and-pop" mentality that characterizes most picture agencies is professionally valuable and artistically desirable. Creativity is not an assembly-line process. Great photojournalism is not fostered in an atmosphere of "bigness." The vital individuality of the photojournalist can be destroyed in a highly charged big-business atmosphere that considers the financial rewards over psychic rewards.

However, a "personal rep," a one-on-one agent who personally represents a photographer, is a rare bird in the editorial photojournalistic business. Most such reps serve advertising, commercial, and studio photographers. In some cases the rep may work for one studio or one photographer who can afford such a luxury because of the comparatively high prices generated for commercial photography. (The standard commission for a rep is 25 percent of the gross.)

Editorial photography, based on day rates that approximate one-fifth of commercial day rates, can hardly support this kind of representation.

The Editorial (Photojournalistic) Assignment Agency

In the late 1960s, John Durniak, *Time*'s director of photography, using Gamma as a virtual house picture agency, revolutionized news magazine

photography, and impelled other magazines to rely on picture agencies for important coverage. He recognized that picture agencies allowed *Time* wider photographic access to world events.

By the 1990s, the way picture agencies worked with magazines had dramatically changed. News magazines and picture agencies developed a mutual dependence. Magazines like *Time* and *Newsweek* now work largely with contract photographers (albeit many of them are still associated with agencies). Staff photographers have been virtually eliminated. "In today's environment," says Jocelyn Benzakin, head of JB Pictures, "magazines cannot operate without picture agencies. We have made the picture editor's job very easy. For the most part, they can just sit and wait for the agencies to bring them outstanding material and just pick and choose what suits them."

Today while magazines have an abundance of picture sources to select from, agencies specializing in photojournalism are concerned about the welfare of the domestic marketplace for news pictures. Despite the large number of publications using photography, the dearth of publications using extensive documentary feature stories is glaringly apparent and frustrating. The problems for photographic agencies have been compounded by the economic pressures of the recession; reduced advertising revenues adversely affect the number of editorial pages.

As a result, there is not a single assignment agency in the United States today that does only photographic assignments for newspapers and magazines. Some come close to it, but though their philosophical roots are grounded in photojournalism, they must, by necessity, branch out to include selling secondary residual rights in the international and domestic marketplaces and maintaining stock libraries for individual picture sales.

Perhaps the agencies that come closest to being purely journalistic are Contact Press Images, JB Pictures, Saba, and Matrix. These agencies treasure the smallness of their enterprises in their search for personalized representation. The philosophy of limited representations allows for greater concentration on the work of a few photographers.

Throughout the 1970s and 1980s, new agencies developed, resulting from the ambitions of young people to define their own philosophies and control their own destinies. These new agencies, such as Matrix, Saba, Picture-Group, and JB Pictures, have made for a dynamically changing business that allows photographers to find representation that conforms to their respective philosophical, temperamental, and financial needs.

Although very different in structure, Black Star and Magnum most closely identified with each other because of their philosophies, business approaches,

and the strong head-to-head competition that exists between them. Black Star is a profit-making, privately owned corporation. Magnum is a cooperative of photographers of outstanding ability and reputation who share certain goals and have banded together for the common purpose of providing a home-base for their journalistic goals. Both companies recognized the value of extending into journalistically oriented commercial photography as a means of maintaining a strong bias towards journalism.

Fred Ritchin, in *In Our Own Image,* best articulates the philosophy that led to the founding of Magnum in 1947. Ritchin writes,

> Magnum was created as an endorsement of the subtlety and potential of photography when practiced by gifted individuals, and as an attempt to empower photographers by providing them with an independent base and a collegial solidarity, a human warmth from which to work. It attempted to provide the means, after the overwhelming exigencies of World War II, for photographers to travel, to see, to record, and to create, but without being forced to depend upon or follow the directions of any single publication or editor.

The three major international news and feature-oriented agencies, Sygma, Gamma, and Sipa, work almost exclusively with editorial photography. All three are based in Paris but have New York offices. They are huge by agency standards, tremendously competitive, and journalistically insatiable. Almost every major news story that takes place in the world will be covered by one or by all. Sygma and Sipa do no commercial photography; Gamma-Liaison, the American arm of the French agency Gamma, has a separate commercial photography division.

Celebrity photography, which encompasses pictures not only of television and motion picture stars but also includes those of sports figures, politicians, and business executives, is one of the most lucrative niches of editorial photojournalism. The success of Outline, Onyx, Visage, and other agencies in this milieu attest to the opportunity this photographic genre offers. Photojournalism wears many faces. But photographers working in personality photography are at the mercy of publicists and celebrities who exert ever-greater control of the picture taking, the picture editing, and the ultimate use of the photographs.

Photographers should be aware that what the public sees is the controlled public relations image of these successes rather than incisive and revealing portraits that might approach reality. It is difficult, however, for agencies engaged in this aspect of photography to resist the blandishments of a publicist

who demands photo approval as a quid pro quo for allowing that agency's photographer to shoot an important television or movie star.

Inside a Photo Agency: Black Star

As the former president of Black Star, I am familiar with how the agency came into being, how it has evolved through the years, and what it is today. The contrast between the Black Star of the mid-1930s and the Black Star of the 1990s is dramatic. Those fifty-five years of existence have encompassed dynamic changes dictated by shifting attitudes, improving film and camera technology, and an expanding magazine market for photography.

Black Star owes its existence to Adolph Hitler and the repressive atmosphere against Jews and anti-Nazis that he created in Germany during the 1930s. The virulent anti-Semitism and repressive political atmosphere stimulated three close friends to renounce their commitment to their native Germany and emigrate to the United States.

They were three remarkable men whose diverse backgrounds, abilities, and personalities complement each other. One partner was the rotund and brilliant theoretician, Kurt S. Safranski, an influential editor in the giant Ullstein publishing company. Safranski may indeed have been the father of modern photojournalism. He was the editor of the *Berliner Illustrierte Zeitung* and was among the first people to use pictures in sequence to tell a story. In the 1920s, Safranski was using pictures by photographers like Dr. Erich Salomon, Alfred Eisenstadt and Martin Munkacsi on the pages of his influential newspaper. He teamed with Dr. Kurt Korff, the editor of Ullstein's woman's magazine, *Die Dame,* to produce picture stories in the pages of that magazine as well. Simultaneously, Stefan Lorant, another acknowledged genius and photojournalism pioneer, was doing the same at the *Muenchner Illustrierte.* Lorant and Safranski were among the first editors to realize that one picture made a single direct statement, but once another picture or series of pictures was placed in juxtaposition with that image, a new dimension of meaning emerged. From that simple premise, the early picture story was born.

The second founder was Kurt Kornfeld, a scientific book publisher in Germany who is probably most responsible for the Black Star misnomer, Black Star Publishing Company. The original Black Star dream was to have a picture agency with a book-publishing complement. The involvement with book publishing only materialized in part some thirty years later, when books based on photographic subject matter were developed. Gregarious, ebullient, and full of continental charm, Kornfeld's outgoing personality attracted out-

standing photographers to the Black Star fold and his humanity endeared him to the *LIFE* editors and researchers.

The final member of the Black Star founding troika was Ernest Mayer, former owner of Mauritius, a German picture agency. He brought to the trium-virate not only a keen business mind but a Renaissance intellect with little tolerance for the superficial. He was a voracious reader. Mayer's Monday tradition was to bring to the office a shredded Sunday *New York Times*—actually a stack of clippings, each one an editorial idea.

The summer of 1941 changed my life. It was the summer hiatus between my junior and senior years at New York University, where I had shown a penchant for hijinks and a lack of interest in my chosen major—accounting. I had just completed one frustrating and depressing day working in a fur-dyeing establish-ment in New York's garment center. My best pair of covert-cloth trousers had been splattered with dyes and looked like Joseph's many-colored coat. As I wheeled the furs through the garment district, I thought to myself that my years of education had prepared me for a better and more challenging summer job.

Fate lent a hand. Black Star's accountant, Irving Wertheimer, was also the accountant for my father's small produce store. "Black Star, the picture agency, needs an assistant messenger-boy for the summer," confided Mr. Wertheimer. "Are you interested?" he asked.

"Yes!" I said. "But what's a picture agency?" Fifty years later, I'm still trying to figure it out. It is what you make it, and no two agencies are exactly the same. From experience I have learned what a picture agent is: mentor, purveyor of photographers and pictures, psychiatrist, financier, editor, researcher, idea person, negotiator, stimulator, and the quintessen-tial middleman.

Black Star opened a new world. Delivering picture packages quickly gave way to assisting photographers like W. Eugene Smith, Philippe Halsman, Fritz Goro, Walter Sanders, and Herbert Gehr. Under the tutelage of Ernest Mayer, I learned how to crop square pictures to eliminate superfluous elements and produce vertical and horizontal compositions. Mayer taught me about content and the importance of using every part of the negative to impart information. When I returned from more than three years Air Force service during World War II, I picked up at Black Star again. Gradually I developed additional skills; researching and writing suggestions for stories to be done on speculation or assignment and representing photographers and ideas to my own clientele. On January 1, 1964, I became the president.

The Black Star of today is a microcosm of the photographic agency busi-ness. For the purposes of this book, I use it as an example of what photogra-

phers can find at different agencies because I know it from firsthand observation. It is a multi-service agency grounded in photojournalism. No aspect of the photographic marketplace is ignored in the interest of finding established or new uses for the photograph. Its door is always open to new talent. Without the constant infusion of new photographers it would ultimately wither and die. It recognizes that the photographer and the photograph are its most important products.

Every editorial assignment starts with an idea. News stories are generated by events, feature stories by people's accomplishments or activities. In the agency business, as everywhere else, the race goes to the swift, the clever, and the innovative. Similarly, for the news photographer, being in the right place at the right time is paramount. Those photographers who are well informed about the world can make the best judgments about where their work will be in demand.

Let's look at a successful collaboration between photographer and agency, in which the activities of each party were complementary and important. It doesn't always happen this way, but it's nice to contemplate the things that work out well in the imperfect world of photographer-agency relationships.

John Launois has been associated with Black Star since 1954. His career includes being a contract photographer for *LIFE* in the 1950s and for the ill-fated *Saturday Evening Post* in the 1960s. In 1973 *National Geographic* published his essay on longevity, a story idea generated by Black Star, presented by the photographer to the editors of *National Geographic,* embellished by the editors of the magazine, and executed by the photographer.

It all started with a clipping I found in *Paris Match* magazine, which reported on the activities of Dr. Alexander Leaf during his investigation of the reported longevity of the inhabitants of Villacabamba, Ecuador. I suggested the idea to John Launois as a possible story proposal for *National Geographic,* where Launois's credentials as a contributor were excellent. He, in turn, presented the proposal to the editors of the magazine.

They reacted with definite interest and added their editorial input. *National Geographic* would be interested in assigning the story if other communities reputed to have long-lived inhabitants could be included, specifically Hunza in the Himalayas and the legendary Abkhazia in the Soviet Caucasus. Their inclusion would afford the opportunity to observe three different communities embodying three diverse cultures and lifestyles on three different continents and perhaps make scientific judgments related to the influence of topography, climate, diet, quality of life, reverence for age, and other factors. The big problem was getting permission to photograph in Hunza from the Indian

government, which had a history of denying journalists entry into this area. Through Launois's professionalism, ingenuity, and perseverance, permission from India materialized, and the assignment came to fruition. John Launois, photographer, joined with Leaf as the writer to produce the multi-page story in *National Geographic.*

The story doesn't end there. After publication in the magazine, all the residual unpublished pictures were packed into little yellow Eastman Kodak boxes and returned to Black Star. The pictures were reedited to make a cohesive and coherent presentation for international syndication. Duplicate transparencies of the selected photographs were then distributed and were published world-wide, thus generating important secondary income for the photographer.

Today, almost two decades later, individual pictures from that assignment continue to sell as "stock pictures," providing a continuing sinecure for the photographer. The body of work that the photographer has produced through the years continues to generate income through the sale of residual rights. Photographic agencies, as repositories for those collections, are constantly called upon by magazines, advertising agencies, book publishers, and encyclopaedias for access to reproduction rights for photographs.

The Expanding World of Stock Photography

I used to be fond of saying that there is no pot of gold at the end of the stock picture rainbow. I was wrong. The market for existing photographs, commonly referred to as stock photographs, is not simply expanding; it is exploding.

When I first started in the photography business, you could count the number of stock photographic agencies on one hand. In 1993, the Manhattan yellow pages listed more than one hundred stock agencies, some specialized, some general, and at least two twenty-first-century agencies that treat photography as big business and forswear the "mom-and-pop" philosophy that had characterized the growth of the agency business. One agency, The Image Bank, adopted a franchising philosophy. It became a public company that sold its name and the imagery of the photographers it represents to entrepreneurs all over the world. More recently Eastman Kodak purchased all the stock in the company, ostensibly to facilitate Kodak's entry into the world of compact discs. Where once almost all the major stock photography agencies were in New York, today they exist in all parts of the United States, and there are many such agencies springing up throughout Europe and Japan.

There was also a time when stock photographs were treated with cavalier

disdain by magazine editors and purchasers of photography. Existing photographs had a lesser value than photographs taken on assignment. I can still hear that constant refrain emanating from clients on the other end of the telephone line as the bargaining process began: "But it's only a stock photograph. We don't pay regular rates for pictures that we pick up." Never mind that the reason they are using the picture is that it fits perfectly as an illustration for their story. Never mind that the stock picture had to be archived, stored, researched, and retrieved upon request. Never mind that the picture may have been taken in the farthest and least-accessible corner of the world at considerable expense. Never mind that it may have been a picture of great historical significance. Stock pictures were viewed as second-class photographs. But that is no longer true. Agencies' resistance to lowering their rates plus clients' recognition of the inherent value of existing photographs have combined to give greater respectability to the stock photograph. Newer methods of handling and promoting stock photographs, the development of stock photography catalogs at great expense, and the use of video disks to bring stock photography collections to clients have brought greater ease of access to and increased the value of stock photography.

The Image Bank and Comstock are the two largest stock photography agencies in the United States, both primarily serving the commercial advertising photography marketplace, which is, of course, the most lucrative area of stock photography. The Image Bank stresses their interest in "photographers who can consistently supply us with both artistically and technically superb images." They require a five-year contract for exclusive worldwide stock representation. They market the work of photographers through a network of fifty-eight locations around the world.

A talk with Henry Scanlon, who along with photographer Tom Grill founded Comstock, has given me insight into a stock photographic agency that in 1975 ventured into virtually uncharted waters by bringing direct-marketing techniques to the sale of photographs and in 1990 advanced the business through state-of-the-art computerization.

Forty-four-year-old Scanlon likes to think of himself as the "Nostradamus of stock photography." That characterization refers both to the vision that drove Comstock to become one of the biggest stock agencies in the world and to a seemingly heretical 1980 prediction that has become reality in the 1990s. He correctly forecast, "The day is coming when to be a professional photographer, it will be absolutely imperative that stock photography be a component to your career. The day is coming when you will not be able to be a strictly assignment photographer."

"Stock photography has become so important," continues Scanlon, "that I have no doubt that it is taking away from assignment photography at this point. Photographers who didn't listen to me ten years ago are nervous about it and perhaps some are resentful about it. Photographers who did what was necessary to make stock photography an element in their careers are doing fine and in many cases it is the most important part of their livelihood."

Looking even further ahead in the 1990s, Scanlon predicted,

> It is going to be virtually impossible, if not absolutely impossible in the coming years, for small stock photographic agencies to survive. The tremendous expenses involved in running an agency properly is enormously complicated. Comstock is the only agency where every transparency is bar-coded. There is no way a small agency can begin to afford the expenses involved in keeping up with the technological demands. We want to find a way not to lose the creative dynamism fostered by a smaller entity and enfold that in the economics of scale generated by a large agency.

Contrary to the demands of journalistic editorial photography, which places primacy in well-composed photographs, Comstock's Henry Scanlon suggests that a good stock photograph is not necessarily perfectly composed. Rather, he argues that it is "diligently composed, sometimes deliberately off-balance." On the commercial side of photography, the photograph is merely a building block to be used by an art director. Photographs may need to have some open areas so type can be put in position. The photograph will only be part of a total message designed to sell a product.

Henry Scanlon makes the following suggestions to photographers:

1. Everything takes time. Patience is necessary. One can't expect to develop a body of work that will generate a substantial return in one or two years. Five years is probably a minimum.

2. Study the marketplace. See what kind of pictures are being used in advertisements. Look at textbooks and magazines.

3. Be responsive to changing markets. Photographic styles are always changing.

4. Numbers and quality are the two most important words in stock photography. Your pictures have to be technically perfect and should not be designed as "art photography." You are shooting for a pragmatic audience interested in publishing pictures that are direct and without artistic affectation. The more pictures you have, the greater the opportunity for sales.

5. Concentration on a specific area or subject matter will enhance your salability. Develop a reputation for a certain kind of photograph or a specialization in a certain subject matter. It might be science, animals, the sea, sports,

rock musicians, authors, children, babies, teenagers, the elderly or any number of other categories that might interest you.

6. Be honest with yourself. Self-delusion about your photographs is a sure road to disaster. Don't be upset or put off by criticism from people in the stock photography business. They know what their clients want and need.

7. Get model releases whenever you can. Model releases expand the horizon for potential sales of your people photographs. Without them, your sales are limited to editorial publications at modest editorial prices. Model released pictures can be sold for commercial purposes (i.e., corporate brochures and advertising), which bring much higher prices.

8. Technical skills are a given. The most important factor in one's career development is the development of the mind. Become a well-rounded person, a curious person, a good communicator.

The Importance of Being Earnest about Model Releases

Model-released stock pictures are significantly more valuable than unreleased pictures. For agencies concentrating their sales effort in the commercial advertising area, model releases are an imperative. Stock photography agencies know that big bucks reside in advertising and the general commercial (as opposed to editorial) outlets and increasingly demand that all photographers provide released photographs.

Getting model releases is not an easy task. For the editorial or journalistic photographer producing pictures on assignment for magazines or newspapers, it is almost an impossibility. When covering news events, demonstrations, or doing spontaneous street photography, photographers have to be responsive to found moments. The photographer cannot make photographic decisions based on the availability of releases, or ruin a situation by stopping and asking people if they would be willing to sign a release before they are photographed in interesting natural and ongoing moments.

Legally, the use of non-released pictures is limited to editorial use in a newsworthy story of public interest or when dealing with an educational or informative article. This means that for all practical purposes, model-released photographs are preconceived, planned, manufactured pictures. This also means that unless the photographer is very skillful in posing pictures and directing people, the resulting photographs will have a commercial, undocumentary, artificial look. Setting up pictures goes against my personal journalistic photography aesthetic, but it is what one must do to succeed in selling photographs to the commercial market.

I think it is possible to make these model-released pictures and still retain a natural quality in which the subjects have dynamic body language and look realistic and spontaneous. I remember a photographer many years ago who did many editorial stories based around subject matter with his own family. They were all artificially created ideas developed in the photographer's mind, but the situations were photographed and directed in such a way that it would be impossible for the unsuspecting viewer to know that the pictures were anything but real moments caught by an intuitive and responsive photographer. This kind of fictionalizing, though unacceptable in pure journalistic photography, has merit in making pictures for illustrative purposes.

Advice about the Photography Business

I have always supported the theory that a photographer or agency is not in business for a day. They are in business for a lifetime. Leaving behind a trail of embittered clients who feel exploited is no way to build a relationship. This is not to suggest that the photographer should not insist on protecting his or her respective interests and property. It is to suggest that those interests should be balanced by proper ethical business behavior.

The photographer should always identify in writing the rights being purchased in a particular transaction. It seems simplistic to suggest that one should be very careful in clarifying this with the client, but in fact, many times there are great misunderstandings that arise because the parties to the transaction have not been precise in their articulation of rights. Delivery memos should cover the following information:

1. It should be noted that black-and-white prints or transparencies are supplied on a one-time-use basis only, unless otherwise negotiated, and that prints and transparencies must be returned after use. Usually, a specific time period is placed on the retention of the photographs, after which a holding fee should be applicable.

2. Most photographic agencies impose a research fee or service charge when responding to a request. Some agencies consider this fee to be applicable against purchases made from the submission. Others consider it a non-refundable, non-deductible charge that will compensate the agency for the labor-intensive efforts involved in every transaction. Few clients realize the details involved in maintaining a library and the elements that go into every transaction justify this fee. If your business requires that you charge a research fee, be sure you are clear about it up front.

3. A categorical imperative for the photographer or agency submitting pho-

tographs is a statement reflecting the amount of liquidated damages that will be applicable in case transparencies or black-and-white prints are lost, damaged, or stolen. In the case of black-and-white prints, the costs are minimal because the original negative is generally available, but that is not always the case. Still, the effort involved in making a replacement print—the pulling of the negative, the making of the print and all the inherent detail work—is costly by today's standards.

The big problem arises when color transparencies are lost. In 1993, the general applicable standard for liquidated damages for lost transparencies was $1,500 per transparency. Cost is based on the recommendation of the American Society of Media Photographers (ASMP). While recent court decisions have determined that not every transparency is worth as much as $1,500, and many transparencies are worth more than $1,500, that figure terrifies many picture editors and causes not a few white nights when transparencies have been misplaced.

4. Credit lines are photographers' professional life's blood. Photographers or agencies making submissions to clients should insist on credit lines unless permission to omit them is otherwise granted. Most agencies will have a clause in their delivery notes making the client liable for double the ordinary fee when a credit line is omitted or erroneous.

5. It is wise to submit a duplicate copy of the delivery note to the client requesting a signature acknowledging receipt of the material. Should any difficulties arise related to the transaction, you will need that documentation to support any claims you might make for lost or damaged transparencies or prints.

6. Problems involving the use of pictures out of the original context also fall into the "sleepless nights" category. Fortunately, in my experience it is rare for clients to deliberately use pictures in a manner that compromises the agency or the photographers whose pictures are represented.

But a clause about model releases and out-of-context uses of photographs is of greatest import. The photographer should have a clause saying,

> Unless otherwise specifically indicated, transparencies are not model or subject matter released. Therefore, unless otherwise indicated, transparencies are available for normal and generally accepted editorial purposes. By accepting delivery of transparencies, recipient agrees it will not use them unless appropriate releases are received or indicated below, use the transparencies or prints in any way which would give rise to a cause of action by persons identifiable in the transparencies or prints or by persons owning property or identifiable in the photographs.

Pricing Your Stock Photographs

The value of a stock photograph is based on its use. Photographs sold for advertising or commercial purposes are worth considerably more than photographs sold for editorial use to magazines or book publishers. The logic for that differential is indisputable. Just as advertising rates vary according to circulation, the price must always be negotiated based on the number of insertions, the circulation of the publications, the size of the photograph, and other considerations based on the evaluation by the photographer or agency of the uniqueness of the imagery.

Don't sell your photography short! Potential clients have an underlying philosophy that their obligation is to get your photographs as cheaply as possible. Your obligation to yourself as a photographer and to your profession in general is to maintain a standard of pricing that assures you a fair return for the work you are selling.

Hiroyuki Matsumoto—The Samurai Stock Photographer

When years ago I jokingly called Hiroyuki Matsumoto, a Black Star contributor, the "Samurai Photographer," little did I know that that appellation went to the soul of his personality, the philosophy of his life, and the substance of his photographic work. In traditional Japanese culture, the Samurai are an outgrowth of the Ronim, a group characterized as wandering cowboys, lordless and independent spirits with a tradition of hard work.

Matsumoto is indeed the paradigm of a free spirit, who rejects assignment photography and pursues his own course exclusively in stock photography. This approach nets him well over $100,000 a year. It provides him with a peregrinating lifestyle as he charts out new areas of the world to visit and photograph. "This kind of job," says Matsumoto, "doesn't allow for marriage. I'm always on the go. Sometimes I am very lonesome, but I have my Nikon F2 to which I am married, so I am very happy. My travels give me personal pleasure to see new places, new people, new things—never getting old."

Recently Matsumoto had just returned from a forty-seven day trip, on which he visited Australia, China, Japan, and California, a trip that cost about $10,000 for transportation, hotels, food, and 250 rolls of film. The trip was longer than most; Matsumoto generally limits expeditions to thirty days, claiming that beyond that he "loses concentration." He stays at first-class hotels so as to have the best views of the cities. He negotiates press rates for his accommodations.

A native of Chiba City prefecture, a suburb of Tokyo, 47-year-old Hiroyuki Matsumoto characterizes himself as a former Japanese hippie who roamed Europe in the sixties. He came to the United States in 1971 when somebody told him that "money grows on trees" over here. He worked hard and saved money even in jobs as a dishwasher or waiter in a restaurant, and bought a 35mm Minolta camera at a 40-percent discount. He is a completely self-taught photographer. He bought magazines and studied the work of published and successful photographers. His guiding philosophy was "steal from the best." He remembers those days of poverty, commenting that "poor is very bad. No money, no sleep, no girlfriends—eventually your heart is very poor."

Somebody suggested that he might do a story on Harlem. So he rented a small apartment there and attempted an essay on "Harlem as Seen by a Japanese Photographer." "No problems," he recalls, "I smile, very friendly, and I walk fast, so I am not afraid." His lack of success in the syndication of that story convinced him that pure photojournalism takes too much time and doesn't allow the photographer to make enough money.

Matsumoto's ultimate success is instead related to his love affair with New York City. To this day, 80 percent of his income is generated by sales of his New York pictures in three countries—Germany, Japan, and the United States. One picture of the Manhattan skyline photographed from Brooklyn Heights has sold sixty-six times. He attributes the extraordinary sales of his New York pictures to his filtered special effects, suggesting that "straight shots can't make money." He considers New York unique and visually exciting. His pictures show every facet of the city, including not only the great landmarks, but also the people—the children, the businessmen, and every aspect of its vitality. He hopes some day that this body of work will produce an exhibit and a book.

Matsumoto is a photographer with no artistic pretensions; he has great inner strength and confidence as he follows his own independent course. He suggests that his concentration on New York has been important to his career, believing that young photographers choosing the same path would do well to focus their energies on a basic single subject. And above all, he says, "Work like me. I work very hard day and night, before dawn to after dusk. When I am working I have no time to eat. I wait for good light, good timing."

ALL ASPECTS OF FULFILLMENT

The Evolution of Your
Career in Photojournalism

Twenty-Nine Careers
in Photojournalism

Another solution is to look into any young photographer and ask: are any of his pictures as good or better than Edward Weston, Walker Evans, or whoever? The material is out there for anyone to use. Everything in the world has been photographed a few million times and it does not stop.

At this time in the history of photography, everything has been done. All the novelties have been done; yet the pseudo-critics ask for more pseudo-originality. All we have to look for now is, as a picture, does it move my heartstrings? If it does, why should I condemn it because it happens to look like something Weston did?

Few young people have the power, but every once in a while, one does come through with as much power as Weston had. It is the nourishment value of the image that matters.

Minor White, *Interviews with Master Photographers*

In five decades of association with photographers, I have met thousands. As a picture agent I regularly saw the portfolios of approximately five hundred photographers yearly. For pragmatic and instructive reasons, I would like to introduce you to some of the fascinating photographers I have known.

The people you will meet are not all Black Star photographers. They are famous, unknown or in-between, but there is something about each of them that helps us to learn from their failures and successes. Many of them have been discussed in other parts of this book—people like Emil Schulthess. For the most part, in this chapter I have included photographers whose careers teach us lessons.

The photographers I have known defy categories and stereotypes. The genus

"homo photojournalisticus" is, however, a special breed. They are the most sensitive, dogmatic, insecure, egotistical, flamboyant, maddening, and wonderful people you could imagine meeting. They have been my life.

W. Eugene Smith

On my first day at Black Star in 1940, my job was to assist W. Eugene Smith on a McGraw-Hill promotion assignment. Ironically, the great documentarian we have come to know was shooting nine setup studio photographs replete with models. My job was to replace the flashbulbs on three of the four synchronized flash extensions used for every exposure. Smith hand-held the fourth extension alongside the camera; from this he triggered the simultaneous shutter release and set off the flashbulbs.

The constraints of time demanded that I be fleet-footed in my circum-navigation of the studio to change the flashbulbs after each exposure. Unfortunately, my fleetness of foot far exceeded my deftness of movement, for during the second setup I bumped into Smith's tripod, sending his camera crashing to the floor. He accepted this seeming disaster with graciousness and proceeded to photograph for several hours until the job was completed.

Then as he kicked over everything in the studio, I came to know first-hand the volatility of W. Eugene Smith. "What's the matter, Mr. Smith?" I innocently asked. "I don't know if I have a god-damned picture from the time you kicked over the tripod!" he replied. "I preferred to use my Ikoflex in lieu of another camera and I don't know if the lens was damaged when you knocked over the tripod."

The reader will be pleased to know that the pictures turned out well and so did the Chapnick-Smith relationship. He has been integral to my life in photography, and to this day my efforts on behalf of the W. Eugene Smith Memorial Fund are a personal tribute to this remarkable photographic storyteller.

There are those who characterize Gene Smith as a saint who was constantly martyred at the hands of short-sighted photojournalistic powers. It is not so simple. Nothing can ever be reduced to such black-and-white absolutes. The legend of W. Eugene Smith is based on fact, embellished by sycophants, and fed by our need for heroes. Gene Smith fought injustice in the real world and in the magazine world as he saw it.

If there had been no *LIFE* magazine to battle, Gene would have created one. Struggle against the powerful and the privileged was as much a necessity to W. Eugene Smith as the film he used in his camera. He was at once the supreme egotist, the supreme craftsman, and the supreme idealist. He took

himself and his work so seriously that everything became expendable—fortune, family, and children included—in pursuit of his vision of himself as a photographic artist.

Yet even stripped of the patina of legend, the legacy of W. Eugene Smith still remains: his is an awesome body of work that inspires countless photographers worldwide. He taught us about storytelling in pictures, about structure and coherence in a photographic essay, about art and humanism in photography. Smith's work represents the intensity of passionate and compassionate photojournalism. It is filled with tenderness and anger, with affirmation of life and impatience with needless death. As such it continues in the traditions of the great social documentarians.

In his prologue to *Minamata,* his book on mercury poisoning in Japan, Smith said,

> This is not an objective book. The first word I would remove from the folklore of journalism is the word "objective." That would be a giant step toward truth in the free press. And perhaps "free" should be the second word removed. Freed of these two distortions, the journalist and photographer could get to his real responsibilities. My belief is that my responsibilities within journalism are two. . . . My first responsibility is to my readers. I believe that if I fulfill that responsibility, I will have automatically fulfilled my responsibility to the magazine.
>
> Photography is a small voice at best, but sometimes—just sometimes—one photograph or a group of them can lure our senses to awareness. Much depends upon the viewer; in some, photographs can summon enough emotion to be a catalyst to thought. Someone—or perhaps many—among us may be influenced to heed reason, to find a way to right that which is wrong, and may even be inspired to the dedication needed to search for the cure to an illness.

Le Grand Charles—Charles Bonnay

In contemporary photographic folklore, there exists the stereotypical character of the fearless, globe-trotting photojournalist. Handsome, charming, a bon vivant with a cigarette dangling from his lips, he electrifies every room he enters with his own "war stories." He is a character straight out of a Hemingway novel: brash, self-confident, and macho.

This character may have been born in fiction, but Charles Bonnay came very close to personifying this picture of the devil-may-care photojournalist. Bonnay knew no fear. No story was impossible, no exploit too daring. Bonnay spent decades courting death in pursuit of his assignments. He told amazing

stories about each narrow escape, but unlike Robert Capa and others, Bonnay was not a victim of a war he was covering. Ironically, after a lifetime of derring-do, Bonnay died in April 1986, of leukemia only five days after learning of his illness. His exposure to radiation during his coverage of the first French atomic bomb tests in the Pacific may have killed him.

Many of you may not have heard of Bonnay—or "Le Grand Charles," as his friends called him. That sobriquet was usually reserved for Charles de Gaulle, another Frenchman who lived on a grand scale. But while General de Gaulle was haughty and autocratic, our Charles was gentle and warm. Bonnay's courtly manner and omnipresent smile belied the inner toughness that enabled him to survive his exploits.

Bonnay failed as magnificently as he did everything else, and there was always an unbelievable story to accompany each failure. But more often, he succeeded. That meant beautiful spreads in the world's great news magazines, such as *LIFE, Paris Match,* and *Stern.* To him, those pictures were worth venturing next door to death.

Born in Paris in the 1930s, Bonnay's early life and schooling were dictated by World War II. At school in Paris, he was a practical dreamer, studying both electrical engineering and motion picture directing. Bonnay, it seems, wanted to be a film director—but the war effort demanded technical skills.

In 1951, France was preoccupied with its colonial problems in Indo-China. Bonnay was drafted and sent to Vietnam as a French Army combat film photographer. Tired of dragging around heavy movie equipment, he turned to still photography. A paratrooper as well as a photographer, Bonnay parachuted into Dien Bien Phu in 1953 to photograph the French capture of that city in France's ill-fated attempt to defeat the Vietnamese insurrection. In 1954, Bonnay left the army and became a free-lance still photographer working for advertising and public relations firms. Soon he was working for *Paris Match* and Black Star.

Editor Sean Callahan tells an apocryphal tale about how Bonnay began working for *Paris Match.* The picture editor supposedly asked Bonnay, "Why should we use you instead of other photographers? What special qualities do you have to offer?" Without a word, Bonnay opened the window of the second-floor office and jumped out. When he bounded back upstairs from the street a few minutes later, the editor hired him on the spot. Even if Bonnay's photographic ability hadn't been proven, the editor was at the very least convinced of the Frenchman's courage, flair, and impetuousness.

Bonnay used his talents as parachutist and photojournalist more than once as Le Grand Charles. In 1961, the world was excited by the hijacking of the

Portuguese ship the *Santa Maria* in the Atlantic. Bonnay rented a creaky cargo plane and parachuted barefoot into the water alongside the *Santa Maria*, hoping that he would be taken aboard the ship.

Bonnay was quick to correct the story that he had hoped to land on the deck of the ship. According to *Time* writer Sam Angeloff, who interviewed him in 1966, Bonnay explained: "I was barefoot and there was such a wind. A man would have to be crazy to jump onto a ship like that!" Using a borrowed Brazilian Army parachute—which he had repaired with Scotch tape just minutes before—Bonnay landed beside the boat, his camera bag tied to his knees. He later said he found it hard to understand "why I didn't drown in the boiling waters." Flailing around in the waves, Bonnay waited patiently to be rescued by the *Santa Maria's* crew. But his plan was foiled when a United States destroyer rushed to his side. The crew had to drag the wet Frenchman aboard.

"Those damn guys." said Bonnay. "They wanted to charge me for 45 minutes of destroyer rent. So I told them I'd sue them for keeping the *Santa Maria* from picking me up. I could have made some wonderful pictures."

Bonnay made his most famous parachute jump in 1961 when he and two other Frenchmen landed on top of Mont Blanc in the French Alps. In retrospect, he said it was one stunt he would not repeat. As Bonnay told the story,

> The drop zone was a triangle about 30 meters on each side. There was wind. When I pulled the ripcord, I was sure that the chute had not opened. But I looked up and it was open full. The air was so thin up there, it was as if I was a rock. We plummeted straight down.
>
> If we hadn't hit the drop zone, there wasn't anything else to hit. On the Italian side there were lots of rocks. On the French side there was a big slippery rock which extended for two thousand meters, and all you would have found at the bottom would have been my bones.

Miraculously, Bonnay and his two friends hit the ground safely. The publication of Bonnay's photographs earned the trio international fame.

Much of Bonnay's most memorable work came from his coverage of the Vietnam War. He arrived there in 1963 in time for the American-supported coup against South Vietnam's President Diem. His photographs of that country for *LIFE* are among his best-known work. Bonnay made several trips to Vietnam during the war and estimated that he spent a total of four years of his career covering it.

In 1972, *LIFE* went out of business, and Bonnay's career slowed down for the next decade. He rented an island in Tahiti for next to nothing and left his active life as a photojournalist for one of peaceful isolation. During those ten

years, Bonnay's only excitement was an occasional visit to the mainland to play chess—another game at which he was an expert.

Whatever inspired Bonnay's return to photojournalism in 1981 is open to question. Was it another case of the "action junkie" syndrome? When Bonnay arrived in California that year, most of the journalistic action was in Central America. He drove straight from California to El Salvador. With the help of *Time*'s picture editor, Arnold Drapkin, and JB Pictures' Jocelyn Benzakin, he established a second career covering the unpredictable Central American political scene.

Benzakin's small, dynamic picture agency and her personalized approach were ideal for the rejuvenated Bonnay, and he quickly became JB Pictures' star photographer. Benzakin remembers him with unabashed affection and admiration.

"Charles was always willing to help other photographers, particularly young photographers to whom he imparted his knowledge of war and the strategies of war," she says. "He never had an ego problem. Most times he never cared to see his pictures. The event, the adventure, was more important to him than seeing his work."

Arnold Drapkin became his biggest booster in the last two and a half years of Bonnay's life, during which time 90 percent of his work was published in *Time*. Drapkin says,

> I was amazed that after a ten year hiatus he was able to come back to photography without missing a beat. His pictures were good right from the start.
>
> I always found it difficult to reconcile the presence of this quiet, gentle and extraordinarily polite man with the visualization of him in the jungle with the Contras, or jumping out of airplanes.
>
> I had to overcome the objections of the *Time* bureau chief and a writer about going out on dangerous assignments with that "crazy Frenchman." They later attested to the fact that I could not have put them with anyone more experienced or more careful in a high-risk business—or one less likely to get anyone into trouble. He knew how to take care of himself and the people with him.

Although death came unexpectedly to Le Grand Charles, he was ready. There was no fear and no self-pity. The world of photojournalism misses this extraordinary gentleman.

Gordon Parks

Gordon Parks stands out as the African American photographer who has achieved the greatest recognition in photojournalism. His "firsts" are impres-

sive. First Julius Rosenwald Fellowship in Photography, first and only black photographer to work for Roy Stryker's Farm Security Administration group, and first black staff photographer at *LIFE* magazine.

Parks, born in 1913, recently said, "I've long since learned there's no such thing as not being able to do something you really want to try." He is truly a Renaissance man who has extended his horizons beyond being a lionized and recognized photojournalist. From his earliest jobs as a railroad porter, short-order cook, and piano player in a bordello, he has gone on to become a still photographer, writer, composer, and film director. During the twenty years he worked as a *LIFE* staffer, he produced more than three hundred stories, most notably a story on a Harlem gang leader in 1948 and the 1961 profile of a dying Brazilian slum child named Flavio, which precipitated a successful campaign to bring Flavio to the United States for medical treatment. By virtue of his forceful personality and his diverse interests, he was able to convince the editors not to restrict his assignments to covering stories in the black community. He is well known for his Paris fashion pictures made in 1949, the first year he was on the *LIFE* staff.

During the 1960s, his interest in the civil rights struggle led him to shoot stories on the Black Panthers, the Muslims, Stokely Carmichael, and Malcolm X for *LIFE* magazine. Being black and a famous *LIFE* photographer was certainly to his advantage in gaining access to these subjects. During this time he began not only to photograph, but also to write stories. He has written two autobiographical books, *A Choice of Weapons* and *The Learning Tree* and several volumes of poetry and fiction. In 1969, he produced, directed, scripted and scored *The Learning Tree* and became Hollywood's first black director at a major studio. His subsequent screen credits include two *Shaft* films and *Leadbelly.*

Roy Stryker was apprehensive about taking Parks on the FSA staff. According to Parks, Stryker told him, "We have an all white Southern lab staff who hate photographers in general and they'll hate you as a black three times as much." (Ironically, when the FSA unit was breaking up, that same lab staff gave a dinner for Parks, the only photographer to be so recognized.) But Parks persevered and says today that "it was a great group of photographers to work with and learn from. I learned a lot from Stryker. He wasn't a photographer himself but he knew which way the camera should be pointed. He made me look at the camera as a very purposeful instrument. And it became our minds, it became the weapon to speak against anything we disliked in the world in fact."

Carl Mydans

Carl Mydans is one of the outstanding photojournalists of the twentieth century. I met him sometime in the 1960s when we both served as witnesses at the swearing in of Yukiko Launois, the long-time Black Star photo editor, as an American citizen. Although I knew him as an important *LIFE* photographer, my distinct and lasting impression of him has always been that of a diminutive, elegant, erudite, and enthusiastic photographer. Our paths hardly crossed after that until the 1980s, when he began to distribute some of his photographs through Black Star.

I never realized what a giant in twentieth-century photojournalism Carl Mydans had become until I saw a copy of his book, *Carl Mydans, Photojournalist.* Here was a compilation of images that recorded such historic moments as General MacArthur's return to the Philippines and the Japanese surrender on board the *USS Missouri* in 1945. A more-than-fifty-year career is reflected in his pictures of America taken in the 1930s while Mydans was a member of the Farm Security Administration staff under Roy Stryker, World War II in Europe and Asia, the aftermath of the war in Japan, the Korean War, the war in Vietnam, and a miscellaneous collection of personality portraits of some of the eminent figures of our time.

Carl Mydans is not a one-dimensional photojournalist. He writes as well as photographs. In his eighties, he continues to photograph with the same enthusiasm and verve as when he started at *LIFE* as one of its earliest staff photographers. His philosophy about photojournalism is best summed up in the introduction to his book when he says, "From my earliest years I have been fascinated by human behavior. By the time I used a camera seriously, I had become an obsessive people-watcher, observing mannerisms and body-postures, the slants and curves of mouths, the falseness of smiles, the directness and evasions of eyes. When I learned to understand these signals and interpret them, I had found a source of stories as wide and as varied and as captivating as the human race."

Overcoming Physical Handicaps: Lowell Handler and Bruce Thorson

Over the years I have known many of photography's most glamorous stars. Perhaps the most inspiring photojournalists I have met are Lowell Handler and Bruce Thorson, both of whom happen to be disabled, and neither of whom is a household name. For them, talent and dedication are not enough. Through sheer will-power, Handler and Thorson have managed to overcome their dis-

abilities in a profession that presents new and sometimes intimidating challenges every day.

Handler is a victim of a little-known nervous disorder called Tourette's Syndrome, named after the nineteenth-century French doctor, Gilles de la Tourette, who discovered the disease. The syndrome results from an imbalance of dopamine in the neurotransmitters that relay messages to the brain, causing occasional lack of control, such as sporadic, involuntary jerking of the body and loud shrieks.

"A lot of the people I've met who have the syndrome have secluded themselves from the rest of the world," says Handler. "It's natural—nobody knows what Tourette's is. All they know is what they see when they look at you." Although Handler found it difficult to talk about his disease while growing up, he never gave up his dream of becoming a photographer. After receiving his first camera at age thirteen, he says, "Photography was the only profession I ever considered." He realized that he would have to come to terms with his illness. "It's therapeutic to confront the situation," he says. "I am now at ease in my professional life because I am open about the situation."

Handler works mainly on corporate annual reports and non-profit agency brochures, but he also has done magazine work. He is especially proud of a story subsidized by *LIFE* magazine about the life of Dr. Orrin Palmer, a Mount Sinai Hospital doctor also afflicted with Tourette's Syndrome. "Often a handicap can be a new beginning," says Handler. "I think that having the syndrome gives me a greater sensitivity for doing people stories."

Handler occasionally experiences spasms while behind the camera. "I frequently have to shoot pictures with many people involved," he says. "The atmosphere produces stress, and the symptoms are more rampant under stressful conditions. So the first thing I do on any assignment is explain my disease. Most people are very understanding."

In 1990, two events came together to change Handler's life and mitigate the Tourette's manifestations. Dr. Palmer, who had become a psychiatrist after his Mount Sinai residency, told Handler that he was taking the miracle drug of the 1990s, Prozac. This drug generally prescribed as an antidepressant, seemed to also have an impact on obsessive-compulsive disorders or symptoms of such. Coincidentally, *Newsweek* magazine ran a cover story on Prozac. Dr. Palmer suggested that Handler might want to try it. He did. Since then, one pill a day has had a profound and positive effect. Handler's involuntary spasms and outbursts are now minimal. In retrospect, Handler no longer sees himself as a handicapped photographer but as a mainstream photographer. And I continue to admire the guts and good sense that enabled

him to overcome an obstacle that intruded between him and his subjects during much of his working career.

Like Handler, Bruce Thorson views his disability not as an obstacle to his career, but as a motivating force. A staff member of the *Statesman Journal* of Salem, Oregon, Thorson is a one-armed photographer—and a good one. When Thorson was a teenager, his right arm was severed by a telephone pole's support wire when he was involved in a motorcycle accident on a rural California highway. In place of the limb, he wears a prosthesis with a hook that he deftly manipulates. On the job he fits his hook into a grooved block of wood that screws into the bottom of the camera to hold it securely. Thorson has also designed special equipment for shooting with longer lenses, including switches that plug into the camera's motor drive and attach to the lens focusing ring.

Thorson studied journalism at the University of Oregon and taught himself how to process and print black-and-white film. He has worked as a photographer at various newspapers throughout Oregon since 1981. Thorson once functioned as a one-man photo department at the *Daily Tidings* in Ashland, taking pictures, developing and printing his film, and editing his own work—a job many two-handed photographers might have found difficult. "You have to decide that the disability isn't going to destroy your life," he says. "I haven't found anything I can't do. I know of photographers with two hands who can't shoot sports as well as I can."

These two photographers, each with a different disability, inspire others with their determination in the face of physical obstacles. "I'm proud that I can practice photography. I just want to be the best shooter I can be," says Thorson. Handler is also optimistic about his career. "I use photography to interpret the jigsaw puzzle of a world," he says. "I can only look forward to doing more work and doing it better."

Photographers Explore the Surreal and the Bizarre: Diane Arbus and Alfred Gescheidt

Photojournalism and documentary photography is most often identified as related to contemporary events, social issues, and press photography. But photojournalism accommodates multiple disciplines, philosophies and approaches. There is a coterie of photographers like Diane Arbus who have explored people's innermost psychological worlds with disturbing but unforgettable photographs.

Diane Arbus has become a cult figure based on her calculated effort to infiltrate and capture the persona of the weird, the bizarre and the aberrant.

Unlike the press photojournalist, who aims to capture unplanned moments, Diane Arbus admitted to ingratiating herself into the world of the strange, unfamiliar, and peculiar almost as if she was using her camera to get inside her subjects' skin. Her pictures were posed and managed with no attempt to create spontaneity, but rather were intended to record the "flaws" she observed in people.

Arbus became categorized as a photographer of freaks. "Freaks were a thing I photographed a lot," she said.

> It was one of the first things I photographed and it had a kind of excitement for me. I just used to adore them. I still do adore some of them. I don't quite mean they're my best friends but they made me feel a mixture of shame and awe. There's a quality of legend about freaks. Like a person in a fairy tale who stops you and demands that you answer a riddle. Most people go through life dreading they'll have a traumatic experience. Freaks were born with their trauma. They've already passed their test in life. They're aristocrats.

I hesitate to classify and pigeonhole photographers. But, clearly, there are photographers skirting the edges of photojournalism who have explored private worlds, netherworlds, unknown and surreal worlds. Man Ray charted those spheres in the 1920s as Magritte and Dali have done in painting. I have met and interviewed many photographers who have fished the same waters. Their work could be simply categorized as art photography, but often their pictures are used for editorial illustration of articles in magazines.

Probably my favorite photographer in this genre is Alfred Gescheidt, with whom I have shared an off-again on-again professional relationship through the years. Although Man Ray used his artistic talents to explore an uncharted world of surrealistic photography before anyone else, when I compare his work to the ingenuity, madness, outrageousness, and humor present in Gescheidt's, I always think of Man Ray as a "second-class Alfred Gescheidt."

Since the early 1950s, Gescheidt has been manufacturing and combining images that are not only funny, but also have an added dimension as social commentary. Nobody—presidents, kings, or prime ministers—is sacred or protected from Gescheidt's photographic savagery. One of his favorite targets was Ronald Reagan during his presidency. Gescheidt combined President Reagan's head with Sylvester Stallone's body to produce a poster and postcard titled "Ronbo." He has replaced the enigmatic Mona Lisa head with substitutions of famous faces, and he has added incongruous elements to images of the painting. Imagine Jacqueline Kennedy or a bewhiskered cat as the Mona Lisa. Another Gescheidt series has transplanted unusual couples into the "American

Gothic" painting by Grant Wood: George Wallace and Shirley Chisholm, Nancy and Ronald Reagan.

Wild, you say? Gescheidt's inventive imagery shows a doctor using his stethoscope on a skeletonized patient; a basketball player with elongated arms reaching to the floor; and the feet of a smoker extending out from a cigarette machine as he physically attempts to extract a pack. Most remarkable is the technical quality of these photographs, which are without digital manipulation, yet so carefully printed as to make invisible his combination of multiple photographic images.

F. Carter Smith—the Hack Photographer

I often see the credit line of F. Carter Smith these days. I'll never forget his visit to me in 1978, when, as a young, shy, nervous, and slightly ill-at-ease photographer, he introduced his work to me. His portfolio of prints had been finely honed and showed competence, but it wasn't until he showed me a tearsheet from the *Houston City* magazine that my interest was piqued. It struck me then that F. Carter Smith was something special, and I wanted to know more about him. For, in order to support his beginning free-lance photographic career, he had worked four months as a cab driver.

It is not unusual for neophyte photographers to take employment in diverse occupations to support their photography. You will find them working as bartenders, waiters and waitresses, darkroom assistants, ushers, and tour guides. What was unusual about F. Carter Smith was that he used his stint as a cab driver not only to provide quick cash to pay his bills and keep himself afloat as a photographer, but also as the source of an editorial idea. His camera was always on the front seat when he drove through the streets of Houston.

"An incredible cross section of humanity passed through the doors of my cab," said Smith.

> Little old ladies, tourists, conventioneers, businessmen, waitresses, hookers, nurses, students, newcomers learning their way around Houston, topless dancers, junkies, bums, winos, homosexuals, screaming queens, security guards, airline pilots, medical patients from around the world, dishwashers, mothers, beautiful women, cashiers, factory workers, pimps, concert-goers, lecturers, doctors, hockey players, poor families, rednecks, hippies, and foreigners.
>
> When I would stop at a light, I would turn around and quickly snap the fare's picture before the person had a chance to react. I tried to catch them off guard. Of course, they all wondered what I was doing. Most were flattered and wished me success on my project. Only rarely did a fare object to having

pictures taken. And that was usually at night when I had to ask permission first because I had to use an electronic flash.

Every passenger has an idea of what a taxi driver should be like. So I played different roles, from chauffeur to shrink, tour guide to dating service, comedian to interpreter. At times I wish I were still at the wheel of the Checker. I miss the excitement and the desolation of the middle of the night, the smoky jazz over the tape deck.

Smith's short hacking career boosted his photojournalistic career. Distinctive personal experiences based on cohesive editorial ideas are a "must" for every aspiring photojournalist, whether they be achieved with or without the pressure of financial insecurity. In this business you need more than a business calling card. You need a talent calling card that will serve to draw attention to your work. F. Carter Smith had it.

The Turnley Twins

My latter-day photojournalistic life became inextricably intertwined with the careers of the irrepressible prizewinning twins, David and Peter Turnley. They have much in common. Besides being identical twins, they are both outstanding photojournalists with an interest in documenting important international news events. They are both represented by Black Star. They both have backbones of steel, which they use to get access when it seems virtually impossible. They both make full use of the telephone as both a weapon and an extension of their bodies. And they both take memorable photographs.

I first met David Turnley when, as an impulsive and enthusiastic beginner photographer, he came to New York unannounced and unknown to show a set of pictures on McClellan Street he and Peter had taken together while attending the University of Michigan in Ann Arbor. They soon attracted notice from important figures. Then, one day in 1985, David called me from Detroit. He had been discussing with the editors of the *Detroit Free Press* the possibility of his going to South Africa for a protracted period of time to cover the ongoing tensions between the black and white communities caused by apartheid. "Would you be interested in participating in such a project if the rights of resale to the photographs were available to Black Star?"

My answer was an emphatic "yes"; I recognized that seizing the opportunity to have a first-class journalistic photographer covering the events in that country would be a journalistic coup for our company. I subsequently worked out an arrangement with *Detroit Free Press* management promising financial support for the project. I remember saying to the editor with whom I negoti-

ated that "I thought it might eventually lead to a Pulitzer Prize for David and honors for the paper." I was wrong about the Pulitzer, but Turnley's South Africa coverage did bring recognition in the form of the Oskar Barnack Award from World Press Photo in 1986. (David finally did receive the Pulitzer, in 1990 for his coverage of the student uprising in China and the revolutions in Eastern Europe.) This project also led to probably the most definitive color coverage of life in South Africa during 1985 and 1986, publication of the work in magazines throughout the world, the publication of a book, *Why Are They Weeping: South Africans Under Apartheid,* and an accompanying exhibition. Turnley fleshed out his coverage under the assigned auspices of *National Geographic* magazine, which resulted in publication of a major essay in the magazine.

Since the first effort to place David Turnley's South Africa photographs internationally, Black Star has distributed the work David has produced for the newspaper. To the credit of the *Detroit Free Press* and then-assistant managing editor Randy Miller, they carved out an unprecedented role for a staff photo-journalist on an American newspaper. David Turnley, stationed in Paris, be-came a roving international news photographer, developing major projects for the newspaper and responding to major news developments throughout the world. For David, it was the answer to the frustrations of many newspaper photojournalists confined to the limitations of parochial local assignments.

Among the important events that Turnley has covered in recent years are the Armenian Earthquake of 1988, the massacre in Beijing in June 1989, and the unexpected collapse of communism in Eastern Europe in 1989. He was con-stantly in the thick of the action during the 1991 Gulf War in Jordan, Saudi Arabia, and Kuwait. His efforts have brought him great recognition, including designation as "Newspaper Photographer of the Year" in 1988, selection of his photo of "gravesite grief" in Armenia as World Press Photo of the Year in 1988, the Overseas Press Club Robert Capa Gold Medal for "outstanding courage and enterprise," and the Pulitzer Prize.

The recognition of Peter Turnley as one of the leading photojournalists in the world has coincided with David's success, although Peter developed his career differently. I will always remember Peter Turnley wearing a handmade sign reading "I'm Peter" to differentiate himself from his identical twin at the opening of David's "Why Are They Weeping" exhibition at the International Center of Photography. Peter doesn't need to bask in the reflected glory of David; he has carved his own niche. In 1990 he was awarded the important Overseas Press Club Olivier Rebbot Award for "best overseas photographic reporting in magazines and books."

It sometimes seems that there must be more than one Peter Turnley when one sees the number of Peter Turnley credit lines attached to photographs from different places around the globe. This constant peregrination is attributable to Peter's consuming desire to be wherever an important story is developing. As a contract photographer for *Newsweek,* Peter finds living and working out of Paris ideal, because Paris serves as the great jumping-off point for whenever international news events need coverage.

Peter Turnley is not only one of the hardest working photojournalists I know, he is also one of the most resourceful. Logistics is his strong point. If a story breaks, he applies his intelligence and experience, and in a very short time, he has organized his flights, procured the necessary visas, and is on his way to cover the story while less-enterprising photographers are still figuring out what to do. On the Armenian earthquake story, Peter contacted the French medical group going to Armenia to provide medical assistance and flew to Armenia on their chartered plane.

I will never forget a meeting with Peter about three years ago when we discussed the progress of his career. I opened the conversation by saying,

> Peter, you're a fine and valuable photographer to *Newsweek* and certainly your work is saleable to the international market by virtue of your responsiveness to the news. But I sometimes have the feeling that perhaps you're dancing too fast, moving from one story to the other so quickly that you do not have the time or take the time to make more memorable images. In this business, to reach the next plateau of recognition, one needs to slow down, refine, and define the visual disciplines it requires, as well as undertake a project or projects which allow you to photograph one subject in greater depth.

Peter was very receptive to the criticism, recognized its validity and took the challenge. He has now achieved international recognition, and sales of his work in the international marketplace have soared. Peter did a story for *Newsweek* on "The World's Homeless," the fourteen million people who have been rendered homeless in many countries throughout the world. The magazine backed his spending the time and money to cover the homeless in seven countries on five continents.

Above all Peter Turnley is entrepreneurial, meaning that his interest in the publication of the work he has done doesn't end with the completion of a job. He is constantly thinking of potential markets, calling editors of magazines, stimulating Black Star's editors and salespeople, and developing book ideas that utilize his material. The follow-through and subsequent follow-up are often neglected by other photographers. This entrepreneurial sense does not

diminish Peter's vision of photojournalism as having historical continuity. He sees each event he covers as one step on his journalistic stairway, cumulatively forming a global picture made during his life on earth.

David Moore

When I think about David Moore, I think of a rugged outdoor "Marlboro Man" type, square of jaw, direct of eye, powerful of frame. That physical description, however, masks a photographer of keen intellect, sometimes the formalist focusing on his architectural interest, and sometimes the photographic experimenter searching for new ways of seeing and interpreting the human condition. David Moore is my Australian connection. His work has given me greater understanding of the Australian experience and stimulated my desire to someday visit "down under," spend time among the Aborigines in the Outback, and enjoy the wonder of Lord Howe Island.

In the late 1970s, David Moore influenced and changed my rigid orthodox attitude to photographs and opened my eyes to a kind of picture that is less literal and more demanding of the viewer: photographs where the viewer is asked to do some work in order to grasp the meaning, where each element of the photograph is not neatly laid out but retains an innate ambiguity. He was the first photographer to challenge my preoccupation with content and free me to be appreciative of the opinions of Christian Caujolle and others.

David Moore has also been willing to sometimes abandon this strict constructionist and formalistic approach and venture into different ways of seeing. There are really two David Moores—the pragmatic photographer who, during his association with Black Star, was able to bring his journalistic photography to bear both on assignments for *Sports Illustrated, National Geographic, Time-Life Books* and in work for the Exxon Corporation. The other David Moore is the "art photographer," concerned with his personal vision while permitting commercialism to recede.

His career has spanned five decades, and like most other photojournalists of his era, made the transition from black-and-white photography to color. But Moore has created color photographs with the same forcefulness, human interest, and power as his black-and-white photographs. Despite his reservations that "too much color can dull the senses and full color imagery is often just too pretty for the desired emotional response," his color pictures are classics of visual discipline with full understanding of color, light and technical precision. The lesson to be learned from David Moore is that a photographer, far from the American and European markets, can maintain his local constitu-

ency, and by developing a solid relationship with a photographic agency have his interests successfully represented in the growing and important global market.

Charles Gatewood

Charles Gatewood, known for his photographs of what he calls "life on the edge," is one photographer whose photojournalistic work showed us the netherworlds of tattooing, sex clubs, body-piercing, New York night life, and Mardi Gras, reflecting the bizarre, the erotic, the forbidden. We are equally repelled and fascinated by the grotesqueries in his books, *Sidetripping* and *Forbidden Photographs.*

As a result of the reaction to his work Gatewood succeeded in becoming a cult figure in photography. Formally educated in anthropology and art history, he is a social scientist and visual anthropologist. He chose to deal with contemporary subcultures rather than with primitive groups. When he was living in New York's East Village in the 1960s, he got the idea to do a book about the changes shaping America in that period. That idea resulted in *Sidetripping,* Gatewood's word for taking a trip off the main road, not knowing what he would find on the side street. The book was rejected forty times but it was finally published ten years later by Strawberry Hill Publishing Company and became a modest publishing success.

Gatewood recognizes that he is seen by many as an immoral, weird pariah who went over the edge. "A lot of people don't agree with what I do," he says. "Some people have lost respect for me. I've lost friends. They say that I take sensational pictures for the sake of cheap sensationalism, cheap shots that are exhibitionist and exploitative. If I didn't think it was important, I wouldn't have spent so many years of my life pursuing it."

In 1985 still-photographers-turned-cinematographers Mark and Dan Jury did a film on Gatewood and his work. It was called *Dances, Sacred and Profane.* Gatewood calls it

> strong stuff. Parts are hard to look at. I bring back images that people don't want to look at, don't want to deal with. That makes them uncomfortable. It hits too close to home. "But there's more to me than photographing freaks. *Forbidden Photographs* was a personal odyssey, the resolution of a personal crisis through which I was going in the 1970s. I was drawn to a world where people are taking life to the limit—going too far into forbidden territories. . . . This was a catharsis, an exorcism of a lot of feelings I didn't understand.

Christopher Morris

Two of the great satisfactions in the photojournalism profession are to watch emerging photographers grow, and sometimes to participate in the process. An important stepping stone for some of the Black Star staff photographers has been Black Star's intern program, where young people often handle menial tasks in its stock library. Maintaining the library requires the stamping, filing, and often the remounting of transparencies. In addition to the regular staff, the intern program allows students to gain exposure themselves to a photographic agency, learning different aspects of the business and seeing the work of important photojournalists. It also affords interns the opportunity to get critiques of their work and occasionally to fill in as photographers at news events.

Christopher Morris came to Black Star as a part-time intern during his studies at New York's International Center of Photography. His primary interest at the time was in art photography rather than in journalistic photography, but he was soon caught up in the excitement of photojournalism. After his stint in the Black Star library, Morris began working as a stringer photographer in New York.

Knowing the youthful Morris, one would hardly have expected this quiet, gentle man to become a photojournalist intent on covering international conflagrations as they erupted. I observed his steady progression from 1983 and 1984 when he first went to photograph anti-nuclear demonstrations in what was West Germany and took the first of many trips to the Philippines. The Philippine trips led to his making important pictures during the impromptu Philippine elections in 1986 that led to the overthrow of the Marcos government and the ascension to power of Corazon Aquino.

In 1989, Morris was in Eastern Europe covering the fall of the Berlin Wall and the Czechoslovakian revolution; in Asia covering Afghanistan; in South and Central America covering drug-related violence in Medellin, Colombia, and the invasion of Panama. His coverage of a dramatic fire fight during the Panama invasion won international recognition. Now a contract photographer for *Time* magazine after only eight short years as an active photojournalist, Morris is assured of being one of the *Time* team of photographers wherever there's a trouble spot. His coverage of the Gulf War, despite the pool limitations, produced some of the most striking pictures of that conflict.

My friend, Chris Morris, takes many chances in his single-minded, dogged, persistence in the face of danger. I always left him with the admonition to "take care," but somehow he is always in the hottest places where the action is

highest and the danger is greatest. In Chile, where photographers became a target for the enthusiastic supporters of General Pinochet during the plebiscite, Chris Morris was severely beaten. It was only through the intercession and assistance of a colleague, Sipa photographer Wesley Boxce, that he was able to escape a more disastrous result.

During the Gulf War in 1991, Chris was one of the forty journalists and photojournalists captured by the Iraqis, taken to Baghdad, and incarcerated for several days before being released. He received the 1991 Olivier Rebbot Award of the Overseas Press Club for "best photographic reporting in magazines and books" during the year 1990, primarily for his work covering the London Poll Tax riots and the war in Liberia. Since that time, he has been preoccupied with the dismemberment of Yugoslavia, having made more than a dozen trips to that war-torn country.

Chris Morris has shown us the value of exposing ourselves to many disciplines in photography before settling on a direction. His early predilection for art photography was replaced by a preference for news photojournalism once he experienced the excitement and satisfaction that come from being an interpreter of the world scene.

Brian Lanker

My professional association with Brian Lanker has been very limited. I first met Lanker at a Missouri Workshop in 1974, the year after he won a Pulitzer Prize for his story on natural childbirth, which chronicled the story of a woman giving birth by the Lamaze method supported by her husband's participation in the process. It had been a project photographed over months for the *Topeka Capitol-Journal*—a straightforward, simple, everyday story of birth that recorded in moving and emotional pictures the shared birth experience of a Topeka couple.

I often heard Rich Clarkson, Lanker's admiring boss in Topeka, less than gently prod Lanker by saying, "Brian is the most naturally talented photographer. If only he'd use it." Over the years that have elapsed since then, Lanker has surely used that talent. Today he is considered one of the premier photojournalists and image-makers of the world, most recently acclaimed for his book and exhibition project *I Dream a World*. For that project, Brian photographed and interviewed seventy-six African American women activists of the civil rights and women's movements who had not been included in the history books.

Before becoming a magazine freelancer, Lanker paid his dues in newspaper

photojournalism. After leaving Topeka, he became graphics director of the *Eugene Register Guard.* Through the years, Lanker has proved that being considered a "prima donna" because of his transcendent concern for how his pictures are used is a small price to pay for perfection. Lanker is a many-sided professional. He conceptualizes ideas; he photographs with visual discipline and simplicity; he gets close to his subjects; he has great concentration; he does outstanding interviews; and his graphic taste is impeccable. He becomes for any client a sextuple-threat journalist.

Dennis Brack

The hardest working photographer I have ever known is Dennis Brack, who for more than three decades has covered the Washington, D.C., beat for Black Star. Dennis is the consummate professional, perfect for the Washington scene because he brings to his work a knowledge of the political scene, a sense of ethical propriety, respect of his colleagues in a competitive situation, and a thoroughgoing understanding of the intricate complexities of gaining access to important U.S. politicos.

If a motion picture is ever made about President George Bush, Dennis Brack would be perfectly cast to impersonate the President. He looks like George Bush, talks like him, has the body language of Bush, and presents the same Ivy League persona. Brack has helped to establish Black Star's credibility in the nation's capital, and by his manner, actions, and journalistic responsibility, he has heightened the visibility and prestige of the agency in Washington, D.C.

Brack has accompanied every president since Lyndon Johnson on summit meetings and international trips of the presidency. Inevitably, on these trips, photographic coverage is limited to photographic pools. In order to be effective as a photographer for an agency or magazine, one has to understand how pools are managed. Bo Jackson may know sports things better than Dennis Brack, but Dennis Brack knows photographic pools better than anybody. Brack has consistently been depended on by Washington photojournalists to represent their community of interest in seeing that pool coverage is based on fairness rather than favoritism.

Dennis Brack is the master of the single news photograph that sums up the essence of an event. He has based his career on working day-to-day assignments, with each day bringing a new situation and a new challenge on the quixotic, frantic, ever-changing political scene. Though Brack works without a contract, *Time* magazine has relied on his professionalism, his political savvy, and his instinct for the storytelling picture through the years.

No other photographer better understands the peripheral and secondary value of every picture he takes. The secondary sales of Brack pictures produce a sizable financial return, because the subjects he concentrates on are typical of Washington life, the people are constantly in the public eye, and Brack's historical sense pushes him to photograph events destined to be important.

Most well-established, successful freelance photographers are disinclined to speculate. No assignment call—no pictures. If Brack has nothing to do on a given day, one can be sure that he will be on the hill shooting a committee hearing or making pictures of a Washington monument or photographing an important personality whose picture will be valuable in the agency's library files.

Hard work can't be taught. Dennis Brack works hard because he enjoys being in the thick of what is happening, recording it for posterity, and at the same time generating a greater financial return than less-active photographers.

James Nachtwey

No photographer has won more Robert Capa Gold Medals awarded for "outstanding courage and enterprise" than Jim Nachtwey. No photographer has ever received four designations as "Magazine Photographer of the Year" in the NPPA-University of Missouri Pictures of the Year competition. In 1993 he received the premier award in the World Press Photo competition for his picture of a mother carrying her dead child in famine-stricken Somalia.

For six years Black Star represented the work of Jim Nachtwey. Editing a set of Nachtwey pictures is a nonpareil experience. I remember how I was stunned with the power of the pictures, the impeccability of the composition, the quality of light, and the lucidity and directness of the storytelling elements. His consistently perfect exposures indicated his technical mastery over the film and cameras that he used.

Coming from the staff of the *Albuquerque Journal,* Nachtwey first ventured into international hot-spot photography in 1981 when he went to Northern Ireland during the hunger strike of Bobby Sands and fellow members of the IRA. It represented for Nachtwey "a way to break in slowly to dangerous situations." He finds "something alluring about danger. It is exciting. There's a lot of adrenalin flowing."

Nachtwey subsequently joined Magnum and has since continued to dominate international photojournalism. Photojournalism is Nachtwey's life; it may not be all-consuming, but it clearly tops his list of life's priorities. During his college career at Dartmouth, art history gave him the visual disciplines which

are so apparent in his photographs. To be an international photojournalist, covering the most dangerous events, one has to be fearless. He is. One has to want to be everywhere that an important story is taking place. Nachtwey tries to be everywhere. Jim Nachtwey has trained himself to be independent and self-sufficient, calculatedly analytical about his chances for survival in dangerous situations. But above all, Jim Nachtwey stands for discipline—the essential ingredient in success in photojournalism. Intellectual discipline. Visual discipline. Technical discipline. Physical discipline. And personal discipline.

Yoichi Okamoto

Yoichi Okamoto was my friend. He died in 1985 at the age of 69. Oke or Okie, as he was called by almost everyone who knew him, was an important figure in the short history of photojournalism. Perhaps young photographers can learn from some of the reminiscences to follow.

Yoichi Okamoto was not a giant in photography in the same sense as Kertesz, Weston, Adams, or Penn. In photographic history, however, he will be remembered as the man who revolutionized photographic coverage of the American presidency. It was Oke who seized the moment, the opportunity, and the challenge of documenting and humanizing the larger-than-life figure of President Lyndon B. Johnson. No photojournalist before or since Okamoto has been able to produce a more complete historical photographic record of a president or presidency.

In retrospect, I have been trying to sum up what it was about both as an individual and as a photographer that contributed to his success. Oke had a consuming interest in the world that surrounded him. His insatiable curiosity about people and places was intrinsic. Music, art, literature, politics, sports, science, philosophy, and technology were his playing fields.

Inquisitiveness is indispensable to the photojournalist. It sharpens insight, gives depth and meaning to photographs, and establishes a human communication bridge to the subject. Okamoto was genuinely interested to learn who people really were and what they believed, rather than to accept the facades they presented to the world. That characteristic was what made Okamoto equally at home with the Indian elephant driver who came to the U.S. as President Johnson's guest and with prime ministers, kings, and the world's political greats.

Oke was meticulous and orderly in mind, body, and dress. Despite being a Nisei (a Japanese born as a native of another country) in a Caucasian society, he was resolved to be more American than any Mayflower descen-

dant. He seemed to want to blend into wherever he was placed, eliminating any ethnic differences resulting from his Japanese ancestry. The internment of Japanese Americans during World War II left a psychological scar that constantly impelled him to greater effort, greater concentration, greater accomplishment.

Oke blended so well that he reveled in telling the story of the time the president had important guests at the White House. Johnson sent his press secretary, George Reedy, to summon Oke for a photo session. Attesting to Okamoto's unobtrusiveness was his response to Reedy's call. "I've already been there," he said. Okamoto had taken his pictures but had been the proverbial fly on the wall. Nobody had noticed. The lesson is clear. To penetrate beyond superficial, external levels, to reveal the complex real persona, a photographer must overcome the subject's camera-consciousness and become an accepted part of the environment.

I will never forget the day Oke was fired by President Johnson. I was in Washington visiting the U.S. Information Agency, where Okamoto had worked prior to becoming the presidential photographer. When I got to the picture department, I was surprised to find Oke putting his things into one of the desks. "I've just been fired!" he said. The firing had been precipitated by a *Newsweek* article. The magazine had reported on Okamoto as the President's personal photographer who had shot nineteen thousand negatives over three months. In the midst of an economic austerity drive, the appearance of waste, combined with Johnson's mistaken feeling that Oke had generated a self-serving article, stimulated the rift.

Shortly thereafter, a guilt-ridden president reconsidered. The nineteen thousand negatives translated to five rolls of 35mm film shot per day, hardly overshooting by any contemporary photojournalistic standard. Oke became the only White House staffer to be fired and later rehired.

John Durniak, former *Time* picture editor and *Look* managing editor, was a long-time friend and professional associate of Okamoto's. In recalling his photographs of the Burger Supreme Court for *Smithsonian* magazine, Durniak said,

> I can't think of anyone else who could have gotten that kind of cooperation. Oke had class. When he talked to people, they felt they were in the hands of a responsible individual, somebody who would not take advantage of them.
>
> I think that was one of the things that appealed to President Johnson. Oke was a student of human behavior. He understood President Johnson's moods. He knew where he should shoot and when it would be intrusive. He also knew that if Johnson read him out, it might be for five minutes, or five days,

or five weeks. But it wasn't forever. They had one hell of a relationship, the depth of which only Johnson and Oke knew.

Class, depth, integrity, insight, human understanding, and sensitivity: those qualities are not required on every photojournalistic assignment. Many successful people get along without them; but they surely help when you're photographing on the Washington scene where political paranoia prevails and the photojournalist wants to be privy to moments of political history.

Durniak also remembers that Okamoto was never satisfied with his work. He always wanted to improve on what he was doing. Durniak remembers that "every six weeks during his White House stint, Okamoto would get together twenty-five, fifty, or one hundred prints. He would send them out to four or five people he respected and ask, 'How am I doing? What did I miss?'"

According to Durniak, one of the people to whom Okamoto sent those prints was John Morris, former picture editor of the *New York Times* and the *Washington Post,* and Magnum picture-agency chief for several years. "Morris would faithfully sit down and raise hell with his pictures," says Durniak. "As a result, Oke would push himself harder. And, never satisfied, he'd go the extra mile to keep himself sharp and make the most of the opportunities available to him." Another Okamoto lesson for everyone.

The good photographers, the great photographers, have no limiting sense of self-importance. None of us knows it all. There's always something to learn. And even in a privileged position, Oke sought and absorbed the opinions of his colleagues.

Lynn Johnson, a Black Star photographer, once worked as an assistant to Okamoto. One of his values, she remembers, was his personal restraint and respect for individual privacy that transcended professional concerns. He taught her that getting the picture is not everything. When Hubert H. Humphrey, the grand old man of liberalism, was dying of cancer, Oke was asked by a national magazine to photograph his final days. "I turned it down," he wrote to Lynn, "although it may have produced a great picture that left his image more indelible in the public mind. But it meant my asking Muriel (Mrs. Humphrey). I loved them, and I know they liked me. But just because she might have said 'yes,' I had to turn the assignment down."

Another letter to Lynn Johnson is worth quoting. Okamoto on female photographers: "Just remember—stay yourself and don't get tough! It happens to female photographers without their becoming aware of it."

Oke was a true friend, a patient golf partner, and good companion. We miss him.

Ivan Massar

One of the best experiences I had in photojournalism was my professional and personal association with Ivan Massar. Ivan was and is the epitome of gentleness, carrying it through all aspects of his life. I first met him in the late 1940s, after he had returned from a youthful hegira on which he and his photographer friend Leonard Schugar had entered the heady field of the burgeoning postwar European publications.

After my own *Illustrated Leaves of Grass* book, which illustrated passages from Walt Whitman's poetry with photographs, Grosset and Dunlap, the publisher, was anxious to continue the series. My keenness for Whitman's poetry was matched by a high regard for the writing and philosophy of Henry David Thoreau, another great nineteenth-century transcendentalist. In Ivan Massar, I found a photographer whose life and professional work embodied the true spirit of Thoreauvianism. The publisher was pleased to accept Ivan as the photographer to best illustrate selected prose passages from *Walden* and from Thoreau's journals.

Ivan and I selected passages that were visually translatable. Ivan provided evocative photographs of Thoreau's writings and contemporized them in a relevant twentieth-century context. In his introduction to *The Illustrated World of Thoreau* Massar wrote,

> I read *Walden* in the navy at the age of eighteen. The first act of my life that I can attribute to Thoreau's influence is my going over the hill in the navy. Having been 'decorated' with six battle stars, I became a pacifist. It was the first time I had dared to question anything that was universally considered right.
>
> Since then, I have felt a kindred spirit linking Thoreau's written journals and my photographic journeys. Thoreau's journals focus upon a narrow geographic range of Concord and elsewhere in New England. But his influence has rippled out into the world. My journeys have taken me into and around the world, but always with a desire to focus and simplify, because I have learned from Thoreau how far I can travel by enjoying what is underfoot. I have applied Thoreau's precepts in my photography by slowing down, taking a closer look, and learning to see. I have learned that a good picture is a simple picture: one undiluted statement rather than a glimpse of everything.

We later developed a project involving the poetry of Edna St. Vincent Millay, which Massar chose to illustrate with a series of abstract black-and-white pictures. I always think of the book, *Take Up the Song,* as a "tiny jewel," an extension of Massar's special vision in which he reduces, simplifies, and

abstracts studies from nature. He sees beauty everywhere and permanently records it.

Ivan Massar proves that photography is an all-embracing medium, encompassing many visions and many disciplines. This is the man who photographed the steel mills of Pittsburgh for Roy Stryker, who covered the march from Selma to Montgomery during the civil rights era, who delivered medicine to Vietnam as part of a Quaker Action group, who traced the origins of Unitarianism in Transylvania, and who lived with his family in the Seychelles of the Indian Ocean in search of a simpler lifestyle and a richer life experience. He also proves that ideas for the photojournalist are not always found in the news of the world; that literature can be an inexhaustible source of visual inspiration.

Charles Moore

The year was 1962. A young photographer from Montgomery, Alabama, came to see me having worked as a staff photographer for the Montgomery *Advertiser*. He had come to New York to make his way in photojournalism, and after three months had found a cold, unyielding, and professionally unrewarding city. Charles Moore had with him some historic photographs that he had taken for the paper. Included among them was a series of pictures of a man who ultimately became the guiding spirit of the civil rights movement, Dr. Martin Luther King, Jr. That series showed Dr. King being arrested for the first time in 1954, in Montgomery, arms twisted behind his back as he was led up the steps of the police station and booked at the police desk. He also had two frames taken at a 45-degree angle that captured the beating of two black women with fists and bats on the streets of Montgomery. Rather than encourage Charles Moore to stay in New York to pursue his career, I told him I felt that one of the great stories in American history was unfolding in the South. He came from the South and understood it. Going back to Alabama to document the events taking place there would provide the chance for Charles to do work he was uniquely qualified for.

Charles Moore went back to Alabama with a guarantee of a small weekly salary and a pledge of support from Black Star. That decision resulted in his being thoroughly involved in some of the important events that defined the civil rights struggle. His coverage of the bloody riots at the University of Mississippi kicked off when U.S. marshals assured the right of James Meredith to enter that university: it became a major story in *LIFE* magazine. What followed was a series of great *LIFE* features about such milestones as the Birmingham riots, the attack on the blacks attempting to cross the Pettus

Bridge in Selma, Alabama, and the triumphant Selma-to-Montgomery march, which raised the spirits of the whole civil rights movement. Black Star's distribution of these and other photographs of Charles Moore's contributed to the change in the American perception of this struggle, helping in the elimination of segregation laws.

In 1988, Charles Moore received the Eastman Kodak Crystal Eagle Award in the NPPA–University of Missouri Pictures of the Year Competition. The Crystal Eagle Award is given to a body of photographic work which has influenced public perceptions on important issues of our time. As the first recipient of the award, this long-delayed honor for Moore recognized that his news pictures had helped to change the world. The historic value of his work is reflected in *Powerful Days*, a retrospective illustrated book recalling the civil rights period.

The lesson here for aspiring photojournalists is that one has to recognize great turning points in social history, to seize the opportunity to bear witness to them, and to remember that what is in your backyard may be the stepping stone to your success.

Diane Koos Gentry

Tenacious, that's Diane Gentry. A lesser woman with less determination would probably have thrown up her hands after multiple rejections by traditional trade book publishers. In the 1960s, I had developed an association with Diane Gentry through Black Star. I was impressed with her photography, her ideas, her ability to articulate those ideas, her writing, and the warm personality that allowed her to penetrate the lives of her subjects. So, when she approached me in the early 1970s with an idea we called "Rural Women," I was eager to support her project.

It was a time when the women's movement was beginning to make its inroads on the American consciousness, and the media pointed to the changing roles of women in American society. But Diane Gentry felt that there was a strong, rugged, independent and spirited kind of woman whose story was being neglected and who represented frontier work-ethic values that were well worth preserving. After one year of research she settled on ten women in nine states, covered over twenty-three thousand miles in her van, and extensively photographed and interviewed each of those women. Among her subjects were a Vermont farmer, a western rancher, a Gulf-coast shrimper, a nurse-midwife, a coal miner, a Zuni teacher, and a farm activist. With her project she engaged in a personal, mini-FSA documentary that has taught us something about

America, about women, about happiness, fulfillment, conflicts, tragedies and the experiential baggage we all tote through life. The results of this project can be found in the book *Enduring Women*. Diane Gentry pursued publishers with single-mindedness and finally found a university press that recognized the literary and photographic merits of the project. What gives this book greater value is the mid-1980s follow-up on all the subjects in the book photographed in the 1970s, so that the reader gets to know how well or poorly these people have done.

Diane Gentry's work illustrates my recurrent principle that one need not travel to faraway countries for good editorial material. Great ideas emerge from simple subject matter found in the everyday stuff of life.

James A. Sugar

Jim Sugar was a contract photographer for *National Geographic* magazine, which means that he was assured of a certain number of working days per year at their standard day rate. In the freelance photography profession, this arrangement afforded him psychological freedom from the financial insecurity built into the freelance equation. It also assured him special consideration for *Geographic* assignments.

Being a contract photographer allowed him to make other representational arrangements that could augment the basic income the contract generated. After watching the work of Jim Sugar over the years, I was particularly happy to add him to the Black Star staff for two reasons. Aside from attracting an obviously salable talent like Sugar, Black Star needed more photographers for annual report assignments, and Sugar's work reflected a special aptitude for making the strong, illustrative color pictures needed in corporate photography.

Sugar has carved out a special niche for himself as a "conceptual photographer." His fertile imagination can translate difficult concepts into visual images that make the concepts immediately understandable. Thus, Sugar is particularly appropriate for assignments like one on the "greenhouse effect," which was treated by *National Geographic* in its October 1990, issue entitled "Under the Sun—Is Our World Warming?" Over the years, he has built a huge file of pictures related to the natural world and how it is affected by natural phenomena.

Sugar's ability to interpret scientific phenomena is best illustrated by the lead picture in *National Geographic*'s article on gravity. The image, now a classic, shows repeated exposures on one film of an apple and a feather

simultaneously falling, both at the same rate of speed, despite the disparity in weight and bulk, thus proving the immutability of gravity.

Since much photography and photojournalism is illustrative in nature, conceptualizing is highly valuable, and then technically executing conceptualizations becomes important. Sugar constantly expands his technical knowledge by taking lighting workshops and experimenting so he can create spectacular imagery in all his work. Sugar has recently given up his *National Geographic* contract to become expert in the computer graphics area which he sees as a valuable component for his future.

Claus Meyer

He went from drying prints in a commercial darkroom to becoming one of Brazil's leading photographers—that is the story of Claus Meyer. He is a classic example of a photographer who, by dint of curiosity, hard work, and a bold spirit, was able to develop a career in photojournalism.

I first met Claus when he had a job in the G and W darkroom that served Black Star's needs. Claus had emigrated from Germany with little knowledge of photography and spent the early 1970s doing general darkroom work.

Looking at good professional pictures can be as important a photographic educational experience as courses in a photojournalism school. Claus looked. Claus learned from looking. Claus began to take pictures of news events in his spare time and began to sell some through the Black Star library. And one day, Claus Meyer abruptly moved to Rio de Janeiro, Brazil, and was hired as a staff photographer with Editores Bloch, one of Brazil's largest magazine publishers. There he became a skilled technician and refined his vision. Rather than stay on in New York where there were thousands of beginning or established photographers, Claus Meyer opted for a faraway country where he could establish his credentials. After a stint with Bloch, Claus Meyer started his own agency in collaboration with other photographers and imposed his own creative stamp on the work of his colleagues. He proves that the adventurous spirit that took him to a strange country with a strange language, supported by hard work made him a success.

Anthony Suau

The turning point of Tony Suau's photojournalism career came with his Pulitzer Prize award in 1984. Tony's Pulitzer resulted from carefully sharpened feelings for an important news story, his confidence in his instincts when

others were not supportive, and the guts to invest his life savings in a story that intrigued him. He had read a short paragraph in a newspaper about the drought and resulting famine in Ethiopia that were causing thousands of deaths. At the time, Suau was a staffer for the *Denver Post,* which did not see its way clear to sending a photographer to cover a story so far from Colorado, but encouraged him to take the gamble.

Suau withdrew ten thousand dollars from his limited bank account and headed for Ethiopia, where he made a series of shocking photographs that captured this disaster's human toll. He had discovered one of the most important stories of the 1980s long before the 1984 BBC documentary that focused world attention on the systematic destruction of masses of people.

One knew that Suau was destined for greatness during his undergraduate days at Rochester Institute of Technology, when he graduated with high honors with a bachelor's degree in photojournalism. He immediately joined the photographic staff of the *Chicago Sun-Times* after a summer internship, where, following his first year of employment, he was named "Illinois Photographer of the Year." In 1981, he joined the staff of the *Denver Post* then headed by Rich Clarkson, under whose tutelage so many major newspaper photographers have matured. Rich Clarkson introduced me to Tony at the University of Missouri with the comment, "Keep an eye on this guy. He's overly cocky, but he's a great talent." I kept an eye on him. When he came to New York to free lance, Suau spoke to all the major New York agencies. He came to see me and chose Black Star, I think, because I made a representation to him that suited his need for complete freedom in his career. Recognizing his unerring journalistic instincts, I told him that Black Star would support him on any idea he thought important. We fulfilled that commitment, resulting in a long string of successful stories.

Now living and working out of Paris, Suau has covered the major world events of the 1980s—the political crises in the Philippines, South Korea, and Pakistan; the Palestinian intifada; the Armero volcanic eruption in Colombia; the Afghanistan conflict; the destruction of the Berlin Wall; and the overthrow of Communism in Eastern Europe.

In 1989, taking a breather from news coverage, Suau embarked on a personal project documenting eleven different religious pilgrimages in Europe. Choosing black-and-white photography, he produced a powerful series that has been published in major magazines all over the world. Once again he proved that great editorial ideas are not necessarily complex. This simple idea was available to any photographer, but it was Tony Suau who was willing to set aside the time to do it, giving up other assignments to make it

happen. It is just this kind of commitment that allows some photojournalists to reach the top. Tony has it.

John Launois

In every life there are relationships that go beyond ordinary professional associations. Since 1952, when I first met the youthful John Launois, an expatriate Frenchman who became a dual-citizenship American, our lives have been tied with a continuous thread. John likes to recall that I was the one who had such supreme confidence in his potential that I convinced the Black Star powers to give him the munificent sum of twenty-five dollars a week as a guarantee, enabling him to take up residence in Japan and start out in the international photographic field.

John Launois initially worked as an assistant to Joe Pazen, a freelance photographer based in California who distributed his pictures through Black Star. Earning next to nothing, Launois was able to learn about strobe lighting and develop technical expertise and discipline during his association with Pazen. He also learned a lot from Pazen about the development of editorial ideas, an important ingredient in his own growth.

Having served as a GI in Japan during the Korean War, Launois was anxious to return to the site of a wartime romance. His dream of marrying foundered on a suicide threat by the girl's mother if she married a foreigner, but postwar Japan was a good place for a beginning photojournalist. Launois began to send speculative stories to Black Star. His first published one was on a Japanese noodle man. The pictures were sent by airmail, which led to a criticism from Mr. Mayer, one of the original Black Star principals, that the expenditure was unwarranted: this not being a news story the package should have been sent by sea mail!

After struggling for some time, Launois began to get assignments from *LIFE* magazine and made the most of the opportunities. Of particular note was his coverage of the anti-United States riots precipitated by the visit of President Eisenhower's press secretary, Pat Haggerty, to Japan. Launois achieved a journalistic coup in 1959 as the first postwar Western journalist to travel on and do a photographic essay on the fabled Trans-Siberian Express traveling from Japan through Siberia to Moscow. He also met and married a woman named Yukiko, who subsequently became my colleague at Black Star and one of the best picture editors in the agency business.

Launois parlayed his relationship with Hank Walker, a former *LIFE* staff photographer, into a contract with the *Saturday Evening Post,* when Walker was the picture editor there. The weekly *Post* permitted Launois to do major color

stories of substance, including some on water pollution, air pollution, Miami Beach, religion, and the fiftieth anniversary of the Russian Revolution in 1967. The recognition he received for his color work led to extensive assignments for *National Geographic* magazine, such as "Japanese Women," "Eastern Canada," "Longevity," "Vienna," and his peak moment as the first photographer to photograph the newly discovered Tasaday stone age tribe in the Philippines.

The years working with *LIFE,* the *Saturday Evening Post,* and *National Geographic* established Launois as a supreme professional, the perfect color technician with a most disciplined eye, and a rare photographer who combined intellect with solid research and conceptualization. He never went into an assignment without becoming well informed and thoroughly knowledgeable about the subject.

From 1964 to 1966, Launois participated in one of the biggest financial misjudgments of my professional life. A Black Star photographer, Joe Covello, had come up with a novel concept he called "moving stills," which he thought had great adaptability to the audio-visual field. His theory was simply that if one shot pictures with a motorized camera, extracted every fourth image, and projected them in sequence, one would create the illusion of motion. It was a great idea whose time had not yet come.

Black Star hired two electronic engineers who devised a digital logic system for the programming of adapted projectors. Launois gave the idea shape and thematic concept, but we needed a method that could project images on multiple screens. The split-second quick cuts that have become commonplace on today's television screens were conceived and executed more than two decades earlier by Covello and Launois. Unfortunately events defeated the project, but I will always remember, however painfully, the creative energy and brilliance that Launois brought to it.

The demise of the original *LIFE, Look,* and the *Saturday Evening Post* created a vacuum in the career of John Launois as it did for many other photojournalists who had done so well in the star system created by the magazines. Launois found it difficult to suddenly stop chronicling world issues and events. His legacy to photojournalism, however, is a body of timeless pictures that are used and reused today.

Werner Wolff

When I returned from my Air Force service to Black Star in 1946, I met Werner Wolff, who had joined Black Star as a staff photographer. Werner, who had come from Germany to the United States in the Hitler era, started as an

apprentice in the Pix Inc. darkroom. Pix was one of the original 1930s photo agencies, where Alfred Eisenstaedt was the leading photographer.

During World War II, Werner Wolff served in the American Army in Italy, first in a carrier pigeon outfit for the Signal Corps and then after being transferred, on *Yank* magazine as a photographer-correspondent. He followed the Italian campaign as the GI's fought their way up the Italian boot. He was one of the first to enter Hitler's redoubt at Berchtesgaden.

I have always felt that the photographers who worked in the early days of photojournalism, restricted by the demands and disciplines of larger format cameras, were provided with technical groundwork that was very important to their careers. Werner Wolff was indeed the perfect technician with a well-ordered sense of composition. In the several decades we worked together and the countless assignments he did in black-and-white and color, I can never remember him doing an assignment that did not meet critical standards. His was a pragmatic vision, not a poetic one. His camera was a communicative tool that spoke directly to the viewer without nuance or ambiguity.

Werner Wolff is a quiet man. A *LIFE* editor once commented: "He is the only photographer I ever knew who was not temperamental." He may not have become well known outside his field, but he is secure in the knowledge that he always turned in an exemplary job. Wolff traveled with Eisenhower to thirteen countries and with John Kennedy to Europe for the Kruschev confrontation in 1963. Werner Wolff proves that it is possible to be a photojournalistic generalist and earn a living for over five decades through conscientious, honest dedication. Werner, however, is well remembered for one early daredevil assignment for *LIFE* preserved in a Camel cigarette strip advertisement. When the television antenna was placed above the tower of the Empire State building, Werner was hoisted in a bosun's chair above the tower, where he made a spectacular vertiginous photograph of the Manhattan streets below.

In my years as a picture agent, I never met a more scrupulous photographer where a client's money was concerned. If Werner Wolff rode the subway, he didn't charge for a taxi. If he had a grilled cheese sandwich for lunch, it didn't become a ten-buck expense account item. In a profession where photographers frequently turn in creative expense statements, Werner's personal probity will long be remembered.

Bob Krist

The loud-mouthed, dirt-kicking, flamboyant baseball player and manager of the Brooklyn Dodgers and the New York Giants, Leo Durocher, is credited

with coining the phrase, "Nice guys finish last!" It ain't necessarily so. In photojournalism, where egocentricity is prevalent, Bob Krist is a normal, virtuous "nice guy" who is courteous under pressure and exhibits warmth in his dealings with editors, colleagues, and subjects alike. This has not been detrimental to his career.

Bob Krist is a photojournalist whose work appears regularly in such publications as *National Geographic, Travel and Leisure, Islands,* and *National Wildlife.* His assignments have taken him from the remote glaciers of Iceland, to secret voodoo ceremonies in the jungles of Trinidad, to active volcanic craters off the coast of North Africa. He is also a sought-after photographer in the world of corporate annual report photography, managing to easily switch between the two worlds of commercial and editorial photography. His success is not only predicated on charm and graciousness. His photographs of landscapes and people are evocative, have a strong sense of place, and exude a kindness that is innate. I have the feeling that some young photographers who are overly aggressive and crass would do well to emulate Bob Krist. Nice guys finish first!

Kosti Ruohomaa

God made Maine, and Kosti Ruohomaa photographed it. For two decades, this "Boswell of Maine characters" (as he was once described by a critic), recorded his feelings for the pastoral scene, the sea, and the people who lived and worked close to nature.

Kosti Ruohomaa was an artist. The word art is thrown around with abandon in photography, and photographs are often compared to the works of Renoir and Rembrandt, but Kosti's photographs stand by themselves. A Ruohomaa picture is distinctive and looks only like a Ruohomaa.

He thought of himself as another H. L. Mencken; he loathed conformity. I think that was why he photographed rugged Yankee individualists who, despite their insularity, fought with a passion for the preservation of simple values and the dignity of the individual.

Kosti Ruohomaa may have been the greatest essayist of all Black Star photographers. His essay, "Winter Nights," is included in the book commemorating the ten best *LIFE* magazine essays. It is hard to find in his collection any outstanding pictures taken in urban America. His work best showed his love for the land and especially for Maine and its people.

Kosti photographed in his backyard. That backyard was Maine and New England. I remember that he once did a story on "New England Folklore"

based on sayings in the book, *It's an Old New England Custom.* The book's chapter headings reflected traditional wisdom—"It's an old New England custom to reach a ripe old age" or "It's an old New England custom to talk about the weather"—and provided the inspiration for Kosti's photographs.

He found photographic themes in the weather and did essays on fog and rain. He found stories in one-room schoolhouses, town meetings, ox pulls, country fairs, farm auctions, in kids playing in a barn, and even in the adventures of a Maine schoolboy going home from school. It was as if he sensed that a way of life was disappearing from the American scene, that a simpler existence was being replaced by the ever-intruding complexities of urban life. He seemed desperate to preserve images of country America before it disappeared forever.

Kosti was an alcoholic who died young. For the people of Maine, he was their chronicler; for me, one of the photographers I loved the most. Being a photographer with little technical knowledge allowed him to take risks that better trained photographers would have been afraid to take. But, in the process, he achieved pictures that were beyond the capabilities of those with more limited vision.

Joseph Rodriguez

For most of us, our lives have been dictated by our ethnic heritage and our formative environment. If Kosti Ruohomaa's was the rugged landscape of Maine mirrored in the craggy insularity of its people, Joe Rodriguez's backyard was "El Barrio," a term applied to the Latin enclave in upper Manhattan.

The secret to Joe Rodriguez's modest success as a photographer stems from his recognition of his roots and his desire to interpret the colorful, complex, high-spirited, musically flamboyant, family-oriented, religious world of the immigrant Latinos who settled in East Harlem. They are an integral part of the population mosaic that characterizes life in polyglot New York.

I first met Joe Rodriguez when he came to Black Star as an intern from the International Center of Photography student program. Joe is a diamond in the rough, little concerned with presenting an image of sophistication. He is open. He is real. What you see is what you get. He didn't become a professional photographer right away. He paid his dues as a researcher in the Black Star library, learning from observation of the pictures he saw, simultaneously studying with Fred Ritchin at the International Center of Photography. There he got involved in a class project on Spanish Harlem that he later turned into a personal project of his own.

I was always impressed with his ambition and his sincerity. When he decided to "fish or cut bait" and chose to make photography his career, he came to me with a plan to document "El Barrio" like never before. I gave him moral and financial support. He was able to capture many aspects of life in the Hispanic community that had been shielded from less knowledgeable and less sympathetic photographers. He got cooperation from drug addicts and priests and was welcomed into the lives of the diverse people that inhabit this Hispanic ghetto.

Armed with a penetrating series of photographs, I arranged for Joe to see Tom Kennedy, the newly appointed director of photography at *National Geographic* magazine. Kennedy, impressed with the photographs, initiated further support for Rodriguez, and Rodriguez was assigned to do a more comprehensive coverage of "El Barrio." This ultimately resulted in a multi-page cover story in *National Geographic.*

In 1993, Joe Rodriguez worked on a year-long project financed by a grant from the Alicia Patterson Foundation. At great personal risk he explored the world of Los Angeles gangs that have turned America's urban ghettos into violent shooting galleries. His background prepared him well for the task of gaining the confidence and respect necessary to establish the rapport with gang members that such a project requires.

Joe Rodriguez, like many other photographers who have opened the doors to photojournalism, did it by exploring the world with which he was most familiar. You may succeed just as well by opening your own back door.

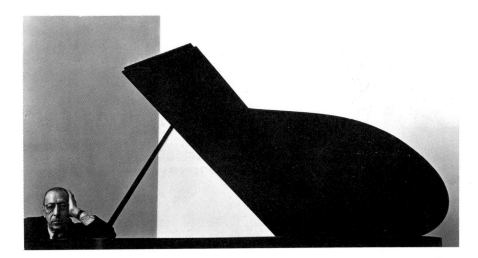

Igor Stravinsky/1946

New York City. Arnold Newman constructs his photographic portraits with rigid compositional discipline. In this striking pose, Stravinsky is positioned so that the piano is almost an extension of his body. The sharp black lines of the piano and the subject are boldly delineated against the simple grey-and-white background.

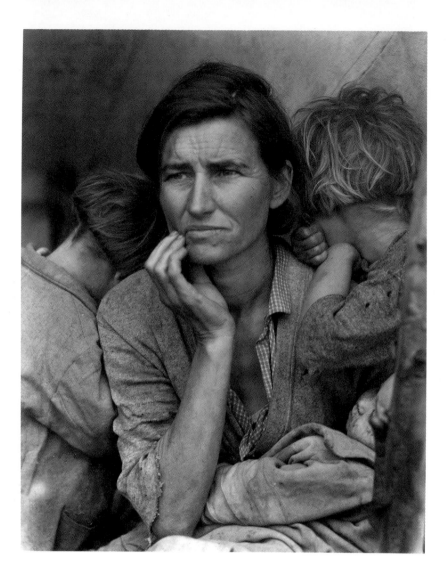

©Dorothea Lange

Migrant Mother, Nipoma, California/1936

Lange took this photograph while working for Roy Emerson Stryker on the Farm Security Administration project. It is the best-known picture from that project. She wrote, "She told me her age, that she was 32. She said that they had been living on frozen vegetables from the surrounding fields, and birds the children had killed. She had just sold the tires on her car to buy food. There she sat in that lean-to tent with her children huddled around her, and she thought my pictures might help her."

©Yousuf Karsh

George Bernard Shaw/1943

Karsh writes of his first meeting with Shaw, "He came bursting into the room with the energy of a young man, though he was almost ninety years old. His manner, his penetrating old eyes, his flashing wit, his bristling beard were all designed to awe me . . . with me he assumed the role of a harmless Mephistopheles and devil's advocate."

©Lori Grinker

Mike Tyson/Contact Press Images, 1988

Grinker found former heavyweight champion Mike Tyson when he was 12 years old and already under the tutelage of the legendary prizefight manager Cus d'Amato. She documented his evolution from young street tough to boxing champion. Women like Grinker have invaded sports photography, previously an exclusive male bastion.

I Dream a World Cover/1987

Lanker, as part of his book project, *I Dream a World,* made seventy-five portraits of black women who have changed our world. Septima Clark, whose quiet dignity is evident in this portrait, was one of the unsung heroines of the civil rights movement. She believes that literacy is the key to empowerment.

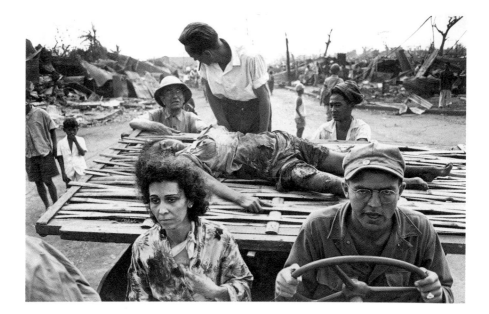

Philippines/Life Picture Service, 1945

Wounded Filipina women are transported to a field hospital in a makeshift ambulance during the street fighting for Manila in World War II. Carl Mydans, the photographer, broke down a bamboo fence and placed it on the jeep to hold the body of one wounded woman; she died twenty minutes later.

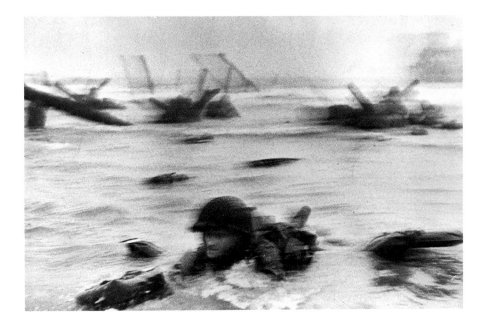

D-Day/1944

Robert Capa challenged the odds with his daring exploits until his untimely death in Indo-China in 1954. On June 6, 1944, Robert Capa was part of the first assault wave on the Normandy beachhead. His photographs preserved for eternity the drama of the massive onslaught against the Nazi war machine. This and other Capa pictures of the landing were published in the June 19, 1944, issue of *LIFE*. Etched against the ghostly shapes of invasion craft in the background is the slithering figure of a GI under fire reaching the beach.

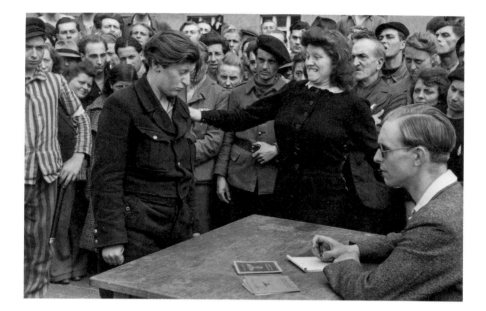

Collaborator, Dessau/Magnum Photos Inc., 1945

At a deportation camp in Dessau, Germany, in 1945, a Gestapo informer is recognized by a woman she denounced. It is an explosion of passionate retribution during which all eyes are focused on the drama being played out in front of them. This is truly a "decisive moment," when all elements of situation and composition combine to form a coherent whole.

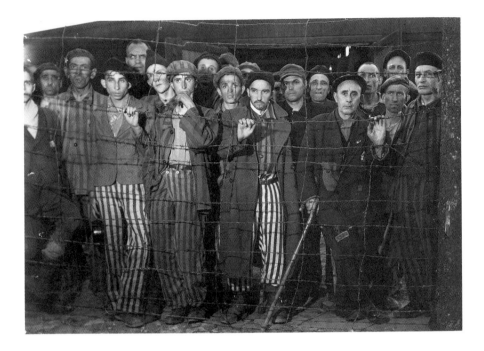

©**Margaret Bourke-White**

Buchenwald/*LIFE* Picture Service, 1945

The living dead of Buchenwald. On assignment for *LIFE* magazine, Bourke-White was among the photojournalists who witnessed the liberation of Buchenwald and revealed to the world the horrors of the Holocaust.

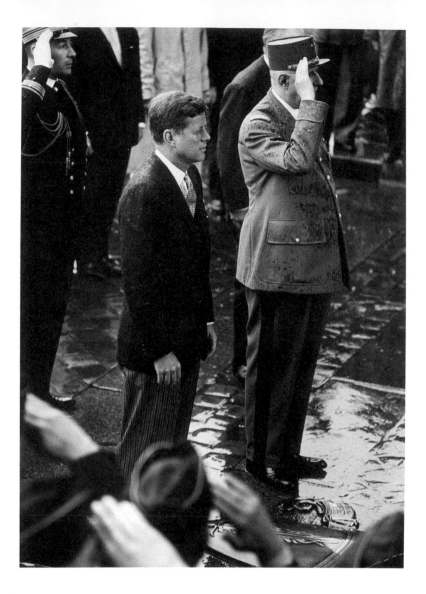

©Werner Wolff

JFK and de Gaulle/Black Star, 1963

One of the first acts of newly inaugurated President Kennedy was to travel to Europe to establish his credentials as a world leader. The trip included a disastrous summit meeting with Soviet leader Nikita Khrushchev and an opportunity to meet with French president Charles de Gaulle. De Gaulle and Kennedy withstood a driving rain in Paris during a ceremony at the Arc de Triomphe.

©Cornell Capa

JFK Chair/1961

President John F. Kennedy. As the leader of Magnum Photos at the time, Capa organized a project for Magnum photographers to document the first hundred days of the new Kennedy administration. The work was subsequently published in book form in *Let Us Begin*. For his part, Capa took this unusual view of JFK in his presidential chair in the Oval Office; a metal plate on the back of the chair is imprinted with the date of Kennedy's inauguration.

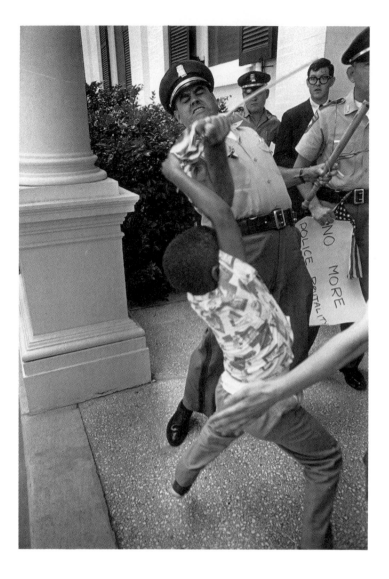

Mississippi Summer Project/1964

A Mississippi highway patrolman arrested Anthony Quinn, 5, son of Mrs. Alene Quinn of McComb, Mississippi, during a voting rights protest staged at the height of the civil rights struggle. When Quinn refused to give up a small American flag he was holding, the patrolman ripped it from the boy's hands. Herron was the architect of the Mississippi Summer Project in 1964, which brought together a group of photographers to document civil rights events in that state.

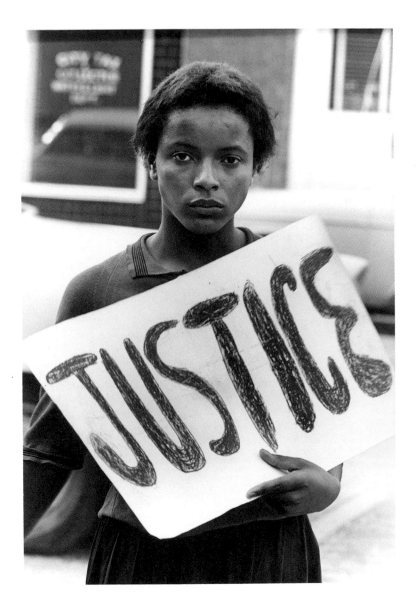

Justice/Black Star, 1961

During the 1960s, Black Star photographers like Declan Haun took photographs that defined the civil rights movement. Signs generally do not make great pictures, but faces often do. The eyes of this stern, confrontational, and determined civil rights demonstrator demand the viewer's attention.

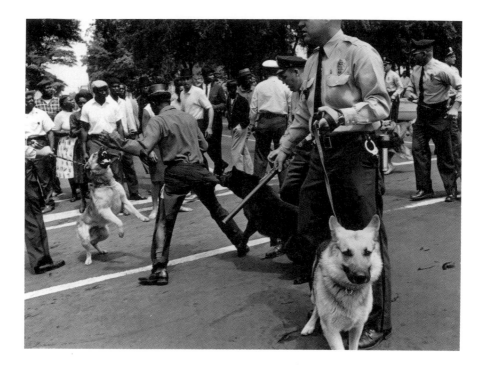

Birmingham Dogs/Black Star, 1963

April 1963 in Birmingham, Alabama, proved to be a turning point in the civil rights movement. All America was shocked by images of police dogs, fire hoses, and clubs being used by Bull Connor's police to quell the demonstrations. Moore's photograph, originally published in *LIFE* and used extensively in all media since, has become the central image of this event.

Dogs Legs/Magnum Photos Inc., 1974

The whimsical humor of Elliott Erwitt is reflected in this dog's eye view of "Felix, Gladys and Rover." Erwitt's work has been called Chaplinesque. When asked to comment on the deeper meaning in his personal photographs, he exhibits his disdain for pomposity by saying, "Take another look at the snaps."

©**Gordon Parks**

Muslim Women/1963

The Muslim women's corps was led by Elijah Muhammed's daughter Ethel Sharrieff at the Chicago headquarters temple. Dressed in white, the women were seated separately from the men, prohibited from singing or dancing, and trained in the traditional homemaking arts. This photograph was taken by Parks while he was on an extensive *LIFE* assignment, for which he received unlimited access and cooperation.

Coretta King at Funeral/Black Star, 1968

Schulke was one of only three photographers allowed inside the church during the memorial service for Dr. Martin Luther King, Jr. The bereaved widow, Coretta King, sat with stately dignity among the political dignitaries who had come to pay tribute to the leader whose philosophy of nonviolence had generated widespread support for the civil rights movement.

©**Bill Eppridge**

Bobby Kennedy Assassination/*LIFE* Picture Service, 1968

The year 1968 was one of unpredictable, nearly unbelievable news events. Martin Luther King, Jr., was assassinated. Lyndon Johnson removed himself from consideration for a second term, and Senator Robert Kennedy's June victory in the California primary, which virtually assured him the Democratic party's presidential nomination, turned to disaster when he was assassinated as he was leaving a Los Angeles hotel.

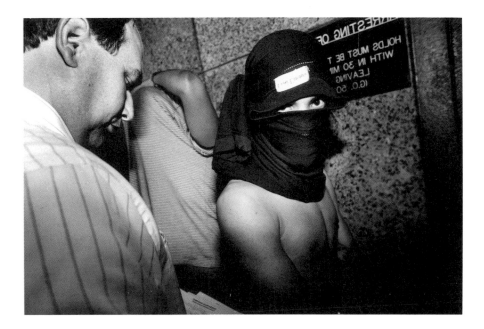

Houston Homicide/Matrix, 1991

"Gay Basher" murder suspect, July 4, 1991. In 1991, Shames was assigned by *Texas Monthly* magazine to spend 20 days with the Houston, Texas, homicide police. During those 20 days, Houston had 39 homicides. It was the beginning of Shames's long-term project on homicide done under the sponsorship of NPPA-Nikon and financed by their $15,000 sabbatical grant. Shames's photographic life has always been project-oriented, and many of his projects have been underwritten by grant programs.

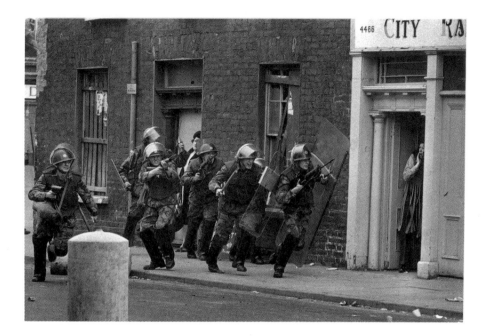

Ireland/Magnum Photos Inc., 1975

"They're like Samurai warriors," wrote McCullin of the British troops charging a group of stone-throwing youths in Londonderry, Northern Ireland. The aggressive body language of the soldiers is emphasized by the fear and shock in the faces of the two women hiding in the doorways.

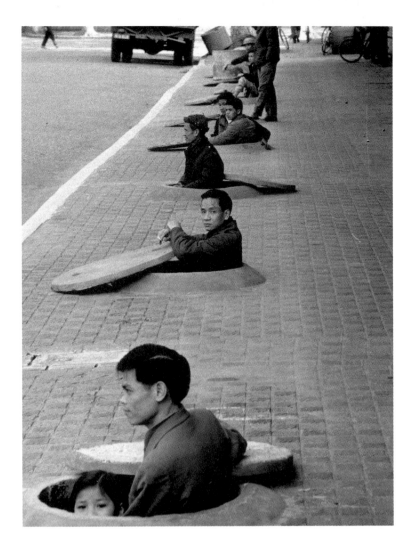

©Lee Lockwood

Hanoi Bombing/1967

In the midst of the Vietnam War, access to North Vietnam by Western journalists was virtually cut off. In February and March 1967, Lee Lockwood got through and brought back this memorable image of air-raid shelters on the Hanoi streets. During Lockwood's stay, American bombing of Hanoi occurred four or five times. This photograph was made during one of those raids. Throughout the city, one-person precast cement shelters were installed in the streets. "This picture" says Lockwood, "has always reminded me of a scene from Beckett. It reflects the strength of the Vietnamese people who bore up under the bombardment with patience and calm—stoic, enduring and heroic."

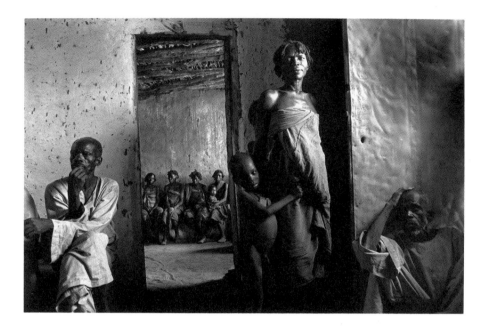

African Clinic/Magnum Photos Inc., 1985

How many pictures can one find in this complex picture by Salgado of a dispensary in the town of Ade, Chad? I see four distinct photographs skillfully combined into one perfectly composed photograph in which every part of the frame adds dimension and information for the viewer. The dramatic chiaroscuro light is a trademark of this master photographer.

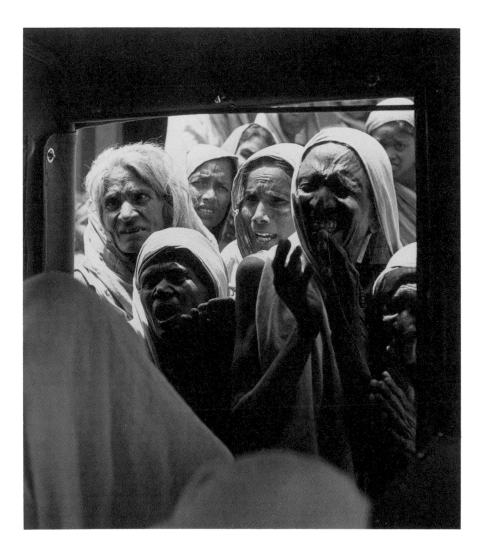

India Famine/Magnum Photos Inc., 1951

Famine in Bihar Province, India. Swiss photographer Werner Bischof was the first new member accepted to Magnum by the original founders. Among his early efforts was the coverage of famine-stricken India. Bischof was found dead on May 16, 1954, after his jeep went over a cliff in the Peruvian Andes. He was 38 years old.

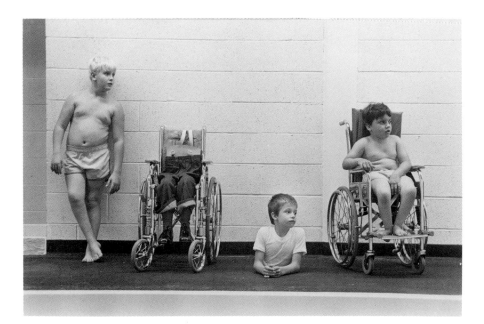

Kenny/Black Star, 1984

While working as a staff photographer for the *Pittsburgh Press,* Lynn Johnson came across Kenny, a malformed child with a birth defect called sacral agenesis: he has no hips or legs. This photograph shows Kenny, mainstreamed in school, resting on the floor away from the prosthetic device and the wheelchair that he sometimes uses. The musculature of his upper body is well developed, and most of the time he propels himself—in his chair or on a skateboard—with his strong arms.

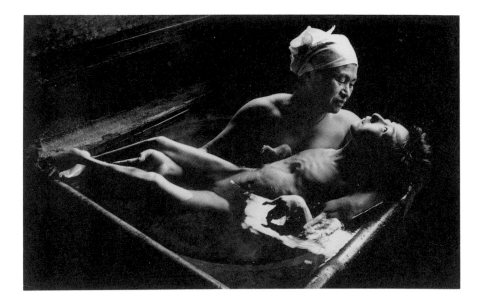

Tomoko in Bath/Smith Family/Black Star, 1973

Smith and his wife, Aileen, spent 1972 through 1975 chronicling the story of methyl mercury poisoning in the waters surrounding Minamata, a Japanese fishing village. The toxic mercury waste came from the effluents poured into the waters by the Chisso Corporation, an industrial giant in Japan. Tomoko was one of the many inhabitants of Minamata whose motor functions went completely out of control; many of those poisoned died.

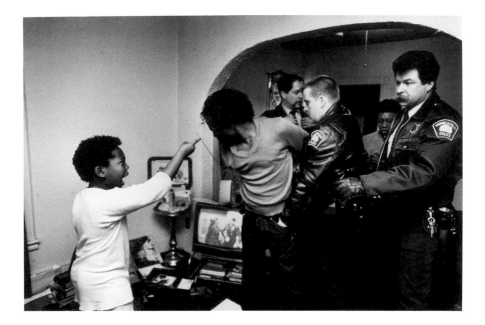

©**Donna Ferrato**

Domestic Violence/Domestic Abuse Awareness Project, 1988 (©1993)

"I hate you! Never come back to my house," screamed an 8-year-old at his father as police arrested the man for attacking his wife. This signature photograph is representative of the gritty real-life situations Ferrato encountered during her 12-year project documenting domestic violence.

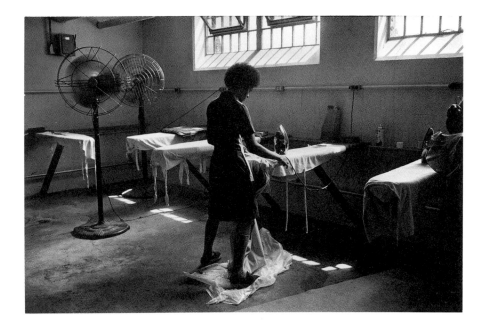

©**Melissa Farlow**

Phyllis White, Prisoner/1983

Phyllis White inherited a world of violence, crime, and punishment, in which she has been a victim, a criminal, and a prisoner. She figures she had spent about nine years in confinement—about a third of her life—for numerous charges from forgery to reckless homicide. Three felony charges led to three separate terms in Kentucky Correctional Institution in Peewee Valley, Kentucky, where all inmates have jobs. Phyllis says, "I think I made my worstest mistake by saying I wanted to go to the laundry. The laundry was so hot. It would take me 15 minutes to iron one state dress—15 cents a day." This photo is from a story published in the *Courier-Journal Magazine,* Louisville, Kentucky, August 7, 1983.

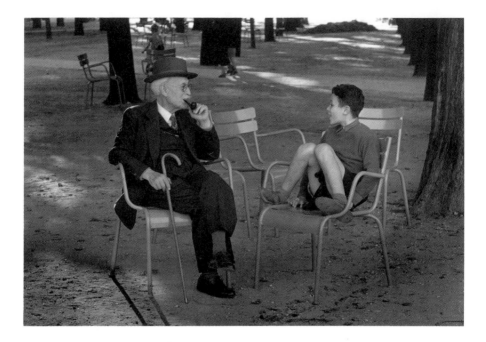

©**Ivan Massar**

Old Man and Youngster, Paris/Black Star, 1949

"On my daily stroll through Jardin de Luxembourg in Paris in 1946, I saw this pair in animated conversation. I was touched by the obvious love and admiration shown by each to the other," says Massar. This photograph served to illustrate a Henry David Thoreau passage on old age in the book I worked on with Massar, *The Illustrated World of Thoreau.*

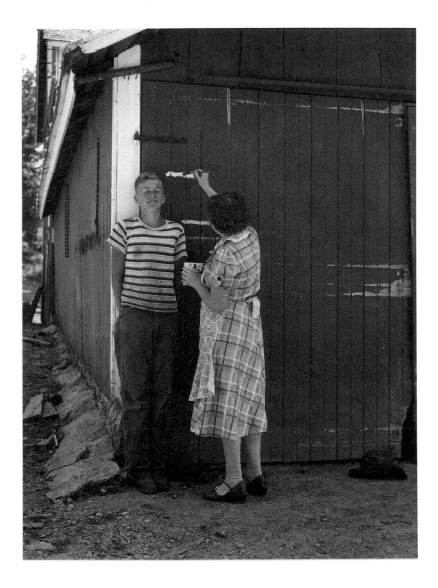

©Archie Lieberman

Farm Boy/1955

Photographing the 40-year life cycle of the Hammer farm in Scales Mound, Illinois, has become an integral part of Archie Lieberman's career. Two books, *Farm Boy* and *Neighbors,* have resulted from the effort. Bill Hammer, Jr., is shown here being measured by his proud mother, with white paint marking his youthful growth as compared with previous years.

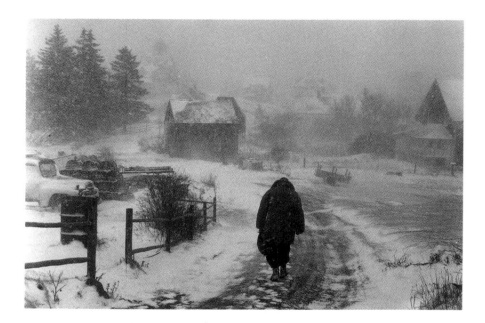

Monhegan Island/Black Star, 1957

Maine's picturesque Monhegan Island attracts many tourists in the summer but is home to only a few hundred "down-Easters" through the long hard winters. Ruohomaa, Maine's most famous photographer, captured this moody moment as a lobster man made his way home past the lobster pots on a dismal winter day.

Antarctica/Black Star, 1957

The course of the sun (December 29–30) at the South Pole. During the International Geophysical Year 1957–1958, Schulthess spent several months in Antarctica. Only at the South Pole itself does the sun circle above the horizon 24 hours a day for 6 months. Using a homemade fisheye camera placed horizontally—the lens pointing at an exact right angle to the zenith—the entire horizon could be brought into the picture. This 18-hour exposure shows the course of the sun at the exact center of the South Pole, probably the first photographic record of the "southern end" of the axis of the earth. Schulthess was precluded from going to the South Pole, but he gave his equipment and instructions to the navigator on the polar flight. Because the plane's equipment needed repair, a 2-hour stay was extended, thus allowing for the longer exposure.

Washington, D.C., Sisters of Charity/Black Star, 1956

The snapshot aesthetic is foreign to the disciplined visual approach that David Moore brings to his photography. His attention to form and composition reflect his architectural background. This serendipitous photograph of nuns taken from a high vantage point reveals shapes reminiscent of budding flowers.

Mandrill/Black Star, 1989

Sumy, an 18-year-old mandrill, is part of the Carmen Hall private collection at the Ringling Brothers Barnum and Bailey Circus. Mandrills live in the thick tropical forests along the African coast, but their natural habitat is being destroyed by man's depredations, and they are now an endangered species. This mandrill was photographed in an alien environment by James Balog as part of his book and magazine project on *Survivors: A New Vision of Endangered Wildlife.*

©John Launois

Tasaday/Black Star, 1972

Tasaday mother and child. A 24-person Stone Age tribe was discovered living in a cave on the island of Mindanao in the Philippines. Launois, accompanied by Charles Lindbergh, was the first journalist to make photographs of this primitive tribe, which were published by *National Geographic* magazine.

©Joe Rodriguez

Black Child with White Doll/Black Star, 1987

As part of his photographic essay on the Hispanic barrio in East Harlem, Rodriguez captured this poignant image of a poor black girl with her treasured white doll. This self-assigned photographic essay was subsequently supported by *National Geographic* and published as a cover story.

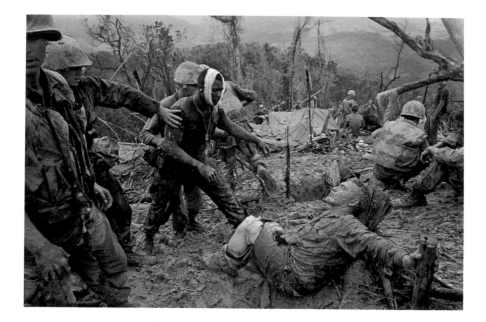

©Larry Burrows

Vietnam, 1966

A wounded GI reaches out to a stricken comrade in this photo. Described as the "compassionate" photographer, Burrows's war photography reflects his desire to "shock the uninterested people into realizing and facing the horrors of war." Larry Burrows died in February 1971, when the helicopter in which he was flying wandered into an area dominated by North Vietnamese anti-aircraft positions and was shot down.

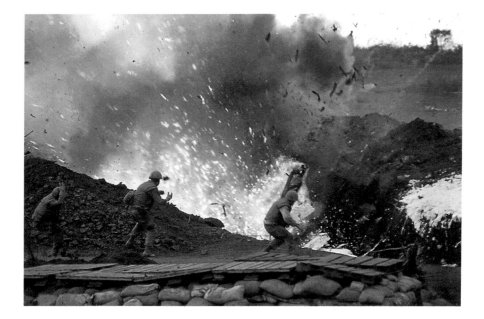

Khe Sanh/Black Star, 1968

Two weeks after this picture was made as part of a series documenting the battle for Khe Sanh in Vietnam, Robert Ellison was killed, when the C-47 in which he was returning from Saigon to Khe Sanh was shot down by the Vietcong. Twenty-four years old when he died, he will long be remembered for his courage, his enterprise, and his instinctive sense of composition and for making one of the great battle series in the history of war photography.

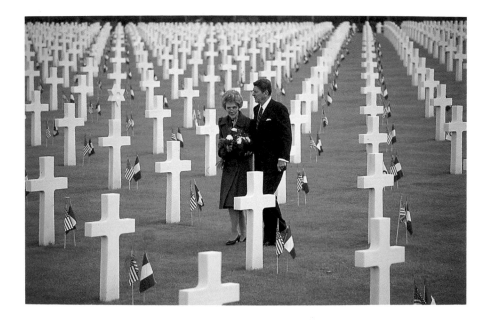

Reagans in American Cemetery/Black Star, 1984

On the 40th anniversary of D-Day, a solemn President Ronald Reagan and wife, Nancy, walked among the sea of crosses at the American Cemetery that overlooks Normandy. Buried there are thousands of Americans who died in the assault against the German entrenchments on Omaha Beach.

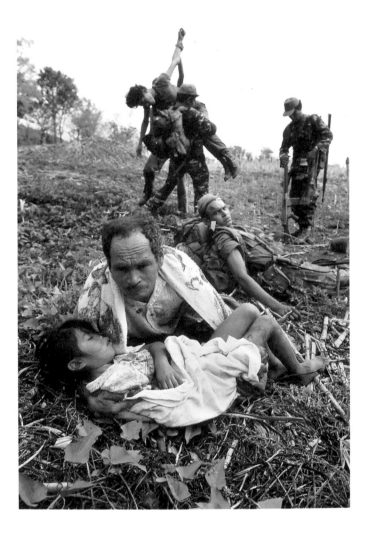

©James Nachtwey

El Salvador/Magnum Photos, 1984

A patrol of counterinsurgency troops was ambushed by rebel guerrillas in San Miguel province in the mountains of eastern El Salvador. Two soldiers were killed in the fight, and some peasants caught in the cross fire were wounded. As the casualties waited for an evacuation helicopter, more shots were fired, and the father of a wounded girl dropped to his knees to protect her with his own body. What strikes me about this photograph are the multiple stories being told in different levels of the photograph, a tribute to Nachtwey's visual acuity, his well-defined compositional sense, and his technical proficiency.

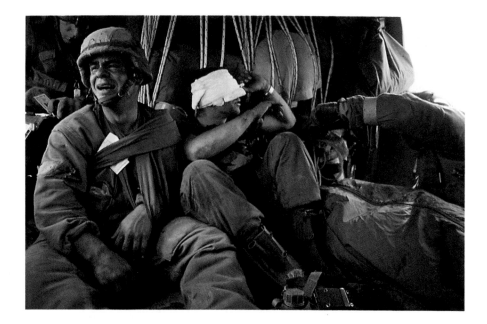

David Turnley

Iraq War/Detroit Free Press/Black Star, 1991

Caught in this photo is the anguished cry of an American soldier, Ken Kozakiewicz, after learning that the driver of his Bradley fighting vehicle was killed when it was hit by allied fire during the Gulf War. Michael Tsantarakis, center, was wounded at the same time. This is one of the truly emotional photographs taken during a war in which photojournalists' access was severely limited by the authorities.

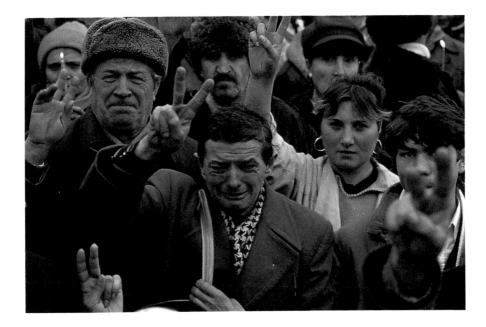

©**Peter Turnley**

Romania/Black Star 1989

The overthrow of the despotic Ceaucescu government in Romania's revolution was met by the citizens with a mixture of joy and sorrow: joy in the promise of freedom; sorrow for those who had died to achieve it. In this photo, more of the war dead are taken away in a truck headed for Belo Cemetery in Bucharest.

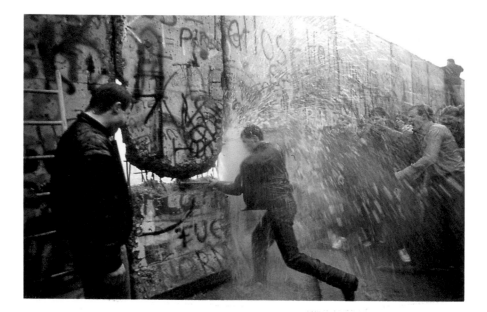

Berlin Wall/Gamma-Liaison, 1989

On the evening of November 9, 1989, a brief surprise announcement by the crumbling East German government stirred Berliners on both sides of the Berlin Wall: the wall was coming down. Within hours, the crossing points were stormed. Ecstatic West Berliners smashed the wall with hammers and chisels and frenziedly climbed its heights. Here the hammer of history slams into the graffiti-covered wall at the Brandenburg Gate, only to be met by an East German water cannon.

Yugoslavia/Black Star, 1991

In this photograph, Morris captured the grief of a young wife at the funeral of her husband, a Croatian policeman, who was killed during an ambush in Croatia on August 11, 1991. Morris spent the better part of two years covering the ethnic strife in Yugoslavia as a contract photographer for *Time*. Many journalists were killed during the bloody struggle, which has left the former Yugoslavia in ruins and displaced hundreds of thousands of people.

©**Charles Mason**

Whales/Black Star 1988

The attention of the world was riveted on the plight of three whales trapped under the Alaskan ice. An international outpouring of sympathy and concern brought about the cooperation of the United States and Soviet governments, who combined resources to break the ice and free the whales for their annual migration southward. Here Alaskan Eskimos tenderly stroke a frustrated whale as it seeks escape from its entrapment.

©Fred Ward

Toxic Waste/Black Star, 1984

The dump site at Swartz Creek, Michigan, one big open sewer of dangerous chemicals, was designated one of the first EPA Superfund sites. The state and the EPA spent more than 20 million dollars moving 120,000 tons of waste and contaminated soil to be buried elsewhere. During one of Ward's visits, it was determined that one contaminated open lagoon contained an oily sludge laced with PCBs. An EPA technician wearing a Moon Suit for protection used a plastic pipe to lift sludge from the oily lagoon. "Suddenly," says Ward, "the problem was clear, the danger evident, and the magnitude of the clean-up was apparent. I had related hazardous waste to people and shown the danger of handling it."

Cowboys/National Geographic Society, 1985

A *National Geographic* assignment first led Sam Abell to trace the steps of Charles Marion Russell, the cowboy artist of the American West. Abell described this photograph of branding and castration at the Ken Rosman Ranch as the best image he could make in a photograph in terms of communication and content and the use of every part of the frame front to back and side to side.

Meryl Streep/Contact Press Images, 1981

Meryl Streep, photographed in New York City in August 1981 while Leibovitz was a staff photographer for *Rolling Stone* magazine. The relationship she established between Streep and greasepaint is representative of the Leibovitz penchant for preconceived conceptual portraiture.

©**James A. Sugar**

Feathers and Gravity/Black Star, 1989

The lead photograph illustrating a *National Geographic* article on gravity showed Sugar's conceptual ability to visually interpret a scientific principle. The caption for the photograph said, "Newton was right. Objects will fall at the same rate in a vacuum. Feather and apple fall at the same rate in a vacuum chamber containing 50 mm. of air at Nasa/Ames in Sunnyvale, California."

Ideas: The Life Blood of
the Photojournalist

He is the greatest artist who has embodied, in the sum of his works, the greatest number of the greatest ideas.

John Ruskin, *Modern Painters*

Photojournalists need more than technical skills to succeed. Well-thought-out ideas are their most important asset. I have always been haunted by two contrasting images of hypothetical professionals. One could walk around the block and develop twenty editorial ideas worthy of exploration. His colleague could walk from Paris to Moscow and back and be at a loss for a single usable story idea.

I recently saw that still-marvelous old black-and-white motion picture *Inherit the Wind,* with Spencer Tracy playing the part of Clarence Darrow and Fredric March as the character representing William Jennings Bryan. The film is based on the landmark "Scopes monkey trial" in which a Tennessee schoolteacher was prosecuted for teaching the theory of evolution in a public school. Frustrated by the prejudiced judge, who denies him the right to call expert scientific witnesses, Darrow cross-examines William Jennings Bryan as the self-proclaimed expert on the Bible. During the course of his testimony, Bryan maintains that the only truth comes from the Gospel, to which the lawyer-protagonist replies with great emotion that "an idea is a greater monument than a cathedral." To dismiss new ideas is to preclude progress. Where would we be today if we had rejected the Pythagorean theorem or Isaac Newton's law of gravity? Openness and receptivity to new ideas in any area that affects man's growth arc absolutely essential.

When considering the importance of editorial ideas, I am concerned that photographic educators and institutions are too preoccupied with developing

the technical proficiency of America's student body. They virtually never train photography students to recognize photographic ideas, to develop and research those ideas, or to learn where ideas come from. Nor do they help to provide strategies for the effective presentation of ideas to editors.

In my early days in the photo agency business, I would often say to Kurt Kornfeld, one of the Black Star founders, "You know, Mr. K., I was thinking . . ." Before I could finish the sentence, his normal response was, "Howard, my boy, thinking is a matter of good luck!" An amusing comment perhaps, but it may not stand up. Relating thought processes to games of chance trivializes the one thing that distinguishes man from other forms of animal life. Thinking is an adventure. Thinking is power. Thinking is fun. To the photojournalist, thinking is a must in the development of editorial ideas.

There are, of course, photographers who survive making great or even adequate photographs of commonplace subjects. Some are just button-pushers, who fill in the spaces with ideas preconceived by art directors or picture editors. They are professional, technically competent, and useful in that they deliver the goods according to the demands of clients. This is particularly true in advertising photography or illustrative editorial photography, where the art director is king or queen, and the illustrations have to fit concepts sold and already approved by the clients. In photojournalism, ideas are at least as important as the other elements (technique, composition, content, selection of detail, sensitivity, rapport with the subject, storytelling abilities) that go into the making of a picture story, photographic essay, or news coverage. Without ideas there are no stories.

Granting that the job of magazine editors is to develop ideas that reflect the magazines' interests and audience, I would suggest that it is a rare publication indeed that will rely exclusively on staff editors to develop all concepts and stories in-house. They constantly turn to freelance photographers and other sources for new ones. The free lance can profit by this receptivity to outside ideas by being prolific, thereby enhancing his or her value to the publications. As the photojournalistic marketplace expands, the most successful photographers will be those who generate the most and the best editorial ideas.

The age of profligate magazines is long gone. Never again will we see bureaus of a magazine in every major city of the world. The new economics of magazine publishing dictate reduced overhead, careful control over expenditures, and reliance on freelance writing and photographic talent to fill many editorial needs. The photographer responsive to what is happening in his or her corner or other parts of the world can serve as an independent research arm and source of ideas for the magazines.

Even failed story suggestions have positive peripheral benefits because editors appreciate your interest in their magazines, and they may later reward you with assignments as quid pro quo. Doesn't it make sense that editors will be more inclined to use those photographers who have expressed most interest in their publications by making suggestions? The submission of ideas also gives the freelance photographer a valid reason to keep in more frequent contact with assigning editors.

Becoming an Idea Person

H. G. Wells said that "human history is in essence a history of ideas." Any photographer can be an idea person! If your mind is devoid of ideas, you can train yourself to develop intellectual processes that produce ideas and learn how to explore the existing raw material that can be turned into stories. No photographer who lives in a vacuum can develop ideas. Ideas come from people who have varied interests and a curiosity about the world and the people that live in it.

I remember many years ago having a discussion with the director of photography of a major American picture magazine. It had a staff of more than twenty photographers, some of whom, by virtue of the magazine's promotion, had become famous and financially secure. The photography director bemoaned the fact that his staffers were no longer hungry and driven by the same demands as the freelance photojournalists. Many of his photographers had retreated into wall-to-wall comfort and were no longer a source of new ideas for projects. Photojournalists have to be constantly expanding their world, exposing themselves to new people, new ideas, new experiences. David Douglas Duncan could never have done his monumental work on Pablo Picasso had he not pursued contact on several levels. Flip Schulke's multi-year documentation of the Reverend Martin Luther King, Jr., would never have been possible without his dogged persistence in covering the civil rights leader and the personal relationship he established with him.

Photojournalistic ideas must be visually translatable. Some ideas are so visually loaded that it would be almost impossible for a photographer to bring back an unpublishable set of photographs (for instance, skydiving, mental institutions, teaching one-year-olds to swim, childbirth, famine, street demonstrations, riots, the Amish, firemen fighting fires).

Other ideas are more difficult to photograph and depend on the interpretation of the photographer—say New York City, the Hudson River, and New York women. These are visual ideas, but much depends on whose vision. Jay

Maisel's New York would be much different than W. Eugene Smith's. Jay Maisel's photographs would reflect his preoccupation with wonderful color juxtapositions; Smith's depiction of New York would probe the depths of the human condition, center on wrongs to be righted and social concerns to be spotlighted. These editorial concepts are so subjective that the photographer's personal stamp determines the ultimate result.

Gordon Tenney, now deceased, was a Black Star photographer in the 1950s. Intrigued with the visual possibilities of the area surrounding New York Harbor, he proposed it as a subject to several magazines without success. It was one that depended on the photographer's interpretation; editors could not visualize or anticipate what he intended. Tenney's only option was to undertake the pictures without an assignment. He did so: he produced some preliminary images that provoked interest from *Fortune* magazine, and he ultimately wound up with an assignment and a published portfolio.

Human interest ideas will give you the greatest challenge. They will test your skills in dealing with people to make credible, storytelling pictures about the reality of their lives and feelings. That's much more stimulating and exciting than photographing inanimate objects.

Black Star's Lynn Johnson is a former *Pittsburgh Press* staffer. Her greatest asset is her ability to elicit trust from the people she photographs, and she has overcome many obstacles to produce pictures in sensitive situations. Her gentleness, shyness, and quiet unobtrusiveness mask her single-minded purposefulness when doing human interest photography. Her *LIFE* magazine story on a woman who overcame the psychological and physical debilitation of a double mastectomy is a classic. It's an inspiring document on a subject of concern to the millions of women who have engaged in the same battle.

Good ideas badly researched and badly presented are a waste of everybody's time. Busy editors do not want to be bothered with an indiscriminate avalanche of suggestions for which the photographer hasn't done his homework. A presentation should be articulate and succinct, outlining the essence of the idea, its visual possibilities, the time required to shoot it and the estimated expenses to produce it. The editor can then make a judgment as to whether it works within the budgetary limitations of the publication.

Bad editorial ideas make bad stories, or, to paraphrase current computer jargon, garbage in, garbage out. The successful photojournalist has to refine his or her ability to recognize deficiencies in an editorial idea based on lack of visual translatability, lack of conflict, logistical difficulties, problems of cooperation, or content. The mission of the photojournalist is to produce exciting

pictures on exciting subject matter. It is not the job of the photojournalist to reduce the world into one continuum of visual tedium.

Although there is great demand for self-contained, single, storytelling pictures, the experienced photojournalist will recognize that one picture does not a picture story make, nor does a captured moment of violence, nor do pictures of dead bodies. In the sophisticated world of visual communication, where we have a surfeit of those images, gratuitous brutality and death scenes are overrated; such scenes should only be included when they are important to the understanding of the events pictured.

Study the character of the publication to which you are submitting your idea. Tailor your submission to the defined needs of the publication. Editors appreciate photographers who make intelligent submissions based on knowledge of the distinctive needs of the magazine.

The Good Ideas around You

Photographic ideas are everywhere—in newspapers, magazines, books (fiction, nonfiction, poetry), music (like Debussy's "La Mer"), and on television news and feature programs. They relate to your life. They are in your head. The original idea that is not based on an event is the most distinctive kind of editorial idea. It can rarely be duplicated.

When Jim Richardson was a staff photographer at the *Topeka Capital-Journal,* he spent more than three years photographing life in the two hundred-pupil high school in Rossville, Kansas. The idea of documenting that high school's life was based on his knowledge of rural small-town life in Kansas. It is unlikely that another photographer would simultaneously have had the same idea. For Richardson it was a career-influencing personal project that landed him a series of picture pages in the newspaper, increased his prestige with the newspaper's editors, generated national publicity for his work, and ultimately resulted in publication of a major photographic essay in *LIFE* magazine and a 196-page book titled *High School USA.*

Good ideas are not necessarily complicated ones. The simplest are often the best. I think back to Archie Lieberman's photographic book *Farm Boy,* in which he photographed the life cycle of the Hammer farm family in Southern Illinois over a twenty-year period. A simple idea available to us all, but Archie Lieberman had the insight to develop it and the perseverance to follow it through over two decades.

The pre-Helen Gurley Brown *Cosmopolitan* magazine assigned a story to photographer Cal Bernstein when he was a free lance in Salt Lake City, Utah.

Cal had suggested a story on a high school married couple in Ogden, Utah, whom he had found. There were such couples in almost every city and town in the United States for other photojournalists to examine, but it was Cal Bernstein who recognized the value of the idea. He presented the idea and it was accepted.

I remember, too, another editorial idea that Cal Bernstein sold to the long-forgotten *Pageant* magazine. In its day, the *Reader's Digest*-size magazine was noted for getting the most bang for the buck out of its photographic essays. A limited-budget publication, it could not compete with *LIFE* and *Look* on obvious major stories. It made up for its financial limitations by responding to offbeat subject matter and innovative ideas. The photographers loved working for *Pageant* because the graphic designers always gave a thoughtful and striking display to multi-page formats.

Cal's story was called "The Rebirth of Loren Peck." It addressed a situation that was repeated over and over in communities across the United States. Loren Peck, an American GI, became a vegetable after automobile accident injuries. The Veteran's Administration in Ogden, Utah, was determined to rehabilitate him and restore some semblance of normality to his life. Cal spent six months on the story, periodically visiting Loren Peck, observing therapy sessions, and concluded his story by showing Loren's new life as an automobile mechanic.

The story was not only a journalistic success but an instance where the presence of the photographer was an important factor in the progress made by the patient. Psychiatrists and doctors at the VA Hospital were convinced that Cal Bernstein's continued interest and friendship during those six months did more for the rehabilitation of the young man than all the therapy combined.

Cal Bernstein was proof that locale is not a drawback in the development of story ideas. Some photographers might say, "Nothing ever happens in Salt Lake City, Utah." Or Gadsden, Alabama. Or Marietta, Georgia. In time, Cal Bernstein used Denver, San Francisco, New York, Salt Lake City, and Los Angeles as freelance bases and was equally successful in all of them. Not only was he a good photographer—he was also a prolific idea man.

Have you visited your local college, university or medical complex lately? You may find fascinating research projects in science, education, or the humanities that would make good story ideas.

Intelligently used, newspapers are a rich source of other salable ideas. Read them, clip them carefully, and use them extensively as the point of departure for further research, exploration, or expansion. If you don't have a good newspaper in your area, subscribe to such papers as the *New York Times,* the *Wall Street Journal* and the *Washington Post.*

Ideas can come to you at any time. Be prepared to keep them in a notebook, or carry a miniature tape recorder or one of the laptop computers that are used by many working photojournalists. An idea may come to you out of the proverbial blue while you are shaving, or listening to the radio in the middle of the night. Or you might see a feature story on television that has potential for you.

If you're a freelance photographer, progress isn't your most important product—ideas are. If your idea quotient is deficient, you can, through hard work, develop a keen insight into the elements that make for salable visual ideas. Keep a steady stream of carefully prepared suggestions flowing. Seek out new experiences so that you can not only broaden your perspective but also expose yourself to possible story ideas. Meet new people, expand your social life, go out of your way to meet people with different interests. Your photographic persona should be like a sponge, waiting to absorb and digest new ideas. With those suggestions you will lay the groundwork for future assignments as you work on current commitments. Try it. All you have to lose is the postage.

Flip Schulke, a Florida free lance, is constantly looking for story ideas. He is a maverick among photojournalists. He is curious, verbal, dynamic, and persistent. He prides himself on the fact that during his thirty-five-year career as an editorial photographer, he has managed to avoid commercial assignments. He has done this by finding and developing ideas, selling them to editors, and exploiting the secondary foreign and domestic markets.

"I'm interested in almost everything," he says. "I read voraciously and watch cable and foreign television news shows. The more you widen your knowledge, the better journalist you can be. I always make sure I know more about the subject than the photographers I'm competing with. But you have to love learning for its own sake, not for the sake of making more money."

The *New York Times:* A Source of Great Ideas

The *New York Times* prides itself on being the newspaper of record. It has been and continues to be one of the great newspapers of the world. Its far-flung bureau reporters penetrate remote corners of the world, reporting on geopolitics, art, science, sports, and every facet of daily life. You don't have to read the *New York Times* to be well informed, but reading a newspaper can certainly be a valuable habit.

Once, as an experiment, I decided to try reading newspapers as a source of editorial ideas. I took a week of the *Times,* read every word, and selected all

the possible ideas that could be found on its pages. I came up with fifty-one possible stories. Admittedly they were not all great, but they all had visual possibilities. Some were applicable to general publications, others to specialized magazines. Some were more pictorial than others. The challenge here was to prove that finding ideas takes many hours of research and reading.

These ideas came from regular news columns, letters to the editor, opinion columns on the op-ed page, editorials, the "week in review" section, the science section, the arts and leisure section, book reviews, and advertisements—every department of the paper. I heartily recommend this exercise to anyone who feels there's a shortage of story ideas. I can almost guarantee astonishing results.

Many of the potential stories suggested by a study of the newspaper are personality stories. I have long thought that most personality stories are too superficial. But spending time and developing the confidence of a subject allows for greater penetration into the lives of the subjects. Magnum photographer Eve Arnold's multi-page essay on Joan Crawford many years ago was a spontaneous, real-life look at the Hollywood star rather than a preconceived and manipulated set piece that fulfilled a public relations dream.

David Douglas Duncan revealed Picasso as a man whose art permeated every moment of his waking day. Fred Ward's book, *Portrait of a President*, took three months to photograph and showed us the human side of the Ford presidency. To produce a quality portrait story requires as much research and investment of time as any other photographic endeavor.

Ideas for a Global Marketplace

I have constantly made reference to the fact that the photojournalistic marketplace is global, that the market for ideas does not begin and end with major American magazines. I would suggest that the global marketplace in the aggregate is financially more important than the U.S. market. The successful editorial agency and photojournalist can no longer treat foreign markets as auxiliary markets. In some cases, they become primary markets for ideas that may not be salable in the United States, where the interest in mass-media publications is limited. A regenerated market in England, an ever-expanding Italian market, with many competing magazines, and vital French and German publications should be explored.

Understanding the global marketplace necessitates study of foreign publications. It also requires a knowledge of the mind-set of the editors who serve the interests of their constituencies. It is important to know that the French have a

great interest in African subject matter, based on their historical involvement in African affairs. A residue of the British Raj still generates English interest in India.

Newsweek's director of photography and former New York head of Sipa Press Jimmy Colton says that the European market has an almost insatiable appetite for stories in the following categories:

1. Colorful features emphasizing the bizarre if not crazy lifestyles of the American people, what Colton calls "wacko stuff."

2. Negative stories about the United States, anything that feeds the negative image of the "Yankee imperialists"—drugs, sex, rock and roll, the homeless, etc.

3. Entertainment personalities well known on the international scene.

4. Animal features are a big hit in Europe. In France, where dogs are loved almost as much as in England, any story showing dogs in incongruous situations will be a sure seller (i.e. a waterskiing dog, a skateboarding dog).

For most of the years at Black Star, Yukiko Launois and I made the judgments as to which stories would interest the international market. There's no sure-fire way to determine what will sell. Sometimes we went on just plain gut-instinct; other times we might have made a decision based on the quality of the photography and the uniqueness of the story. It is interesting to note that the sale of a story in one country does not necessarily presage the sale of the same story in the other countries being serviced.

Presenting Your Ideas

I once asked different picture editors to tell me how their publications reacted and responded to the presentation of ideas from freelance or outside photographers. Some of these individuals are no longer with the publications they mention, but their comments are nevertheless valid, informative, and helpful.

The seemingly gruff but always professional Robert Gilka was for many years the director of photography at *National Geographic*. He was the patron saint of young journalistic photographers, many of whom today owe their status to his no-nonsense guidance. Many young photojournalists' ultimate ambition is to be "staff" at the *Geographic* or at the very least be assigned by the magazine and see their work published in multi-page formats. There are few publications left in the world in which in-depth photojournalism predominates; *National Geographic* is one of them. So if you want to present an idea to *National Geographic* with at least a modest chance of acceptance, heed the words of Bob Gilka.

Yes, the development of ideas and presentation of ideas to editors is of prime concern to free lance photographers. And, yes, it well may be their greatest deficiency. But the free lance who complains about not being able to sell an idea may also be the one who shoots himself in the foot. Preachers on the subject have been telling writers and photographers to "know your market."

At the *National Geographic* this means having a first-hand knowledge of what subjects "old yellow" has published in the last five or even ten years. Or it means having the common sense to look at the *National Geographic* index, which is available from The National Geographic Society, Washington, D.C. 20036.

In the index a free lance can tell in a minute if a subject he is thinking of has appeared in the *Geographic* and when. The fact that the subject has appeared will not in itself be lethal to the idea. The free lance may have a different angle, a more up-to-date theme, a special and important reason for doing another article.

Why bring up what seems to be so obvious? Simply because many free lance photographers—some of them "name" shooters—have come to us with ideas for stories we have published within the last six months.

When a free lance comes at us with an idea for a story on Hong Kong three months after we have published an article on that city, one must wonder just how well the free lance has studied us as a market. We do not print profiles about living subjects, yet we receive suggestions for such stories every month. Of course, two days after someone reads this, he or she may see a story about a living person in the *Geographic*. But it will be the exception to the rule.

National Geographic publishes many stories about places—cities, states, countries, areas—typical subjects in the minds of the casual student of the magazine. But we arrive at the subjects with some care. If, for example, we do an article on Mexico City (August, 1984), we do it because we know from research the place is a city in trouble, a city growing so fast it cannot possibly sustain all the people who flood into it. We do it, too, because we can make Mexico City an object lesson. We can tell our readers that happens when too many citizens of one country leave the farms for the big city. And we can tie our Mexico City story to a sidebar on the population explosion.

Too often we get suggestions for a story on a geographic subject and the contributor does not convince us the subject is worthwhile. It is as if the free lance has looked at the index and has found that we have not published a major piece on Paris, for example, since 1972. So he tosses off a suggestion on Paris and sends it to Washington. But nowhere in the suggestion is there a reason why we should do such an article. The contributor would have been as well off if he or she had tossed a dart at a map of the world, then suggested a story on the city or country where the dart struck.

When an editor receives a story idea, the first question he is going to ask is: "Why should we do this story?" Other questions may include: "Will this story be of interest to our audience?" or "Does this free lance have his facts straight; is that really the situation in East Paducah or the Southern Sudan?"

A story suggestion should be so convincing that the editor will feel he just cannot afford to let the opportunity go by. The reason "why" should be established well up in the written suggestion. It should not be buried deep in the precis.

Freelancers should be aware that the timing factor is important. Some stories just cannot be done before their time, yet we get numerous suggestions that may have potential next year or over the long haul. A hypothetical example: the Corps of Engineers finally has been promised funding for the long-planned Marshkill dam in North Dakota. The conservation-minded free-lance, aflame with zeal, writes in and tells us all that is bad that is going to happen when the dam is complete and 500 square miles of waterfowl habitat is drowned. All this may be true, but what can be done now, not on a news basis, but in a magazine the normal lead time of which is six months?

Obviously the style and presentation of the idea are important. A few years ago, a freelance submitted an idea about a story on the railroads of India. I turned down the idea, simply because I was not convinced in reading the suggestion that the story was for the *Geographic*. First of all, we seldom do articles strongly oriented toward things, rather than people. Second, this suggestion was not at all provocative. It did not hint at any excitement. It did not point out that Indian railroads pass some fascinating places, such as the Taj Mahal, and traverse some rough country such as the foothills of the Himalayas. No. Based on this suggestion the railroads of India did not look like our kind of topic.

But later, when the idea was submitted anew by Steve McCurry, a photographer who had been in India and could point out the visual excitement in the subject, and Paul Theroux, a writer who already had proven he could make railroads live on a printed page—then we went after it and the result was published in June, 1984.

How to present ideas? Editors seem always to be the busiest people in the building. They have much to read, so suggestions should be concise. General Eisenhower used to insist to his staff that wartime memorandums be held to a single typewritten page. That's not a bad idea for the freelance, although sometimes a subject is so complex, the suggestion will have to run longer.

Most editors are literate. For them, a misspelled word or punctuation mark, or an error in grammar is like a stop sign alongside the road. It also causes them to wonder if the writer really cares about what he or she is trying to say. Be literate!

Research should be thorough enough to convince the editor that the free-lance knows of what he writes. In the case of the *Geographic* it is next to impossible to sell us on an idea about a place the freelance has never visited. If the research is so contemporary it quotes experts, those experts should be identified and their qualifications set forth. When, for example, John Launois suggested a story on aging to the *Geographic*, he cited Dr. Alexander Leaf, a

leading authority on aging and a member of the staff at a leading Massachusetts hospital.

What are the visual possibilities of the proposal? If, for example, the suggestion is for a historical piece, how can it be illustrated? Example: The *Geographic*'s story called "Flight To Freedom" (July, 1984), a piece about the underground railroad. The subject offered few ready-made picture ideas, but Louie Psihoyos, a creative photographer, developed photographic illustrations which made publication possible.

Does a proposal need to be accompanied by a portfolio of the freelancer's work? Yes, if the portfolio is not known to the *Geographic*. Such a portfolio should show the photographer's versatility—ability to work with people, make the big scene, handle lights, and all the rest a good generalist can do.

The percentage of ideas from free lances which are finally approved by the Geographic's Planning Council is low, certainly less than 1%. But this is misleading. We receive large numbers of suggestions from outside sources. At one meeting we considered more than 100 United States story suggestions. Most of what we publish is by freelances.

Christiane Breustedt, formerly photo editor of *Geo* in Germany and now deputy editor-in-chief of *Saison* magazine, does not give assignments to photographers whose work she does not know. She evaluates ideas in relation to the photographer's work. She says,

> The photographer has to convince me visually (through his or her work) that he/she is capable of translating an idea into photographic images. For example: If a photographer suggests a story on a synchronized water ballet and their training conditions, I don't want to see a portfolio full of portraits.
>
> I am often stunned by the lack of imagination photographers use in the presentation of their stories. I often feel that the photographer is often not personally convinced of the soundness of the idea since answers to questions are all too often vague and unconvincing. It is the task of the photographer to make proposals that are convincing and exciting to me as the photo editor.

Smithsonian magazine is basically a text-driven magazine that rarely accepts editorial ideas generated from the photographic side of the fence. Caroline S. Despard, the picture editor, suggests that

> if a photographer has worked with me before, the best approach is to telephone and give me a brief run-through of the idea. I can usually respond immediately as to whether we have already covered the subject or if it is not right for us for any one of a number of reasons. Sometimes there is no clear-cut reason; it simply doesn't feel right. If there's the faintest chance that the idea might work for us, the photographer should go on to the next step; this step is where a photographer unknown to me should start.

The *Smithsonian* magazine needs a concise page or two depending on the complexity of the story. The proposal should cover:

1. A general introductory description of the idea.

2. Magazine. Is there a peg? What are the main points to be covered. Mention any specific events or facts that can be contributed without extensive research.

3. Suggest a writer and/or expert on this particular subject. Note specific picture possibilities. If there are time limitations, such as events that must be covered or sacrificed, the photographer should mention them here. There is a discouraging side to the proposal business for photographers. Most of our stories come from writers as text proposals and are commissioned by the text editors. Text editors are rarely enthusiastic about photographers' suggestions for subjects and writers.

Photographers frequently send in ideas on broad general subjects or well known happenings that are rejected. Some time later we may run such a story and the photographer feels abused. The fact is that such ideas are not copyrighted. The same proposals come from many directions. It may come in from later that such an assignment has been made.

Sample of a Good Proposal Offered to and Accepted by
Smithsonian Magazine

The Unique Problem of Pollen Allergies by Yoav Levy

Synopsis: This proposal is about the POLLEN ALLERGY PROBLEM that strikes millions of Americans each year. It deals with the scientific studies being done on this subject as well as the types of treatment that exist so far. As a freelance photographer, I am not proposing to write the article, but to produce the visuals with a varied gallery of photos using my best talents as a photojournalist, having experience with lab situations in general and with scientists and doctors more specifically. My studio will make available the possibility to produce MACRO shots. My agency can make available SEM (SCANNING ELECTRON MICROGRAPHS) of pollens produced by our collaborator and friend, Dr. Dennis Kunkel.

More Information from my Readings:

The National Institute of Allergy and Infectious Diseases estimates that more than 14.6 million Americans have hay fever each year and another 9 million are victims of asthma, which can be a serious companion to pollen allergy.

The physical and emotional suffering of the allergic person are well recog-

nized and the lost earnings and medical expenses due to pollen allergy is correspondingly high. It is, without doubt, an important issue of a national scale.

Some Interesting Facts:

1. Neither hay nor roses are common causes of hay fever or rose fever. Instead the culprits are grasses, trees, and weeds, the anemophilous or wind pollinated plants.

2. A single ragweed plant can produce 2 trillion pollen grains during its life span.

3. Alaskan pollen has been found in Oregon and rural New York State pollen has found its way to Wall Street.

4. To be airborne, pollen is somewhere between 15–50 microns in diameter, small enough to be invasive of the human nasal structure.

5. Somewhere in the neighborhood of 100 plant species produce pollen that can be significantly responsible for human allergy diseases.

Visual Potential

The unbelievable beauty of plant allergens (ragweed, flowers, or trees) will be shown with a gallery of color MACRO shots (1 to 1, up to 12 times) of their flowers. Samples will be taken from scientists if shot during March/April 1984.

Option:

In addition to macro shots, we can provide stock photographs of Pollen Scanning Electron Micrographs. If specific requirements are given, we will ask our collaborator, Dr. Dennis Kunkel, to furnish us with more pollen from plant allergens. (Please see samples in our proposal kit.)

I shall follow the major scientific studies related to Pollen Allergies done in this country. I would like to visit the ragweed (hay fever) study lab of the Mayo Clinic and Foundation, the seasonal pollen allergic studies at Rockefeller University and Cornell University, and the disease studies of airborne allergens at Johns Hopkins University. I shall follow scientists involved in these studies, their lab and the cases they work on. My experience in lab situations is unique due to the specialty of my photo agency in science and technology. I shot many scientific profiles and lab environments during the year for major publishers.

Moreover, the human interest side, with patients being part of the various types of treatment being done at different treatment centers in the country, will

be covered (i.e. The Dr. Albert Mallen Ecologic Center (Connecticut) with their PROVOCATIVE SUBLINGUAL TESTS. Also I will follow skin test centers using diluted pollen to test their patients.)

Training Oneself to Develop Mind Ideas Based on Specific Themes

I have said that one can train oneself in the development of editorial ideas. Let's try to take some specific subject areas of common interest to us all and see how many editorial ideas we can generate in those areas. All it takes is creative thinking, letting the brain explode in all directions, a kind of private brainstorming. The list that follows will be based on my thoughts. I am sure that those of you who attempt it will find dozens of ideas to add to the lists.

The Farm

1. "Four Seasons on the Farm"—This can be done as one major project and show how life and work and the natural surroundings on one particular farm are conditioned by the seasons—spring, summer, fall, and winter. Or one could do individual features on each of the seasons.
2. "Bachelor Farmer"
3. "The Farmer Takes a Wife"
4. "Farm Wife"
5. "Farm Boy"—This would detail the life of a twelve-year farm youngster, his chores, his relations to animals and the land, etc.
6. "Summer Storm on the Farm"
7. "Drought"
8. "Farm Auction"
9. "The Bankrupt Farmer"
10. "The Computer Comes to the Farm"
11. "Organic Farming"
12. "Biotechnology on the Farm"
13. "Farm Bureau Agent"
14. "Amish Farm"
15. "Blind Farmer" (or other handicaps that have been overcome)
16. "Dairy Farmer"
17. "Fish Farming (Aquaculture)"
18. "The Barn"
19. "Blizzard on the Farm"
20. "The Vanishing Small Farmer"

21. "Agribusiness"

Try to think of other generic subjects that could give rise to visually expansible ideas. Here are some that come to mind:

Old Age

Stories about the elderly homeless, the accomplishments of vital older people in incongruous activities (as airplane pilots, hang gliders, cheerleaders), foster grandparents, Alzheimer's disease, longevity, centenarians (or septuagenarians, octogenarians, nonagenarians).

Weather

Missouri mud, monsoon, mud season in New England, hurricane!, tornado!, typhoon!, hurricane hunters (pilots who track hurricanes and fly into the eyes), summer heat.

Rural America

Sunday in the country, Saturday night in small town America, polluting the rural landscape, changing rural America, an aerial view of rural America.

Some Basic Rules for Submitting Picture-Based Ideas to Editors

1. The idea should be visually translatable.

2. We're talking journalism. We're talking communication and content. In writing the proposal, it is not necessary to spell out preconceived individual pictures, but the text of the story suggestion should be replete with visual imagery.

3. The idea should be presented in a tight, cohesive, simple proposal.

4. The proposal should address why the specific publication should be interested in publishing a story on that subject. If it is a special interest magazine, mention the interest of that magazine's readership in the subject. Or there might have been a specific news event that provides a peg for the idea, making it particularly relevant.

5. The idea should have a nucleus, a central theme, a core from which the elements of the story radiate. Unfocused, generalized ideas based on news events alone should be avoided unless you're dealing with news magazines like *Time, Newsweek,* and *U.S. News and World Report,* which are more concerned with individual pictures than with comprehensive stories.

6. Proposals for stories should reflect strong personal interest in the idea. If you're not keen on the idea in its presentation, how can you expect to inspire the editor to give a positive response? The photographer should be well informed about the subject and be able to give thoughtful, specific, concrete responses to questions from the editor.

7. Sell your ideas enthusiastically, whether in person or through written proposals. Selling enthusiastically doesn't mean using generalized statements like "I think this would be a good subject for your magazine." Instead you give specific reasons why the story would be appropriate for the readers of that publication.

8. Above all, research, research, research. Researching a story idea requires patience, diligence, and hard work.

Developing a
Photojournalistic Aesthetic

In life, courtesy and self-possession, and in the arts, style, are the sensible impressions of the free mind, for both arise out of a deliberate shaping of all things and from never being swept away, whatever the emotion, into confusion or dullness.

William Butler Yeats, *Essays and Introductions*

Before you can develop an aesthetic and find a distinctive style, you must first define yourself. What are your enduring interests and deepest concerns? This definition calls on your sense of self and demands its honest evaluation. Your interests and concerns will and should manifest themselves in the subjects you choose to photograph and the manner in which you do so. Are you a people person? If so, involve yourself with photographing human subject matter. Interested in the environment? Pursue questions relating to the preservation of the natural world. An adventurous person might pursue risky subjects of photography. Knowing yourself is the foundation of genuine style.

Developing a Style

Style refers to individualism, distinctiveness, and flair. It is what differentiates the ordinary from the extraordinary. Sometimes it means "personality"; sometimes it occurs naturally, and at others it is cultivated by public relations people. The development of a singular identifiable personality is important to the photojournalist. Editors often respond to the sheer force of the photographer's personality in their reception of an idea or their choice of a particular photographer.

Style may also refer to the vision of the individual as reflected in his or her work. The work of great painters, architects, and musicians is recognizable by this kind of style. Picasso painted in many styles, reflecting the different periods of his creativity and his search for new ways of seeing. Rembrandt, Renoir, Matisse, and Andy Warhol all had unmistakable artistic styles. So did Giacometti, Louise Nevelson, and Noguchi. Frank Lloyd Wright's architecture, Cole Porter's lyrics, and Richard Rodgers's music all served to make their creators paradigms of style in their respective fields.

In photography, too, we look for the identifiable style. Diane Arbus had a confrontational style, one heightened by her subject matter—freaks, freaks, freaks. W. Eugene Smith's style was based on the possibly calculated development of his own victim-personality combined with his professional preoccupation with chiaroscuro effects in his prints. Ansel Adams depended on perfect reproductions of his subjects, the primeval landscapes of the American West. Ken Heyman recently developed a "hipshooting" style that magnified the happenstance beyond the photographic eye's scope.

For each of these photographers, the style of their pictures is dictated by subject matter and the use of methods that are consistent with their own vision. Thus they make their own ways of seeing recognizable. One cannot imagine Diane Arbus taking pictures with the casual carelessness of Ken Heyman, or Gene Smith finding satisfaction in an Ansel Adams-like landscape.

For the working American photojournalist in a field where objectivity is demanded, developing a personal style may seem to be an antithetical approach. But photojournalists in Europe are encouraged to put a personal stamp on news events, so an examination of the differences between the two journalistic codes may help broaden what American photographers and editors are willing to accept as news photography. The American aesthetic has already begun to make room for a more European approach.

The American Aesthetic in Photojournalism

It is difficult for the American photojournalist to develop a distinctive look, since traditional journalistic values stress content and communication rather than style. Most American photojournalists are traditional and emulative, responding to editorial demands for direct, unambiguous photographs.

In the past, the University of Missouri, which has schooled many of today's foremost newspaper and magazine photojournalists, subscribed strongly to that view. Today in Missouri's photojournalism sequence, the students are introduced to the European aesthetic and the special ideas of a diverse group of photogra-

phers. They are encouraged to be open to different ways of seeing and expressing themselves rather than being bound by past traditions or inflexible standards.

Bill Kuykendall, who became head of the Missouri photojournalism program in 1986, talks about the program's past and future.

> For the past thirty years or so, there has been a sort of mind-molding triumvirate—the University of Missouri (through the Pictures of the Year competition), the National Press Photographers Association (through its clip contests and educational seminars), and *National Geographic* (through its unmatched visibility as a standard setter and the influence of its heroic photographers)—that defined professional values and goals for many newcomers, sometimes for the better, often for the worse.
>
> I think often of the McLuhanesque book, *They Became What They Beheld*, when I consider how this triumvirate shaped my own values and the values of many of the students who today come our way. Indeed, those in my basic photo class who have the greatest trouble discovering how to see freshly are those who have already been imprinted by the conventional value system and who are too intent on fleshing out their portfolios with the proper mix of sports, evergreen features, low-key portraits, and short stories.
>
> At one end of the student spectrum today is the poor but bright graduate student with no photo experience, a bachelor's degree in English or anthropology, blissfully unaware of the monthly clip contest winners. At the other end is the brash, former high-school news- and sports-shooting yearbook photographer replete with motor drives and long fast lenses, who often views college as a finishing school or a place to network and troll for internships. It's great having both around. Fortunately, however, there are more and more of the former. This makes for a healthier mix of ideas and diverse career discussions that challenge each student to look inward for the answers to how he or she can become his or her best.

American photojournalists have long admired "the decisive moment" thesis advanced by Henri Cartier-Bresson, which demands the coming together of all elements of the photograph in a formalized compositional structure. Such pictures are straightforward, narrative, and understandable. They ask the viewer for visual literacy but do not ask for anything more.

For those who share my picture-editing philosophy, events pass before the photographer's eye and the camera's lens. The photographer's obligation is to distill the event and make it intelligible and understandable to the viewer in an objective way. The American aesthetic I have held through the years admires coherence, content, and composition. Underlying this theory is a need for truth and objectivity, and a belief that the photojournalist serves as an eyewitness to history.

Few American photojournalists have chosen to deviate from the accepted orthodoxy of traditional photojournalism in their search for personal styles. Most photographic staffs on American newspapers are interchangeable, endorsing the same photographic and journalistic aesthetic. I have, indeed, always encouraged a pictorial narrowness that has emphasized coherent photojournalistic literacy in place of experimental or ambiguous imagery. I still subscribe to a journalistic philosophy that serves the photographer and the public well.

Brilliant work can be and is done within the strict definition of inherited journalistic criteria. The *LIFE* essays of W. Eugene Smith, such as "Country Doctor," "Nurse Midwife," and "Man of Mercy" (Dr. Albert Schweitzer), have inspired many photographers. Bill Eppridge's "Needle Park" is still remembered as a groundbreaking essay in interpreting the human devastation wreaked by heroin addiction. Pulitzer Prizes have been awarded to such photographers as Brian Lanker, for his powerful images of a mother and father during childbirth, and Anthony Suau, for his confrontational images of starvation in Ethiopia, which aroused the consciousness of the world.

The European Aesthetic in Photojournalism

There are many ways of seeing and photographing, and each has validity. This was brought home to me in 1985 and 1986 through my association with Christian Caujolle, the French picture editor.

Christian Caujolle's approach to pictures is representative of the contemporary European attitude toward photojournalism. His generation is turning away from Cartier-Bresson's "decisive moment." Robert Frank has a highly interpretive style. This subjective and existential approach has revolutionized photography in general and photojournalism in particular.

Rudolph Wurlitzer, writing in *Robert Frank,* described Frank's pictures as "images from the back roads of culture, the sad-eyed margins where the process of life is most exposed. . . . No one performs, no one arranges an object or turns a profile. Death is here, and celebration. Loneliness and hope, decay and poetry, grief and survival, and those rare moments when a man happens on his own essence. Lives frozen and illuminated and transcended within their own routines."

Caujolle, a former director of photography at France's *Liberation* newspaper, applies the same subjective approach to his work at VU, the French picture agency he founded. It syndicates *Liberation* pictures and offers coverage of contemporary arts, politics, lifestyles, and fashion.

In February 1985, when we served as international jurors at the World Press Photo Competition, in Amsterdam, Holland, we sat next to each other through five intense days of picture judging. In spite of the miasma created by Caujolle's chain-smoking, it didn't take me long to realize that I was working with a picture editor with an uncommon intellect and a devotion to photojournalism. We again judged together in 1986 in Amsterdam and subsequently worked as editors on *A Day in the Life of America.* I was with him again as one of the judges of the 1986 W. Eugene Smith Grant in Humanistic Photography. Although Caujolle and I often disagree, we share the same feelings about photography.

"Editorial decisions are political decisions," says Caujolle. "I am not interested in objectivity. I am interested in the photographer's emotion. I want the photographer to think about the best manner to express what he was thinking and feeling about the events he was photographing. It is the responsibility of the editors to find out how the photographer feels about his pictures and not to use them out of context to substantiate editorial viewpoints." Because of my conversations with Caujolle, I began to question the rigidity of the American demand for objectivity and noninvolvement. I have come to be more receptive to allegory and symbolism and less intolerant. While I still search for an elusive truth in a photograph, I also watch for the unexpected image that has greater complexity and drawing power. Photographers who experiment and achieve looser, less rigorous, more provocative and unpredictable treatments offer much to the future of American photography.

English photographer Bill Brandt recognized that photography is still a very new medium and that everything must be tried and dared. To dream, to dare, to try, to experiment, and to surprise: those are the challenges for photographers who want to jettison visual predictability.

Contemporary war photography shows us how static and unimaginative American photojournalists have become. The locations of each war may change, but the pictures remain the same—clinical and entirely expectable. "Being there" may no longer be enough in a visually sophisticated world surfeited with imagery. Perhaps one must go beyond the dead bodies that no longer shock a public that, since Vietnam, has been served televised carnage with their evening meal.

The American versus the European Aesthetic

To better define the difference between the American and European aesthetic, I asked Christian Caujolle to take two photographs of comparable

thematic material and delineate the difference. We chose two photographs: one by W. Eugene Smith, the other by Robert Frank.

Caujolle recognized that comparing the work of two photographers by arbitrarily choosing one picture by each is an oversimplification. Both photographs were made in South Carolina in the 1950s. Although the subject of these pictures, the relationships between black women and white children, is the same, the social situations shown in each is different. Smith's picture is from his "Nurse Midwife" essay on Maude Callen, a black licensed nurse who gave medical care to more than ten thousand people in a rural four-hundred-square-mile area of South Carolina, published in *LIFE* magazine. Frank's is of a black nursemaid and her white charge in Charleston, and it appears in his book, *The Americans.*

Here is Caujolle's view of these two photographs:

> For me what is most important is the difference in the approach of the two photographers to their common subject. Frank's picture is a single direct shot focused on two people that romanticizes the issues of racial inequality and segregation. Frank is travelling, stopping to photograph small vignettes that touch him emotionally.
>
> W. Eugene Smith's photograph also speaks about human relationships. But Smith's framing and focusing include much more information than Frank's portrait. Smith's picture is more precise and, therefore, journalistic in its content, and it arouses a different emotion in the viewer. Smith is reporting, telling a story.
>
> These two photographs are beautiful in their aesthetics and emotional content, as well as their humanity and honesty. I don't think one is better than the other. They serve as first-rate examples of two different traditions— European and American—to demonstrate the immense creative possibilities of looking at the world through a camera.

The lack of specific detail in Frank's picture lets it draw out different emotions in different viewers depending on the personal conditioning of the observers. Smith, the pure storyteller, provides much specific information, creates a very clear picture of what is happening, and asks the reader to accept his evaluation of the moment. This specificity enables him to control the response.

The discussion about these two pictures and these two photographers leads us to the familiar conclusion that truth is not absolute, that there are different kinds of truths, the emotional versus the factual. No matter how hard we try to eliminate ambiguity, it is an inherent component of every photograph. More so in the Frank picture, where the image focuses on the relationship of the white child to the black nanny with no peripheral information to give us a sense of

place or additional contextual facts. We, therefore, must rely purely on our own response to the image. The factual evidence in the Smith picture leaves little work for us to do. Maude Callen, as presented by Smith, is just an overworked servant of her time.

Decisive and Indecisive Moments

In the introduction to Elliott Erwitt's *Photographs and Anti-Photographs,* John Szarkowski, former curator of photography at New York's Museum of Modern Art, wrote, "In comparison with the great issues of the time, the subject matter of Erwitt's pictures is small beer indeed. His simple snapshots are no more heroic than the hapless and untidy lives of individual men. They deal with the empty spaces between happenings—with the anticlimactic non-event. . . . Over their inactivity hangs the premonition of a pratfall. From these unmemorable occasions, Erwitt has distilled, with wit and clarity and grace, the indecisive moment."

To those who have honored Henri Cartier-Bresson's "decisive moment" photography, this is heresy indeed. But even when I disagree with John Szarkowski, he makes me think. So I've been thinking about "the indecisive moment."

I think American photojournalism has become overly preoccupied with "capturing moments." Many people misunderstand or misinterpret what Cartier-Bresson meant by the "decisive moment." To him, it was the moment when form, design, composition, light, elements, and events all came together in a unified whole at the precise and perfect moment for the photographer. We Americans, however, have tended to equate "decisive moments" with maximum dramatic impact derived from animated physical expressions. We look for moments of birth, death, confrontation, and violence. There is more to the documentation of the human condition than the chronicling of dynamic events at decisive times. Most of our lives are devoid of them. We are pretty ordinary, doing ordinary things, on the dull edge of tedium. For visual journalists, perhaps the time has come to rethink the philosophical basis that determines not only how we photograph but what we photograph.

It is comparatively easy to find visually loaded subject matter in the headlines of the week—the Mexico earthquake, Hurricane Gloria, the Iran-Iraq War, the Ethiopian famine, Iraq's invasion of Kuwait, the fall of the Berlin Wall and the like. I respect anyone who covers these events and produces strong pictures. There is, however, a greater challenge for the photographer who uses the commonplace as his arena. This is where "indecisive moments"

are found, in the daily experiences of people who go through the repetitive routines that make up much of our existence.

Indecisive moments can be photographed decisively. W. Eugene Smith's essay on the Spanish Village is a classic example. Smith documented the stuff of life with depth, intelligence, form, content, and meaning. Indecisive moments are all around us, waiting for an energetic and observant photographer with a camera to shoot. "Daily life" photography offers individuals more freedom to seek out their own vision and the opportunity to develop a recognizable style.

Personal Projects

Projects are what I live for. That's why I became a photographer—
to be able to get deeply involved in an issue, to take it from
beginning to end, and get involved with all aspects of its ful-
fillment.

Stephen Shames

Throughout the world, photojournalists are working on personal projects. These are long-term, independent projects generally not subsidized by newspapers, magazines, or book publishers. They are often the projects that are closest to the photographer's heart; they can be the key to effective photojournalism and career advancement. W. Eugene Smith pursued personal projects throughout his career; his famed "Minamata" essay epitomized the independent project fueled only by the photographer commitment. He carried it out with his wife, Aileen, over a four-year period.

Every photojournalist can undertake an independent photographic project, but few do. You have to be self-demanding, self-motivated, and stubborn. You have to be willing to spend many hours, maybe years, on the project, and subordinate other pleasurable aspects of your life to it. But, above all, you have to have an idea. It doesn't have to be an idea with great social significance in some distant country where every vista is pictorially loaded. The commonplace is sometimes equally rewarding, and it has the advantage of being less expensive to produce. You can literally do a project in your own backyard.

Bill Owens's backyard was Livermore, California. In the late 1960s he was working as a Livermore newspaper photographer. In his spare time, he began to photograph his neighbors and the life they lived in their tract homes. Owens explored the social phenomena of existence in his book, *Suburbia*. He later followed up with other projects. One, based on the American penchant for

joining groups, resulted in a book titled *Our Kind of People*. Another, for which he photographed people at their occupations, was titled *Working, I Do It for the Money*.

Freelance photographer Jill Freedman found two of her independent, long-range projects where she lived in New York City. After her successful *Circus Days* book project, she set out to document the life of New York firefighters. Her study became a photographic book called *Firehouse*. She followed it up with a set on New York's finest in *Street Cops*.

In addition to the previously mentioned small town high school project, Jim Richardson worked for many years documenting life in Cuba, Kansas. Richardson describes Cuba as a "nondescript town on the harsh land of the Kansas prairie." Cuba has a population of three hundred people, whom Richardson hoped to use to answer some of the questions "about why we are social beings, why people live close together, why some things work and others don't, why in some places we make a travesty of our own existence."

Cuba, about ten miles from where the photographer was born, is a place where, according to Richardson,

> events come in small doses and people are waiting for things to happen, where one has to learn to pass an afternoon worthlessly. It is a harsh land which gives a living only grudgingly, where dust is more plentiful than rain.
>
> When I go to Cuba, it strikes me what a wonderful privilege it is to be a photographer—nothing prepares you for some of the wonderful, unplanned, and unimaginable simple moments you encounter. How great it is to stand midstream in life and feel it swirl around you as real as a prairie. Any long-term production attracts professional attention. The depth of time adds quality to the pictures. It certainly helps me professionally and in my photography. Cuba is mine. Nobody has any claims on it but me. The story is important, so what I'm trying to do is talk about the town, the people, what's going on in Cuba.

Anthony Suau, a Black Star staffer and a Pulitzer Prize-winner for his coverage of the Ethiopian Famine in 1983, continues to pursue projects because they are basic to his photojournalistic philosophy and his career goals. He has long since established his bona fides as one of the world's outstanding photojournalists. He does not use this approach as a career-builder, in the way that a newcomer to the profession might. Personal projects are his career.

In 1989, Suau hit on a comparatively simple editorial idea that was there for the taking by any photographer. Although many photographers had covered individual pilgrimages and religious festivals in Europe as individual story entities, Suau brought new dimension to the idea by undertaking to photograph nine different pilgrimages in six different European countries. Thus he hoped

to show that these pilgrimages in Europe were but a microcosm of the hundreds of religious celebrations that take place annually in both Eastern and Western Europe. From Portugal to Greece, from Ireland to Poland, millions flock to sanctioned holy sites to do penance or in search of miraculous cures. Worshippers spend many days walking to places like Fatima in Portugal, climbing mountains in Croach Patrick, Ireland, or crawling on all fours to church shrines like those in Tino, Greece. Most of these sites are recognized by the Roman Catholic Church, which gives impetus to the "believers" who undertake these pilgrimages.

Suau's project was executed in black and white despite the overwhelming demand for color in contemporary magazines. Yet as a well-conceived idea, brilliantly executed, it generated worldwide sales at top prices. The time and expenses required to cover several events in many countries were eventually more than justified.

"In attempting to present these events as objectively as possible," says Suau, "I have tried not to pass judgement on these situations, but to present my visual impressions of their existence. This may help to show that despite the disparities of the major religions—Muslim, Jew, Christian, and Buddhist—there is a similar appeal among all faiths in their search for miracles and through spiritual pilgrimages."

Anthony Suau continues to pursue this personal project in Eastern Europe now that the Iron Curtain has been opened and there is greater accessibility for Western photographers. Where this will ultimately lead is difficult to tell. Suffice to say that Suau is building a body of work on a subject of great interest to him, replete with dramatic subject matter, and of great import in understanding man's penchant for religion and his fascination for ritual.

Lynn Johnson, a Black Star staff photographer, is a gentle lady. Her soft-spoken presence masks her relentless strength and follow-through on ideas that interest her. There are few photographers I have met through the years who can penetrate the lives of others under the most difficult circumstances and gain their trust and confidence. As a photographer, she is not a dispassionate observer. She shares the lives of the people she photographs, always caring, always considerate of their privacy, never exploitative. Two distinctly different projects that Lynn brought to me at Black Star stimulated the agency's interest in her work. One was a project on skyscraper construction in Pittsburgh that captured the strength and courage of the men who tempt fate on narrow steel beams to build steel, concrete, and glass monuments. The other was a set of photographs of Kenny, a child who had been born malformed with a birth defect known as *sacral agenesis.*

While driving in Aliquippa, Pennsylvania, looking for an ending to a *Pittsburgh Press* story on the grim future of a depressed industrial town, Lynn Johnson and a reporter, found something else. Johnson recalls,

> We stumbled upon a child of promise; a unique story. In the rear view mirror, I could see clearly that the vision in the half-light was a child.
>
> A boy, a torso, arms, hands and a head was seated upon a battered skateboard. No hips, no legs, no tennis shoes. The car bumped to a stop against the curb. I continued to stare in the mirror, an opportunity to study, undetected, this apparition. How could it be, this half child? His body looked too small to contain all the organs necessary to sustain life. And yet, he moved with the ease of any child on a summer's night; feisty energy barely contained by his mother's voice. Determined to meet this remarkable youngster, I stepped from the protection of the car and stood on the sidewalk, waiting.
>
> Waiting, feeling the fool, I saw a knowing smile on the mother's lips. Certainly this wasn't the first time a stranger had stood in the middle of the sidewalk gaping at her son. She was patient with my silence and my foolish questions. We didn't understand then that this evening would affect all our lives. Not in a grand way, like a death in the family, but in a thin, constant way, as a thought one carries in the back of one's mind. At the oddest moment it asserts itself in a chuckle or flash of discomfort; a fist so tight the nails leave an impression. Can one measure life by a series of strangers turned friends? If so, mark this moment, these strangers.

That chance meeting led to a photographic project that lasted four years. Lynn Johnson listened, learned, and "gained a speck of wisdom from the visual documentation of Kenny's life." Lynn showed Kenny in different aspects of his existence, his relationship with his family and friends. She also showed him as he used his superior-upper-body strength to propel himself up and down stairs, or was being measured for prosthetic devices, or was being main-streamed in school and became involved in activities usually denied anyone with a major handicap.

Lynn Johnson's photographs of Kenny capture the tenacious spirit and dignity of one disabled child. They tell us that we have to go beyond pity and the rejection of all that is not pretty. Kenny represents the 394 million physically disabled people in the world who can become a potent labor force. Only through a long-term commitment could a photojournalist achieve a story like this. Photojournalists spend most of their time jumping from one assignment to another, going in and out of lives as if through a revolving door. It is rare that photojournalists get the opportunity to explore personal worlds in depth.

Peter Turnley is a contract photographer for *Newsweek* whose special relationship as a contract photographer with the magazine affords him an occa-

sional opportunity to divorce himself from traditional news coverage and
undertake more comprehensive subjects. As I've discussed before, in 1989 the
editors of *Newsweek* assigned him to photograph the world's homeless, some
fourteen million refugees, deserving of media attention. War and famine have
combined to create this twentieth-century phenomenon of inconceivable hor-
rors as displaced persons proceed on grim journeys across borders in search of
food and safety.

Turnley photographed refugees in Africa's Sudan and Malawi, in Mexico,
Pakistan, and Thailand, and in the strife-torn Gaza strip, where Palestinians
have lived in makeshift hovels for decades. What Turnley found was an eerie
sameness in the camps despite differences in ethnicity, culture, and topogra-
phy. Boredom, enforced routine and idleness pervade the atmosphere in all the
camps. And through it all, says Turnley, "there is a spirit of survival and a very
quiet dignity, even in the face of almost total loss."

Turnley's project, the homeless of the world, while not a speculative one,
reflects the indomitability of the human spirit in the face of brutality, humilia-
tion, and starvation. The yeoman efforts of the United Nations to feed and
house these displaced persons is only a band-aid that barely keeps them alive.
Equally important, according to Jean-Pierre Hocke, United Nations High
Commissioner for Refugees, is to see that these men and women who have
been separated from their countries "retain their dignity, their will to control
their destiny." Turnley's pictures, particularly because of the international
nature of the subject, were widely and extensively published as a major pho-
tographic essay in every country of the world where they were offered.

Newsweek's financial commitment to and moral support of the homeless
project points up the value of being a contract photographer, which affords the
photographer closer editorial contact and a more receptive editorial ear to such
a proposal. Turnley earned his stirrups by responding to every international
breaking-news story. I am sure that this was a consideration in the minds of
Newsweek's editors who wanted to reward him with a significant long-term
photographic project.

Sometimes projects take the form of cooperative ventures, where several
photographers work in concert; the aim is altruistic and the impact profound.
In 1987, Michael Evans, former personal photographer to President Reagan,
was approached by the Washington, D.C.-based Families for the Homeless, a
nonpartisan coalition of congressional, administration, and media families, in
partnership with the National Mental Health Association, to head "Homeless
in America: A Photographic Project."

Evans hired five photographers—Mary Ellen Mark, William Pierce, Eli

Reed, Eugene Richards, and Stephen Shames—and a consulting photographer, Jim Hubbard. He also recruited seven student-intern photographers, solicited outside contributions from 240 photographers, and ultimately generated 33,000 images from the professional and student photographers and an additional 2,000 from outside contributors to the project. The results of this attempt to raise public consciousness about U.S. homelessness were brought together in a book, a videotape, and a traveling exhibition that opened at Washington's Corcoran Gallery in 1988.

Stephen Shames's involvement with the "Homeless in America" project closely coincided with one of his own on child poverty. He focused on some of the more than twelve million children of poverty adrift in contemporary American society—children living in welfare hotels, abandoned buildings, cars, and church shelters. His work was published in the book, *Outside the Dream: Child Poverty in America.*

Steve Shames is currently a free lance and has a contract with the *Philadelphia Inquirer* guaranteeing him a specific amount of yearly work. At different times of his life he has been in and out of free lancing, perhaps because it allows him greater professional freedom and personal choice of subject matter.

Shames is a product of the 1960s. His photographic career has been dominated by social issues. He explains, "In college at Berkeley I was caught up in the anti-war movement and the civil rights movement. I realized early on that I could do more to change public perceptions by using a camera than I could as an active political type. I realized that I could take pictures that seemed to affect people. Photography, therefore, became an extension of my social commitment."

I think of Steve Shames as a one-man FSA project, working in the tradition of Dorothea Lange, Russell Lee, Gordon Parks, and their colleagues of the 1930s. Child poverty, though the most well-received undertaking by Shames, is not his first one. It followed many unfulfilled stories on teenage sexuality and on the Black Panther movement that influenced him.

Perhaps the most important of his earlier projects was one on child prostitution that Shames began in 1979. Shames had learned that young boys known as "chickens" were hustling, selling their sexual services, on New York's Forty Second Street. After weeks there meeting the people and observing the scene, Shames decided to feature the life of one such young boy and produced an essay dealing with a previously forbidden documentary subject. To this day that story has yet to be published in the U.S. with the exception of several pages in the NPPA-University of Missouri Photojournalism Yearbook in recognition of an award during the annual competition. It was, however, success-

fully distributed in Europe and had extensive publication in Germany's *Stern* magazine.

Although the material remained unpublished because of the U.S. magazine market's penchant for positive material, Shames used his child prostitute pictures to substantiate a proposal about child poverty for which he was awarded an Alicia Patterson grant. Shames estimates that in total the child poverty project cost close to $100,000: $25,000 came from the Patterson grant, $20,000 from the Evans homeless assignment, $20,000 of his own money, money from sales of the material throughout the world, and the support of Marian Wright Edelman's Children's Defense Fund, which co-sponsored *Outside the Dream*. Shames credits Marian Wright Edelman's stimulus; in 1984, she said to him, "You ought to do something on child poverty which has increased dramatically in the first four years of the Reagan administration." He did.

When asked about his work, Shames says,

> Your career should not be your main motivation. It only helps if you do projects for the pure love of them. Don't worry about the commercial aspects. The important question is what subject are you willing to spend two, five, or ten years of your life working on even if at the end there is no compensation.
>
> Projects like child poverty give one the chance to show people what you can do and what you are interested in and your commitment. It allows you to learn by doing, to get involved with all aspects of the work. You can be producer, photographer, writer, promoter, fundraiser. . . . Photographers have to get out of their ivory towers and do the hard work not only of producing the material but learning what to do with it when it is done.
>
> This project has given me ego gratification and a sense of accomplishment. It is the best thing I have ever done in terms of pictures and political impact because I see it is an anthropological work which people will be able to look back on in future generations and say "this is the way it was in America in the 1980s."

One of the longest, most durable, perhaps never-ending projects with which I have come in contact is that of the erudite African American *New York Times* staffer, Chester Higgins, Jr. For twenty-three years, Higgins has been traveling around the world in search of the African Diaspora, taking photographs of the dispersed peoples from the African continent now living predominantly in North, Central, and South America, the Caribbean, and western Europe.

This project, called *Two Worlds/One Heart: The Transatlantic Communities of the African Diaspora* is about the relationship between peoples whose ancestors were African. In Higgins's words, this still-unfinished work, now numbering 275,000 images, "explores the notion that despite the separation in

time and space from the African continent, peoples of the African Diaspora display a surprising number of traits that link them to the ancestral cultures of Africa."

Photography is well suited to anthropological studies of this kind, and Higgins is assisted by the expertise of anthropologist Elliot P. Skinner, who has done extensive fieldwork in West Africa, South America, and the Caribbean. The project, when completed, will result in a book and exhibition.

Milton Rogovin, a retired optometrist living in Buffalo, New York, was seventy-four years old when he received the W. Eugene Smith Grant in Humanistic Photography in 1983. The grant was given to support his twenty-year picture documentary of the men and women who work beneath the earth's surface in coal mines from Appalachia to Turkey. Rogovin started his series of portraits dealing with miners and their families in the hollows of West Virginia and eastern Kentucky in 1962. It took him nine summers to complete his work in Appalachia. The choice of subject matter was consistent with Rogovin's interest in working among the poor, "the forgotten ones," as he calls them, quoting the German artist Kathe Kollwitz.

Kollwitz, a graphic artist and sculptor who used her work as a form of social protest, says in *The Diaries and Letters of Kathe Kollwitz,*

> My real motive for choosing my subjects almost exclusively from the life of the workers was that only such subjects gave me in a simple and unqualified way what I felt to be beautiful. For me the Koenigsberg longshoremen had beauty; the Polish jimkes on their grain ships had beauty; the broad freedom of movement in the gestures of the common people had beauty. Much later on, when I became acquainted with the difficulties and tragedies underlying proletarian life, I was gripped by the full force of the proletarian's fate.

Rogovin's "Family of Miners" project has taken him to many countries. Early on, he spent much time in northern France photographing coal miners. He made contact with officers in one of the coal-mining unions, which later facilitated his work in Scotland and Spain. His documentation of the coal miners of the world is not limited to showing the men at work, but also includes pictures of them at home, in their gardens, at bars, drinking, playing darts, dancing, and engaging in the peripheral activities that reflect their lives in the round.

James Balog not only wanted to photograph every nearly extinct animal species in zoos and wildlife parks, but also to create environments reflecting the alienation of these animals far from their natural habitats made inhospitable by man's depredations against nature. This can be seen in the book *Sur-*

vivors: A New Vision of Endangered Wildlife, which represents a dramatic innovation in wildlife photography. He transported his entire studio by van so he could construct sets in the animals' enclosures, juxtapose the natural and unnatural, and convey the full impact of the global threat to endangered species and their habitats.

Black Star's involvement with Balog's project revealed the feasibility of multiple marketing. It also proved that those who rely on the magazine market alone suffer from restrictive tunnel vision. Challenging one's entrepreneurial skills can make it possible to explore less traditional outlets that can finance a personal project through multiple usage.

As commonly practiced, wildlife photography portrays animals living in an undisturbed wilderness. According to Balog,

> this may be an appealing and comforting notion, but it is a fantasy. In fact, the ecology that evolved in the middle of the seventeenth century has been profoundly disrupted. Because visible wildlife habitats have been extensively destroyed, animals have become extinct at an unprecedented rate. Most of the well known large mammals are currently threatened. For them, the earth is now an alien ecosystem. Paradise has indeed been lost. Why not, then, create images suggestive of this very alienation?

Although the idea kept eating away at Balog, it also scared him because of its logistical and financial complexities. He realized he couldn't get backing for a visual proposal without photographs to justify it. So he made an initial commitment of several thousand dollars toward making photographs to tangibly and visually define his idea and recruit potential support. With these photographs he achieved his big breakthrough. Ray DeMoulin, then vice-president in charge of the Professional Photography Division of Eastman Kodak, contributed the necessary seed money. This financing, combined with a small grant from the Colorado Council for the Humanities, was enough to justify his first exposures of zoos and marine parks.

Balog honed a strong telephone pitch down to a sixty-second presentation and found that his zoo and wildlife park contacts immediately grasped the concept and offered no resistance to his proposals. He asked precise, pointed questions about the nature of the location, the animal's behavior, and how the equipment could be set up.

> Inspired by Irving Penn's "Worlds In A Small Room," I designed this collapsible room made out of 2' x 4's, canvas and plywood. We only used the room once, but the effort was justified by the results achieved with the "leaping leopard." We ultimately found that we could use the structural elements in place in the animals' enclosures. We solved the problem of background paper

ripping by using painted muslin. It was wrinkly and crumpled, but we lighted it in such a way as to eliminate those drawbacks.

One doesn't undertake something like this without the virtue of patience. Some shootings only produced two frames. The animals had a finite tolerance and attention span in photographic sessions that lasted between twenty minutes and an hour. When they came on set they were curious, interested, and somehow intrigued by Balog's presence. When that curiosity dissolved in irritation, getting good pictures of the animals became impossible. There was no physical manipulation of the animals, although food was regularly used as an incentive.

With Black Star's financial support and its sales effort for which Aaron Schindler served as the project coordinator, Balog found diverse outlets for the highly unusual photographs that resulted. Subsequent financial aid from the Eastman Kodak Company helped to make an Eastman House exhibition and American tour possible. Additional seed money came from magazines, and serial sales were made to more than a dozen publications internationally, including *National Geographic.* A book publishing contract was negotiated with Harry N. Abrams. Dye transfer color prints were sold to photography collectors directly and through galleries. Sales of posters and postcards followed.

Although the structure of this project was not as carefully preconceived as its success might indicate, the experience has broadened my view of what personal projects can achieve. It provides a basic agenda that can be formulated by other photographers; one should recognize, however, that the economic climate that allowed for corporate support in 1988 and 1989 has materially changed. The current atmosphere is less conducive, and Kodak corporate generosity might be less likely now.

Yes, indeed, personal long-term photojournalistic projects are a passport to success. Many photographers who have come to see me over the years have asked the question, "How do I get to the next level in my career development?" My answer is to encourage them to undertake personal photojournalistic projects that enhance their skills, provide greater accessibility to editors, and improve their reputations. Such projects also teach them things about themselves: about their ability to conceive a viable and interesting editorial idea; about their journalistic competence; about their self-discipline and staying power; and about their absolute trust in their work.

The Photojournalist as Writer

Without knowing the force of words, it is impossible to know men.

Confucius

How many words is a picture worth? Is it one thousand, as suggested by the overused cliché, or ten thousand, as suggested by an ancient Chinese? More? Less? These numbers are absurd and illusory. One can accept the premise that often a photograph or group of photographs can best reflect the quality of a vista, the ambience of a room, or the import of an event more clearly and quickly than words. But it is rare indeed that photographs can stand alone in a journalistic context without words.

Many photographs produced as art need no further explanation. I have even advocated experimentation with visual poetry to the exclusion of words. One might, for example, do visual poems on such subjects as summer, wind, raindrops, and love, in which the photographer can tie together evocative imagery much as poets tie together words that have a visual texture.

In photojournalism, David Douglas Duncan's Korean War images in *This Is War* needed no textual amplification to describe the horrors of that war and show it as a microcosm of all war. Exceptions such as this notwithstanding, few individual pictures can do without words. Few exist outside the framework of an event. Freezing a particular moment in time freezes only that moment. It tells nothing of what preceded that image or what followed it. Only the photographer can place the picture in perspective by providing the necessary background information. That's when the photographer becomes a photojournalist and fulfills the obligation to the editor and the reader to present the photographs with a description capturing the nuances of meaning that distinguish the professional observer from the casual onlooker.

Sad to say, too many visually articulate photojournalists cannot or do not

provide sufficient background information and captions for their photographs. This is one reason editors have demoted certain photographers to the second rank. Certainly editors respect their opinions less than those of photographers who show they know the importance of verbal information and can use words effectively. The ability to express oneself well is also valuable in presenting story proposals to editors. A well-defined, well-written proposal for a picture assignment will obviously be better received and get greater consideration than one that is casually presented.

The value of good identifications and captions should not be underestimated. I have seen frantic editors up against deadlines expending valuable time, energy, and emotion in a last-minute effort to get caption information from an elusive photographer away from home on a new assignment. If the editor is working with a truly professional photographer, this is unnecessary. At the minimum, a working photojournalist should provide detailed and accurate captions with his or her photographs. Editors prefer to hire freelance photographers who recognize this obligation.

I have heard Michael Rand, the man responsible for the success of the *London Sunday Times* magazine, say that one of the biggest problems the magazine has in dealing with visual editorial ideas is finding a writer-photographer team that is compatible, where words and pictures are equal and the interconnection of the two journalistic elements is perfect. Very often Rand will turn down a story suggestion from a photographer for the simple reason that he cannot find a writer who can do the subject justice.

Newspapers and magazines alike have an editorial bias in favor of words. All are word-driven publications in which photographs are auxiliary, used as illustrations to spice up the editorial package. Most top editors at publications throughout the world have reached their preeminence with words as their medium. Recognizing Michael Rand's perennial problem and contemplating the importance of words in the editorial scheme leads me to encourage all photographers to go beyond the basic identifying of photographs. They should supplement their pictures with background reports and anecdotes from which stories and captions can be written. Some photographers even develop their writing skills well enough to provide entire articles.

Words and the Magazine Photographer

Visual sophistication should add to one's descriptive word power, not diminish it. Lee Lockwood and Fred Ward are two photographers whose writing abilities have contributed greatly to their success in photography. *LIFE*'s Carl Mydans is

impressive with words as well as with pictures. Gordon Parks is a man of many talents, not the least of which is his ability to write prose and poetry.

Lee Lockwood began his career as a writer and then added the additional dimensions of photography. He knows that

> an ability to write is a tremendous advantage to somebody who wants to photograph for magazines. One obvious reason is that it gives the photographer a chance to earn more by doing the whole story himself, while saving the magazine editor a good deal of money (double expenses and double travel).
>
> Unfortunately, however, in my experience, magazines that are willing to assign one person to both write and photograph a major story are few in number. Perhaps this reflects that fact that most magazines are set up with the text departments totally separated from the picture departments. Picture editors deal with photographers, text editors with writers—and never the twain shall meet. Whatever the reason, there won't be many opportunities to do both.
>
> Perhaps there aren't that many photographers around who can. After all, we're not talking about technical competence here. For in writing, much more than in photography, a sense of personal style is of great importance. And it takes a long time and a lot of work to develop that. Nonetheless, a photographer should not hesitate to develop some basic writing skills in addition to his camera craftsmanship. They will stand him in good stead.
>
> No matter how good the writer is on a story, the photographer will see different things and often will be shooting when the writer isn't present. Sometimes he will be asked to travel to distant places to shoot illustrations for a story being written back here. A photographer who can observe journalistically and furnish a readable file of information and caption material to his editor along with his pictures will be remembered with gratitude as a person with an extra arrow in his quiver. He or she may be given another assignment just because that photographer can do that extra all-important job which others cannot. It has happened to me.

There are more important reasons for a photographer to be a wordsmith. Many photojournalists are increasingly concerned about the use of their photographs out of context. Pictures used as illustrations for both articles and news reports have, on occasion, distorted the meaning of the original material. Regrettably the photographer is viewed as an auxiliary.

Lee Lockwood suggests that

> as a writer, you usually have much greater control over the final editorial content of a story than as a photographer. Too often, in most magazines, pictures are ultimately used as mere grist for the editorial mill, as illustrations for what the words say. Editors rarely ask photographers for their own input as to how a story should be framed or to comment on or provide perspective

for what they have seen. This, in spite of the fact that the photographer is often a principal (and sometimes the only actual) witness to the events being journalized about.

Lockwood's own odyssey combining text and pictures began with a professional career as a writer doing stories for the U.S. Army. He later became a part-time correspondent for the German pictorial weekly, *Bunte Illustrierte,* and in that capacity, began assigning photographers to cover stories with him and for him.

> And then, the final crossing took place. I started photographing stories myself. Even much later on, after I had joined Black Star and had done major stories for *LIFE, Look,* and most of the best magazines around, I think I still saw myself as a writer who had gotten sidetracked taking pictures. In this respect, I believe that writing ability hindered my development as a photographer. Because I saw photography as an adjunct to my writing (a professional stepchild, as it were), I never bothered to learn the fundamentals of my craft as I should have. Until recently, that is, and I am now a much better photographer technically than ever before in my career.
>
> My greatest satisfactions in journalism have come when I have written and photographed (e.g. "North Vietnam" and "The Berrigan Circle" for *LIFE,* and the book *Castro's Cuba, Cuba's Fidel*). In the last instance, I did both writing and photography, and had the final editorial say as well.
>
> Book publishers let the author say whatever he wants. Magazine publishers tend to feel that they are keepers of some ideological grail that requires them to edit stories to fit their own point of view, particularly when the content is in any way political.

Fred Ward evolved as a writer, building on the foundation of his photographic skills. He recalls that from his graduation in 1959, with a master's degree in journalism and communications, his time was mostly devoted to freelance photography. "Professionally, life was proceeding well," says Ward, "but it was obvious that there were few ways to grow and expand. I was constantly busy with varied assignments, but satisfaction, increased income and growth were limited."

Fred Ward's breakthrough from straight photographic assignments to ones including text came on a *National Geographic* assignment. Although no immediate article was planned, Fred was photographing the worst fire and drought conditions ever experienced in the Everglades. Ward recounts,

> As I got into the story, I found there was much more to it than fires and drought. South Florida was under the stress of uncontrolled growth. The conditions really reflected a much larger problem. As I flew over the fire in a

small plane and banked, it suddenly occurred to me — no one had seen this but me. I grew up here. I understand the implications of South Florida's growth. It is only reasonable that I should tell this story. I wrote a short piece and submitted it to *National Geographic* as a suggestion for a major article.

It is much to *Geographic*'s credit that they have always had an enlightened outlook about contributors both writing and photographing stories. That background of receptivity led to my lead article on the Everglades, which was published in January, 1972.

That article did much for me. It catapulted me into a new and more satisfying stance that enabled me to plan my year by researching and proposing major pieces. Writing enhanced my reputation at *National Geographic*. I was no longer just another free-lance photographer looking for work. I was now someone suggesting articles and delivering finished material combining text and photographs. This brought higher payments and prestige.

Since that first successful double-threat picture and text effort on the Florida Everglades, Ward has done several combined pieces for *National Geographic,* most recently producing something unprecedented: two articles (by one writer-photographer) in the July 1990 issue of the magazine ("The Timeless Mystique of Emeralds" and "The Coral Reefs of Florida Are Imperiled"). The emeralds story is the latest in his series of *Geographic* articles on gemstones and precious metals.

A natural outgrowth of training himself to write has led Fred Ward heavily into book production, which combines his photographic and text capabilities. His credits include *Golden Islands of the Caribbean, The Home Birth Book* and *Inside Cuba Today.* He currently is self-publishing five single-topic all-color gem books, each resulting from projects taking one year or more for *National Geographic* magazine. The resulting control implicit in his desktop publishing operation permits him to monitor all aspects of photography, text, design, typography, promotion and sales. *Rubies and Sapphires, Emeralds,* and *Diamonds* are now available, to be followed in 1994 by *Pearls* and *Jade.*

Ward reflects that "this is quite a turnaround for a photographer who turned to writing as an afterthought. It is the logical use of my time and the best marriage of magazine and book publishing that allows me to get deeply involved in a topic for months or years and produce material from that involvement that will be beneficial both artistically and financially."

The Ward way, the Lockwood way, your own way—it doesn't matter. If you're just beginning to study for a photojournalistic career, it is important that your education include courses that will advance your verbal literacy as counterpart to your visual literacy. If you are a working photojournalist, developing writing skills may open up new opportunities for your photographic skills.

Words reveal details of the story that the pictures can't. And the desire to tell a story is what makes a photographer a photojournalist.

What Is a Good Caption?

Several years ago I received a letter from *Popular Photography* reader Bill Shuman, who wrote, "What is a good caption? I know that it is 'who, what, when, where, why,' but various sources lead one to believe that this can be anything from two to three words to a complete accompanying manuscript. I also know that different markets will have different requirements—but this leads me to the original question—what is a living, breathing example of a good caption?"

The caption is the least understood, most neglected or abused segment of photojournalism. It is least understood because few take the trouble to evaluate the role of the caption in the total picture story. More often than not, captioning is delegated to the least experienced writers on the staff. The result is too often insipid and uninformative captions, in which the words are redundant.

Two distinct aspects of captioning should be considered: one is the need for a photographer's own captioning expertise; a second, equally important concern is how the information provided by the photographer is ultimately used by the editors in preparing final copy. I have never seen a caption of "two to three words" that amplifies the photograph. The only thing that can be provided in such limited scope is geographic location. Nor have I ever encountered a photographic assignment that required "a complete accompanying manuscript" as a caption.

What I have seen over the years are pictures submitted without even the simple, basic information needed for intelligent captioning. The editor who finds a photographer who understands the importance of detailed captioning will be mighty happy.

In supplying information to magazines, the photojournalist should develop an intelligent and intelligible system of keying roll and frame numbers to the captions. I have yet to see an improvement over the *National Geographic* caption books, which are given to photographers before they go on assignment for the magazine. The photographer who uses these caption books efficiently makes the editor's job easier and provides permanent identifications that will add immeasurable value to that photographic file for residual sales. Since not everyone works on assignment for *National Geographic,* other photographers might do well to set up their own captioning books.

Each page should include the following: name of story, date, type of film

used, special developing instructions, roll number, and frame number. Each frame on the roll of film is specifically keyed to a caption.

Captions that seem to come out of nowhere are dangerously suspect. Many years ago a national magazine published a series of photographs that showed life behind the Iron Curtain. I recall a picture of a howling dog silhouetted against the horizon in the fading and forbidding late afternoon light. It was a time of great confrontation between the Western democracies and the Soviet Union.

This harmless picture could have been taken anywhere in the world. If it had been taken in Michigan, the caption might have read, "A dog greets signs of nightfall with anticipation of nocturnal outings looking for sex." But because it was taken behind the Iron Curtain, the caption read something like, "A dog bays dismally. . . ." The editors were trying to tell us something. American dogs bay happily, but dogs behind the Iron Curtain have miserable lives, heeling under Marxist oppression. The reader must always look out for liberties taken with captions based on inadequate information or a conscious attempt to conform to editorial bias.

Photojournalism is composed of three basic and equally important elements that form a cohesive whole. The text block gives the background of the story and sets the empirical stage for what happens. The photographs visually depict these events. The captions provide non-redundant information that promotes a better understanding of the photographs. Too often the captions are extracted and refined from the basic text block. Each of the three basic elements in the picture story has its own job to do. We don't need to read the same facts two or three times. Not only is space valuable, but consideration for the reader dictates a sharply focused, well-defined editorial package.

National Geographic is probably the most sophisticated practitioner of the captioning art. There are no one-liners. One gets the feeling that the editors have worked as hard on the captions as they have on any other part of a story.

Read, for example, some of the captions in the July 1990 issue of *National Geographic.* They are energetic and informative. In a story called "Long Journey of the Pacific Salmon," a caption reads, "Glistening salmon fins surround a swimmer in the sea east of Sakhalin. Ready to spawn, the fish feel the pull of the Ochepukha River. But officials have blocked their way because a drought has made the water too warm. The salmon collect at the river's mouth until the barrier comes down in the cool of the evening."

In the same issue, the caption to a Fred Ward photograph in the "Emeralds" story reads, "In this seething pit, the pendulum of violence swings at will among thousands of guaqueros, treasure hunters seeking the emeralds of Mex-

ico, source of the world's biggest and best for perhaps a thousand years. Atop the slope of the government mine, bulldozers scrape away shale to expose likely emerald deposits, then shove tailings down the hill. Guaqueros tap streams to hose through the leavings. Guns or knives are standard equipment; murders average one or two each day."

The same quality and care is evidenced in the captions to the incredible series by Lennart Nilsson in the August 1990 issue of *LIFE* magazine; the photographs, made with "complex hi-tech tools such as scanning electron microscopes and tiny endoscopes that can peer inside a woman's womb," show how human life begins.

Pictures of the egg two hours after human conception are described as follows:

> Like an eerie planet floating through space, a woman's egg, or ovum, has been ejected from one of her ovaries into a fallopian tube, where it will remain fertile for about 24 hours. The luminous halo around the ovum is a cluster of nutrient cells feeding the hungry egg. A closer view shows that the 100 or so sperm cells that survived the journey up the reproductive tract are busily stripping the nutrient cells from the ovum. Over the next several hours the sperm will begin beating their tails as they rotate like drill bits into the outer wall of the egg.

Who, what, when, why and where? You bet. But more than that: descriptive, succinct, and informative.

During the administration of President Gerald Ford, I was involved with the publication of a combined picture-and-text book, *Portrait of a President,* with photography by Fred Ward and text by *Time*'s Hugh Sidey. The photographer and author placed special emphasis on the information and depth of the Sidey captions that accompanied the photographs.

I have chosen one caption to illustrate my point.

> The president gets his soul into a backhand on the White House tennis court. Many people are unaware that there is a court here because it is well hidden by planting. The court is only a few yards from the Oval Office on the South Lawn and it stands ready at all times for presidential action. Other staff members can sign up to play when the court is not set aside for the president. Ford wears an elastic support on his weakened right knee. Though left-handed, the president plays tennis with his right hand.

This caption goes beyond the ordinary lazy one, which might have been something like, "President Ford plays tennis on the White House tennis court." In the expanded Sidey caption we learn the specific location of the

court, to whom it is available when not being used by the president, why the president wears an elastic knee-support, and that the president plays tennis right-handed, even though he is left-handed. Other captions in the book are full of informative tidbits of information and quotes provided by the photographer. A skilled caption writer can underline the key points of the photograph and clue the reader into what is happening in the photograph and why.

As in all aspects of photography, there are no categorical rules to be followed for captioning. Newspapers' needs are similar to those of magazines. They ask the professional newspaper photojournalist to take notes and make observations that permit the editors to write telling captions.

The Photojournalistic Book

Having a book published is the ultimate fantasy of many photographers. The deterioration of mass-circulation, picture-oriented magazines has forced photojournalists to seek alternative markets for their most serious work, and books have become an increasingly important means of expression. The photojournalistic book allows the photographer to express himself in greater depth than any magazine permits. Perhaps W. Eugene Smith would have continued as a *LIFE* staffer until the magazine's demise if his work on Dr. Albert Schweitzer in Lambarene had been published to his satisfaction. Smith quit *LIFE* because he felt that the editors had treated his six-month coverage superficially and had not adequately shown the full dimension of Schweitzer's multi-faceted personality. But it was perhaps unrealistic to expect that any magazine could provide the space to do justice to the months of photography Smith had devoted to Schweitzer. A photographic book could have made use of the many Schweitzer images subsequently displayed at the famous "Let Truth Be the Prejudice" show organized by Cornell Capa at the Jewish Museum.

Respect for picture books continues to grow in publishing circles as the audience for them expands. Photojournalistic books are an accepted part of contemporary book publishing. It is rare indeed for such books to be big moneymakers, but having a project or body of work published in book form

can propel a career while satisfying the photojournalist's need to cover important subjects.

Books need depth, breadth, and dimension. Much too often, newspaper and magazine photographers try to expand limited stories into full-length books. They are guilty of visual redundancy and overinflation; a book is a medium demanding extensive research and careful structuring.

My first experience with a picture book stemmed from my desire to do one almost forty years ago. The year was 1956. I was suffering my first mid-professional-life crisis. I went to Ernest Mayer, then Black Star's president, and moaned that "although I like my work, I feel frustrated that I am not being creative. I would like to be more involved in the final product, where I generate the idea, sell it, edit the pictures and see the pictures printed on the page representing my editorial thinking." I will never forget his words. "Howard," he said, "you just talk about being creative. If you really wanted to be creative, there are plenty of opportunities for you here at Black Star. The fact is that you are satisfied to spend your working hours at Black Star, go home to your family in the evening, enjoy your wife and children, and on weekends to play golf. You're not willing to give up anything to satisfy the creative urge you're talking about." I had to admit he was right. The opportunities were present at Black Star if I was willing to seize them. That conversation changed my life.

For many years I had been a reader of Walt Whitman's poetry, which struck me as being closely related to photography. Walt Whitman was possibly the most visual of American poets, his words constantly evoking visual images. For example, in "Leaves of Grass" he talks about grass as "the beautiful uncut hair of graves." And in another verse, he writes, "The big doors of the country barn stand open and ready / the dried grass of the harvest-time loads the slow-drawn wagon / the clear light plays on the brown gray and green intertinged / the armfuls are packed to the sagging mow." Pictures indeed.

Why not take selected passages from Whitman's "Leaves of Grass" and illustrate them using pictures and words that would reinforce each other and add a dimension of interpretation to Whitman's words? For the next year I read and selected Whitman passages that suggested pictures. Then I went through the Black Star files to find appropriate photos. I did two things that had not been done before in this genre: I contemporized the poetry with the pictures, illustrating Whitman's nineteenth-century words with twentieth-century pictures. And as I worked, I came to realize that most similar treatments had used single pictures to illustrate single poems or discrete passages. I recognized that it was possible to go beyond this simplistic technique and use passages of poetry as the basis for expanded photographic essays.

I finished my work, but for fifteen years the book lay dormant. Then Lew Gillenson, chief editor, overcame the opposition of Grosset and Dunlap's president and undertook the publication of the book in 1971. Its time had come. The existentialist philosophies of Whitman, Thoreau, and Emerson appealed to the youth of America, with their independent spirit and non-materialistic values. During the next few years, *The Illustrated Leaves of Grass* went into several printings and ultimately sold upwards of 100,000 copies. That led to successful publication of *The Illustrated World of Thoreau,* and ultimately, *The Illustrated Eternal Sea*; the latter used the writings of thirty important writers who had written about the sea.

Monographs and Books

Photographic books cannot all be lumped together into one category. Monographs are retrospective books based on selected images from a photographer's career. I have been more concerned with thematic books that deal with specific subjects of a journalistic nature. Through the years, I have poured my energy into book projects related to the major photojournalists Black Star represented, recognizing it as one of my duties in the representation of those photographers.

Before starting Kitchen Arts and Letters, a specialized bookstore, Nahum "Nach" Waxman was an editor at Harper and Row. Waxman edited a series of photographic books under the Colophon imprint and experimented with developing a literary form out of visual material. "Monographs of a photographer's work," said Waxman in the late 1970s, "certainly have a legitimate place. These are books in that they look physically like books, but don't attempt to do more."

With the Colophon experiment, Waxman brought to photographic books the same kind of consideration and care that any book, with or without pictures, deserves. He says,

> Why should a photographic book be exempt from being put together with some kind of order or logic? Any other approach is degrading to the photographer and degrading to the project. If you're editing a novel, you check to assure that the plot works and the various elements work together. Successful photographic books require symmetry, evolution, and logical progression. The same kind of intelligence one applies to rooting out the subject and producing the individual images should be applied to putting the book together.

I am not at ease with the commonly held belief that, in photojournalism, the photograph is required to dominate the text. Wilson Hicks, *LIFE*'s first picture

editor, had great respect for the photograph, but that never diluted his equal respect for the written word. What follows will not glorify the photograph at the expense of words, but rather will explore the state of the art in combining picture and words cohesively and intelligibly within the covers of a book.

What Makes an Idea a Book

The most difficult part of book publishing starts with the development of the book idea. None of the production problems equals the difficulties posed by the thinking and discovery process and the shaping of the work into a whole. Some photographers are not sufficiently disciplined to define a goal and follow through in a very specific way. There is a great temptation to skim off the obvious without concern for what essentially distinguishes the book from a magazine story. Many photographers are self-indulgent prima donnas who think that what interests them interests everybody. What makes books work is developing original and exciting subject matter. Some photographers have lost their sense of adventure or the impetus to show the grittier aspects of existence.

Three picture books by Bill Owens, *Suburbia, Our Kind of People,* and *Working, I Do It for the Money* were book publishing phenomena in the 1970s. Owens, a former newspaper staffer at the *Livermore Independent* in California, was more than a photojournalist: his books reveal that he was also a sociologist and an anthropologist. His pictures explored aspects of the American scene, but they were not single pictures made in a vacuum. They were consciously produced under thematic umbrellas. The pictures were supplemented by quotations from his subjects, which expressed their attitudes about lifestyles, social structures, and occupations.

The books are not judgmental. He showed his subjects as they were and allowed the readers to form their own opinions, according to their own preconceptions, prejudices, and individual attitudes toward life. I have met people who read *Suburbia* and found it a devastating portrait and others who thought it glorified suburban life.

There are lessons to be learned from Owens's books. First, the race goes to the dedicated. There is no room for dilettantes. More important, one doesn't have to travel around the world to find good pictures that express strong ideas. The simple, the familiar—your personal world—can yield significant statements. Owens turned his talent to subjects at hand, starting with the suburban tract housing in which he and his family lived at the time.

Landmark Photographic Books

I've told my daughters that after my demise, their most valuable legacy will be my collection of photographic books, which include signed copies of books by Karsh, W. Eugene Smith, Brassai, and other leading photographers of our time. I am a compulsive photographic book collector, and when I look through my eclectic library, I see many books that I hope photojournalists will have seen elsewhere. Retrospective books on Robert Capa, Lisette Model, Gjon Mili, Elliot Erwitt, Dorothea Lange, Harry Callahan, Andre Kertesz, Carl Mydans, Marc Riboud, Berenice Abbott, Weegee, Annie Leibovitz, Ansel Adams, Philippe Halsman, Henri Cartier-Bresson, and Werner Bischof. Books on photographic history that I consider essential reading include *In Our Time: The World as Seen by Magnum Photographers, A World History of Photography* by Naomi Rosenblum, and *Photography in America* by Robert Doty.

Among the thematic photographic books that have long impressed me are Robert Frank's classic *The Americans;* Roman Vishniac's *A Vanished World,* with his haunting images of Polish Jewry in the 1930s; Richard Avedon's *In the American West;* Mary Ellen Mark's *Ward 81,* an exploration of a female ward in a psychiatric institution; and two of Arnold Newman's books, *One Mind's Eye* and *Artists.*

There is no dearth of books dealing with social and environmental issues. Any list of essential reading would include W. Eugene and Aileen Smith's *Minamata,* a powerful indictment of environmental pollution; Bruce Davidson's *East 100th Street,* a look down a ghetto street; and Charles Moore's *Powerful Days,* with its gripping photos of protesters in the civil rights movement.

My interest in photographic books was first stimulated by *You Have Seen Their Faces,* photographed and written five decades ago by the then–husband-and-wife team of Margaret Bourke-White and Erskine Caldwell. It remains the classic photojournalistic book, combining Caldwell's text describing the relationship between poverty and the depletion of the land in the Deep South with Bourke-White's eloquent photographs showing the day-to-day life of poor southerners.

Photographic books are expensive to produce so their list prices are higher than general trade books. The high price often results in limited sales, but this is not always the case. Some recent photographic books have sold in strato-spheric numbers. *A Day in the Life of America* ($39.95), compiled from the work of the world's two hundred leading photojournalists, sold upwards of one million copies. Brian Lanker's *I Dream a World* ($24.95 in paperback and

$40.00 in hardcover), a series of portraits and interviews with outstanding black women, sold more than 250,000 copies. Admittedly, special circumstances, like publication of the material in magazines like *Newsweek* for the former and *National Geographic* for the latter, contributed to the outstanding sales. But we can analyze those elements and use them to advantage in the future.

More recently, my book-publishing efforts have related to topical journalistic subject matter done by the gifted Turnley twins, Peter and David. These efforts have been done in collaboration with Stewart, Tabori and Chang, noted for its quality illustrated books. David Turnley's *Why Are They Weeping? South Africans Under Apartheid* (1988) was the publisher's first venture into photojournalistic book publishing. It was successful and was followed by David and Peter Turnley's *Beijing Spring* (1989), which documents the Chinese student rebellion of 1989 and its abortive end in the June 4, 1989, massacre. That book led to the Turnleys' *Moments of Revolution* (1990), after Eastern Europe was released from the Communist yoke in 1989, and democracy's tide swept across Europe.

Photographers with strong individual points of view and something to say are exploring controversial subject matter and contributing to the increasing flow of photojournalistic books. Eugene Richards's *Exploding into Life* gives us new insights into the personal experience of a woman's battle with cancer. Phillip Jones Griffith's *Vietnam Inc.* blames the Vietnam disaster on American stupidity rather than evil, emphasizing the futility of trying to impose our democratic system on a deeply ingrained Oriental communism.

Personal projects by photojournalists like Jill Freedman have taken us behind the scenes to explore the worlds of the police, firemen, and circus performers. Abigail Heyman's *Growing Up Female* is a personal photographic odyssey of an emerging feminist. Her more recent work *Dreams and Schemes* deromanticizes the wedding ritual and reveals that marriage is not always predicated on love and romance. Donna Ferrato's book on domestic violence, *Living with the Enemy,* explores a prevalent social phenomenon and brings home the incredible statistic that there is a woman battered every eighteen seconds in our supposedly enlightened society. No subject is closed to "concerned photographers" who select significant subject matter rather than spectacle.

Publishers, Packagers, and Corporate Sponsors

Photographers interested in pursuing the book market should realize that it's more complex than the magazine market. The book editor cannot always

expose himself or herself for face-to-face discussion of projects. So the photographer should prepare a written presentation that will stand on its merits. The presentation should include a proposal of one or two pages maximum describing the project and the perceived market for the book. Many times there is more than one constituency for a book. Identifying those constituencies will stimulate the publisher's interest. Jim Balog's *Survivors: A New Vision of Endangered Wildlife* had three constituencies, namely the photographic community, animal lovers, and people concerned with the preservation of the environment.

The proposal should also include an outline or table of contents, a sample text or description of what the text will be, sample photographs with detailed captions, and biographical information about all project participants. Presentation of a dummy is fine, especially if one is approaching a publishing house that does not specialize in illustrated books, but a poor or badly prepared dummy is a liability.

A book commitment is a far cry from a magazine picture story assignment. Many people expect an immediate response, imagining that the editor will flip through the photographs and fall dead on the spot. It rarely happens that way. Book editors are sometimes frustratingly indecisive in making project decisions. The proverbial patience of Job is an absolute necessity in selling a book to a publisher. So much money is involved in book making that publishers not only rely on their own instincts but also depend on the acumen of their marketing division. Depending on the publishers, it might be wise to approach several simultaneously, including the sentence "This is a multiple submission" at the end of your cover letter to indicate that you will sell your book to the first respondent who expresses interest if the conditions are acceptable. If you develop a sense of your own worth and the worth of the project that is not shared by the first publisher you approach, don't despair—publishers make mistakes. *Jonathan Livingston Seagull* is a case in point. It was turned down by many editors before being accepted and becoming a commercial success.

Some book publishers, mainly those specializing in illustrated books, prefer to handle design and production themselves. But sometimes publishers whose lists consist primarily of text-only books will only consider taking on packaged books. Some illustrated book publishers will also buy packages. Packaged books are ones for which the project's creators supply either camera-ready mechanicals or bound books.

On occasion, in addition to selling books in the regular manner to publishers with negotiated advance against royalty contracts, I felt compelled to get involved with elements of production. In one instance, my concern for the

quality of reproduction led me to make a special contract with Doubleday to provide them with finished books. This book project, *Night Train at Wiscasset Station,* was one that dealt with the life and photographs of Kosti Ruohomaa, who primarily chronicled life in New England, especially Maine.

Kosti was a close colleague and friend who died at an early age. I owed him and his memory a beautiful book. I was anxious to oversee its design and production because many of his black-and-white pictures had delicate shadings that needed to be preserved. Doubleday was receptive to my proposal to control the design and to deliver both softcover and hardcover books at an agreed-upon price per copy.

It was an expensive lesson. My original financial calculations called for printing the book with one single printing impression rather than a duotone or double-black process. When I went on press at Morgan and Morgan, the Dobbs Ferry printer, I was disappointed in the quality of reproduction. When I discussed my despair with my wife, I told her that it would cost ten thousand dollars more than had been budgeted to make new plates and print with a two-pass process. She said, "Do it. If you don't, you will never forgive yourself and you will kick yourself all over the lot for years to come. You've lost more than ten thousand dollars in your lifetime." The book was never a huge success, but I am satisfied that we did what had to be done to preserve the integrity and loveliness of the work.

On two other occasions, I undertook to deliver finished books. In both cases, the effort was greatly rewarded. Jim Richardson's *High School USA* and Ivan Massar's *Take Up the Song* are very different books: the former had a documentary approach that dealt with life in a small high school in midwestern America, the latter was an abstract beautifully photographed interpretation of the poetry of Edna St. Vincent Millay.

For much of his career, Bob Adelman, an inventive, voluble photojournalist, has been involved with photographically oriented books, dating back to the 1970s. Not just a complainer about the state of photojournalism, Adelman put together a series of self-packaged books with a collaborator, Susan Hall. *Down Home, Ladies of the Night,* and *Gentleman of Leisure* are three successful results of the Susan Hall–Bob Adelman collaboration. These books looked to film's cinema-verité tradition for their inspiration.

Bob Adelman's book-packaging philosophy epitomizes rugged individualism. Although recognizing the publisher's functions for distribution and sales, he has a missionary commitment to artistic control over the end product. Adelman believes that other photographers can apply his techniques and manage their own publishing destinies. He suggests that much more should be

done by photographers in regional publishing. A sympathetic printer, an interested chamber of commerce, or a "rich cat" can help bring the book to completion.

> It often doesn't require so much money. Sometimes you would be better off making a small investment in your own project. Let it happen. Much more of that kind of publishing should be done—photographers can make their own statements in their own way. It isn't as formidable as you might think. Initially I thought it was somewhat arrogant to suggest that I would deliver manufactured books. I found out that a lot of books are done that way. Publishers have become aware that a large audience exists for photographic books.

What if publisher after publisher tells you that the market is "too limited," but you believe there's a market and you know you can reach it? What next? There are alternatives. One can take up Adelman's suggestion to try to contact the local chamber of commerce. Or there are private sources of funding, particularly if yours is an issue-oriented book that might attract an organization trying to generate interest in that issue. For example, if you had a book related to abortion, pro-choice organizations such as the National Organization of Women might offer limited funding. B'nai B'rith, an important Jewish service organization, did, in fact, make possible Lori Grinker's book on Jewish women. The Children's Defense Fund supported Steve Shames's book on child poverty.

So you have a great idea and a great proposal. A publisher loves it but won't give you the money to complete the photography, and you can't afford to do so on the advance they are offering. Or they love the idea but consider it too risky without some financial help. The publisher will probably suggest that you find corporate sponsorship. The first place photographers start is with the Professional Photography Division of the Eastman Kodak Company, the most highly visible company in this area.

Prior to the 1984 Olympics, which were sponsored by Fuji, the Eastman Kodak Company rarely, if ever, got involved in funding photojournalistic projects, photographic books, exhibitions, seminars, or institutions. As a result of the inroads made by Fuji film in the professional photographic market, Kodak perceived that something was required to preserve and increase its market share.

Under the leadership of Ray DeMoulin, then a Kodak vice-president and director of the Professional Photography Division, Kodak plunged into giving substantial financial support to diverse projects. Saint Ray, as he was often called by those to whom Kodak has been a benefactor, has developed an overwhelming presence in this area. In book publishing, Kodak money strongly

supported books like those in the *A Day in the Life* series, *The Power to Heal,* James Nachtwey's *Deeds of War,* Brian Lanker's *I Dream a World,* and many others. There are other companies that recognize their self-interest in supporting photographic projects and books. The current economic recession has made them less generous; however, that should not deter you from seeking possible sponsors for your book project.

Negotiating a Book Publishing Contract

Photographers seem to be intimidated by publishers and may wrongly think that publishers are doing them a great favor in considering their books. But if your project stimulates the interest of a publisher, it is because you have offered a potential source of prestige and profit to the publisher. The acquiring editor would not be negotiating with you if he or she did not think the product you have to offer might be a mutually profitable book. You should follow through every step of the way to insure that the finished product fulfills your conceptualization.

Soon after a publisher expresses real interest in your project, the money question comes up. To a publisher, this means how large a royalty advance will be paid. Is a lawyer necessary in negotiating a book publishing contract? Like most questions, the answer is "yes" and "no." There is an old legal cliché that "a lawyer who represents himself has a fool for a client." I know a number of photographers who readily admit to a lack of business acuity. Yet, when the chips are down and a contract is about to be drawn, many photographers plunge into an unfathomable legal abyss without benefit of the expertise of a lawyer, literary agent, or photographic agent. Contracts are drawn not to define the goodwill of the moment, but to prevent the misunderstandings of the future. There is no better way to protect against those misunderstandings than to define your objectives in advance.

If you are going to bring a lawyer or agent into negotiating a book contract, it's best that that person is brought in at the beginning. After both sides have gone through the trying experience of negotiating a basic agreement on terms, it is almost impossible to renegotiate without destroying a relationship. Just the existence of a third party cannot be underestimated in the negotiating process and in helping you to get more of the conditions that are important from your point of view.

One admonition: don't sign the contract the day you receive it. Read it. Reread it. Then reread it again, and if you're going to be represented by somebody active in the negotiations, discuss the clauses carefully. Understand

what each clause means. Even the most complicated legalese can be deciphered with patience and a little help. If you don't have a lawyer, ask your editor to explain clauses you don't understand.

The best books are made by people who care. Caring starts with the contract you draw with the publisher. A good publisher will respect your concerns and will negotiate in good faith on those points that you indicate are important to you. Andy Stewart, formerly of Stewart, Tabori and Chang, is a publisher who is sympathetic to the artistic and editorial concerns of the photographer. On the three contracts I have negotiated with him, he has bent over backwards to accommodate the views of the photographer. He cares about making beautiful books and knows that often the artist's input will make the difference.

A proper sequence of events should be as follows:

1. See your lawyer or agent as soon as you have a publisher interested in your book.

2. Explain to the lawyer your objectives, what your financial situation is, and what your expectations are. Decide on the royalty advance you require.

3. Discuss the royalty advance offered with your adviser, or let the adviser negotiate that amount as well.

4. Show the lawyer or agent a copy of the contract. Once the publishers have decided they want your product, you know there is leverage and almost invariably room for movement in the contract. The areas that I consider of particular concern for photographers attention and consideration are as follows:

Copyright: The photographs should be copyrighted in the photographer's name. Where a writer is also involved, the text should be copyrighted in the name of the text writer.

Rights: The subsidiary rights to photographs have value in peripheral areas. Do you want to restrict the rights of the publisher to use the pictures only in the connection with the book? You may wish to retain the rights to sell individual photographs in other media, such as audiovisual presentations, television, filmstrips, posters, calendars, greeting cards, magazines, etc. Do you want to restrict the sale of the pictures in essay form to magazines in the United States and the international marketplace? This market is considerable and requires sophisticated understanding and special selling techniques with which many publishers are not familiar and about which they may not be knowledgeable.

In many cases, the residual rights can be more financially rewarding than the advance on the book contract. If the publisher has made little contribution in financing a project that has resulted in the book, there is usually little reason for you to surrender the revenues to be generated from sale of first, second, or supplementary serial rights.

Foreign Rights: Many publishers exploit the possibilities for simultaneous co-publishing ventures with publishers in other countries. For expensive color or black-and-white duotone printing, the addition of copies to the print run for the use of a foreign publisher can significantly lower the unit cost of a book and make it more economically feasible for the publisher.

If your publisher has no expertise or contacts in this area, it would be better to retain those foreign publishing rights for your own benefit. Or, failing that possibility, you might wish to limit the rights of the publisher to a specific period, after which time the foreign rights would revert to you if the publisher has been unsuccessful in selling those rights.

Royalties: Generally the minimum percentage on the list price of hardcover editions of a nonillustrated book sold in the United States allows for 10 percent on the first 5,000 copies sold; 12½ percent on the next 5,000 copies sold; and 15 percent thereafter.

Photographic trade paperbacks generally are limited to 7½ percent royalty on selling price. It should be pointed out here that since the costs of illustrated book publishing are much higher than general publishing of text without photographs, the photographer might have to reduce the royalty expectations to accept royalty payments on "net" or "revenues" rather than on "list price" to make the publication possible.

Controlling the Product: Your concerns about design, quality control, repro-duction, credit lines, and content should be discussed and precisely spelled out in the contract. The verbal commitments of yesterday quickly disintegrate into the corner-cutting of today unless specific assurances are written into the contract guaranteeing your right of final product approval.

There are, of course, myriad other details to the contract that all require your detailed inspection. The amount of the advance, how it is to be paid, frequency of royalty statements, sharing of subsidiary rights, the care of transparencies, negatives and prints provided to the publisher—these are all points that must be carefully reviewed.

Checklist for a Photographic Book Contract

Amount of advance
Royalties: hard cover, soft cover
Royalties on special sales
Royalties on foreign editions
Care of negatives, prints, and transparencies
Copyright

Credit lines
Model Releases
Control of design
Control of reproduction quality
How will the book be promoted and publicized? Is there a promotion
 budget?
Right of final approval of text and pictures
Subsidiary rights to photographs: audio visual, television, posters, calen-
 dars, greeting cards, post cards, note cards, magazine illustrations, etc.
First serial rights, before book publication
Second serial rights, after book publication
Foreign serial rights

Helping Your Book Reach Its Market

I have long felt that many book publishers have an antediluvian approach to
the sale and promotion of a published book. It seems incomprehensible to me
that publishers will invest upwards of one hundred thousand dollars to make
well-designed, well-constructed, well-printed books and then rely on old-
fashioned approaches to sell those books.

Publishers are much too passive about most of their books once they are
published. Books on the list that have been written by authors with the biggest
names are those that get the greatest advertising, promotion, and public rela-
tions support. The rest of the list just grinds itself down and out. But selling a
million copies of a nonfiction illustrated book like *A Day in the Life of America*
was no accident. It was attributable to major support from sponsors, multi-
publication of the pictures in magazines and newspapers, including a cover
story in *Newsweek* magazine, lecture tours, and a great many sophisticated
direct marketing techniques.

"The calm before the calm." That's how Roger Cohen describes the relative
quiet that greets the publication of a new book in the September 3, 1990 issue
of the *New York Times.* After years of effort, publication day finally comes, the
photographer-author is exhilarated and anticipates "accompanying fireworks"
only to find that nothing happens and the book is relegated to "instant obliv-
ion." "Bewildered by the lack of advertising," says Cohen, "the apparent
inertia of publishers and the absence of their books in stores, the authors get to
know a euphemism widespread among publishing houses: they are told that
their book will be 'review-driven.' Roughly translated, this means that no
money will be spent promoting them. Like abandoned infants, the books

quickly die. . . . For authors, who feel that their books are unloved and wilting wallflowers, there is an alternative that is growing more popular: invest in advertising your own book."

I agree. A book, any book, your photographic book, only begins to live when it gains public acceptance. Your job doesn't end when the pictures and text are turned over to the publisher. I think it is essential that you use all your energies and all the contacts you have developed over the years to generate publicity for the book. This should be undertaken in cooperation with the publisher if possible. On every photographic book in which I am involved, I send out copies to my contacts at newspapers and magazines throughout the country, asking them to bring the book to the attention of the reviewer for their respective publications. In the case of Jim Balog's *Survivors: A New Vision of Endangered Wildlife,* we placed portfolios in newspaper Sunday magazines, simultaneously developing publicity for the book and income for the project.

Bill Owen's efforts didn't stop with the publication of his books. "I liked doing my own publicity and promotion," he says. "I persuaded the publisher to give me $300 with which I made up 30 portfolios. I wrote letters and sent these portfolios to *Parade* magazine, the *Boston Globe* and other people who use photographs. I got paid for them, but more important were the millions of people who saw the pictures in newspaper and magazine publications. It stimulated the sale of books."

There are no secrets to getting your photographic book published if you have a relevant idea whose time has come. Its time has come if it is a subject of more than passing interest, if your photographs are thoughtful, incisive, and revealing, if your presentation is professional, and if you are willing to put in the many hours it takes to make it possible.

The Photojournalist and the Portrait

Treatments and illnesses may change, but the very special relationship between the doctor and the patient will always be the cornerstone of medicine. I have often thought of this special relationship, when the rapport between the photographer and the sitter is not unlike that established in a doctor's consulting room, where a patient does not fear to reveal his inner self to a frustrated physician.

Yousuf Karsh, *Karsh*

Portraits of previous generations tie us to our predecessors, give us an understanding of who has gone before and a sense of continuity. Today's photography is rooted in the older art of portraiture. The contemporary photographer—whether amateur or professional, studio artist or social documentarian—is often called upon to produce portraits that are revealing and provocative. But whatever their style or purpose, portraits are always a challenge to create and to view.

Until the discovery of photography in the nineteenth century, only the well-to-do could afford portraiture. Great painters and sculptors were financially dependent on portrait commissions from the upper classes. The advent of photography made portraiture available to the masses. The stiffly posed daguerrotype became popular so quickly that an estimated three million photographic portraits were made in 1853, only fourteen years after the public introduction of the process.

According to Robert Sobieszek, curator of photography at the George Eastman House in Rochester, New York, the purpose of the photographic portrait "has been to record the faces and figures of kin, acquaintances, and the famous. As a document, the portrait becomes a form of visual biography utilized for both immediate recognition and historical recollection." Great

portraits are revelatory of the inner person as distinguished from the outer shell. They capture the human spirit by responding to the subtleties of facial expressions, the sardonic or sympathetic lines of the mouth, the brittle hardness or soft compassion of the eyes, and the inevitable lines and folds that define the facial landscape. The viewer's challenge is to read the telltale signs in the photograph that articulate and define the sitter's individuality.

Throughout a typical career, the photojournalist will be called upon to do more photographic portraits than any other kind of assignment. Look through the pages of your daily newspaper. You will find them full of portraits of politicians, business executives, and just plain folks who are doing interesting things in the community. On the obituary pages, you will always find photographs of the best known figures who have died.

Many of the photographs you find in the news magazines are what we call "significant portraits," relating the individual to the singular accomplishments they have achieved, discoveries they have made, issues they have confronted, or new products they have patented or developed. Significant portraits are not just simple head shots to show a person's likeness. They are more complex and combine elements to pass along additional information, reflecting the importance of the individual's contribution to industry, science, education, sports, the arts, or whatever his or her area of interest might be.

No magazine, mass media publication, or special interest publication is devoid of portraiture. Among the steadiest users of portraits are magazines, which virtually demand simple but attention-getting imagery to attract the reader. The visual staple of the business magazines are portraits of chief executive officers, chairpersons of the board, up-and-coming or down-and-going people on the corporate ladder. Book publishers usually use portraits of famous people on the front covers of biographies and invariably use authors' portraits on back covers or flaps. Photojournalists working in the corporate world had better hone their portrait skills if they want to effectively compete for annual report assignments and work for corporate publications.

In taking better portraits, the photographer must aim to go beyond the photographic snapshot of record. Portraits that will be remembered and appreciated are those that penetrate public masks, revealing the inner person beneath. This can be achieved by capturing facial expressions, an unconscious hand gesture, a contemplative look. The portraitist can rely not only on the face, but also on the peripheral elements in the surrounding environment that reveal the essence of an individual's life. Dramatic lighting and careful composition can create moods that convey subtle visual information about the sitter.

Outstanding portrait photographers are all technically proficient and are

determined to get beyond each subject's external image. Portrait photographers need to be equally at home with princes, politicians, and paupers. Developing rapport with the subject is mandatory. The ability to communicate with the subject increases as the transaction between the photographer and the subject takes place.

Photographers differ in the milieus in which they work, the subjects they choose, and the philosophies that dictate their stylistic approaches. By studying the work of master portraitists, both classical and contemporary, you will find that your imagination will come into play. Portrait making can mean creation of uncommon, exciting, provocative, and rewarding pictures.

Arnold Newman: Environmental Portraits

Arnold Newman, in *One Mind's Eye,* recognized that no portrait is the ultimate portrait of an individual and is at best a fleeting image. In his words, "No one picture can ever be a final summation of a personality. There are so many facets in every human being that it is impossible to present them all in one photograph. When I make a portrait, I don't take a photograph. I build it, seeking all those graphic elements that will express the most typical common denominator of the subject as I see him within the obvious limitations of a single image."

Newman's environmental portraits are meticulously constructed and composed. They use every millimeter of space to provide content and information about his subject. His 1942 portrait of artist Piet Mondrian poses the artist with graphic elements that suggest the geometric forms that characterize Mondrian's paintings. A 1948 photograph of Eero Saarinen shows the architect seated in the famous Saarinen chair isolated against a white background. But perhaps his most famous photograph is of Igor Stravinsky. This classic Newman environmental portrait, economical, perfectly composed, and graphically impeccable, shows a small Stravinsky head and shoulders juxtaposed against the graceful cleflike lines of a grand piano. In a Newman portrait, nothing is left to chance. One recognizes that he is in complete control of the subject and the elements he selects to interpret that subject's milieu.

Richard Avedon: Unsparing Detail

The approaches of other great contemporary portrait artists are diverse. Richard Avedon's camera has been characterized as "cruel," exhibiting little sympathy for its subjects. They are usually posed against a seamless white

background with every wrinkle, wart, pore, and hair follicle seen in the starkest detail, as if observed under a magnifying glass. Avedon portraits are unsentimental, unromantic, and often unflattering. They are confrontational and in direct contact with the viewer. The eyes meet you head-on and are sometimes hard, sad, wise, disdainful, cynical, bitter, baleful, or inquiring, rarely smiling. Looking at Avedon's portraits for *In the American West,* it seems as if the camera lens becomes a scalpel that goes inside the individual and peels away every layer of artificiality.

Philippe Halsman: Journalistic Realism

Revelation seems to be the key word for all photographic portraitists. *LIFE* magazine provided the late Philippe Halsman with the opportunity to photograph many of the luminaries of the twentieth century. The early picture editors at *LIFE* recognized his special ability to make portraits of celebrities. His portraits graced more covers of *LIFE* than did those of any other photographer in its history. "This fascination with the human face has never left me," Halsman said. "Every face I see seems to hide—and sometimes, fleetingly, to reveal—the mystery of another human being. Later capturing this revelation became the goal and passion of my life."

Halsman, born in Riga, Latvia, was not interested in making "arty" portraits. Of the important portraitists of our time, he was probably the most realistic and the one who isolated the "decisive moment" in his approach to the journalistic portrait for a major mass-circulation magazine.

His portraits keyed on the elements that defined the personalities of his subjects or the characteristics that identified them in the public mind. Thus, through Halsman's distinctive lens we see an ebullient Maurice Chevalier, a voluptuous Sophia Loren, a seductive Gloria Swanson, a pugnacious Winston Churchill, a clownish Imogene Coca, a pensive Marc Chagall, and a grave, sad-eyed Albert Einstein, who seems disturbed that his relativity theory helped produce the ultimate weapon of destruction. And sometimes he zoomed in on features: the incomparable eyes, nose, and lips of Louis Armstrong; the piercing eyes and upswirled moustache of Dali; and the classic noses of Jimmy Durante, Barbra Streisand, and Jean Cocteau.

Karsh: Glamour and Body Language

The pantheon of outstanding portraitists would be incomplete if the irrepressible, internationally prominent Karsh were ignored. The great statesmen,

artists, scientists, and literary figures he has photographed have proudly de-
scribed themselves as being "Karshed."

I once thought that Karsh portraits were too slick, too formulaic, too static
for my photojournalistic taste and aesthetic. After viewing a Karsh retrospec-
tive exhibition and studying his book, *Karsh,* I recognized his remarkable
ability to capture classic portraits of twentieth-century greats. Karsh relies on
hands, eyes, and body language to aid in interpreting the essence of these
individuals. Notice, for example, Winston Churchill's hands and body stand-
ing for the indomitability of the British spirit in 1941, the regal disdain ex-
pressed by King Faisal's left hand, and the prayerful hands of President Jimmy
Carter. Or study the crinkly eyes of Nikita Khrushchev, the compassionate
eyes of Eleanor Roosevelt, the intense eyes of Fidel Castro, the penetrating
eyes of George Bernard Shaw, and the closed eyes of a meditative Helen
Keller and a prayerful Dr. Albert Schweitzer. It soon becomes clear that Karsh
was waiting for his subjects to provide the elements to make portraits that
reflected their own greatness.

His black-and-white portraits of Winston Churchill (1941), Eleanor Roose-
velt (1955), George Bernard Shaw (1943), François Mauriac (1949), Helen
Keller (1948), Ernest Hemingway (1957), and Humphrey Bogart (1946) stand
as images that capture the charismatic qualities of the people he photographed.

Brian Lanker: Portraits of Dignity

Recently, from the ranks of pure photojournalism, Brian Lanker produced a
portrait project based on a simple idea executed with grace, simplicity, and
compassion. In *I Dream a World,* Lanker set out to make portraits that would
underline the power and strength of black women who changed America. The
portraits reveal the individuality and dignity of those remarkable women, few
of them household names among whites. Lanker's photographs are quiet and
resolute, technically perfect, carefully conceived, and sympathetically executed.

Annie Leibovitz

Annie Leibovitz is the rock star of portraiture. She has the uncanny knack of
getting her subjects to respond to her theatrical suggestions and be photo-
graphed in situations that are energetic and inventive. Her milieu is celebrity
photography, to which she was introduced while working for *Rolling Stone*
magazine in the 1960s. Looking at her pictures, one realizes that hours, per-

haps days of thought and conversation with the subject have gone into the conceptualization of each photograph.

In his introduction to her collection, *Annie Leibovitz Photographs,* Tom Wolfe writes,

> In the ten years since I first met her, Annie has changed from a shy girl to a woman with a personality. She prefers to move in with her subjects days before she starts taking pictures. She moves in like a Bermuda high. We happen to live in an era of skinny, topless celebrities. When a camera appears, it's all you can do to get them to keep their clothes on their bony X-ray bodies. But some of the poses in these pages can only be accounted for by the Leibovitz influence. I can't imagine what, other than that, induced Lauren Hutton to pose nude in a mudbath . . . or Calvin Klein to pose like Sabu gone coy . . . and I don't even want to conjecture about Robert Penn Warren.

Other Important Portraitists

One doesn't have to be a big-shot magazine photographer or a high-priced New York studio photographer to take interesting portraits. Many unknowns have left legacies of great portraits, such as the late Michael Disfarmer's photographs of his rural neighbors in Heber Springs, Arkansas, taken between 1939 and 1946. The key to Disfarmer lies in the simplicity of his work, his understanding of his rural neighbors, and his documentation of a nostalgic, untouched period in American life.

In contemporary times, two remarkable women have shown us distinctly different portrait styles and preoccupations. The previously mentioned Diane Arbus, who photographed the freaks and outcasts of society's netherworld, is one. Some might not characterize her as a journalistic portraitist, but I think she qualifies in that her photographs have a confrontational style.

Marie Cosindas is the other. Her painterly Polaroid color portraits are reminiscent of Rembrandt and Vermeer in their use of light, composition, and mood. There is nothing casual, unstructured, or informal in the way the subjects are posed along with the elements that surround them. They are a formalist's dream. Cosindas's portraits set her apart from the other photographers we have discussed in that the lushness and richness of the colors she captures also have the nuances of a painter's palette.

Since portraiture is an important feature in photographic work, photographers would be wise to concentrate on developing their skills in this area. The photographers I have discussed have raised portraiture to a high art with substantial monetary returns.

Workshops, Awards, Contests, and Grants

So you have to think fast. Think while you're standing up. And moving around, eating and brushing your teeth.

Declan Haun (describing the Missouri Workshop)

In the development of a photojournalistic career, continuing growth, education, and personal promotion go together. Although the well-established photographer with a track record and a strong client base can afford a more relaxed profile in these areas, the young photographer trying to develop a reputation should actively pursue workshops, awards, and grants.

Let's first talk about workshops. There are dozens of them. They have proliferated throughout the United States, and you can find them in locales ranging from the gritty urbanity of New York to the rugged coast of Maine, the folksiness of the Ozarks to the majestic splendor of Yellowstone. You can study at the feet of contemporary master photographers or learn firsthand about the real world of photojournalism from editors and working journalists. If you're interested in nature photography, you will find nature workshops. You can find specialized workshops in everything from nude photography to portraiture, landscape to underwater photography, graphic design to photojournalism.

At the same time, workshops afford you the opportunity to network and to meet important figures in the editorial profession as well as some who are only legends in their own minds. You will be able to show your portfolio to people who count and who can be influential in advancing your career.

University of Missouri Workshop

Over the years I have participated in about fifteen University of Missouri workshops, one of the truly great learning experiences in photojournalism. For forty years the Missouri Workshop has been helping prepare photojournalists for the real world.

In 1943, fresh from his triumph as head of the Farm Security Administration photographic project, Roy Stryker was developing the first extensive photographic documentation of American industry for Standard Oil of New Jersey. Simultaneously, Clifton C. Edom, an obscure, newly appointed photography professor at the University of Missouri—a place far from the seats of photojournalistic power—was expressing his frustration and disenchantment with photographic education. At the time, the teaching of photojournalism was in its most rudimentary stages; the tremendous impact of *LIFE* and *Look* on the photography of that period was only beginning to be felt in academia.

Edom, needing a contact in the real world, began a correspondence with Stryker, a man for whom he had enormous admiration. Six years later, as an outgrowth of that correspondence, the Missouri Workshop was born. Five staff members and twenty-seven students gathered in Columbia, Missouri, for that first workshop. Stryker, *Ladies Home Journal* picture editor John Morris, the *Milwaukee Journal*'s Stan Kalish, and photographers Rus Arnold and Harold Corsini made up that first staff.

Today, the Missouri Workshop stands as the photojournalistic legacy of Cliff Edom and his wife, Vi. Under Edom's direction, it has evolved as a crucible for visual and journalistic disciplines to which hundreds of photojournalists have, over the years, exposed themselves. It is a tremendous learning experience that many say is a four-year college education condensed into one exhilarating, exhausting, brutal week. The leadership passed in 1987 to Bill Kuykendall, the current head of the university's photojournalism department, who brings a personal vibrancy and vitality to his job.

The uniqueness of the Missouri Workshop lies in its itinerant campus. Since its inception in 1949, thirty-five Missouri communities have welcomed an onslaught of photographic probing by some fifty workshoppers, ten or twelve staffers, ten darkroom technicians, and a few assorted hangers-on for one week in October.

Through the years, Edom established a tradition that forsook homogeneity in favor of staff diversity—of background, temperament, knowledge, philosophy, opinions, and expertise. Each staffer had a role to play. The injection by "heavies" of modest doses of fear and terror was counterbalanced by doses of sympathy from staffers more supportive of crushed psyches. "The burrs under

the saddle," as Cliff Edom called them, were brought in to be provocateurs, to advance unorthodox, sometimes maddening ideas, and to incite controversy.

The philosophical underpinning of the Missouri Workshop staff is content-oriented, decisive-moment, storytelling, communicative photographic journalism. Much of what I am today in a photojournalistic sense, my aesthetic and editorial senses, and the tenets I preach to photographers, have derived from my accumulated years of Missouri Workshop experience.

One can't understand the Missouri Workshop without understanding the Edoms and their impact on it. Cliff Edom died in 1990. The Edoms conformed to many preconceptions about homespun rural midwesterners. Cliff Edom's combative, jutting jaw, direct eyes, and close-cropped white hair were no facade hiding nuances or sophisticated subtleties. He was not immediately likable, but most people ended up loving him. He was intolerant of stupidity, unyielding in his principles, uncompromising in his values. There were no secrets or mysteries about him—he was honest and straightforward. What you saw was what you got.

"The workshop makes you think," says photojournalist and editor Declan Haun.

> You get thrown into an arena in a small Missouri town with all sorts of new people, new situations, and new experiences. Everyone knows what you are doing or not doing. So you have to think fast. Think while you're standing up. And moving around, eating, and brushing your teeth. Think while you're hungry, mad, and frustrated. Think while they're looking at you. You!
>
> That's why the place works. You have to work and you have to think, or else you have to find some mighty large excuses. And then you're on your own again and not quite the same as you were before.

Bill Garrett says, "If the student is at all sensitive, the pounding, the sharing, the involvement will give the student a pretty good idea if photojournalism is for him, or her. That's a very important—hell, critical—step in a person's life."

The 1982 Workshop

I was a staffer at the Clinton, Missouri, workshop in 1982. Clinton is eighty miles from Kansas City, within minutes of the Harry S. Truman Dam, and boasts one of the largest town squares in the world. With 8,373 inhabitants in its nearly ten square miles, it allows for intimacy and accessibility like the many other communities Cliff Edom chose throughout the years.

Rich Clarkson, veteran staffer of the workshop, says that "one of the marvelous things that Cliff did was to locate the Workshop in small towns. He wisely

kept it away from the cities. Small-town people are less inhibited, more open, less aware of photographers, and unaccustomed to saying 'no' to everyone."

The student body, forty-seven in 1982, began to arrive in Clinton on Saturday from as far away as California, New York, Texas, and Arizona. They were a cross-section of photojournalism—male, female, freelance photographers, newspaper staffers on small-town weeklies and big-city dailies, college students, and four armed-services photographers. But aggressive or shy, polished professionals or comparative newcomers, they all shared strong apprehensions because stories of sadistic staffs bent on humiliating the students had been passed from workshop to workshop.

I was the Sunday kickoff speaker, and my talk stressed the importance of *the idea,* the first building block of the workshop week. The idea—tight, cohesive, visually translatable, and replete with human interest—should challenge individual capabilities. I entreated the students to use their ingenuity, get out in the town, talk to people, and dig for the interesting subjects that exist wherever people are.

A boot camp atmosphere pervaded Monday. The students were timorous, hesitant, intimidated, and vulnerable. Curt Billhymer, a communication specialist from St. Louis, later recalled, "At first I think I was so intimidated, I was put off by the martinet attitude of some of the staff. But on the whole, people were very gentle with me. I think some of the things I did with the camera could have been a source of public amusement, but they didn't make it so."

Korean-born Ken Paik, formerly graphics director of the *Baltimore Sun* and a former workshop student, played the role of chief drill sergeant. "You're here! You'll learn! By the end of the week you'll love it," he barked. "And don't try to con me, because I make a living out of not being conned by photographers."

"There's nothing personal in my scathing, hard-boiled approach," Paik insisted. "People without the determination, guts, or toughness to survive in this business should get out of it. The business is getting tougher all the time."

But Rich Clarkson and Bob Gilka, serving as co-directors of the workshop, assured the photographers, "The staff will not chew you up and spit you out." Gilka stressed, "This is an exercise in photographic thinking—picture story thinking." *Sports Illustrated* photographer Bill Eppridge told them to "dress appropriately. People are always more comfortable with people they look like." Then *Seattle Times* photographer, now freelancer, Chris Johns relieved some of the tensions for the students by recalling his own experience as a student at the Missouri Workshop. "I was shell-shocked. I was scared to death."

From the first moment, the workshop credo that forbids set-up pictures was

emphasized. No element in the photographs to be taken is to be moved, managed, manufactured, or manipulated. Photographers accustomed to creating and directing pictures approached this dimension with apprehension. They soon learned that with the right discipline and restraint, it is possible to make meaningful, unmanipulated, spontaneous images with impact.

By nightfall on Monday, each student had to have a story assignment approved by the staff. The staff based their evaluations on samples of the photographers' previous work, which were reviewed at those sessions. Some of the students had subscribed to the *Clinton Daily Democrat* and came prepared with story ideas gleaned from the newspaper. Bad or sloppy research, fuzzy thinking, and inarticulate expression were all exposed in these grueling sessions. As in all previous workshops, students with clearly conceived editorial ideas received speedy approvals. Other students frenetically chased their tails, researching and re-researching to find acceptable editorial ideas. Throughout the story-idea interviews, the emphasis was on themes and identifiable story lines. "The day in the life of" approach was disdained and discouraged. The staff demand was for deeper revelation through spontaneous, unplanned, unposed, unpredictable moments.

Having cleared the first hurdle, with story lines approved, the workshoppers moved into the critical phase of the workshop experience. Now they no longer talked pictures. Now they had to make them. Workshoppers are not allowed to use flash or any other supplementary lighting and are limited to ten rolls of 35mm black-and-white film. This discourages indiscriminate scatter-shooting. It encourages visual discipline while the photographers wait for meaningful moments important for the story line. The film limitation is also dictated by the logistical realities with which the workshop has to deal—a primitive darkroom setup, the handling of nearly five hundred rolls of Tri-X film quickly, the editing of the contacts, and the making of slides for critique sessions.

If the Missouri Workshop is an ego-shattering process, where people's preconceptions about pictures and photography are being torn down and then rebuilt, the critique sessions were where it happened. Quick editing by the staff, who attempted to look at all assignments, combined with a yeoman effort by the darkroom staff produced more than one hundred slides for the first critique session Monday night.

During the first 3½ days, the photographers shot, the editors edited, both editors and students discussed, and the staff critiqued. Some photographers continued to flounder. With others, the transformation bordered on the miraculous. Stories came into better focus, the photographic moments became sharper and more incisive, the compositions became better defined and less confusing.

For the later critique sessions, redundant criticism was avoided, and the staff concentrated on selecting exemplary photographs for slide projection.

Thursday's traditional staff-student football game and picnic served as a brief respite for the workshoppers before an all-night layout stint, where the challenge was to ruthlessly distill their photographs into succinct layouts. This was the final element in the Missouri Workshop learning experience. Manipulating the tiny 35mm contact prints in infinite combinations over several hours was but a prelude to the traumatic Friday when the layouts were submitted to staff teams for approval.

For some, this was an exhilarating process. Their story ideas and the pictures coalesced into a strong visual narrative. For others, reality hit hard—photographic sow's ears could not be transformed into silk purses. For them, compromise and salvage made the best of badly photographed or non-visual editorial ideas. Good or bad, all the layouts got approved. The weakest layouts provided the most fruitful lessons. Top stories and layouts sailed through with little discussion; the problem stories stimulated agonizing discussions pinpointing photographic and editorial deficiencies. Violent staff disagreements on story focus, picture selection, and picture juxtaposition often erupted in this process.

Friday evening, 15 percent of Clinton's population filed past the tables at the Civic Center and viewed the prints on display. Story subjects came to view pictures of themselves. They and their neighbors enthusiastically greeted the visual documentation of their town by the workshoppers.

By week's end, the boot-camp-like arrival was forgotten; a summer-camp-like departure ensued for staffers and workshoppers alike. Workshopper Charles Hernandez, a photographer with the State Cancer Center in Columbia, Missouri, said, "The first two days I was just going to give it up. Pack it in! Just go home! I quit! That's how bad I felt. Then I said, 'I'm just going to work at it.'" In the interim, 47 photographers shot 465 rolls of film and made 16,740 exposures in this small Missouri town.

When I spoke to Cliff Edom in 1982 about the future of the workshop, he was visibly moved. "Whoever takes it over will have a different slant," he said. "I hope he does! It's been said, and I don't say this as a matter of conceit, that when we give it up, it will be the end of an era. Someone else will have to take up the baton—there'll be new ideas. It's time. That's the story of the world, always in transition. We have to let it change. Truth and falsity remain the same."

As Edom spoke, my mind wandered. I thought about the workshop's profound impact on me. I thought about how it conditioned and influenced my thinking about pictures and journalism. My yearly visits have been times of inspiration and renewal—they have widened my horizons and limited my

insularity. I have learned more than I have imparted—about photographers, photography, and people.

The Missouri Workshop is not perfect. Nothing is. Sometimes I think the workshop is too intense, too demanding, too traumatic in the unrelieved pressure on the students. I recommend it to aspiring photojournalists, because once having been to a Missouri Workshop, they will never see pictures the same way again. Given that not everyone can attend, one can still benefit from the ideals and philosophy associated with the workshop.

Bill Kuykendall and Duane Dailey, who now run the Missouri Workshop, are committed to the "traditional emphasis on unmanipulated documentary photography. The Missouri Workshop will continue to be about research, planning, and anticipation; about faithfulness to the story and respect for the subject and reader. We want to continue providing an experience where information and values can be exchanged from one generation of dedicated journalists to another."

Other Workshops

A complete listing of the most important photographic workshops is given in Henry Horenstein's *The Photographers Source*. The ones that particularly impact on photojournalists are the following:

Focus Workshops
New School for Social Research

66 West 12th Street
New York, New York 10011
212-741-8923

International Center of Photography
Education Department

1130 Fifth Avenue
New York, New York 10128
212-860-1754

Missouri Workshop
School of Journalism

University of Missouri-Columbia
27 Neff Annex
Columbia, Missouri 65205
314-882-4882

Northern Kentucky University
Summer Photography Workshop
Highland Heights, Kentucky 41076
606-572-5423

Photographers Workshop
The Center for Photography
59 Tinker Street
Woodstock, New York 12498
914-679-9957

Lisl Dennis
Travel Photography Workshop
508 West Cordova Road
Santa Fe, New Mexico 87501
505-982-4979

Photographic Contests and Awards

Journalistic photography must go on without regard to awards that the photographs may bring. The journalistic need to inform and interpret should be the driving force. But, purity of motive aside, being recognized through awards and contests adds to one's reputation and ultimate professional advancement. Many photojournalists have eased their paths to recognition in newspaper and magazine photography by the energetic and intelligent use of contests. Contest prizes add luster to photojournalists' careers and provide ego gratification. Even more important, picture editors note who get the awards.

Until recently, free lances and staffers on smaller newspapers found it tough to go up against the photographers of top-quality color spreads from *National Geographic* and *Time* that had been whipped into shape by their sophisticated art departments. But the rules have changed. The prestigious national and international competitions now allow for the presentation of duplicate slides instead of art-directed layouts. More unaffiliated photographers are applying, finding that the new rules have leveled the playing field, and their chances for recognition are enhanced.

Over the years, I have judged many National Press Photographers' Association district competitions, the NPPA-University of Missouri Pictures of the Year (POY) competition and World Press Photo (Holland Foundation) in Amsterdam. Each year, new records for submissions are set at those competi-

tions. Despite the overwhelming number of submissions, I cannot help but feel that potentially prizewinning work by gifted photographers is being ignored because many photographers either find it too troublesome to enter or are apathetic about contests.

The influential picture people of the world scan the results of contests and respond to awards. The photojournalistic ambitions of James Nachtwey have been greatly advanced by his four Robert Capa Gold Medal Awards for "courage and enterprise." POY "Magazine Photographer of the Year" awards have helped many careers. Pulitzer Prizes are noticed and respected. Anthony Suau's Pulitzer Prize and continued success in contests through the 1980s were instrumental in establishing his reputation.

In 1990, the enterprising David and Peter Turnley built on an already well established career with recognition for their work in 1989. David Turnley won both the Pulitzer Prize and the Robert Capa Gold Medal Award in 1990; Peter Turnley received the Overseas Press Club Olivier Rebbot Award for best photojournalistic reporting from overseas. Entering and winning contests is an important form of personal promotion for photographers. The care and effort expended by these photographers and Black Star in photographic competitions is justified by success those photographers have achieved.

Judging photo contests is not an exact science. The makeup of the jury is obviously significant in the selection process. It reflects individual attitudes toward content, visual impact, graphic design, news background—and yes, even political orientation. The judging systems aren't perfect. But my experience indicates that generally the cream rises to the top. Mediocre pictures die quickly. Confused pictures without a strong center of visual interest attract no attention. The familiar, the banal, the clichéd, and the cute picture usually provide moments of comic relief for the judges but get little consideration. So, in submitting to contests, a photographer must be his own toughest picture editor, ruthlessly editing out anything marginal.

Think about it. The judges are going to see an incredible number of pictures in a few fifteen-hour days. Sometimes they will be suffering from visual burnout and physical exhaustion brought on by the literally thousands of images passing before their eyes in quick succession. The preliminary decisions must be made in seconds.

To survive, the pictures presented must be simple and direct. They must have striking, instantly grasped content plus strong graphic elements. And they must have few, if any, distracting elements that dilute the main message. The important word to remember is content. The subject matter must be compelling and revealing. Superficiality survives only first glances. Judges

will be looking for entries in which the photographer has gone the extra mile, stayed after other photographers have left, and so has recorded deeper truths or previously unrevealed emotions.

Events usually dictate contest winners. Admittedly the more dramatic the event, the greater the visual impact of the photographs. But great photographers get the most out of these subjects. Lesser photographers diminish the same events and make acceptable, commonplace pictures. Suffice to say that the photojournalist's unending quest for dramatic subject matter is often found in violence, tragedy, and conflict—the handmaidens of press photography. Coverage of such events helps your chances of winning.

But contest winning should not be an end in itself. Outstanding work will generate its own psychological and professional awards. Still, the satisfaction and rewards that come from recognition by your peers can spice up your current activities, help you to find an alternative to a job you don't enjoy or open the doors to new horizons, so go for it!

Grants

Grants in photography can be very helpful to photojournalists wishing to complete personal projects or produce a specific body of work. Cash fellowships are awarded to photographers by a variety of governmental, government-funded, and private organizations for work already completed.

The W. Eugene Smith Grant in Humanistic Photography is aimed at photojournalists working in the humanistic tradition of Smith. I am one of the three founders of the W. Eugene Smith grant. John Morris, an illustrious picture editor with many publications and former director of the Magnum agency, and Jim Hughes, former editor of *Camera Arts* and author of the Smith biography, *Shadow and Substance,* joined me in that effort. As of this writing, there have been thirteen recipients of the main grant which began at ten thousand dollars and has gradually been raised to twenty thousand dollars to support works in progress. In addition to the main grant, five thousand dollars is available for supplementary grants to be made at the discretion of the judges. Recipients of the grant have included some well known names in photojournalism like Sebastiao Salgado, Eugene Richards, and Gilles Peress. They also include previously unknown photographers. The Smith grant is funded by Nikon Inc.

Guggenheim Fellowships are given to a very small number of photographers, but they are certainly important and prestigious grants for photogra-

phers to aspire to. Robert Frank's *The Americans* was produced under Guggenheim auspices when he received a fellowships in 1955 and another in 1956.

The following grants and fellowships would be most applicable to photojournalists. Because eligibility and deadlines vary, contact the sponsoring organizations directly for more information.

John Simon Guggenheim Memorial Foundation
90 Park Avenue
New York, New York 10016
212-687-4470

NEA/Visual Arts Fellowships
National Endowment For The Arts
Room 729, Nancy Hanks Center
1100 Pennsylvania Avenue
Washington, D.C. 20506
202-682-5448

Grand Prix International Henri Cartier-Bresson
c/o Centre National de Photographie
42 Avenue des Gobelins
Paris 75013, France
011-1-45-35-43-03

Awards a prize of 250,000 French francs, about $50,000, to enable recipient to complete a specific black-and-white reportage in the Cartier-Bresson style. Co-sponsored by American Express.

NPPA/Nikon Documentary Sabbatical Grant
1622 Forest Hill Drive
Louisville, Kentucky 40205
502-582-4607; 502-452-9471

Working daily newspaper photojournalist gets three-month sabbatical and $15,000 to cover expenses to shoot a self-chosen long-term project illuminating the theme, "The Changing Face of America." The work should address a significant change in national trends, whether social, economic, political, or related to other pressures. Sponsored by National Press Photographer Assn. and Nikon, Inc.

The Mother Jones Photography Awards
The Mother Jones International Fund For Documentary Photography

1663 Mission Street
San Francisco, California 94103
415-558-8891

In 1990, an annual worldwide competition was established by the Photo Fund, providing substantial grants for the creation of outstanding new photographic essays. A global network of nominators recommended candidates from every continent. Nine documentary photographers were chosen as finalists, and competed for $16,000 in cash grants. Awards were presented to three of the finalists. Applications for the awards can be obtained by writing to the Photo Fund in San Francisco.

Three $2,500 grants to help winners travel, buy materials, or support themselves as they complete a body of work or finish a specific project.

The Alicia Patterson Foundation
Fellowship Program For Journalists

1001 Pennsylvania Avenue, N.W. Suite 1250
Washington, D.C. 20004
301-951-8512

The Alicia Patterson Foundation Program was established in 1965 in memory of Alicia Patterson, editor and publisher of *Newsday* for twenty-three years. One-year grants with a stipend of $25,000 are awarded to working journalists to pursue independent projects of significant interest and to write articles for the *APF Reporter,* a quarterly magazine published by the Foundation.

The competition opens in June. All entries must be submitted by October 1. Applications are accepted from U.S. citizens who are print journalists with at least five years of professional experience. Photographers in recent years have been successful in receiving this fellowship (1989, Maggie Steber for "Haiti After Duvalier"; 1985, Stephen Shames for "Child Poverty In America"; 1983, Frank Johnston for "Faces of the 1980s: America a Nation in Transition").

The W. Eugene Smith Grant in Humanistic Photography
International Center of Photography

1130 Fifth Avenue
New York, New York 10028
212-860-1781

$20,000 grant to main recipient; $5,000 awarded at the discretion of the jury. To fund "work-in-progress" project in humanistic photography working in the tradition of W. Eugene Smith.

In addition, many regional, state, and county arts councils and commissions offer grants and fellowships to photographers. For more detailed information, see the book *Money To Work: Grants For Visual Artists,* which is available from Art Resources International for $8.00. The address is 5813 Nevada Avenue N.W., Washington, D.C. 20015; 202-363-6806.

TRUTH
NEEDS NO
ALLY

Creative and Ethical
Issues in Photojournalism

Ethical Concerns in Photojournalism Today

> Now I had found my way to the idea in which affirmation of the
> world and ethics are contained side by side; now I knew that
> the ethical acceptance of the world and of life, together with the
> ideals of civilization contained in this concept, had a foundation in
> thought.
>
> **Albert Schweitzer,** *Out of My Life and Thought*

Ethics, journalistic responsibility, credibility, good taste, and professional
behavior are interrelated. Ethics do not exist in an esoteric vacuum; they are
not part of a code one puts in a corner to check against on special occasions.
We all can tell the difference between right and wrong. When we shade that
difference it is most often done consciously, no matter how we rationalize and
justify actions that may be dishonest or manipulative.

Ethics are a system of moral principles that serves as the foundation for
the way we conduct ourselves as human beings. A sense of ethics is what
stimulates our sense of outrage and disgust at the obscenities we have wit-
nessed in our lifetime—the Holocaust, war, poverty, starvation, rape, and
murder.

Protecting Media Credibility

As writers, photographers, or broadcast journalists we have the power to
elevate or destroy. We can influence judgments people make on the crucial
issues of our time. We had better be honest and accurate with every picture we
select and think of the consequences of each picture taken. The roots of
photography lie in reality. Almost daily that reality is corrupted by irrespon-

sible photographers and editors. How can we expect the readers and viewers to believe a Holocaust, a Vietnam or a Watergate if they know that a local event has been staged or manipulated for the camera? Every time a photographer takes a false picture, every time an editor publishes an untrue picture, our believability goes down the tube.

The media, as never before, is being looked at with suspicion by the man in the street. When Pulitzer Prizes are rescinded because of manufactured journalism, when TV documentaries are seen to be flawed by exaggeration and misrepresentation, when paparazzi photographers go beyond reasonable limits of celebrity pursuit, when editors sensationalize, distort, and even create photographs by pasting elements together—our collective credibility is at stake.

Over the years, I have edited thousands of contact sheets of pictures of public personalities. Oftentimes a photographer will take as many as two rolls of 35mm film, which means seventy-two exposures during a speech made by a politician. Let's take former President Richard Nixon. I make no secret of my abhorrence of his presidential actions during his tenure in office. I had many opportunities to select pictures that would have shown him as malevolent, benevolent, feisty, inspirational, or statesmanlike. The contact sheets from one speech could reflect any or all of these Richard Nixons. Which is the real Richard Nixon? Which transitory moment do you select as a responsible editor? Obviously, such editorial selectivity is subjective. Ten different editors will choose ten different pictures in line with their individual perceptions of which photograph best represents the Nixon persona. For my part, I always avoided any conscious effort to select negative pictures that would reflect my personal dislike of his policies, tactics, and behavior. I think I played fair with Richard Nixon.

Is a photographer precluded from engaging in unlawful activity in pursuit of a story? A recent example concerned the actions of a writer-photographer team involved in a *Detroit Free Press* project, a comprehensive story on "24 Hours of Drugs in Detroit." Manny Crisostomo, a 1989 Pulitzer Prize-winner, admitted to buying a radio from his subjects, who bought crack with the money.

Manny Crisostomo and his fellow reporter acknowledged the linkage between their purchase of the radio and the subsequent crack buy. Crisostomo alerted the editors after the image's publication, and the editors removed that photograph from circulation, considering it tainted by the circumstances surrounding its origin.

Recognizing Conflicts of Interest

Bill Strode was the assistant director of photography at the *Louisville Courier Journal and Times* from 1967 to 1975, a co-recipient of two Pulitzer Prizes and an NPPA president. In a 1976 speech at the Rochester Institute of Technology, he spoke with eloquence and concern about photojournalistic ethics. His words continue to be relevant today.

> As photojournalists we have one of the most important jobs in society. It requires that we be honest, responsible journalists. Why then is the image of the journalistic photographer less than desirable, and why has it been that way with the general public and our own editors for years? Part of the answer is that the entire press has a credibility problem.
>
> The sad part is that most of the criticism of the press, and consequently its credibility, is justified. We have brought the criticism on ourselves. How many times have you heard people say: "You can't believe what you read in the newspapers?" Often it is true. Sometimes we don't report or photograph as accurately and precisely as we should. Our boorish behavior and our mass coverage have brought about more and more press conferences and events staged for the press. The result is the control of the press.
>
> We must set standards for ourselves which enhance our credibility. This means taking a hard look at ourselves. Is it wrong for me, as a photographer working for a news-gathering organization, to moonlight or free lance for companies which may have a major involvement with the news? Think about it. Can you as a photographer do commercial work for a company one day and cover a confrontation on the picket line in front of that company's plant for a newspaper or magazine the next day?
>
> Of course you can. I have done it. I am sure you have. The question we should ask ourselves, because the public will be asking it for us, is whether or not we should be placing ourselves in that position.
>
> If it is wrong, and I hope you agree it is, for a writer who is covering politics for his publication to be writing speeches for the governor, then shouldn't we say that same about photographers and conflicts of interest. What troubles me is that photographers are not giving enough thought to the question—let alone the answer.

George Will, the popular syndicated columnist and political pundit, was severely criticized for acting as President Reagan's opponent during practice campaign debates during the 1986 election. Acting in such a dual capacity called into question Will's journalistic objectivity and credibility. It is clear that journalists must lean over backward to preserve not only the appearance but the reality of ethical behavior.

Responsibility to the Subject

What is the responsibility of a photographer in the face of violence or threat thereof? Is the photographer's first obligation to attempt to stop violence, or is the photographer's first responsibility to get the pictures recording the event?

As in many of these behavioral and ethical questions, there are no easy answers. Throughout this book I have stressed the importance of a photojournalist's humanity as an underpinning for his work. Whenever possible we should make every effort to discourage violence or at the very least alert the proper authorities so that they can do whatever is necessary to prevent the loss of life. If this fails and the disturbance is ongoing, the photojournalist should follow the action and record the event.

Shooting Stock on Unrelated Assignments

Many photographers recognize the importance of secondary sales of their photographs in foreign countries, to peripheral markets in the United States, and as stock photography for decades to come. Many photographers use every assignment as an opportunity to overshoot and expand future stock potential.

It seems apparent that this raises a conflict of interest issue on two levels— that the photographer will be so concerned with generating file pictures that his or her efforts on the assignment will be diffused to the detriment of the assigning publication, and that the photographer is using the publication's expense reimbursement for film and processing to build up his photographic file. It is unethical to shave on someone else's beard. I've said before that one can't serve two masters. The photographer on assignment has the obligation to produce pictures for the publication as economically as possible. If he chooses to overshoot for his own purposes, those expenses should be absorbed by the photographer and not passed along to the client.

Manipulation of Images

With the advent of computerized equipment and the introduction of electronic still camera systems, it is now possible to quickly and easily combine elements, alter colors, and manufacture photographs. This new technology has prompted concern in the photojournalistic community that we are at the frontier of widespread abuse that will deeply affect the credibility of journalistic photography. Equal doubts are expressed about the photographer's copyright protection as he envisions the selection and combination of visual elements

from several photographs, which create new images with new meanings. These are real concerns magnified by the technological ingenuity of our time. We should not forget, however, that it has long been possible to alter photographs with skillful airbrushing, to rephotograph color slides with a Repronar while introducing new elements into the color pictures, and to retouch negatives or color transparencies in order to eliminate elements in the photograph.

There have been several well-publicized instances in which doctored photographs using the Scitex Response system have been published in magazines and books. A spate of articles based on these instances has begun to eat away at public acceptance of visual images as believable documents. One of the earliest instances was the movement of the pyramids on a *National Geographic* cover in order to accommodate the vertical cover format. This was followed by the movement of a moon in a horizontal picture to allow for a vertical cover of a cowboy on a horse in the successful *Day in the Life of America* book. And then there was the well-publicized cover on *TV Guide* where Oprah Winfrey's head was placed atop the lissome body of Ann-Margret without any indication that the final image was a composite.

The advanced technology of digital imaging has made image manipulation into child's play. Photographers everywhere now have Macintosh or other desktop computers capable of changing images by adding and subtracting elements in the photograph. This tool in the hands of unethical photographers can lead to more widespread journalistic distortions. The ultimate price could eventually be a further dilution of the public's acceptance of the photograph as a credible witness to events.

Remember Maryland's Senator Millard Tydings? A well-respected member of the United States Senate in the 1950s, Senator Tydings lost an election as the result of a manufactured photograph of him standing with U.S.A. Communist leader Gus Hall, which was distributed by Tydings's political enemies during his ill-fated campaign. This fabricated picture destroyed his political career.

I recall another instance of a manufactured news picture that was published in a German magazine. The subject was the stormy marriage between Christina Onassis and her Russian-born husband. At the time the couple was living in a Paris apartment. The German illustrated weekly used a picture of the husband and wife exiting together, purporting to give the impression that the two were still on good terms. The picture was a lie! In fact, the picture was a composite, made from two separate photographs of Christina and her husband emerging separately. Even without the use of computer technology, it was possible to manage this photographic fraud.

Is there ever justification for the alteration of a journalistic photograph? No. A news photograph is sacrosanct. It is witness to history. It tells the story of an event. The reader of the newspaper or magazine will make considered judgments about that event based on the words of the reporter and the images of the photographer. No editor, art director, or designer has the right to undermine the veracity of the photograph or to compromise its integrity.

Is It Real? Or Is It Digitized?

So said an ad in a recent publication advertising a conference on photojournalistic ethics in St. Petersburg, Florida. Such conferences are proliferating since the digitized manipulation of news pictures receives greater coverage in the media. Recognizing the threat posed by the emergence of electronic technology that permits facile and unrecognizable alteration of photographs, the Executive Committee of the National Press Photographers Association (NPPA) drafted this special statement of principle on November 12, 1990, in Tempe, Arizona, and it was subsequently revised by the NPPA Board of Directors on July 3, 1991:

> As journalists we believe the guiding principle of our profession is accuracy; therefore, we believe it is wrong to alter the content of a photograph in any way that deceives the public.
>
> As photojournalists, we have the responsibility to document society and to preserve its images as a matter of historical record. It is clear that the emerging electronic technologies provide new challenges to the integrity of photographic images. This technology enables the manipulation of the content of an image in such a way that the change is virtually undetectable. In light of this, we, the National Press Photographers Association, reaffirm the basis of our ethics: Accurate representation is the benchmark of our profession.
>
> We believe photojournalistic guidelines for fair and accurate reporting should be the criteria for judging what may be done electronically to a photograph. Altering the editorial content of a photograph, in any degree, is a breach of the ethical standards recognized by the NPPA.

The Associated Press, not only the most important source of news photographs in the world, but also the leader in development of the "electronic darkroom" and electronic transmission of digital imagery, has also concerned itself with the long-range implications of the new technology. In a carefully worded statement in November 1990, Vincent Alabiso, Executive Photo Editor of the Associated Press, released the following statement:

Electronic imaging raises new questions about what is ethical in the process of editing photographs. The questions may be new, but the answers all come from old values.

Simply put, The Associated Press does not alter photographs. Our pictures must always tell the truth.

The electronic darkroom is a highly sophisticated photo editing tool. It takes us out of a chemical darkroom where subtle printing techniques such as burning or dodging have long been accepted as journalistically sound. Today these terms are replaced by "image manipulation" and "enhancement." In a time when such broad terms could be misconstrued we need to set limits and restate some basic tenets.

The content of a photograph will NEVER be changed or manipulated in any way.

Only the established norms of standard photo printing methods such as burning, dodging, black-and-white toning and cropping are acceptable. Retouching is limited to removal of normal scratches and dust spots.

Serious consideration must always be given in correcting color to ensure honest reproduction of the original. Cases of abnormal color or tonality will be clearly stated in the caption. Color adjustment should always be minimal.

In any instance where a question arises about such issues, consult a senior editor immediately.

The integrity of the AP's photo report is our highest priority. Nothing takes precedence over its credibility.

Is it ethical for art directors to alter photographs for illustrative purposes without the photographer's permission? *Esquire* magazine some years ago asked for color portraits of President Jimmy Carter from the Black Star stock library. At the time they were requested, there was no indication that the magazine expected to use the photographs in an unorthodox manner. The picture selected was ultimately used on the cover with one of Carter's gleaming white teeth painted black. Neither Black Star nor the photographer was ever consulted about the alteration, but in my opinion we should have been. The way the picture was used might well have precipitated a controversy with the White House that could have adversely affected the accreditations of the photographer to the White House and his personal relations with the Carter family.

The impact of technology and the concomitant ease in manipulating photographs has stimulated a rash of books and articles in newspapers and magazines on the subject. Although I recognize the importance of addressing the problem, I fear that this almost frenetic preoccupation with the subject will further serve to undermine public confidence in all photographs. I remain convinced that unethical people have always done unethical things and will

continue to do so. Responsible editors will continue to maintain the high principles that have always governed their editorial judgments. The editorial community is well aware of the dangers posed by sophisticated digital technology and is alert to the potential abuses to which it may be put.

Posed Photographs

What about other kinds of photographs? Advertising illustrations are presumed to be manufactured with artificial elements. Retouching in that industry is prevalent, and the images are frequently art-directed. Posed editorial illustrations for articles in newspapers and magazines should be so identified if the pictures can possibly be interpreted as realistic or spontaneous images, particularly if professional models have been used to create the illustration. Such posed illustrations for magazines and newspapers should be labeled as "posed by models"; otherwise the public will believe that they are seeing actual moments. This should apply to pictures of reenactments of crime as well.

What are the permissible bounds for set-up pictures? If a photographer knows that a situation does take place in the routine course of a subject's activities, is it ethical to direct the individual to recreate the situation?

I am not naive. I know that because of the time and money constraints that face photographers on newspaper and magazine assignments, the above practice is frequent. There is hardly a journalistic photographer extant who hasn't at one time or another directed the subject to recreate an activity that he or she would normally engage in during the course of their daily routine. Not only are the situations recreated, but the subject is asked to repeat the activity until the photographer is satisfied with the composition, the body language, the facial expressions, and the other elements that make for an interesting photograph.

Obviously the pictures resulting from this kind of approach are not lies, nor are they truth. They are photographic "factions," fictional photographs based on fact. The problem is that they are created moments presented as real ones. Such pictures don't harm anyone. They don't misrepresent the truth and they serve a purpose so that the storytelling photographer can compress his coverage of the subject in the allotted time given for the production of the story. I suggest, however, that in an ideal world there is a better way to do things. Photographers will make better and more spontaneous imagery without setting up. Magazines will get better pictures if they will allow the photographer sufficient time to let things happen naturally, rather

than force them to create pictures in order to get a diversity of situations within a prescribed period of time.

Issues of Privacy

Does paparazzo Ron Galella have a right to the unlimited pursuit of Jacqueline Kennedy Onassis and family in his attempt to get salable photographs? Do other paparazzi have unrestricted license to harass celebrities like Madonna and Sean Penn in spite of their objections and intrude on their public appearances? What are the limits of legitimate pursuit, or when does it become invasion of privacy?

The courts have already ruled that Ron Galella does not have unlimited license to track Jackie Onassis, to shadow her movements, and poke a camera in her face at every opportunity. Ron Galella is limited in the distance he must maintain, and the courts recognize that although Jackie Onassis is a public figure, she does have a right to privacy. Clearly Ron Gallela has gone beyond the bounds of decency and propriety in his unyielding pursuit of a subject.

In 1978, Clarence Arrington, a financial analyst for the Ford Foundation, was walking along New York City's Fifty-Seventh Street. He was sartorially elegant in a conservative three-piece suit. Clarence Arrington is black. His photograph was taken by freelance photographer Gianfranco Gorgoni on assignment for the *New York Times Magazine* to illustrate an article titled "The Black Middle Class: Making It." Arrington sued the *New York Times,* Gorgoni, and Contact Press Images, Gorgoni's agency, for invasion of privacy based on Sections 50 and 51 of the New York State civil rights law. Arrington's complaint alleged that he never knew his picture was taken, never gave his permission for the picture to be used, and never knew that it would be prominently published on the cover of the magazine. He further complained that he disagreed with the content of the article and found it "insulting, degrading, distorted, and disparaging" not only to the black middle class in general, but to himself as its exemplar.

In April 1982, the New York State Court of Appeals reversed lower courts and made an astounding decision which reverberated throughout the photojournalistic community. It held that the *New York Times* was not liable by virtue of First Amendment privilege, but held that Gorgoni and Contact Press Images were liable under the law because they sold the photograph for the purpose of trade.

The irony of the Arrington decision is that the same picture used in the same way, but taken by a *New York Times* staff photographer would not have pro-

voked an adverse decision. The effect of the ruling was to have a chilling effect on freelance photographic activities, on the use of huge photographic collections taken for editorial purposes where the photographs were "unreleased." Ultimately recognizing the impact of the decision on the public's right to know, the New York State legislature rectified the language of the aforementioned sections of the law so that First Amendment rights of newspapers and magazines are transferrable to freelance photographers working on assignment for them.

Despite this salutary legal outcome, the Arrington case should give us all pause. I think Arrington's privacy may indeed have been invaded, not by the photographer, but by the user of the photograph. The picture was used in a context that gave the presumption that Arrington was symbolic of the middle class and therefore held the opinions expressed in the article. Photographers must be vigilant to assure that their pictures are used in a proper context and are not used in a manner which will compromise or embarrass the people in the photograph.

Ethics and Grief

Some of the most moving photographs of our time show grief in the aftermath of war casualties, automobile accidents, drownings, earthquakes, and assorted disasters. Is the photographic recording and ultimate publishing of pictures of grieving relatives immoral, unethical, insensitive, or an invasion of privacy? Or, since the people appear publicly, does that make them fair game for the journalistic photographer?

Some of the more memorable war pictures ever made have concentrated on the impact of war on civilian populations. Dmitri Baltermants's famous picture titled "Grief," taken during World War II, is the paradigmatic photograph of this genre. Perhaps we can justify war pictures of this kind because they contribute to the cumulative record of images defining war as unacceptable human behavior. But what purpose does it serve to record the grief of a mother whose child has just been killed by a car as he rode his bicycle? Or a couple on a beach mourning the loss of a drowned child? The main purpose of these pictures is to sell newspapers, to titillate their readers at breakfast time, and to increase circulation with sensationalism.

I recently spoke to an editor who gave up newspaper photography because he could not personally countenance the demands of newspaper photojournalism for just such photographs. His concerns about invasion of privacy forced

him to a moral judgment—taking and publishing such photographs was anathema to his personal ethics.

Jim Hughes had been a newspaper photographer at the *New Haven Register* in Connecticut. One day he came upon a scene where a doctor steering a speedboat had been pulling his wife on waterskis. When she fell off them, the doctor doubled back to help her. In the process the speedboat ran over her, severing one breast. The doctor took his wife to the dock and tried frantically to save her life. Jim Hughes documented the whole tragedy and was rewarded with a large photograph splashed across the front page. The following week he was assigned to cover another accident. It was then that he realized that this kind of photography was repellent to him. He resigned from that paper and never took up newspaper photography again.

Ethical Dilemmas

A rereading of the National Press Photographers Association (NPPA) Code of Ethics points up its inadequacy in dealing with abuses. It is filled with platitudes that encourage truth, honesty, objectivity, and high standards of ethical conduct. The American Society of Magazine Photographers (ASMP) also encourages professionalism and integrity, but it has no current published code of ethics. Developing a rigid code may be an impossible task.

Ethics and morality are intensely personal. Throughout my career, I was often torn between business expediency, my obligations to the photographers we represented, and the demands of responsible journalism. I am no saint. I have made many mistakes. But there is one example of proper but financially costly personal behavior that I recommend to the tabloid journalists who play so loosely with the truth and pay enormous sums of money for celebrity pictures.

It was just after the marriage of singer Eddie Fisher and Elizabeth Taylor, after Fisher had broken up with Debbie Reynolds. Fisher and Taylor were the targets of the paparazzi. One of Black Star's photographers, assigned to cover their vacation in Palm Springs, had staked out their house. He came upon an opening in the hedge, which gave him an unobstructed view of a patio where a bikini-clad Taylor and Sabrina, a model friend, were fooling around with Eddie Fisher. The photographer's long-lens photographs were potentially valuable on the international market.

The pictures arrived in New York complete with reports about how they had been achieved. What to do? My conviction was that since the pictures were taken unbeknownst to the subjects, that it was an invasion of privacy. Recog-

nizing the financial potential and my obligations to the photographer, I chose a course that tried to salvage the best of a bad situation. I took contact prints and enlargements to the Taylor-Fisher public relations firms, Rogers and Cowan, explained the circumstances as to how they had been taken and asked that they be reviewed by the subjects for approval. The pictures were sent to California and personally given to Liz Taylor and Eddie Fisher by Warren Rogers. I wish I could tell you that personal integrity was rewarded with blessings to publish the photographs, but they have never seen the light of day. I have no regrets. I think that over the years, the ethical behavior displayed on that occasion has stood me and Black Star in good stead and added to our reputation for fair dealings with photographers and the subjects they photographed.

And so it should be with photojournalists throughout their careers. To aim for the highest ethical, moral, and journalistic standards of taste. Fair play may preclude an occasional sensational picture and the big bucks that it might generate. But it will allow you to sleep better, like yourself more, and contribute to the collective ethical consciousness of your chosen profession.

Finding an Ethical Structure
in Photojournalism

To be persuasive, we must be believable. To be believable, we must be credible. To be credible, we must be truthful.

Edward R. Murrow

In 1954, *LIFE* magazine published a photograph of Dr. Albert Schweitzer in Lambarene as part of the famous essay "Man of Mercy" by W. Eugene Smith. The editors did not know at the time that the published image had been created in the darkroom, that the symbolic hand and saw in the foreground were not in the original negative. It has also since come to light that Smith was not always the spontaneous photographer and that many of his photographs in the equally famed "Spanish Village" essay were set-up photographs.

Recently, a former picture editor of *LIFE* magazine condoned this, saying, "I understand and approve of what he did. The hand and saw do not change the content of the picture, although they improve its composition. This picture shows how human Smith was—that even a photographer of his legendary sincerity and talent felt driven to cheat a bit when he found his subject wasn't up to snuff."

I disagree. I do not believe that in the need to make more interesting, surprising, or better-composed pictures a photographer should manipulate or set up pictures. I am not a W. Eugene Smith basher. I think that his place in photography is well deserved. He said that "my first responsibility is to my readers." Not quite—his first responsibility was to truth and accuracy.

Defining Photographic Fiction

Photojournalism and photographic fiction are not interchangeable. Although photojournalistic pictures can and should be artistic, the demands of journalism supersede artistic concerns. The unwritten compact between the journalist and the reader is that the words and pictures reflect reality. Any fooling around with that compact undermines the respect of the reader. It challenges credibility and redounds to the disadvantage of all journalism, photographic or otherwise. Journalism should be irreproachable. First Amendment rights provide protection for journalists and photojournalists but carry equal responsibility for integrity.

That is why the Pulitzer Prize was taken away from *Washington Post* reporter Janet Cooke, when it was learned that her shocking story of a nine-year-old heroin addict was not real but was a figment of her overzealous imagination. That is why CBS was threatened with the loss of an award for its prize-winning coverage of an Afghanistan battle, which is supposed to have been manipulated by a freelance producer.

Photojournalists should *take* pictures, not *make* pictures. Press photography, photojournalism, provides the eye of authority, a necessary role in our need to establish the credibility of the flow of images that for more than 150 years has interpreted and documented our times. To preserve that authority, pictures must be unimpeachable and unquestionable. That means that the photographer cannot pose, recreate, tamper with, manipulate, manage, rearrange, direct, or in any way intrude on the reality of the event being photographed.

Photographers can do whatever they like, just as writers can, but to be a "photojournalist," one must stay in the realm of nonfiction. A novel can be historically accurate and reveal truths about human nature, yet it is still fiction. Likewise, a photograph can be emotionally affecting, yet wrong in fact. And journalism must always be right in fact.

The Impact of Photojournalists on Events

By their very presence, photojournalists alter events. There is a tendency for people involved in them to change their behavior in reaction to the cameras pointed in their direction. In fact, much of contemporary visual history is based on created media events and photo opportunities—created with the full knowledge that still and television cameras can be used to advance the advocacy of special causes.

Sophisticated viewers of photographs recognize the intrusiveness of photog-

raphers and their influence on events. Calm crowds at a pro-choice abortion rights demonstration erupt in sound and fury at the first sight of a camera. Rock-throwing young Palestinians during the Intifada save their angriest salvos for the time when they know the television and still cameras are in action.

Most press photographers are cognizant of the impact of their presence at events. They realize the difference between witnessing and directing, but some photographers incite demonstrators, and that goes beyond unobtrusiveness.

Kinds of Manipulation

In all of the foregoing, I have been positioned on the most uncompromising moral ground. In the real world of professional photojournalism, there is hardly a photographer who, at one time or another, has not resorted to setting up a picture. It is important to distinguish coverage of news events, pure press photography, from the varied assignments that the professional photojournalist is called upon to do.

Sometimes the photographer must illustrate certain key points in an article. Economic realities dictate that in such situations, the photographer must take photographs that approximate reality as nearly as possible. Given the strictures of limited time and money, I believe that all too often the photographer takes the easy way out and controls the situations rather than trusts in their natural follow-up.

Let's pragmatically explore the territory of manipulation and find a viable code of ethical behavior that we can live with. We should recognize, however, that this is a very gray area.

Alterations in the Lab

If we're talking journalistic pictures, we should avoid tampering with the negative or transparency in any way that will alter the meaning of the photograph. That particularly applies to the cropping of a photograph.

To crop or not to crop? There are some photographers who insist that the frame of the photograph is inviolate, and once the image is made, they insist that the full frame be published. I respect that position and the rights of individual photographers to preserve the aesthetic integrity of the frame. On the other hand, I recognize that the editorial and design departments of assorted publications demand cropping. If the substance of the photograph is undistorted by the cropping, I find it acceptable. Cropping often adds to the

visual impact of photographs. Witness Eddie Adams's famous Saigon photograph of the suspected Vietcong being shot by a Vietnamese general. The Associated Press cropped version has become the image we all remember. The cropping dramatizes the confrontation. It can be argued that the rest of the frame adds ambiance and information, showing the reactions of the people in the street who witnessed the event.

The same can be said of Malcolm Browne's photograph of the immolated monk in Vietnam, which is primarily known for its cropped version. Or the Nick Ut photograph of the napalmed child running down the road. In both those cases the Associated Press cropping focuses on the most dramatic elements to the exclusion of those that dilute impact even if they add information. In none of these cases can we criticize the editorial judgment that led to the cropping. The best photographers usually compose to include elements that best fill the frame. It is upsetting and unnerving when the photographer's individual vision is changed by unnecessary and capricious cropping. Editors and page designers, particularly at the wire services and newspapers, should be responsive to the photographer's concerns.

Negative sandwiching of journalistic photographs is unacceptable. Combined images are integral to the work of surrealistic photographers like Alfred Gescheidt and Man Ray. They have used sandwiching techniques with such skill that they have created a new world full of exaggeration and humor. This is a specialized photographic art form in which the created images cannot be mistaken for documentary photographs.

Retouched reality is an oxymoron. So, once again, as it applies to photojournalism, I have to come down on the side of no retouching. Spotting of prints is acceptable in order to remove dust spots or foreign matter that affects the quality of the prints and should be distinguished from retouching, which changes the inherent content of the photograph.

Electronic Manipulation

Computer-age photography and digitized imagery is currently causing great concern and soul-searching. The temptation to create photographic fiction is enhanced by the relative ease of electronic manipulation with the new technologies. Fred Ritchin, author of *In Our Own Image,* has documented some examples of journalistic practices by magazines and books that have violated previously accepted precepts.

Newsweek magazine electronically combined pictures of Dustin Hoffman and Tom Cruise taken at different times and in different places to suggest that

they were in the same room. We have already discussed *National Geographic* magazine's electronic repositioning of the pyramids in a cover shot to accommodate their vertical cover format and *A Day in the Life of America*'s vertical cover, made by moving a tree and the moon in a horizontal transparency. And the editors of *Rolling Stone,* in their desire to present a more peaceful image of Don Johnson and Philip Michael Thomas of "Miami Vice" fame, electronically removed Johnson's shoulder holster and pistol from a color photograph.

It has always been possible to effect changes in photographs through traditional retouching practices. The difference is that, with the advent of the Scitex machine and subsequent computer technology, manipulation has become more accessible and less detectable. It remains to be seen whether the collective journalistic conscience will check the potential abuses by recognizing their inherent threat.

Setting Up Photographs

In June 1948, a speech that W. Eugene Smith was to have given at a Photo League symposium was aborted by a grounded flight from Pittsburgh. It was then published in the *Photo Notes.* Smith wrote,

> The majority of photographic stories require a certain amount of setting up, rearranging, and stage direction to bring pictorial and editorial coherency to the pictures. Here the journalist photographer can be his most completely creative, and if this is done for the purpose of a better translation of the spirit of actuality, it is completely ethical.
>
> If the changes become a perversion of the actuality for the sole purpose of making a "more dramatic" or "salable picture," the photographer has indulged a "poetic license" that should not be. This is a very common type of distortion. If the photographer has distorted for more unethical reasons, it becomes a matter of the utmost gravity.

Gene Smith was not alone in addressing this subject. Almost every working photographer has confronted this vitally important ethical question and set personal codes regarding setup or directed photographs. Back when newspaper and magazine photographers used Speed Graphics or Rolleiflexes that required multiple flash for indoor work, spontaneity was not only hard to come by, it was impossible.

Look at the FSA work of the 1930s or the *LIFE* issues of the first two decades. By necessity, control and manipulation were the name of the game. It is common knowledge that with every early *LIFE* assignment, a preconceived shooting script was provided to the photographer as guidance for the coverage.

Granted, it was only a guide, but it reflected the picture editor's ideas seen from his desk-eye view of the assignment's potential.

But this is the 1990s. The changes in camera and film technology have made it a truism that anything we can see, we can photograph. And sometimes we even get pictures of what we can't see. There is no excuse for the photojournalist to manipulate people in real-life situations or to preconceive a decisive moment. It is the photographer who has to do the moving, not the subject who has to be moved. The photographer, quietly and unobtrusively, must aim to minimally affect the event or people being photographed. We are seeking storytelling pictures as close to reality as possible, not photographic fiction in the guise of journalism.

The yearly University of Missouri workshop developed by Professor Cliff Edom has fought for more than three decades against the "setting-up syndrome." As I explained in the chapter on workshops, each year some fifty photographers descend on a small Missouri town, each challenged to do a picture story on a chosen subject. Shooting at 2400 ASA, the photographers are limited to natural-light photography and not allowed to control the subjects' movements or schedule or to direct the pictures in any way.

Most of the young photographers have never photographed that way before. In that one intense week, under the scrutiny of the staff, they learn that you can make spontaneous, emotionally moving photographs by being witness to real-life dramas.

Photojournalists are often called upon to make significant or environmental portraits where "setting up" is not only acceptable but almost imperative. The photojournalistic portrait that one finds in magazines like *Time, Newsweek, Forbes, Fortune, U.S. News,* and *LIFE* and in all newspapers in the United States, is formulaic and predictable. More often than not, the photographer trots out his or her big strobe lights, pulls in props that will say something about the individual, takes test polaroids, and makes a portrait *Manhattan Inc.* style. These are quick, slick portraits not designed to reveal personality, but they serve to show what the people look like.

Celebrated portraitists like Karsh, Arnold Newman, Annie Leibovitz, and Richard Avedon cannot be categorized as pure photojournalists. Their aim through their portraiture is to reveal more about the individual than can be achieved in the fifteen-minute grab portraits described above. Their work demands time to let them gain perspective about the individuals they photograph and develop rapport with the subjects. Their styles are dramatically different. The only thing they have in common is that the final result is achieved through control—of the subject, the lighting, the background, and

the elements in the photograph. Their portraits are the ultimate set ups. This in no way diminishes their stature.

When Pictures Are Set Up for You

Photo opportunities are known in journalistic vernacular as photo-ops. Photo-ops are designed by the handlers of politicians to manipulate the media for image-building of the people they represent. They have no relation to reality. They are motivated by self-interest, designed to give the impression that the press has free access to the White House, when in fact the press is allowing itself to become a party to journalistic collusion. Presidential images in recent years have been built on White House and summit photo opportunities. The television and print media are willing accomplices. The press agrees to participate in this fraud because newspapers and the press services are afraid not to as long as the possibility exists that the competition will be there. I wonder what would happen if nobody showed up for a photo opportunity. I have this fantasy image of the president of the United States standing with a visiting dignitary, waiting for a press corps that didn't show up and finally, asking an abashed press secretary, "Where are all the photographers and reporters?"

Examples of manipulated media events are limitless. Those who understand the power of the visual image in a visual age can control the world. Adolf Hitler and his propaganda minister, Goebbels, recognized it and perpetuated an image of Nazi invincibility based on still and motion pictures. It was as powerful psychologically as the Stuka dive-bombers and Panzer tanks were militarily. But today a political campaign in the United States has as much spontaneity as a movie kiss.

So let us grant that in a world dominated by photo opportunities devised by public relations persons and media advisers, objective truth becomes less visually attainable. Does that give television and print photojournalists license to set up pictures, to stage events, to distort reality? I suggest that it not only doesn't give them that right, but it mandates that photographers use the camera to search for more truthful moments.

Those more truthful moments can often be found after the pack photojournalists have deserted the scene, when the play-acting has run its course and when the planned and planted enthusiasm has diminished. The photographer who stays around will often be rewarded with off-guard and more revealing takes.

Subjectivity versus Deceit

It is fashionable to say that the camera lies, that the selective eye of the photographer or the choice of lenses being used determines what aspect of an event is presented. I will grant that selective eyes and selective lenses give the pictures greater subjectivity, but to "lie" means to deliberately deceive. The selectivity practiced by a photographer is little different from the subjective observations of a word journalist. The camera didn't lie when it recorded the deaths of the villagers at My Lai, the massacre in Beijing, the charnel houses in the World War II concentration camps or the shootings at Kent State.

Cameras don't lie, people do. But responsible photographers should try to photograph things as they are "not the way they would like them to be."

In May 1963, Charles Moore photographed the Birmingham, Alabama demonstrations. Some of his pictures were published in *LIFE* magazine and have been credited with having changed American perceptions about the civil rights struggle. His pictures of police dogs biting blacks and firemen turning high-pressure hoses on protestors brought home the gratuitous cruelty of the authorities visited on the demonstrators.

I well remember Charles Moore pointing out one sequence of photographs that ostensibly showed a black woman lying in the water on the ground apparently suffering from physical abuse. He warned me not to print those photographs because the lady had thrown herself into the water. Although she seemed to be in pain, she was reveling in the experience. A less responsible photographer might have presented those images in their apparent context without calling the editor's attention to the actual situation.

There are times when the actions of individual journalists discredit our profession. It therefore becomes imperative that we hold ourselves to the highest standards of ethical behavior. Not because we want to forestall further depreciation of our credentials, which have come under attack by the most repressive forces in society, but because as Dr. Schweitzer said, "Truth has no special time of its own. Its hour is now—always."

Living on the Edge: Taking Risks in Wartime and Peacetime

To conquer without risk is to triumph without glory.

Pierre Corneille, *Le Cid*

Photojournalism is hazardous. It's not for the fainthearted or those unwilling to risk personal danger. Reporting what happens in the world puts photographers on the edge of constant disaster. Wars, riots, volcanic eruptions, earthquakes, tornadoes, and floods are just some of the threatening events photojournalists cover. But these risks are not always from the violence of the scene covered. Flying in primitive planes in primitive areas, driving on bad roads, and exposing oneself to disease come with the territory. So any photojournalist worth his film approaches any assignment aware of what he may face. Once aware, the careful photojournalist will take every precaution to prevent personal injury and insure successful completion of the assignment.

Looking for Bang-Bang

War, poverty, and misery are the most seductive sirens of photojournalism. They reflect the conflict and drama of man's life-and-death struggle for survival. The most compelling in this troika of visually loaded subject matter is that obscenity—war. Obscene though it may be, hazardous though it may be, it continues to attract a large group of photojournalists, who traipse to obscure places to record its horrors. Is war photography worth the risk? Some photographers go to a war zone for money, some for ego satisfaction, some to prove their machismo, some out of dedication to communication and journalism, some to make an instant reputation, and some for adventure.

The impulse to document war is not new. Even before the camera was perfected and the war photographers of the nineteenth and twentieth centuries began to record their historic images, there were other artists who attempted to sketch what their eyes had seen. But the camera offered more immediate and credible pictures. Since Roger Fenton made his comparatively static battle photographs of the Crimean War, photojournalists have been "looking for bang-bang" with increasing spirit and intensity.

In the photojournalistic vernacular, "bang-bang" is synonymous with action, producing photographs approximating the archetypal Robert Capa photograph showing the instant of impact when a bullet struck a Spanish Civil War soldier. Editors revel in "bang-bang" pictures, and readers are fascinated by them.

This recklessness is fostered by a journalistic climate that rewards imprudent judgment with instant fame or money if the gamble pays off. Though thoughtful people in journalism question the high price of coverage of every armed conflict that erupts on Planet Earth, no self-respecting reporter will deny the validity of coverage, or even the responsibility of editors, writers, and photographers to cover these wars. Those words and pictures enlighten the present as well as the past. Conversely, compassionate human beings will be saddened as we tick off the names of gifted writers, photographers, and television cameramen who have been seriously wounded or killed. That somber list has grown too long. Voices are emerging that advocate ameliorating the inherent danger of war photography.

The most important British photojournalist of our time is Don McCullin. His photographs covering the wars in Vietnam, Cyprus, the Congo, Biafra, and Lebanon are compelling indictments against war. McCullin has taken his chances, but writes in his book, *Homecoming,*

> I don't believe you can see what's beyond the edge unless you put your head over it. I've many times been right up to the precipice, not even a foot or an inch away. That's the only place to be if you're going to see and show what real suffering means. . . . When I was younger, I did it to become famous. But now there doesn't seem to be any point in going that close more because the law of averages will claim me, and I don't want to die in someone else's war for a lousy photographic negative.

War also exacts an emotional toll on photographers. McCullin says,

> People sometimes fail to understand how much the photographer is emotionally disturbed by what he photographs. They think that all photographers are just ruthless and relentless. . . . I'm still interested in photographing

people, but I would like to show their way of life without their being on the floor in front of me bleeding. I don't want to be labeled as just a war photographer. In many ways war is all too easy to photograph. You just have to grit your teeth and hope you can keep your eyes open.

Indeed, when McCullin returned to the war scene in El Salvador in 1984, despite his promises that his world would be centered around life in England, he suffered a broken arm and two broken ribs for his efforts.

For photojournalists, war coverage has changed. It used to be that photojournalists and medics were rarely injured, though they were never immune to the impersonal scattershot of land mines, stray bullets, shrapnel, and downed aircraft. But in many conflagrations today, the risks have been heightened by the lack of disciplined troops on both sides and their illiteracy, the penchant of some journalists to choose sides, and the competitive media pressures for increasingly dramatic photos.

Between 1978 and 1982, Harry Mattison was a freelance photographer associated with the Gamma-Liaison photo agency. A former fine arts photographer and assistant to Richard Avedon, his photography during that period was inextricably bound up in the events in Nicaragua and El Salvador. Mattison is a thoughtful and sensitive man. Reacting to the suggestion that increased competition among photographers enhances risk, Mattison says, "I have a strong sense of family with other photographers. Cooperation will always take precedence over competition. I know there are some people who feel an enormous sense of competition, and I feel that does create an anxiety that might lead them to make mistakes."

To Mattison,

> War is the direct manifestation of absolute moral corruption. You'd better have a message that you take into combat because, unless there's a consciousness that I haven't reached yet, I sincerely believe that you won't find one there. I mean, there are only those pieces of metal around you whose sole purpose for manufacture is to terminate someone's existence. How do you photograph that?
>
> Once you wise up, every image shouts, screams, or howls, "Stop! Don't do this! Killing human beings is insane!" After a while, as exhaustion takes you in, you only get to whisper. This is very painful. You understand that you are speaking in light, but this profession will never change anyone's actions.

Today, forty-four-year-old Harry Mattison is in the midst of a community-based photographic project in Washington, D.C. At some point he realized that he didn't have to leave home to do important work, that he couldn't ever be a Sri Lankan or a Vietnamese, he could only be an American. Rather than be a

transitory observer, he yearned for the opportunity to have a more tangible relationship with the people he photographs. His three-year work at Sursum-corda, a two hundred-family public housing project, allows for greater person-alization of the work and fulfills a desire for more control over the final use of his photographs.

Former Black Star staff photographer Anthony Suau has been in almost every hot spot that has erupted since 1985. He is not an action junkie looking for highs from risk. Nor does he undertake dangerous assignments to establish his credentials. His reputation was secured in 1983 when he was awarded a Pulitzer Prize for his coverage of famine in Ethiopia. He does what he does because he wants to be where the significant stories of our time are developing.

"It's my job," says Suau.

> I accept assignments to do something risky and dangerous, but I'm a careful photographer. War scares the hell out of me. There's nothing there that I enjoy and it's not my desire to be a great war photographer. I'm more caught up with political movements, with the struggles of repressed people demon-strating against their oppressors. I'm more passionate about showing the background that propels people into the streets to demonstrate and risk their lives to effect change.

Although he has covered fighting in such places as Eritrea, Afghanistan, and Sri Lanka, the one experience that stands out as most dangerous was the 1989 fighting during the revolution against Ceaucescu in Romania. Suau de-scribes a tumultuous scene in which guns were handed out to civilians unfa-miliar with weapons, Securitate police were sniping from the rooftops, and there was random, indiscriminate gunfire. Photographers working under such situations were unable to always find protective cover, not knowing from which direction the shooting would come.

Suau in action, as described to me by an observer, was quick, catlike, and assured. Suau attributes his ability to move quickly to being unencumbered by too much equipment. He limits himself to a maximum of three camera bodies, preferring to carry only two, and only two lenses, a wide-angle 28mm or 35mm and a 135mm lens. He wears no bulletproof vest because "it slows you down tremendously, particularly in tropical areas. The ability to move quickly is more advantageous to me than wearing a jacket. I make decisions with split-second timing and flow with the action."

Sygma photographer Patrick Chauvel is famous for his photographic work over two decades. He has been in many battle zones, including Ireland, Af-ghanistan, Lebanon, Laos, Vietnam, Mozambique, and Central America. He

has been wounded and held captive and has scraped through narrowly on several occasions. On December 21, 1989, Chauvel was critically wounded when caught in crossfire between two groups of American troops in the Panama invasion. At the same time the Reuters photographer, Malcolm Linton, was shot in the leg, and Juan Antonio Rodrigues, on assignment for Spain's *El Pais* newspaper was killed. The Panama story showed many instances of hostile, angry, and desperate Panama Defense Force troops roaming the streets and taking hostages. There were also some nervous, inexperienced, and not-very-bright American soldiers undergoing their first armed conflict. Under such chaotic circumstances, the hazards to the photographers obviously increased.

Since 1986, Christopher Morris, a Black Star staffer and former file clerk in our picture library, has covered big stories in a dozen countries, including the drug war in Colombia; the political ferment in Chile, Nicaragua, the Philippines, and Czechoslovakia; and the fighting in Liberia, Afghanistan, Panama and Yugoslavia.

Chris Morris has not emerged unscathed. In Colombia his shoulder was dislocated while covering the "war on drugs" when a roof in the Bogota airport collapsed as he was photographing the arrival of U. S. helicopters. In Chile he suffered a broken nose, and his cameras were smashed by the Chilean police who are known as "Carabineros." The Carabineros seemed to enjoy attacking journalists to vent their frustrations prompted by the referendum defeat of General Augusto Pinochet. AFP photographer Cristobal Bouroncle suffered head wounds in the same attack and one-hundred-pound *Newsday* photographer Liliana Nieto Del Rio was brutally kicked and beaten and suffered a hairline skull fracture in the same incident.

Of the five Black Star photographers working in the Gulf War, two, Anthony Suau and Chris Morris were among the forty journalists unaccounted for during the conflict's final days. Their disappearance for five days before being released in Baghdad caused great anxiety.

Tony, Chris and other photographers, electronic journalists, and reporters from many countries left Kuwait City when they heard that there was civil warfare in southern Iraq. Some traveled alone or in pairs, others as part of impromptu convoys. After they passed the last American checkpoint in southern Iraq, nothing was heard from these journalists. They were detained by the Iraqi army, presumably because Saddam Hussein wished to keep the world from getting first-hand reports of the strife that had broken out between his Republican Guard loyalists and the Shiite Moslem majority that lives in Southern Iraq.

Chris Morris had teamed up with *Philadelphia Inquirer* staffer Todd Buchanan

in Kuwait City on Saturday, March 2, 1991. Alone in a car that Morris had rented, they photographed what Morris describes as "a parking lot of death" in Kuwait where fleeing Iraqi tanks, loaded trucks, and armored personnel carriers had been devastated by coalition air strikes. They came upon a group of Iraqi Republican Guards, who allowed themselves to be photographed for about forty-five minutes.

They also came upon a group of Iraqi refugees fleeing from Basra who said that the city was under the control of the Shiites. Buchanan and Morris debated whether to continue on to Basra, but concluded that it would be risky based on the advice of Iraqi soldiers, who had told them that "you have no Iraqi visas and you have Saudi license plates."

Morris attributes his later predicament to his susceptibility to the journalistic competitiveness syndrome. "As a journalist," he says, "you rely on your instincts knowing how far and how hard to push. Competitiveness caused me to stop listening to my instincts for self-preservation." Morris describes a scene a few kilometers past the American checkpoint when he and Buchanan had decided to turn back without proceeding to Basra. First a British TV crew came roaring by, soon followed by many cars that contained other journalists, photojournalists, and foreign television crews. Not to be beaten by their colleagues in an important story, Morris and Buchanan were caught up in the convoy and also rushed headlong toward disaster.

Morris says that he placed his car last in the convoy, calculating that if anything untoward did occur, he would quickly whisk the car around, peel away, and head back toward the safety of the coalition positions. Morris and Buchanan gambled and lost. When the convoy was stopped, their alternative plan was thwarted by the quick action of the Iraqis, who poked weapons into their car.

The captured journalists were loaded into vehicles and taken to Basra, where the heavy fighting between the Shiite insurgents and the Iraqis was taking place. After one night they were moved to a safer location, a military supply center south of Basra. Morris describes a scene where thirty journalists were put in a twenty-five-foot terrazzo-tiled square room. Morris had rescued his sleeping bag, but the other journalists shared the few blankets that were given to them. Finally, after six days, the journalists were turned over to the Red Cross in Baghdad, and the nightmare episode ended—to everyone's relief. The cost for Morris and *Time* magazine: one vehicle, three camera bodies and a Leica, twenty-five rolls of historic pictures that are still cached in the confiscated vehicle, and days of apprehension and concern.

Not so lucky was Gad Gross, who was shot in cold blood by Iraqi soldiers

while covering the Kurdish rebellion in northern Iraq for *Newsweek* magazine. Gross, the Eastern European correspondent for JB Pictures, had been traveling with a Kurdish rebel named Bakhtiar in Kirkuk, Iraq, along with two journalist colleagues, Frank Smyth, a CBS freelancer, and Alain Buu of Gamma-Liaison. Trapped in the middle of an artillery assault, Bakhtiar and Gross took refuge in a house, where they were later discovered by the Iraqi soldiers and machine-gunned in a fusillade of bullets.

Gad Gross was twenty-seven years-old when he died on March 29, 1991. Lost was a Harvard magna-cum-laude graduate who planned to attend either Yale or Columbia Law School. Jocelyn Benzakin says of Gross that "he had a deep understanding of world events and contemporary history and was always determined to think beyond the actual photography to the issues and implications involved. He was passionately concerned about human rights and defending the interests of oppressed minorities."

These stories underscore the frightening reality that danger is the constant companion of the contemporary war photographer. Photographers need all the mental ammunition they can muster to not only get into the right places at the right times, but to get out safely with photographs. Intelligence, caution, and planning are elements essential to the photographer's survivability.

Prerequisites for Survival in a War Zone

For photographers considering war photography, the challenges are clear: to be responsible as journalists and to stay alive. These are not mutually exclusive considerations. Often safety and objectivity go hand in hand; prejudices revealed may precipitate retaliation. Concerned editors want *the* pictures but not at the cost of sending decent, dedicated people into the sporadic uprisings or the war of the week.

The badge of courage and honor in photojournalism is to bring back informative photographs that reveal the truth as you see it. Before you can be a war photographer, you have to be a photographer. There's no award for death or shrapnel in your body. Shrapnel can't be published!

During the height of the fighting in El Salvador in the early 1980s, I had a chance to talk to a worried Tom De Feo, then director of photography at the *Miami Herald*. What particularly bothered De Feo was a climate of unprofessionalism, unbridled risk-taking, and the cowboyism of a ragtag army of photographers ill-prepared to be rigorously disciplined.

"What they didn't realize," said De Feo, "was that the 11-, 12-, and 13-year-old boys carrying thirty-year old carbines and automatic rifles didn't know the

difference between a khaki-attired journalist with forty pounds of gear around his neck and a government soldier. And they didn't give a damn. Life in El Salvador isn't worth much more than the $4.50 a day which is the standard of income in El Salvador."

Given that the rules of war are not only unwritten but likely to be unknown to most of the participants, it may be helpful to current and future war photographers to evaluate these recommendations for survival when taking pictures in life-threatening areas.

1. You should speak the primary language of the country and know as much as possible about the native body language and gestures. Superficial knowledge of the language may give you a false sense of security. If you don't speak the language, make sure you have a guide or local assistant who can help you communicate with the indigenous population of the area.

2. You should be physically fit and know how to protect yourself. Make sure you have all the inoculations against typhus, malaria, and other potential diseases to which you might be exposed.

3. You have to be emotionally stable, resourceful, and intelligent.

4. You have to be well equipped with such life-saving equipment as a custom-made flak jacket.

5. Study the country and its history, and read everything you can lay your hands on about the conditions that have given rise to the armed confrontation.

6. You have to be quick-witted enough to talk yourself out of threatening situations.

7. Don't go on photographic forays with other risk-taking photojournalists.

8. Use careful and mature judgment at all times.

9. Aimless wandering in search of pictures in a war zone can lead to disappointing photographs and potential injury.

10. Above all, be human. This quality may be the best protection a photographer can have.

Psychic and Physical Hazards

Hazards related to photojournalism go beyond shrapnel, bullets, and rocks thrown by demonstrators or vengeful policemen. Anthony Suau has luckily survived years of involvement in dangerous areas unscarred, but the experiences of those years have taken their toll. Suau has permanent damage to his digestive system: he picked up bilharzia, a vascular parasite, in Ethiopia, and spent five days in the hospital being treated with a highly toxic poison that killed the parasite but left him physically weakened for a whole year. Suau is

far from alone in having to cope with the plethora of tropical diseases, amoebas, and parasites that affect many of the Western photographers who cover Africa and South America.

Psychological scars come with constant exposure to extreme violence. Such events can traumatize photographers just as they do bystanders. Machete-dismembered bodies may haunt photographers' dreams for months and even years. Damaging as those scenes may be, many photographers become inured to them. But then making a transition from a world where violence is matter of fact, even commonplace, to everyday life in Paris or New York can be jarring if not impossible. Working in a war zone colors behavior, sensitivities, and relationships with others in unexpected ways.

Christopher Morris, now a veteran of crisis and war photography, needs "about four or five days of quiet time alone" in order to wind down from these experiences. "When I return," says Morris, "I find it difficult to accept dinner invitations because the things discussed seem so trivial compared to the life and death struggles I have just witnessed. My attention span is limited. I know that I am hyper, on edge, less tolerant, and short-tempered. This profession keeps photographers and their wives and girlfriends on a psychological roller coaster."

Environmental Stories Can Be Hazardous to Your Health

Fred Ward is a prudent Washington-based Black Star photojournalist whose career has taken him to every continent. For several months he worked on what he describes as "one of the most difficult and annoying assignments I have ever undertaken," a hazardous waste story for *National Geographic.* This project put Ward in close contact with radioactivity and many dangerous substances—gases, liquids, and solids.

"The main thing," says Ward, "is to keep exposure as low as possible or eliminate it completely." Ward used disposable body suits, hats, goggles, gloves, and steel-toed boots, to cover his body completely. Usually a respirator protected him around radioactivity and poisonous gases, but at an Ohio site he wore a full face-mask to guard against the danger of explosion.

"The obvious need for a photographer is to get at the camera and controls. I wore thin, disposable surgeon's gloves and a Speed Finder in an Ikelite on my Canon F-1 to let me see the full screen from three inches back from the eyepiece. It was a great deal like working underwater." Although he didn't use one on this assignment, Ward later realized that a Nikonos underwater camera would also be impervious to toxic risks and could be washed off when leaving the site.

"Unless the cameras get wet or touch some of the material, I don't worry too

much about them. I wipe them off each time and avoid taking things from the contaminated site with me. I can generally keep everything away from contact with my body or clothing except for my boots. Those I leave at the site for disposal."

A Profile in Courage

Just hours after the worst nuclear accident in history, Soviet photographer Igor Kostin was the first photographer on the scene. "There was still smoke coming out of the reactor," says Kostin, "but I managed to get a few shots off. You could actually feel the silence. It was like a cemetery."

Kostin lives in Kiev, sixty-two miles from Chernobyl. The nuclear accident has changed his life. He has been exposed to five times the accepted level of radiation, is always tired and often has difficulty walking. He has been hospitalized three times for radiation poisoning, but despite the adverse health impact, Kostin is consumed by his passion to continue returning to Chernobyl to document its effect. "This is the only record of what happened there," says Kostin. "I have to carry on."

Kostin is deeply troubled by the devastation he has seen, and particularly by the children described as "the ones who became the innocent victims of our so-called civilization." He talks about himself as finding "it is hard to live among normal people now. A person who has been through hell has a different attitude. He breathes the air and feels the sunshine differently."

Igor Kostin's hell does not lessen his commitment to continue documenting the world's worst nuclear-plant catastrophe, believing that "the people have the right to know." When the final honor roll for preserving that "right to know" is drawn up, Igor Kostin's name will be there.

I have long thought that Armageddon may not result from nuclear confrontation between East and West, but rather from the cumulative effects of the world's careless handling of its toxic by-products in an environmental wasteland. Hazardous waste is the lunatic legacy of an increasingly sophisticated scientific and industrialized society. Photojournalists have an obligation to report on environmental threats, but in so doing they must carefully evaluate the risks entailed and try to minimize them.

Why Take the Risk?

Life does not exist without risk. Statistics show that more Americans die in automobile accidents each year than did in the Vietnam War. Most traffic

fatalities take place within fifteen miles of one's home. There is always an accident waiting to happen.

Photojournalism is for those who get turned on by challenge, by being there, by living life fully. Why do people climb mountains? Or dog-sled across Antarctica? Or hang glide? Or endure hardship to take pictures? Because these are challenges to be confronted that gratify them and benefit others.

On Seeing, Perceptiveness, Time, and Creativity

The seeing of God is not like the seeing of man. Man sees only between the blinks of his eyes. He does not know what the world is like during the blinks. He sees the world in pieces, in fragments.

An artist, too, must see the world whole, he must somehow learn to see during the blinks, he must see where no one else can see, he must see the connections, the betweennesses in the world. Even if the connections are ugly and evil, the artist must see and record them.

Chaim Potok, *The Gift of Asher Lev*

Henry David Thoreau, transcendentalist, philosopher, and writer, could have been a great photographer. Seeing was his forte. But he chose to make his pictures with words. "The question is not what you look at, but what you see," said Thoreau.

His written observations were purely visual—his eyes penetrated the infinite depths of all he saw, his patience revealed layers of nature and human behavior that lay below the surface. That is what photography demands of its best practitioners—the ability not only to look, gaze, and observe, but also to see in an intensely personal way, to strip away the obvious in search of deeper meanings, ironies, incongruities, and juxtapositions.

Watchful Waiting

I once knew a young man who wanted to be a photographer and was attending a school for photography. He showed me his photographs, which, in my opinion, revealed a singular lack of insight or seeing. I invited him to join

me on a visit to the local beach in the area where I lived. I said that we were going to the beach by ourselves, without cameras and lenses. We were going on a "seeing expedition" in which we were going to walk slowly and silently, luxuriating along the way in new visual experiences.

We happened upon a piece of gnarled driftwood, one of those gifts from the sea. We circled it and viewed it from every angle. I wanted to show this young man that one could not just find an object and immediately decide what vantage point would reveal it best. It takes time. It takes study. It takes contemplation. With each view, the driftwood took on another shape, a different texture.

And then, out of the mist, a barefoot man came walking his dog, throwing a ball that the dog either caught in midair or retrieved from the waves. "Let's follow him," I said, "and wait for something not as everyday to happen." It didn't take long. From the other direction another early-morning dog walker appeared, this time an attractive woman. The two dogs romped in the surf, their owners caught up in a chance contact. The scene had been changed into a more significant vignette with better storytelling elements. It was the kind of moment that reminded one of a stalking Cartier-Bresson, following and waiting for that right moment when he was about to depress the shutter saying, "Now! Now! Now!"

The world of the photographer, of the photojournalist, is made up of such "nows," of capturing them as they will never again be exactly duplicatable in light, mood, body language, or what have you. The photographer must practice the act of watchful waiting, of anticipation and instinct, which all develop through observing human behavior and refining one's ability to see.

The Creative Photographer

How many times have you heard a photographer's representative, an art director, a designer, a picture editor, a museum photography curator, an account executive, a photography critic, or just a layman refer to "the creative photographer"? "Creative" is the most overused word in the jargon of this tradecraft and the most underutilized element in its application.

It need not be so! Whether you are a photojournalist, wedding or bar mitzvah photographer, portraitist, industrial photographer, medical photographer or art photographer—you can be creative. Most creative photographers are not born that way. There is an accepted wisdom that creativity is hereditary. I believe that creativity can be assisted, that it can be developed over many years and often parallels the intellectual or artistic growth of an individual. So, the next time you are challenged to take a "creative" picture of a

seemingly boring nut and bolt, ask yourself how you can take a fresh view of a
mundane subject.

You could light that nut and bolt in ways you've never thought of before:
you might stop them in midair with stroboscopic lights, place them in an
incongruous setting, photograph them with a prismatic lens or introduce a
human element. As outrageous as it sounds, you might even opt to do a soft-
focus nude as a background for a sharp nut and bolt in the foreground. There
are no limits to the alternatives if you'll give yourself a chance. The creative
cop-out occurs when you throw up your hands and settle for the obvious.

The term *creativity* suggests originality of thought, a difference of approach
that stems from a person's imagination. Some writers and philosophers have
attributed unusual gifts to the creative process. Others have defined creativity
as the most important element in living. But it is not restricted to the arts. It is
equally important in every aspect of man's existence—from finance to politics
to science and medicine. The energy crisis continues to test our creativity in
producing energy alternatives to fossil fuels. Creative photography has much
in common with any form of it. Talking about it rarely helps develop it.
Talking about it is the last refuge of those who fail to achieve it.

"In the area of expression, people are like trees in a forest," says David
Moore, one of Australia's leading photographers. "We feed on the mulch on
the forest floor until we fall and become mulch ourselves. If our lives are full
and creative, we may in turn enrich life for others."

For Photographs with Staying Power, Take Your Time

When Cicero wrote, "History is the witness that testifies to the passing of
time; it illuminates reality, vitalizes memory, provides guidance in daily life,
and brings us tidings of antiquity," he might as well have been talking about
photography and photojournalism.

"Time!", *Time,* and its related words have everywhere belonged in the photo-
graphic lexicon. We measure exposures in fractions of a second. We shoot "time
exposures" to record the passing of time in a single frame, or use "time-lapse"
photography to speed up time so as to record the growth of a flower. We look for
"decisive moments" to distill in one frame the essence of an event that will best
tell the story. Pictures are "historical," "topical," "timely," and "timeless."

Once we firmly establish that no two pictures are ever exactly alike and that
every syllable of photographically recorded time is unique, we can move on to
the practical impact of time on the work of the photographer and his output.
The Greek philosopher Epictetus wisely counseled, "No thing is created sud-

denly, any more than a bunch of grapes or a fig. If you tell me that you desire a fig, I answer you that there must be time. Let it first blossom, then bear fruit, then ripen."

The most troubling aspect of contemporary photojournalism is the popular misconception that great photographs, even good photographs, do not take time. Picture editors and art directors should recognize that "instant creativity" is chimerical. Too often the photographer is expected to arrive on the scene, whip out camera, film, and lenses, and within minutes, start shooting. Occasionally, the photographer will succeed. But, more often than not, the result will reflect a haphazard and undisciplined approach to the assignment.

Once again a photographer needs time—time to absorb the situation, establish rapport with the subject, scout the ambience of the locale, digest and organize thoughts, and then begin his picture taking. Photography "on the cheap," which unrealistically limits the photographer's time, destroys creative photography. A busy executive who will only give a photographer five minutes for his photograph provides an impenetrable barrier to making a creative portrait. Arnold Newman, Richard Avedon, Yousuf Karsh, or Philippe Halsman would refuse to be handcuffed by such arbitrary limitations. The best that one can achieve under such stress is an unrevealing likeness, not a portrait that shows with reasonable accuracy the character of the individual portrayed.

The "quick shoot" is photography's most prevalent weakness. It contributes to the superficiality of the personality stories we see in our magazines and newspapers. It is rare that we get perceptions of real people in such publications as *People* or *US*. More often than not, we get stereotypical, predictable, and unrevealing pictures.

The great personality essays in photojournalism share one common denominator—depth of time. W. Eugene Smith spent six months with Dr. Albert Schweitzer in Lambarene to capture the complex, ambiguous personality of a man who had been given hagiographic treatment by the media. Only time and access allowed Eve Arnold to provide a deeper-than-public-relations view of Joan Crawford in her well-known *LIFE* essay.

Photography—any type of photography—on the cheap is wasteful and extravagant. Quality requires time. Time requires money. But it is money well spent if it makes for a memorable photograph or photographic essay.

The Need for Patience

A corollary to time is patience. Without it, few photographers are going to reach the heights of their profession. Photographic mentor Minor White recog-

nized this. He said, "You must quiet yourself down before you start to make photographs. . . . You must get everything else out of the way of your concentration, and you come into it as free as possible of all the things you were just thinking about. Set aside some time to let all the garbage go by so as to pay full attention to the photographing."

This Zenlike principle applies to every endeavor, and especially to any creative activity. In photography there is a price to be paid for an itchy shutter finger, for a rush to judgment, for imprecision of thought. It is calculated in sloppy compositions, technical deficiencies, and vague storytelling qualities.

One might dispute many of Susan Sontag's theses in her book *On Photography,* but few can argue when she says, "All photographs are memento mori. To take a photograph is to participate in another person or thing's mortality, vulnerability, mutability. Precisely by slicing out this moment and freezing it, all photographs testify to time's relentless melt."

The Creative Threshold

It is impossible to reduce creativity, and photographic creativity in particular, to a formula. Each photographer has a different creative threshold. In some it's just there, but most have to work toward its realization. It is seldom that inspiration simply strikes, is transmitted through the trigger finger, and comes out as a creative image. More often than not, creativity results from good old-fashioned hard work. One must allow both the mind and the camera to explore all alternatives in solving a photographic problem.

The mind, not the camera, is the key to creativity. Liberal amounts of imagination and fantasy combined with personal observation can open the door to new ideas. Wide reading can promote different ways of seeing by giving the photographer insight into the subject to be interpreted.

One must be open to new concepts yet be independent in thought. The photographer who accepts as gospel the instructions of the art director or picture editor and delivers what they preconceive is little more than a button-pusher or shutter-clicker. There is plenty of room for photographic technicians who can follow other people's instructions, but they shouldn't be confused with creative photographers.

The Creativity of Photojournalists and Photographic Illustrators

Let's talk about two different kinds of photographers—the photojournalist and the photographic illustrator. The creative demands on each are dramati-

cally different. The photojournalist is required to present penetrating views of the society in which we live. Creativity is reflected in the startling visual imagery of individual pictures as well as in the narrative ability of series of photographs. The photographer's selective eye is often the decisive factor. To convey understanding, the photographs need to convey information, content, and meaning in every area of the frame. The photographer's intellect must fuse the historical and contemporary forces which shape an event into a single image.

The photographer must also prepare for the moment when images are made by developing building blocks of knowledge about the subject. Total immersion is the only way. Newspapers, books, magazines, and films have to be absorbed as background for later reference on assignment. The goal is to produce pictures that will add something new to extant knowledge.

The photographic illustrator is a visual problem-solver. He may have to produce a photograph as an editorial illustration or as an advertisement. The illustrator's first challenge is to understand what the photograph must say or do. Unlike the photojournalist who deals with the reality of things, the illustrator may be allowed the full play of imagination and fantasy.

Here, too, the mind should absorb all manner of stimuli. The great illustrative idea may come from writing down stream-of-consciousness lists, from talking uninhibitedly with different people, or from daydreaming and meditating. Each photographer has to find his or her own creative catalyst. What all creative photographers must have in common is receptivity to innovation, improvisation, adaptation, and exploration. One can become creative by willing oneself to be creative, by not settling for competence. "I would sooner fail than not be the greatest," said Keats. Your belief in and desire for creative growth is a giant step forward in your development. Nobody who questions each concept and accepts each assignment as a new challenge need settle for mediocrity.

Perceptiveness

The sibling to "the creative photographer" is "the perceptive photographer." Perceptiveness may be the most important quality of the truly great artist. It implies an instinctive, intuitive insight and understanding based on sensory responses.

We have progressed in the technical art of photography to a point where cameras are idiot-proof. It is difficult to take an out-of-focus exposure. But camera manufacturers haven't added a human brain, human intellect, or hu-

man feeling to the insides of these technological wonders. Cameras are still subordinate to the photographer and his perceptions.

The real world that photojournalists are trying to interpret is not—and never has been—one-dimensional. The media is often criticized for its emphasis on the sordid or the unpleasant. But to understand the world, one must confront the full spectrum of human experience.

Observations of a
Photographic Curmudgeon

The heart has its reasons which reason knows nothing of.

Pascal, *Pensées*

Curmudgeons are supposed to be crusty, churlish, and irascible. Maybe I'm one, although I pride myself that I am experienced in the arts of compromise, reasonableness, pragmatism, and rationality. But I do feel strongly about many things, so indulge me if I seem like a curmudgeon here.

On Emptiness and Ambiguity

Several years ago, Jerry Adler, a *New York Daily News* columnist, described the artistic merits of the now-departed Andy Warhol, the darling of pop art and pop culture, as "emptiness in depth."

Some photographs are ambiguous and lend themselves to several possible interpretations. This inherent ambiguity is predicated on their selection and isolation from the totality of events. They may be taken out of context and are often dependent for interpretation on the mind-set of the individual viewer or the selective eye of the photographer. The Thematic Apperception Test, a psychological test, is administered by presenting photographs for interpretation. As I said in my introduction, the pictures presented are formless and open to any number of responses.

My quarrel is not with the fact that pictures are ambiguous. It is rather with picture people who exacerbate ambiguity and find straightforward, explicit, understandable photographs pedestrian. They also find obscurity, uncertainty, vagueness, and equivocation the preferred criteria in making photographs in-

teresting and exciting. I disagree. I think that journalistic photography demands clarity and lucidity and the avoidance of ambiguity wherever possible. There is a place in photography for mystery and abstraction. The place is not in the pages of newspapers and magazines charged with interpreting the human experience.

Warhol's nihilism is contagious. It has been imitated by many others. It sometimes seems as if the more elusive and incomprehensible the image, the more one reads into the photograph. That vagueness is also carried over into the way we describe photographic approaches and philosophies. The elevation of photography to the heady atmosphere of art has brought with it high-flown rhetoric and hyperbole. What happened to good old-fashioned English? Phrases like "negative space" and "conscious ambiguity" are too often used to mask the limitations of the work.

The Great Delusion

Everybody wants to work for *National Geographic* magazine. Few make it because there are few openings. Those who become staffers at *Geographic* rarely leave. They know that there are few magazine staff jobs in the field that will provide the variety and importance of *National Geographic* assignments.

Most magazines today rely primarily on freelance photographers. Achieving the status of contributing photographer or staff photographer is directly related to the quality of your output, the intelligence of your personal sales effort, and the hard work you invest in your photojournalism career.

Make yourself valuable through your ideas and your photography. Get your pictures where they belong when they are promised. Make every picture count in terms of visual impact and content. Say three things in one photograph while the next guy says the same three things with three photographs. Still photographers are not motion-picture photographers with the luxury of twenty-four frames per second to tell their stories. Magazine editors, whose space is at a premium, appreciate the photographer who can say the most in a single picture. Work five times harder than the next photographer.

On Exuding Confidence and Hiding Your Insecurities

I recently saw a photographer who wanted to show his work for possible inclusion in the Black Star stock library. After an effusive and patronizing introduction, in which he thanked me too much, he recited a long history of rejections he'd received from many other agents. He couldn't understand why.

I asked to look at the pictures. Before showing them, he said that his productivity had been adversely affected by his personal problems, primarily the illness of his wife. "What happened to your wife?" I asked. "You don't really want to know, do you?" he replied. "If I wasn't interested in you as a human being and if you hadn't told me about the problem, I wouldn't have asked the question. Of course, I'm interested," I said. Whereupon I heard the tragic story of his wife's schizophrenia and her institutionalization.

Our meeting went downhill from there. There were apologies and more apologies for not having taken the time to pick out his best pictures to show me. "I have about two thousand good pictures at home that I could have brought," he said. "Maybe I shouldn't show you this sheet." And so it went, his insecurity manifesting itself with every word. I tried to tell this photographer that when he came to see me or any other agent, or when he visited any editor, he should prepare the work carefully, bring only pictures he considered the best examples of his work, and eliminate the mediocre. He should be confident about his work rather than negative in its presentation; negativity is contagious. And really nobody he sees wants to discuss the personal reasons his pictures are deficient. They only judge the pictures, not the circumstances under which they were taken or those that prevented them from being better.

On Luck

I remember once commenting on the elements that contribute to a photographer receiving "Magazine Photographer of the Year," one of the premier awards given at the yearly University of Missouri-NPPA Pictures of the Year Competition. I identified six ingredients, not necessarily in order of importance: commitment, opportunity, support, visual insight, presentation, and luck. The commitment to be where the important stories of the year are taking place, the opportunity to get there, the support of publications willing to finance and publish your work, the visual insight that only the photographer can provide, and a strong presentation.

And luck—that is the intangible element. Luck determines the caliber of the competition, the makeup of the jury, the inherent drama of the events covered, and whether the photographer was in the right place at the right time. But I go back to the famous Edward Steichen quotation; when asked whether success in photography was attributable to luck, he replied unhesitatingly, "Yes it is. But have you noticed how that luck happens to the same photographers over and over again?" And some anonymous sage once said, "Good luck is the lazy

man's estimate of a worker's success. Success often breeds envy in the minds of less successful photographers."

On Overactive Egos and Humility

I think it is important for everybody to have a sense of self, to be confident about their abilities and to communicate that confidence in dealing with clients. For photographers it is even more important, since editors want a self-assured, mature person representing their publications. Having self-assurance doesn't mean that the photographer should project self-importance. A little humility goes a long way. Many gentle, pliable, and accommodating photographers in their early years become demanding and conceited people who accept recognition of good work with little grace or modesty. It is probably well to remember that the hero of today may be the outcast of tomorrow. John Ruskin believed that "the first test of a truly great man is his humility."

Emil Schulthess, a Swiss photographer, has had an illustrious career. His photographic projects on the United States, Africa, Antarctica, and Japan and his groundbreaking panoramic photographs have maintained his reputation throughout several decades as a working photographer. I affectionately remember Emil Schulthess soliciting my advice when he was editing one of his books; I was young and was honored to have him seek my opinion. I also remember his generosity of spirit, his respect for others' opinions, and his openmindedness, since he didn't assume omniscience.

On Giving Away Pictures

Every professional photographer, at one time or another, has received a phone call or letter reading as follows: "Our organization would like to use your photograph in a brochure [or advertisement, or magazine, or audio-visual presentation]. We are a nonprofit organization that has no budget for the purchase of the photograph, and we hope that you will provide the picture without charge." My standard answer is an emphatic "no." I am tired of the exploitation of creative people by nonprofit organizations. You may think this a crass and overly commercial response, but let's consider it for a moment.

What about the person who wrote that letter or made that call? Does that person get paid for his or her job as the editor or art director of the publication? What about the rest of the staff of that nonprofit organization? Do they get paid for their efforts? Does the paper company charge for the paper used in the brochure or publication? Do the typesetter, color separator, half-tone

maker, printer, and binder get paid? The answer is a categorical "yes." So why should the photographer be the one who is asked to contribute the work without compensation? My position is that if everybody is donating their services, and no one is getting paid for a project that is altruistic and idealistic, then, and only then, should a photographer ever consider donating the reproduction rights to his or her photograph.

On Overshooting

For some photographers, overshooting is the order of the day. They have no heart! The problem stems from the acceptance of the 35mm camera, the quick film transporter, and the motor-drive that allows photographers to shoot with machine-gun speed. In the days when press photographers used 4" x 5" sheet film in Speed Graphic and Linhof cameras, or shot 2¼" x 2¼" negatives or transparencies in Rolleiflex and Hasselblad cameras, the limitation on speed made the taking of the photograph a highly disciplined act. Technological advances now allow photographers to speed film through their cameras uninhibitedly. I would not be surprised if someday the *Guinness Book of Records* has a world's record for the number of frames a photographer has shot in one day.

I recall an assignment during my working years where one of our photographers shot fifteen rolls of color film to produce one picture. The film and processing for that one picture alone cost the client in the neighborhood of two hundred dollars. At no time is there any justification for this excessive expenditure of film on a simple one-picture assignment.

Over and above the waste, just remember that someone has to edit the photographs. Have you ever gone through fifteen rolls of film (540 exposures) of virtually the same photograph, taken from the same vantage point with little to differentiate one exposure from another? Picture editors also have occupational hazards such as boredom and myopia.

I have a theory. I can't prove it, but I think that pictures get better when the photographer shoots less and thinks more. The trigger finger should release the shutter only when the chances for success are the greatest—when the light, composition, and the spontaneity of the moment approach perfection.

Where Have All the Journalists Gone?

When Henry Luce started *LIFE* he wrote a credo for the new magazine that was an expression of his own philosophy and his curiosity about the world. Henry Luce was a journalist with extraordinary instincts for what could make

an exciting magazine. It would seem that as we enter the last part of the twentieth century, the visionaries have been replaced by the bean counters. What matters is the bottom line. The deal makers see magazines as just another opportunity for the development of mega-communication empires throwing off big bucks to stockholders rather than as a vehicle to inform and communicate.

I long for the days when we rushed home every Friday to see what miracle of journalism *LIFE* was going to show us that week. But instead of finding miracles, instead of seeing thoughtful and concerned magazines willing to publish earnest and serious work, we are told that there is no place in contemporary journalism for a magazine that features greatness. Instead there's only pap and glitz. I think there's an audience for a stimulating and stirring mass-market magazine that would make use of outstanding photojournalistic work that is available.

On Photographer Bashing

I am strongly opposed to bashing of any kind—gay bashing, Jew bashing, or any other kind of violence directed at any specific group. The recent wave of attacks on the media, specifically on photographers, is particularly disturbing because it puts at risk photographers who have a mandate to report the news. Although it also happens in other parts of the United States, New York's provocative racial cases precipitated an outburst of violence against photographers. The New York Press Photographers Association protested to Mayor Dinkins of New York City that there was a lack of police protection for the press outside the Brooklyn courthouse in East New York.

The attacks took place after the conviction of Joseph Fama on murder charges stemming from the shooting death of Yusef Hawkins, a young black man who was killed by a gang of white youths in Bensonhurst. On May 17, 1990, John Roca, a *Daily News* photographer, was assaulted and knocked unconscious; *New York Times* staffer Michelle Agins was punched in the chest and had to be hospitalized, and Philip Davies of *Newsday* was knocked to the ground. The next day, five mobile television vans, seeking community comment on the Fama conviction, were battered and vandalized. Television reporters and camera crews were attacked.

This followed on the heels of the Teaneck, New Jersey, riots in which young men protested the shooting death of a black teenager. They turned their anger on the press covering the event and injured several photographers in the process. To many people, particularly in urban America, the press has become the

enemy. Photographers, editors, assignment editors, and thoughtful people will have to come to grips with this escalating threat to the press's right to cover these events. They will also have to confront the reasons that some people view the media as an enemy rather than an advocate.

On My Love Affair with Black-and-White Photography

I like color photography, but I love black-and-white pictures. As I sit in my workroom and look at the walls, 95 percent of the photographs I see are black and white. In the 1990s, when every magazine is filled almost completely with color photography, when advertisements are almost all color, I feel suffocated by color. I realize that we see in color, dream in color, and it is color that adds another dimension. But color photography too easily overromanticizes its subject matter, softening and beautifying the stark ugliness of pollution as death-dealing effluent pours into our waters, or capturing piles of dead bodies in lovely living color. Documentary black-and-white pictures hit you where you live. They are direct, realistic, and undiluted by the gentling nuances that color brings to photographs. I wish more magazine picture editors would stump for publication of black-and-white photographic essays in the great tradition of photojournalism.

I recently saw a two-page advertisement in *Graphis* magazine that featured a black-and-white photograph by Magnum's Sebastiao Salgado, taken from his book *The Other Americas.* An accompanying quote read, "The great pleasure for me comes when I am able to establish a relationship of deep complicity and mutual respect with people. Only the honesty and purity of the black-and-white medium, stripped of everything but the essential, allow me to transpose the richness of these human relationships into images."

Whose Responsibility Is It, Anyhow?

There was a time in photojournalism when important photographic projects were sponsored and supported by worldwide magazines. In recent years, the responsibility has devolved primarily on individual photojournalists and in some cases the photographic agencies that represent them. The picture editors of the world have an easy job, knowing that all they need do is sit back, and a constant flow of material will be brought them without any commitment or financial risk on their part.

Such passivity in spite of their financial resources imposes a burden on those least able to afford risk, the individual photographers. Hard-hitting photo-

journalism demands that the mega-media give greater support to the people who give them pictures; otherwise they abdicate their editorial responsibility.

On Participatory Photojournalism

Many people in photojournalism worship objectivity, defining the role of the photojournalist as a dispassionate observer. I disagree. Why shouldn't a photographer have a point of view to articulate, a cause to sponsor or back, or an opinion to advance? I don't believe that anyone in the editorial pecking order can be completely objective in journalism. We are all conditioned by who we are, our socioeconomic status, the education that has shaped our thinking, the political philosophy that governs us, or the relative degree of humanity that affects our actions. That doesn't mean that the photojournalist or journalist has the right to distort reality to conform to opinions of others. Subjectivity in journalism carries with it an obligation to be fair, to present the other side even if it is personally antithetical to your thinking.

During the 1960s, the extensive coverage by Black Star photographers of the civil rights struggle was attributable to my personal belief that the denial of civil rights to a segment of our population was unconstitutional. My sympathies were with those who were willing to bear witness with their bodies and go to jail for civil disobedience, defying discriminatory state laws in the South. I make no apologies for having used my position as a picture agent to encourage publication of pictures, earlier mentioned, when police dogs and fire hoses were used on the demonstrators.

Photographers throughout the years have used their special access to the media to effect change where they thought it was necessary. Jacob Riis's and Lewis Hine's social consciousness brought attention to the plight of poor immigrants and the abuses of child labor; the Farm Security Administration photographers spotlighted social issues during the Great Depression; W. Eugene Smith protested against the human devastation wreaked by environmental pollution. Subjectivity practiced in the name of necessary social and political change should not be condemned.

On the Fragility of Photojournalistic Marriages and Relationships

"Being there" is another necessity for the international photojournalist who wants to be responsive to what is going on. It means having your bags packed, your equipment at the ready, your visas and vaccinations in good order, and

then chasing around the world, responding to each international flare-up as it occurs. It means being away from home and jeopardizing your personal life.

Professional photography, in general, and photojournalism, in particular, strain relationships. Nature photography and travel photography also require extensive world travel and become demanding and destructive. It takes tough and strong people to withstand strains brought on by broken dinner dates with friends, cancelled theater engagements, postponed vacations, and neglected children. A lover can subordinate himself or herself to a partner's career, but I have noted through the years that permanent separations follow. Finding a balance between career and family is a trial for all people in all professions, but it is the most difficult human equation to resolve in the photojournalism profession.

National Geographic magazine understood this very well. At one time *Geographic* had a policy of allowing photographers on inordinately long assignments to take their spouses along for a time at the magazine's expense. In the 1990s, under the pressure of economic retrenchment for magazines, even the traditionally generous *Geographic* has pulled back from such expenditures.

Donna Ferrato says, "The problem facing women is that if you're going to be a photojournalist, you have to spend a lot of time away from home. If you want to share your life with someone, want to have a family, you don't like being in hotel rooms year after year. In order to be competitive with men, you have to have a strong base supporting you, a base of friends and family to allow you to be responsive to the demanding needs of this profession."

Women photographers who have put off childbearing until their late thirties— a period often coinciding with the peak of their careers—are particularly vulnerable to the conflicting pressures of home and family versus the job. In a highly publicized case, Meredith Viera, who worked for "60 Minutes," requested that she be excused from full-time duty to have her second child. Her boss, Don Hewitt, refused, maintaining that he needed full-time reporters and could not acquiesce to her personal needs.

Carol Guzy says,

> Children? It's a constant conversation between my husband and me. He's been ready to have kids for years now, but I've been hesitating because our life style is so unstable. We both do want to have a family. The *Washington Post* is pretty good about maternity leaves. But afterwards is a factor. Day care is incredibly expensive. The *Post* is also pretty good about job sharing. But it's a lot of money you give up. And in an expensive place like Washington it won't be easy.

The human need for stability and roots is basically in conflict with the requirements of the job. In order to succeed professionally, the photographer must give up a great deal. The unattached life-style appeals best to the young in search of an adventure, but a day comes when split-second relationships are no longer satisfying.

On Photographic Pools and Journalistic Access

There were two enemies in the Persian Gulf war: Saddam Hussein and the press. Saddam Hussein remained intransigent and stayed stolidly on an insane course, which caused the destruction of Iraq's infrastructure as well as unbearable hardship on its people. The stunning victory of American technology quickly subdued an Iraqi Army whose military strength had been overestimated or misjudged based on Iraqi claims that had little basis in fact.

The victory over the press corps was achieved before the war in the Gulf began. The press surrendered when it accepted the government ground rules. They limited the access of journalists to the events, and all material was pooled and censored under the jurisdiction of the Joint Information Bureau. These rules provided for the artificial orchestration of the war, denied the people's right to know, and substituted censorship and military briefings for the traditionally independent, courageous, and enterprising coverage that usually obtained.

The invasions of Grenada and Panama were the precursors of the Gulf War. In those two theaters, photographers and writers were under strictly supervised pools, and in Panama the press was kept at a military base for forty-eight hours after the action started in Panama City. The press corps has been unable to reassert its prerogatives since.

In essence, during the Gulf War the international press corps, photographers included, became unpaid propagandists for the U.S. Department of Defense. Supervised coverage and ubiquitous censorship wherever photographs were to be made turned a vigorous press corps into an anguished, unhappy one. The capture of Bob Simon and his CBS colleagues underscored the desperate lengths that committed journalists took to circumvent the government mandates that had superseded their initiative.

When Vice President Quayle said that there would be "no more Vietnams," the majority of the American public believed this meant that the coalition forces would not be forced to fight the war with one hand behind its collective back. To the press it meant that official policy toward the press had changed. The Bush administration sanitized their war for the public and would not

repeat what, in their view, was the mistake of the Vietnam War: letting the press reports and images turn the people against the war.

Photographic pools have been with us for at least forty years. Veteran Washington hand Dirck Halstead, of *Time* magazine, recalls, "White House pools go back at least to the Kennedy years. Since then we have always had them to a certain extent. The pool system was institutionalized and set in stone during the Nixon years with the addition of more photographers who wanted to cover the White House and major events."

It was during the Nixon years that the "expanded pool" concept was born. The expanded pool consisted of the Associated Press, UPI, *Time, Newsweek,* the three networks, the *Washington Post,* and the *New York Times.* Inclusion of regional newspapers was occasionally possible as part of the open-press availability on special events.

For certain events there evolved what is known as a "tight pool." The tight pool includes the Associated Press, UPI and/or Reuters, one magazine, and one network. The tight pool is used only for protective purposes to be sure that an event is being covered along with any other newsworthy contingencies which might come up.

After the debacle in the coverage of the Grenada conflict from which the press was excluded, the Sidle Commission, a blue-ribbon commission, was convened to resolve this troubling issue. On the basis of the Sidle Commission recommendations, the Department of Defense pool was established in 1985. The D. O. D. pool consisted of *Time, Newsweek, U. S. News and World Report,* the Associated Press, and Reuters. The three newsmagazines agreed to rotate responsibility so that one still photographer would be available on a moment's notice to respond to a military emergency. In that way, all three publications have access to the coverage. The release of those pictures is limited to the news magazines, on the theory that the news magazines have made a substantial commitment in manning the pool on a permanent basis. Other publications can get pool material from Associated Press and Reuters.

The extent of governmental control over journalists did not emerge during the euphoric period following the swift and spectacular coalition victory in the Gulf War. Pulitzer Prize-winning photojournalist David Turnley returned from the front and learned that none of his photographs of U.S. casualties had been released by the Joint Information Bureau to any newspapers and magazines. The Joint Information Bureau, a euphemism for the U.S. government pool, seems to have been designed to suppress pictures, not for security reasons, but to forestall showing any that might adversely affect public perceptions of the U.S. involvement in the Gulf War.

Turnley is reported to have been the only pool photographer who maneuvered to have his own vehicle at the front and was able to drive away from his assigned unit to penetrate enemy lines. After learning that his film had not been distributed, he personally rescued the film from the Joint Information Bureau, distributed the photographs himself to Associated Press, his own newspaper, and some magazines. This resulted in the extensive use of his series on a MASH unit and the use of one memorable picture of a wounded GI crying over the death of a fellow U.S. soldier.

The public little understands how they are being manipulated by a political and military hierarchy eager to mask its political agenda in the name of patriotism. Polls have indicated that 80 percent of the U.S. public think that military censorship may be a "good idea." I disagree. There is no evidence that the press historically has been guilty of compromising military security or has leaked strategy that has given aid and comfort to the enemy. The press is sensitive to the need to maintain security in order to protect the safety of the troops. There were no instances in the Vietnam War of either press reports or photographs jeopardizing security. The press could be counted on again to be responsible, to go beyond the Nintendo transmission of Pac Man imagery, and to provide the memorable images that reflect the human side of the war so important in informing the public. Reporters and photographers universally complained about the open hostility exhibited by military personnel, who refused to take journalists to areas or units they requested. One reporter said that he was kept a virtual prisoner in a camp ringed by concertina wire to forestall his movements.

It is useful to look back in history and recall that during World War II, photographers were given greater freedom. In fact most were assigned to units and sent to the battlefield for long periods. This was equally true during the Korean War. Although photographic access was less restricted in both wars, military censorship was very much in evidence, thus affecting the public knowledge of events as they unfolded. We know that some of the most famous images from World War II were not seen or published until much later on. Pictures of the destruction of the American fleet at Pearl Harbor were not published until 1943. The first picture of dead American GI's at Buna Beach was published in *LIFE* months after the battle. There was always concern by the military that the sensibilities of the civilian population would be offended. Fortunately the historical record was preserved even though censorship prevented the immediate release of some important photographs.

Agence France Presse, now one of the big three wire services, along with Associated Press and Reuters, brought suit against the government for denying

their photographers access during the Gulf War, using the First Amendment and the Fifth Amendment as the basis for their action. The case was tried before New York Judge Leonard Sands.

Judge Sands dismissed the action for technical reasons, but according to Washington lawyer Joshua Kaufman, who represented AFP, "if there is such a thing as a Pyrrhic loss, this was it. The judge gave us everything we wanted to establish except for ruling the specific Desert Storm guidelines unconstitutional. He recognized the principle that if a war is open to one segment of the media, it is open to all. The judge ruled, however, that the remedy sought by AFP and other organizations like *The Nation* and *The Village Voice* was not specifically focused."

Judge Sands ruled that the court does indeed have jurisdiction and right of review of Pentagon policies, that Agence France Presse did have legal standing and was harmed by the restrictive policies of the Pentagon, that there is an inherent right of access by the media, and that coverage of such events as the Gulf War cannot be handled in a discriminatory manner. Agence France Presse had claimed that despite being a French organization it has a major presence in the United States by virtue of reaching forty-four million people and thus serving the American public.

The battle of access has yet to be fought. It needs to be fought and resolved in a more equitable manner. Censorship and limited access are the weapons of closed societies. Democracies pride themselves on their respect for the public's right to know, for better or for worse, no matter how painful the news brought by the messenger is.

Dan Rather once wrote in a *New York Times* op-ed piece that "News is a business. It always has been. But journalism is something else, too. Something more. News is a business, but it is also a public trust. That trust is to report the news accurately and fairly, with independence, courage, completely, and with a sustained commitment to excellence."

Government limitations imposed on the press in the Gulf War defy that public trust. It is time for democratic governments to be made to understand that no further erosion of the rights of a free press will be accepted. The initiative must come from the combined efforts of all segments of the media joining in a concerted action versus the government so that these limitations on press freedoms will not be tolerated. Governments are dependent on the media to disseminate messages to the public and would be impelled to recognize a powerful protest.

At the same time, it seems such a waste to have many photographers attend an international summit meeting, each one to make the same basic controlled

images supplemented by the released pool pictures. Wouldn't it make more sense if the news magazines, newspapers, and general-interest magazines and world publications would use that money for special documentary coverage of subjects where an individual stamp was evident.

On Photographic Censorship and the Law

The Supreme Court of the United States has established three basic criteria for the judgment of what is obscene, pornographic, and unacceptable to society. To be defined as pornographic, photography, like the other arts, must be patently offensive, appeal to the prurient interest, or be without artistic merit.

For almost two centuries, U.S. courts have been wrestling with the question of pornography, what it is, and how to deal with it in terms of public and social policy. I remember one wit who said that "pornography is in the groin of the beholder."

The Supreme Court has repeatedly reinforced the 1934 ruling that James Joyce's once-banned novel, *Ulysses,* had to be judged as a whole, that passages of work cannot be taken out of context to make a case for criminal obscenity.

Many cases are cited to amplify that position. But most important to its argument is what is referred to as the "Miller test," which derives from the Supreme Court decision in the appeal on *Miller vs. California* (1973).

Marvin Miller appealed his conviction for mailing unsolicited, sexually explicit material in violation of a California statute. Under the Miller test, the protection of the First Amendment was deemed applicable unless it is found that: (1) the average person, applying contemporary community standards, would find that the work appeals to prurient interest, (2) the work depicts, in a patently offensive way, sexual conduct specifically defined in the applicable law, and (3) the work lacks serious literary, artistic, political, or scientific value.

The Robert Mapplethorpe controversy, in which seven photographs were deemed obscene by the city of Cincinnati, and a felony indictment was brought against the Contemporary Arts Center and its director, Dennis Barrie, will prove to be a landmark case. It will have important implications for the future of journalistic photography. The 7 pictures out of 175 in the Mapplethorpe exhibit were homoerotic and sexually explicit. One shows a finger inserted in a penis, another a forearm inserted in an anus. To those passionately concerned with artistic freedom, the jury's decision that the pictures had artistic merit has been welcomed with relief. Few are convinced, however, that continued attacks on the artistic establishment will not be forthcoming in the future.

Although Mapplethorpe was not a photojournalist, the Cincinnati case has great significance for photographers who choose to explore human sexuality as part of the social landscape and their endeavor to photographically interpret and capture the erotic. Like writers, painters, and sculptors, some photographers have been excited by the camera's ability to record sensual as well as sexual reality. These photographers define their own limits and boundaries. What they have in common is the need and desire to test the limits to which they can push public acceptance of their work and the receptiveness of subjects to be photographed in an area of great personal privacy.

On "Droit de Regard"—"The Right to Look"

Do photographers have the right to control their work, how their pictures are captioned, whether their pictures are to be cropped at the discretion of the graphic designers, and how their pictures are to be finally used on the pages of newspapers and magazines? These are the questions at the heart of the "droit de regard" movement, which began in Arles in 1989 and has since been primarily nurtured by important European-based photographers. Such famous names as Henri Cartier-Bresson, Marc Riboud, William Klein, and Gilles Peress are among the signatories to the group's manifesto.

"Droit de regard" maintains that publishers, historically, have treated photojournalists' work with less respect than they have that of writers. There are glaring instances where the word of photographers as witnesses to events has been ignored by editors, where in the opinion of photographers their pictures have been badly edited or badly laid out with little understanding by the picture editors or graphic designers of the meaning of the pictures and the context in which they were taken. To correct such editing and publishing deficiencies, these photographers are crusading for a greater voice in the use of their material and demanding that the traditional relationship between photographers and editors and art directors be altered.

I don't see this as a black-and-white issue. Too often publishing decisions are made by visual illiterates with little concern and understanding for the photojournalistic process. They treat photographers like plumbers who are bringing back images designed to fit preconceived holes on the printed page. I think the publishing process would be well served if it were more responsive to the information the photographer-witness brings back from the assignment. Eliciting the opinions of the photographer-creator makes great sense on every level— human, professional, artistic, and aesthetic. Such give-and-take communication can only improve the final product. However, the publishing process is a compli-

cated one predicated on tight deadlines that don't always allow for review and consultation with the photographer. If I were an editor and publisher, I would be hesitant to surrender complete control of my editorial product to certain over-bearing and unreasonable photographers. To others, I would be happy to open my doors and my editorial pages for their constructive input.

The answer lies in consciousness raising and sensible negotiation. Editors should recognize the legitimate concerns of photojournalists and make an attempt to accommodate them. Photographers should be equally responsive to the justifiable needs of magazines and newspapers and understand the editorial reluctance to surrender control over the final product. But reasonable compromise is hard to accomplish. It is, however, a worthwhile goal that would benefit photographers and publications alike.

On "Being There"

There is a school of photojournalism which uses "f8 and be there" as its credo for great photography. "Being there" is not enough. Why is it that photographers covering the same event produce pictures of varying and dramatically different quality? Because each photographer has an individual point of view reflected in the elements that photographer chooses to shoot. Because each photographer sees differently. Because each photographer has a differing technical background, which dictates the lenses he or she uses. And because events don't make pictures. Living, breathing, thinking, unpredictable human beings do.

Point-and-shoot cameras do just that. They have a technical brain designed to give good exposures so that one doesn't have to master the intricacies and correlations of f-stops, shutter speeds, and film speeds. Great journalistic photography is a spontaneous fusion of serendipitous elements coming together under the discriminating control of the photographer. There are few great pictures that happen by accident. They happen because the photographer was trained to instinctively react to the moment of decision, isolate the center of interest in a scene, and surround it with the peripheral elements that enhance its storytelling capabilities.

On Getting Close Enough

The words of Robert Capa have become a mantra for the war photographer. He said, "If your pictures aren't good enough, you're not close enough." It dominated his whole approach to war photography, propelled him into the

middle of battle, and exposed him to constant danger. I think that getting close enough is important not just to war photographers, but to all photojournalists who want to get past the superficial.

Don McCullin, in expressing his admiration for the work of William Klein, said, "His photographs were always taken as though the camera were almost rammed up the very nose of the subject." Eugene Richards is another photographer who is so close to his subject matter, sometimes so painfully close, that one gets the feeling that his camera has pierced the skin and literally peeled it away to reveal hidden layers of emotion.

Getting close to the action with the camera does not automatically produce great pictures. Developing a relationship with subjects and an understanding of their lives is perhaps more important than the distance from which you photograph. In order to show what life is like for people in prison, for example, the photojournalist has to know and feel what it's like to have one's freedom curtailed and be confined to one room with bars. The photographer can only find out by gaining the confidence of the prisoner or prisoners, by drawing out the prisoner's thoughts, by getting "close."

Too many photojournalists today stand back when they observe and record moments, afraid to take that extra step to make more pictures. It often results in a cold, clinical approach. Getting close is not easy, but it is worth the effort.

Epilogue: Photojournalism 2000— A Look into the Future

The mind of man is capable of anything—because everything is in it, all the past as well as the future.

Joseph Conrad, *Heart of Darkness*

I am as reticent about trying to look into journalism's future as I am about predicting my own. It is hard to believe that someone who is still incapable of dealing with the intricacies of the VCR, who is terrified of the technological revolution in photography, could have an oracular view of the future.

Looking back on the fifty years of my involvement with photojournalism convinces me, however, that fear of the future is irrational, that past continues to be prologue. Many dramatic changes have taken place in press photography and photojournalism during my time. The sky has not fallen. The cumulative effect of those changes has been for the better. More photographers are producing better work on every level of journalistic photography. They bear out the old French axiom, "plus ça change, plus c'est la même chose."

Changes are taking place in photography with unprecedented speed. The world of digital imaging is at hand. The newspapers and magazines of the future will be electronically produced. A new Kodak electronic camera back that fits on a Nikon F3 is yet another new technological development that leads us toward electronic cameras and may eventually eliminate negatives and transparencies. The universal digital transmission of images will become commonplace in just a few years.

We, who have been used to doing things the old way—taking pictures, handing them over to picture editors at the newspaper, or shipping the film to magazines by couriers—have two alternatives. We can sit around and whine

about our collective condition, cry about the cards that fate has dealt us, and anticipate the worst. Or we can welcome the new technology, turn it to our advantage, and make life easier for ourselves.

Listening to photographers, I have heard their concerns. With the advent of computerized equipment and the introduction of electronic still-camera systems, it is now possible to quickly and easily combine elements, change colors, and manufacture photographs, and they say we are on the brink of widespread abuses of that capability that will deeply affect the credibility of journalistic photography. They are worried about copyright protection and envision the selection and combination of visual elements from several photographs to create new images with new meanings. They see a day when photographic collages à lá Rauschenberg will replace the good old-fashioned news photographs that captured the reality of things as they are, or rather, were.

Those are real concerns. But we shouldn't forget that it has been possible throughout the history of photography to alter photographs. I fear that this excessive preoccupation with the subject of manipulation will create a self-fulfilling prophecy. Unethical people will continue to do unethical things; supermarket tabloids will continue their outrageous, competitive journalism; and ethical journalists will be more on guard against abuses than ever before. Journalism is thoroughly imbued with the highest sense of ethics, as indicated by the new resolution of the NPPA on the subject of image manipulation.

But even more important is the worry that digital imaging will make photography ridiculously easy, that enterprising photographers will be replaced by novices, that communicative pictures with content will give way to snapshots. I don't believe those things will happen.

The photographic technology used today is dramatically different from that used in 1941 when I first started in this profession. The tools of early photojournalism, the Rolleiflex and 4" x 5" Speed Graphics and Linhofs, have been replaced with 35mm cameras. The need to use flashbulbs, sometimes four on an indoor exposure, has been obviated by high-speed films, which allow one to take pictures in virtual darkness. Journalistic pictures today are better and more spontaneous than the pictures of yesteryear. The current technology has enabled photographers to penetrate intimate subject matter that would have been unattainable previously, because of former technological strictures.

What worries me is that the evolution and development of emerging technologies have spawned new photographic marketing techniques that trivialize and demean photographs. CD-ROM (Read Only Memory) disks are being used to distribute photographs as "clip art," with no restrictions on the purchaser's ability to use the photographs. A typical CD selling for one hundred

dollars contains one hundred photographs, usually on specialized subject matter. It is outrageous to sell pictures for unlimited use in perpetuity for a dollar per photograph, even if in the aggregate it generates a substantial financial return. This marketing philosophy of selling photographs by the pound threatens the existing pricing structure, which has been developed over decades.

Photographers looking to the future should be schooling themselves in computer technology, desktop publishing, and making their own CD-ROMs. The future is now. The new jargon, which includes words and phrases like "interactive" and "information highway," is only the forerunner of the vocabulary that will define the photojournalism of tomorrow. The probable advent of electronic books, newspapers, and magazines will not eliminate the need for photographs. The new media may give new life to documentary photography and allow for the use of many more pictures in a series than are now possible on the printed page.

By the year 2000, I expect we will have learned how to tame threatening technological innovations and the electronic imaging monsters. The demand for thinking photographers will still be there. No technology can replace the mind. No machine can heighten one's vision. No electronic darkroom can compose as well as the mind's eye. The same kind of photographers who have justifiably dominated photojournalism throughout its history will be equally well rewarded in tomorrow's communications world.

Bibliography

Abbott, Berenice. *The World of Atget.* New York: Horizon Press, 1964.

Abell, Sam. *C. M. Russell's West.* Charlottesville, Va.: Thomasson-Grant, 1987.

———. *Distant Thunder: A Photographic Essay on the Civil War.* Charlottesville, Va.: Thomasson-Grant, 1988.

———. *Stay This Moment.* Charlottesville, Va.: Thomasson-Grant, 1990.

Adams, Ansel. *An Autobiography.* Boston: New York Graphic Society/Little Brown, 1985.

———. *Yosemite and the Range of Light.* Boston: New York Graphic Society/ Little Brown, 1979.

Ansel Adams, A Monograph. Hastings-on-Hudson, N.Y.: Morgan & Morgan, 1972.

Adelman, Bob, with text by Raymond C. Carver. Introduction by Tess Gallagher. *Carver Country: The World of Raymond Carver.* New York: Charles Scribner's Sons/Macmillan, 1990.

Adelman, Bob, with text by Ira Glasser. *Visions of Liberty: The Bill of Rights for All America.* New York: Arcade Publishing/Little Brown, 1991.

Adelman, Bob, and Susan Hall. *Down Home.* New York: McGraw-Hill, 1972.

———. *Gentleman of Leisure.* New York: New American Library, 1973.

———. *Ladies of the Night.* New York: Trident Press/Simon & Schuster, 1973.

Adelman, Bob, with text by Michael Harrington. *The Decline and Rise of the United States.* New York: Holt, Rinehart & Winston, 1981.

Adelman, Bob, with text by Calvin Tomkins. *Roy Lichtenstein: Mural with a Blue Brush Stroke.* New York: Harry N. Abrams, 1986. Reissued New York: Arcade Publishing/Little Brown, 1994.

Alland, Alexander, Sr. *Jacob Riis, Photographer-Citizen.* New York: Aperture Foundation, 1974.

Diane Arbus. New York: Aperture Foundation, 1972.

Arbus, Diane. *Diane Arbus: Magazine Work.* New York: Aperture Foundation, 1984.

Arnold, Eve. *All in a Day's Work.* New York: Bantam Books, 1989.

———. *In China.* New York: Alfred A. Knopf, 1980.

The Associated Press. The Instant It Happened. New York: Associated Press, 1972.

Attwood, Jane Evelyn. *Legionnaires.* Paris: Editions Hologrammes, 1986.

———. *Nachtlicher Alltag.* Munich: Mahnert-Lueg Verlag, 1980.

Avedon, Richard. *In the American West.* New York: Harry N. Abrams, 1985.

Avedon, Richard, and James Baldwin. *Nothing Personal.* New York: Atheneum, 1964.

Balog, James. *Anima.* Boulder, Colorado: Arts Alternative Press, 1993.

———. *Survivors: A New Vision of Endangered Wildlife.* New York: Harry N. Abrams, 1990.

———. *Wildlife Requiem.* New York: International Center of Photography, 1984.

Bischof, Marco, and Rene Burri, eds. *Werner Bischof 1916–1954.* Boston: Bullfinch Press/Little Brown, 1990.

Bourke-White, Margaret, and Erskine Caldwell. *You Have Seen Their Faces.* New York: Viking, 1937. Reissued New York: Arno Press, 1975.

Brandt, Bill. *Portraits.* Austin: University of Texas Press, 1982.

———. *Shadow of Light.* New York: DaCapo Press, 1977.

Brassai. *The Secret Paris of the 30's.* New York: Pantheon, 1976.

Larry Burrows, The Compassionate Photographer. New York: Time, 1972.

Callahan, Harry. *Photographs.* Santa Barbara, Calif.: El Mochuelo Gallery, 1964.

Callahan, Sean, ed. *The Photographs of Margaret Bourke-White.* New York: Bonanza Books/Macmillan, 1972.

Capa, Cornell. *The Concerned Photographer.* New York: Grossman, 1968.

———. *The Concerned Photographer 2.* New York: Grossman, 1972.

Capa, Cornell, ed. *ICP Library of Photographers.* New York: Grossman, 1974.

———. *Israel/The Reality.* New York: World Publishing, 1969.

———. *Jerusalem: City of Mankind.* New York: Grossman, 1974.

Capa, Cornell, with text by Elizabeth Elliot. *Savage My Kinsman.* New York: Harper & Row, 1959.

Capa, Cornell, and Matthew Huxley. *Farewell to Eden.* New York: Harper & Row, 1964.

Capa, Cornell, with Inge Morath, and John Fell Stevenson. *Adlai E. Stevenson's Public Years.* New York: Grossman, 1966.

Capa, Cornell, and Richard Whelan. *Cornell Capa Photographs.* Boston: Bulfinch Press/Little Brown, 1992.

Capa, Robert, and Cornell Capa. *Capa and Capa: Brothers in Photography.* New York: International Center of Photography, 1990.

Carlebach, Michael L. *The Origins of Photojournalism in America.* Washington, D.C.: Smithsonian Institution Press, 1992.

Carlebach, Michael, and Eugene F. Provenzo, Jr. *Farm Security Administration Photographs of Florida.* Gainesville: University Press of Florida, 1993.

Henri Cartier-Bresson: Photographer. Boston: New York Graphic Society/Little Brown, 1979.

Cartier-Bresson, Henri. *The Decisive Moment.* New York: Simon & Schuster, 1952.

———. *In India.* London: Thames & Hudson, 1987.

Chapnick, Howard, ed. Photographs by Thulani Davis. *Malcolm X: The Great Photographs.* New York: Stewart, Tabori & Chang, 1993.

———. Photographs by Gene Anthony. *The Illustrated Eternal Sea.* New York: Grosset & Dunlap, 1976.

———. Photographs by Ivan Massar. *The Illustrated World of Thoreau.* New York: Grosset & Dunlap, 1974.

———. Photographs by Ivan Massar. *Take Up the Song,* by Edna St. Vincent Millay. New York: Harper & Row, 1986.

———. *The Illustrated Leaves of Grass,* by Walt Whitman. New York: Grosset & Dunlap, 1971.

Clark, Larry. *Tulsa.* New York: Lustrum Press, 1971.

Clarkson, Rich. *Notre Dame Football Today.* New York: Pindar Press, 1992.

Coleman, A. D. *Light Readings in Photography: Critic's Writings 1968–1978.* New York: Oxford University Press, 1979.

Cosindas, Marie. *Color Photographs.* Boston: New York Graphic Society/Little Brown, 1978.

Cunningham, Imogen. *Imogen!* Seattle: University of Washington Press, 1974.

Danziger, James, and Barnaby Conrad, III. *Interviews with Master Photographers.* London: Paddington Press, 1977.

Davidson, Bruce. *Bruce Davidson Photographs.* New York: Agrinde Publications, 1978.

———. *East 100th Street.* Cambridge: Harvard University Press, 1970.

A Day in the Life of America. New York: Collins, 1986.

A Day in the Life of Australia. Sydney: A Day in the Life of Australia Pty., 1981.

A Day in the Life of California. San Francisco: Collins, 1984.

A Day in the Life of Canada. Toronto: Collins, 1984.

A Day in the Life of China. San Francisco: Collins, 1989.

A Day in the Life of Hawaii. New York: Workman, 1984.

A Day in the Life of Hollywood. San Francisco: Collins, 1993.

A Day in the Life of Ireland. San Francisco: Collins, 1991.

A Day in the Life of Italy. San Francisco: Collins, 1990.

A Day in the Life of Japan. New York: Collins, 1985.

A Day in the Life of the Soviet Union. New York: Collins, 1987.

A Day in the Life of Spain. San Francisco: Collins, 1988.

DeKeyzer, Carl. *God Inc.* Amsterdam, Holland: Uitgeverij Focus, 1992.

Doisneau, Robert. *Three Seconds from Eternity.* Boston: New York Graphic Society/Little Brown, 1979.

Doty, Robert. *Photography in America.* New York: Random House, 1974.

Duncan, David Douglas. *Goodbye Picasso.* New York: Grosset & Dunlap, 1961.

———. *Self-Portrait U.S.A.* New York: Harry N. Abrams, 1969.

———. *The Silent Studio.* New York: W. W. Norton, 1976.

————. *This Is War! A Photo Narrative of the Korean War.* Boston: Little Brown, 1951.

————. *War without Heroes.* New York: Harper & Row, 1970.

————. *The World of Allah.* Boston: Houghton Mifflin Company, 1982.

Edey, Maitland. *Great Photographic Essays from Life.* Boston: Little Brown, 1978.

Edom, Cliff, Vi Edom, and Vme Edom Smith. *Small Town America.* Golden, Colo.: Fulcrum, 1993.

Eisenstaedt, Alfred. *Eisenstaedt on Eisenstaedt.* New York: Viking Press, 1985.

————. *Eisenstaedt: People.* New York: Viking Press, 1973.

————. *Eisenstaedt: Remembrances.* Boston: Little Brown, 1990.

————. *The Eye of Eisenstaedt.* New York: Viking Press, 1969.

————. *Witness to Nature.* New York: Viking Press, 1970.

————. *Witness to Our Time.* New York: Viking Press, 1966.

Eppridge, Bill, and Hayes Gorey. *Robert Kennedy: The Last Campaign.* New York: Harcourt Brace & Co., 1993.

Erwitt, Elliott. *Photographs and Anti-Photographs.* Greenwich, Conn.: New York Graphic Society, 1972.

————. *Recent Developments.* New York: Simon & Schuster, 1978.

Evans, Harold. *Pictures on a Page: Photojournalism, Graphics and Picture Editing.* New York: Holt, Rinehart & Winston, 1978.

Evans, Michael. *Homeless in America: A Photographic Project.* Washington, D.C.: Acropolis Books, 1988.

Evans, Walker. *American Photographs.* New York: East River Press, 1975.

————. *Havana 1933.* New York: Pantheon Books/Random House, 1989.

Ewald, Wendy, ed. *Appalachia: A Self Portrait.* Foreword by Robert Coles. Text by Loyal Jones. Photographs by Lyn Adams, Shelby Adams, Robert Cooper, Earl Dotter, Will Endres, Wendy Ewald, and Linda Mansberger. Frankfurt, Ky.: Gnomon Press for Appalshop, Inc., 1979.

Farova, Anna. *Andre Kertesz.* New York: Paragraphic Books/Grossman, 1974.

Ferrato, Donna. *Living with the Enemy.* New York: Aperture Foundation, 1991.

Fralin, Frances. *The Indelible Image: Photographs of War—1846 to the Present.* New York: Harry N. Abrams, 1985.

Frank, Robert. *The Americans.* New York: Grossman, 1969.

Freed, Leonard. *Police Work.* New York: Simon & Schuster, 1980.

Freedman, Jill. *Circus Days.* New York: Crown, 1975.

————. *Jill's Dogs.* San Francisco: Chameleon/Pomegranate Artbooks, 1993.

————. *Old News and Resurrection City.* New York: Grossman, 1970.

————. *Street Cops.* New York: Harper & Row, 1981.

————. *A Time That Was: Irish Moments.* New York: Friendly Press, 1987.

Freedman, Jill, and Dennis Smith. *Firehouse.* Garden City, N.Y.: Doubleday & Co., 1978.

Fulton, Marianne. *Eyes of Time: Photojournalism in America.* Boston: New York Graphic Society/Little Brown, 1988.

Game Day USA: NCAA College Football. Charlottesville, Va.: Professional Photography Division Eastman Kodak/Thomasson Grant, 1990.

Gatewood, Charles. *Forbidden Photographs.* New York: Flash Productions, 1981.

Gatewood, Charles, with text by William S. Burroughs. *Sidetripping.* New York: Strawberry Hill Publishing, 1975.

Gatewood, Worth. *Fifty Years in Pictures: The New York Daily News.* New York: Doubleday, 1979.

Gentry, Diane Koos. *Enduring Women.* College Station: University of Texas Press, 1988.

Goldberg, Vicki. *Margaret Bourke-White: A Biography.* New York: Harper & Row, 1986.

————. *The Power of Photography: How Photography Changed Our Lives.* New York: Abbeville Press, 1991.

Goro, Fritz. *On the Nature of Things: The Scientific Photography of Fritz Goro.* New York: Aperture Foundation, 1993.

Greenough, Sarah, Joel Snyder, David Travis, and Colin Westerbeck. *On the Art of Fixing a Shadow: One Hundred and Fifty Years of Photography.* Boston: Little Brown/Bullfinch Press, 1989.

Griffith, Philip Jones. *Vietnam, Inc.* New York: Macmillan, 1970.

Grinker, Lori. *The Invisible Thread: A Portrait of Jewish American Women.* Philadelphia: Jewish Publications Society, 1989.

Haas, Ernst. *The Creation.* New York: Viking Press, 1971.

————. *Himalayan Pilgrimage.* New York: Viking Press, 1978.

————. *In America.* New York: Viking Press, 1975.

————. *In Germany.* New York: Viking Press, 1977.

Halsman, Philippe, and Yvonne Halsman. *Halsman at Work.* New York: Harry N. Abrams, 1989.

Halsman, Yvonne. *Halsman Portraits.* New York: McGraw-Hill, 1983.

Heyman, Abigail. *Dreams and Schemes: Love and Marriage in Modern Times.* New York: Aperture Foundation, 1987.

————. *Growing Up Female.* New York: Holt, Rinehart & Winston, 1974.

Heyman, Ken. *Hipshot: One-Handed Auto-Focus Photographs by a Master Photographer.* New York: Aperture Foundation, 1988.

————. *The World's Family.* New York: G. P. Putnam's Sons, 1983.

Heyman, Ken, and Lyndon Johnson. *This America.* New York: Ridge Press/Random House, 1966.

Higgins, Chester, Jr. *Drums of Life.* New York: Anchor Press/Doubleday, 1974.

Hine, Lewis. *In Europe: The Lost Photographs.* New York: Abbeville Press, 1988.

Hood, Robert E. *Twelve at War.* New York: G. P. Putnam's Sons, 1967.

Horenstein, Henry. *The Photographer's Source: A Complete Catalogue.* New York: Pond Press/Simon & Schuster, 1989.

Hughes, Jim. *W. Eugene Smith: Shadow and Substance.* New York: McGraw-Hill, 1989.

Hughes, Jim, and Alexander Haas. *Ernst Haas: In Black and White.* Boston: Bullfinch Press/Little Brown, 1992.

Johnson, Lynn. *Pittsburgh.* Charlottesville, Va.: Howell Press, 1987.

Johnson, Lynn, and Joel B. Levinson. *Pittsburgh Moments.* Pittsburgh: University of Pittsburgh Press, 1984.

Jury, Mark. *Playtime: Americans at Leisure.* New York: Harcourt Brace Jovanovich, 1977.

Jury, Mark, and Dan Jury. *Gramp.* New York: Grossman/Viking Press, 1976.

Kalergis, Mary Motley. *Mother.* New York: E. P. Dutton, 1987.

Karsh, Yousuf. *Karsh: A Fifty Year Retrospective.* Boston: New York Graphic Society/Little Brown, 1983.

Kertesz, Andre. *Diary of Light 1912–1985.* New York: Aperture Foundation, 1987.

———. *J'Aime Paris.* New York: Grossman, 1974.

———. *Sixty Years of Photography 1912–1972.* New York: Grossman, 1972.

Kismaric, Carole. *Forced Out: The Agony of the Refugee in Our Time.* New York: Random House, 1989.

Korniss, Peter. *Passing Times.* Budapest, Hungary: Athenaeum Press, 1985.

Koudelka, Josef. *Exiles.* New York: Aperture Foundation, 1988.

———. *Gypsies.* New York: Aperture Foundation, 1975.

Lange, Dorothea. *Masters of Photography Series #5.* New York: Aperture Foundation, 1981.

———. *A Monograph.* New York: New York Museum of Modern Art, 1966.

——— *Photographs of a Lifetime: A Monograph.* New York: Aperture Foundation, 1982.

Lanker, Brian. *I Dream a World: Portraits of Black Women Who Changed America.* New York: Stewart, Tabori & Chang, 1989.

Lartigue, Jacques Henri. *Diary of a Century.* New York: Viking Press, 1970.

Leekley, Sheryle, and John Leekley. *Moments: The Pulitzer Prize Photographs.* New York: Crown, 1978.

The Legacy of W. Eugene Smith. Camera International, American Edition, 1991.

Leibovitz, Annie. *Annie Leibovitz Photographs.* New York: Pantheon, 1983.

———. *Photographs 1970–1990.* New York: Harper Collins, 1991.

Let Truth Be the Prejudice. W. Eugene Smith Catalogue of Jewish Museum Exhibition. New York: Aperture Foundation, 1972.

Lieberman, Archie. *Farm Boy.* New York: Harry N. Abrams, 1974.

———. *The Israelis.* Chicago: Quadrangle Books, 1965.

———. *Neighbors: A Forty Year Portrait of an American Farm Community.* San Francisco: Collins, 1993.

Lieberman, Archie, and Robert Cromie. *Chicago.* Chicago: Rand McNally & Co., 1980.

LIFE: The First Fifty Years: 1936–1986. Boston: Little Brown, 1986.

Livingston, Jane. *The New York School: Photographs 1936–1963.* New York: Stewart, Tabori & Chang, 1992.

Lockwood, Lee. *Castro's Cuba, Cuba's Fidel.* New York: Macmillan, 1967.

Loengard, John. *Classic Photographs: A Personal Interpretation.* Boston: New York Graphic Society/Little Brown, 1988.

———. *Pictures Under Discussion.* New York: Amphoto, Watson-Guptill Publications, 1987.

Lyons, Danny. *The Bike Riders.* New York: Macmillan Co., 1968.

———. *Conversations with the Dead.* New York: Holt, Rinehart & Winston, 1969.

———. *Pictures from the New World.* New York: Aperture Foundation, 1981.

McCullin, Don. *Hearts of Darkness.* New York: Alfred A. Knopf, 1981.

———. *Homecoming.* New York: St. Martins Press, 1979.

———. *Is Anyone Taking Notice?* Cambridge: MIT Press, 1973.

MacDougall, Curtis. *Decision Making in Photojournalism: New Pictures Fit to Print—or Are They?* Stillwater, Okla.: Journalistic Services, 1971.

Magubane, Peter. *Black Child.* New York: Alfred A. Knopf, 1982.

Magubane, Peter, with text by Carol Lazar. Introduction by Nadine Gordimer. *Women of South Africa: Their Fight for Freedom.* Boston: Little Brown, 1993.

Manchester, William, and Fred Ritchin. *In Our Time: The World as Seen by Magnum Photographers.* New York: Norton, 1989.

Man Ray. *Photographs by Man Ray: 105 Works, 1920–1934.* New York: Dover Publications, 1979.

Mapplethorpe. Introduction by Arthur C. Danto. New York: Random House, 1992.

Mark, Mary Ellen. *Falkland Road: Prostitutes of Bombay.* New York: Alfred A. Knopf, 1981.

———. *Streetwise.* New York: Aperture Foundation, 1992.

Mark, Mary Ellen, and Karen Folger Jacobs. *Ward 81.* New York: Simon & Schuster, 1979.

Martinez, Romeo. *Erich Salomon.* Milan, Italy: Arnoldo Mondadori, 1980.

Mattison, Harry, Susan Meiselas, and Fae Rubinstein. *El Salvador: Work of Thirty Photographers.* New York: Writers and Readers Publishing Co., 1983.

Meiselas, Susan. *Nicaragua.* New York: Pantheon Books, 1981.

Meyer, Pedro. *Espejo de Espinas.* Mexico DF: Fondo de Cultura Economica S.A., 1986.

Meyerowitz, Joel. *Cape Light.* Boston: Museum of Fine Arts/New York Graphic Society, 1978.

Middleton, Harry. *LBJ: The White House Years.* New York: Harry N. Abrams, 1990.

Mili, Gjon. *Photographs and Recollections.* Boston: New York Graphic Society/
Little Brown, 1980.

Lisette Model: An Aperture Monograph. New York: Aperture Foundation, 1979.

Moments in Time: Fifty Years of AP News Photos. New York: Associated Press,
1984.

Moore, Charles. *Powerful Days: The Civil Rights Photography of Charles Moore.*
New York: Stewart, Tabori & Chang, 1991.

Moore, David. *Australian Photographer, Vol. 1.* McMahon's Point, Australia: Well-
ington Lane Press, 1988.

———. *Australian Photographer, Vol. 2.* McMahon's Point, Australia: Wellington
Lane Press, 1988.

Muenchner Illustrierte. (Available in U.S. libraries.)

Martin Munkacsi: An Aperture Monograph. New York: Aperture Foundation,
1992.

Mydans, Carl. *Carl Mydans, Photojournalist.* New York: Harry N. Abrams, 1985.

Nachtwey, James. *Deeds of War.* London: Thames & Hudson, 1989.

Newhall, Nancy. *Ansel Adams: The Eloquent Light: His Photographs and the
Classic Biography.* New York: Aperture Foundation, 1963.

Newhall, Nancy, ed. *The Daybooks of Edward Weston: Vol. 1 Mexico.* New York:
Aperture Foundation, 1961.

———. *The Daybooks of Edward Weston: Vol. 2 California.* New York: Aperture
Foundation, 1961.

Newman, Arnold. *Artists.* Boston: New York Graphic Society, 1980.

———. *One Mind's Eye.* Boston: David R. Godine, 1974.

Niccolini, Dianora. *Women of Vision: Photographic Statements by Twenty Women
Photographers.* Verona, N.J.: Unicorn Publishing House, 1982.

Norback, Craig T., and Melvin Gray. *The World's Great News Photos, 1840–1980.*
New York: Crown, 1980.

Norman, Dorothy. *Alfred Stieglitz: An American Seer.* New York: Aperture Foun-
dation, 1960.

O'Neal, Hank. *Berenice Abbott: American Photographer.* New York: McGraw-
Hill, 1982.

Orkin, Ruth. *A World through My Window.* New York: Harper & Row, 1978.

Owens, Bill. *Our Kind of People: American Groups and Rituals.* San Francisco:
Straight Arrow Press, 1975.

———. *Suburbia.* San Francisco: Straight Arrow Books, 1973.

———. *Working (I Do It for the Money).* New York: Simon & Schuster, 1977.

Parks, Gordon. *Flavio.* New York: W. W. Norton & Co., 1978.

———. *Moments without Proper Names.* New York: Viking Press, 1975.

———. *Voices in the Mirror: An Autobiography.* New York: Doubleday, 1990.

Penn, Irving. *Passage.* New York: Alfred A. Knopf, 1991.

———. *Worlds in a Small Room.* New York: Grossman/Viking Press, 1974.

Peress, Gilles. *Telex Iran: In the Name of Revolution.* New York: Aperture Foundation, 1983.

Peress, Gilles, and Nan Richardson. *A Double Diary of the Twin Cities.* Minneapolis: First Banks, 1986.

Phillips, John. *It Happened in Our Lifetime.* Boston: Little Brown, 1985.

Plattner, Steven W. *Roy Stryker: USA 1943–1950 The Standard Oil (New Jersey) Project.* Austin: University of Texas Press, 1983.

Pratt, Davis, ed. *The Photographic Eye of Ben Shahn.* Cambridge: Harvard University Press, 1975.

Reed, Eli. *Beirut: City of Regrets.* New York: W. W. Norton, 1988.

Riboud, Marc. *Photographs at Home and Abroad.* New York: Harry N. Abrams, 1986.

———. *Visions of China.* New York: Random House, 1981.

Richards, Eugene. *Below the Line: Living Poor in America.* New York: Consumer Union, 1987.

———. *Cocaine True, Cocaine Blue.* New York: Aperture Foundation, 1993.

———. *Dorchester Days.* Wollaston, Mass.: Many Voices Press, 1978.

———. *The Knife and Gun Club.* New York: Atlantic Monthly Press, 1989.

Richards, Eugene, and Dorothea Lynch. *Exploding into Life.* New York: Aperture Foundation/Many Voices Press, 1986.

Richardson, Jim. *High School USA.* New York: St. Martin's Press, 1979.

———. *The Colorado: A River at Risk.* Engelwood, Colo.: Westcliffe Publishing, 1992.

Ritchin, Fred. *In Our Own Image.* New York: Aperture Foundation, 1990.

Rodero, Cristina Garcia. *Espana: Fiestas y Ritos.* Madrid: Lunwerg Editores, S.A., 1992.

———. *Espana Oculta.* Madrid: Lunwerg Editores, S.A., 1989.

Rogovin, Milton. *The Forgotten Ones.* Seattle: University of Washington Press, 1985.

Rosenblum, Naomi. *A World History of Photography.* New York: Abbeville, 1984.

Rothstein, Arthur. *The Depression Years.* New York: Dover Publications, 1978.

Ruohomaa, Kosti, and Lew Dietz. *Night Train at Wiscasset Station.* New York: Doubleday, 1977.

Salgado, Sebastiao. *The Other Americas.* New York: Aperture Foundation, 1986.

———. *An Uncertain Grace.* New York: Aperture Foundation, 1990.

———. *Workers.* New York: Aperture Foundation, 1993.

Scharf, Aaron. *Pioneers of Photography.* New York: Harry N. Abrams, 1976.

Schulke, Flip. *King Remembered.* New York: Norton/Pocket Books, 1986.

———. *Martin Luther King, Jr.: A Documentary from Montgomery to Memphis.* New York: W. W. Norton, 1976.

———. *Your Future in Space.* New York: Crown, 1987.

Schulthess, Emil. *Africa.* London: Collins, 1959.

———. *Antarctica.* New York: Simon & Schuster, 1960.

———. *China.* London: Collins, 1966.

———. *Eternal Landscape.* New York: Alfred A. Knopf, 1988.

———. *Millions of Years Ago.* Zurich: Meridian Press, 1987.

———. *Soviet Union.* Zurich: Artemis Verlag, 1971.

———. *Swiss Panoramas.* Zurich: Artemis Verlag, 1982.

Scully, Julia, and Peter Miller. *Disfarmer: The Heber Springs Portraits 1939–1946.* Danbury, N.H.: Addison House, 1976.

Shames, Stephen. *Outside the Dream: Child Poverty in America.* New York: Aperture Foundation/Children's Defense Fund, 1991.

Shaw, Irwin. *Paris Magnum: Photographs 1935–1981.* New York: Aperture Foundation, 1981.

Smith, W. Eugene, and Aileen W. Smith. *Minamata.* New York: Holt, Rinehart & Winston, 1975.

Smolan, Rick, Philip Moffitt, and Matthew Naythons, M.D. *The Power to Heal.* New York: RxMedia Group/Prentice Hall Press, 1990.

Sochurek, Howard. *Medicine's New Vision.* Easton, Pa.: Mack Publishing Co., 1988.

Sontag, Susan. *On Photography.* New York: Farrar, Straus & Giroux, 1977.

Stack, Richard. *Warriors: A Parris Island Photo Journal.* New York: Harper & Row, 1975.

Steber, Maggie. *Dancing on Fire: Photographs from Haiti.* New York: Aperture Foundation, 1992.

Steichen, Edward. *The Family of Man.* New York: Museum of Modern Art, 1957.

Stein, Harvey. *Artists Observed.* New York: Harry N. Abrams, 1986.

Stettner, Louis. *Weegee.* New York: Alfred A. Knopf, 1977.

Strode, Bill. *Barney Cowherd Photographer.* Louisville, Ky.: *The Courier Journal & The Louisville Times,* 1973.

Stryker, Roy Emerson, and Nancy Wood. *In This Proud Land: America 1935–1943 as Seen in the FSA Photographs.* New York: Galahad Books, 1973.

Suau, Anthony. *Revolution.* New York and Tokyo: Takarajima Books, 1994.

Sudek, Josef. *Poet of Prague: A Photographer's Life.* New York: Aperture Foundation, 1990.

Sugar, Jim. "Under the Sun—Is Our World Warming?" *National Geographic,* October 1990.

Swanberg, W. A. *Luce and His Empire.* New York: Charles Scribner's Sons, 1972.

Szarkowski, John. *From the Picture Press.* New York: Museum of Modern Art, 1973.

———. *Looking at Photographs.* New York: Museum of Modern Art, 1973.

Tames, George. *Eye on Washington: The Presidents Who Have Known Me.* New York: Harper Collins, 1990.

Thornton, Gene. *Masters of the Camera: Stieglits, Steichen and Their Successors.* New York: Holt, Rinehart & Winston, 1976.

Tucker, Anne, ed. *The Woman's Eye.* New York: Alfred A. Knopf, 1975.

Turnley, David. *The Russian Heart: Days of Crisis and Hope.* New York: Aperture Foundation, 1992.

———. *Why Are They Weeping? South Africans under Apartheid.* New York: Stewart, Tabori & Chang, 1988.

Turnley, David, and Peter Turnley. *Beijing Spring.* New York: Stewart, Tabori & Chang, 1989.

———. *Moments of Revolution.* New York: Stewart, Tabori & Chang, 1990.

Uzzle, Burk. *All American.* St. Davids, Penn.: St. David's Books, 1984.

Vermazen, Susan, ed. *War Torn.* New York: Pantheon Press, 1984.

Vishniac, Roman. *Polish Jews: A Pictorial Record.* New York: Schocken Books, 1965.

———. *A Vanished World.* New York: Farrar, Straus & Giroux, 1983.

Wainright, Loudon. *The Great American Magazine: An Inside History of LIFE.* New York: Alfred A. Knopf, 1986.

Ward, Fred. *Golden Islands of the Caribbean.* New York: Crown, 1972.

———. *The Home Birth Book.* New York: Doubleday, 1977.

———. *Inside Cuba Today.* New York: Crown, 1978.

Ward, Fred, with text by Hugh Sidey. *Portrait of a President.* New York: Harper & Row, 1975.

Weil, Brian. *Fighting for Life: A Global Perspective on the AIDS Crisis.* New York: Aperture Foundation, 1992.

Whalen, Richard. *Robert Capa: A Biography.* New York: Alfred A. Knopf, 1985.

Winogrand, Garry. *Women Are Beautiful.* New York: Farrar, Straus & Giroux, 1975.

Women See Women: A Photographic Anthology by over Eighty Talented Photographers. New York: Thomas Y. Crowell, 1976.

Index